The World
According to Color

The World
According to Color
A Cultural History

JAMES FOX

ST. MARTIN'S PRESS
NEW YORK

First published in the United States by St. Martin's Press, an imprint of St. Martin's Publishing Group

THE WORLD ACCORDING TO COLOR. Copyright © 2021 by James Fox. All rights reserved. Printed in the United States of America. For information, address St. Martin's Publishing Group, 120 Broadway, New York, NY 10271.

www.stmartins.com

Library of Congress Cataloging-in-Publication Data

Names: Fox, James, author.
Title: The world according to color : a cultural history / James Fox.
Description: First U.S. | New York : St. Martin's Press, 2022. | Includes bibliographical references and index.
Identifiers: LCCN 2021054822 | ISBN 9781250278517 (hardcover) | ISBN 9781250278524 (ebook)
Subjects: LCSH: Colors—Psychological aspects.
Classification: LCC QC495.8 .F69 2022 | DDC 155.9/1145—dc23/eng/20211213
LC record available at https://lccn.loc.gov/2021054822

Our books may be purchased in bulk for promotional, educational, or business use. Please contact your local bookseller or the Macmillan Corporate and Premium Sales Department at 1-800-221-7945, extension 5442, or by email at MacmillanSpecialMarkets@macmillan.com.

Originally published in the UK by Allen Lane, an imprint of Penguin Books, a Penguin Random House company

First U.S. Edition: 2022

10 9 8 7 6 5 4 3 2 1

Contents

List of Illustrations

Integrated Images

Plates

Preface

I first started *seeing* color at the age of six. It was one of those genuinely hot days that used to appear only once or twice in an English summer. I was drinking a glass of iced orange squash in the kitchen when a greenbottle fly entered through an open window. It rattled around the room for several minutes before settling on the table, at which point my mother leaped forward, swung her right arm, and crushed the trespasser beneath a rolled-up magazine. I leaned in to examine the carcass, which twitched in a fetid pool of fluid. But even in that sorry state the insect looked like a precious jewel. Its eyes blushed with the deep burgundy of ripe cherries, its wings shimmered like miniature rainbows, and the emerald greens and sapphire blues on its abdomen exploded into copper and gold. I had never seen anything so beautiful.

All children are naturalists. We all start life fascinated by flora and fauna until, too often, our curiosity ebbs away. In my case, however, the fly triggered another, enduring, enthusiasm. As the summer rolled on, I became increasingly preoccupied with color. In July and August, I counted the reds in the rose petals and the grays in the clouds, trapped butterflies in cupped hands just to see their pigments rub off on my palms, and watched in fascination as our orange lawnmower painted green stripes into the grass. In September and October I collected autumn leaves in the school playground and arranged them in color-coded rows, describing each specimen in a scrapbook with terms like "frog green," "bogey," "wee yellow," and "tractor red." In later years I spent inordinate amounts of time reflecting on the curiosities of color: why did cooked beef turn brown but chicken go white? Why was water transparent, ice gray, and snow white? What

color was human skin, and—crucially—which crayon should I use to draw it?

Jean-Jacques Rousseau once remarked that the hardest things to see are the things we see every day. I'm sure that without chromophilia I would never have found such beauty in banality. Color made everything worth looking at. I was twelve when I even began to perceive it in the dark. I would wait until nightfall, turn off the bedroom lights, and close my eyes tight, then push down on my eyelids as hard as I could bear. As I jabbed and kneaded, the darkness around me lurched into life. Tiny pinpricks of light appeared and vanished like distant stars. Then, gradually, the monochrome murk erupted into oceans of amber, viridian, and vermilion, washing left and right across my visual field. If the conditions were right, those colors coagulated into starbursts, spirals, checkerboards, and matrices of glowing dots. I later learned that those mysterious forms were called phosphenes— tiny photons of light emitted by cells in the retina.

In retrospect my interest in art was inevitable. My first visit to London's National Gallery felt like a school-sanctioned trip to a sweetshop. I stumbled from one room to the next, eyes agog, mouth agape. I was rocked back on my heels by Sassoferrato's Virgin Mary, whose blue robe looked electrically charged, and by Goya's *Scene from the Forcibly Bewitched*, which contained a black so greasy that it seemed to slip off the canvas. Above all, I admired Claude Monet's *Bathers at La Grenouillère*. More than any other painting, it appeared to capture the way that color tiptoes across our world. Monet's waterside scene is made and unmade by its hues. No sooner have the creams, blues, ochres, and blacks become water than they wash away into color again. The painting—like color itself—is trapped in an endless oscillation between subject and object, light and matter. I particularly admired the scarlet dress at the left of the picture—a splodge of red paint that jars horribly with its surroundings, but in doing so flicks the canvas into life; if it wasn't there, the entire composition would collapse. I recall thinking that when Monet stepped back to examine that patch of red pigment, he must have smiled with satisfaction.

"Color," Monet once wrote, "is my daylong obsession, joy and torment." In the time I've spent writing this book, I confess I've often felt the same way. After all, once you begin to notice color—*really* notice

it—you can never escape it. It paints every corner of the world. It lies in wait for us to open our eyes and appears even when they are closed. But for all color's ubiquity, for all humanity's tremendous advances in understanding and manufacturing it, we can never truly possess it. In many respects, color's greatest challenge is that—like music—it resists most attempts to describe it. We have built vast lexicons to explain and classify it over the centuries, but our ever-expanding vocabulary of color terms smothers its quicksilver referents like ill-fitting clothes. Color might be one of those subjects that simply can't be written about.

But I couldn't resist trying.

<div style="text-align: right">

Cambridge
August 2020

</div>

Introduction

I hear the question upon your lips: What is it to be a color?
Color is the touch of the eye, music to the deaf, a word out of
the darkness.

Orhan Pamuk[1]

One day, a young Persian prince was wandering through his palace
when something stopped him in his tracks. He had explored the build-
ing's every room and alcove over the years and thought he could
navigate its corridors blindfolded. But now, in front of him, was a
door that he'd never seen before. Finding it locked, he summoned the
palace warden, who reluctantly gave up the key. A few moments later,
the prince was standing in a room filled with gold, jewels, and count-
less other treasures that sparkled like a thousand suns. His eyes soon
settled on a series of paintings, depicting seven beautiful princesses
from seven different realms. They hung in a circle around an eighth
portrait, of a handsome king clothed in silver and pearls. Who was
this noble ruler, and what had he done to deserve such attractive com-
panions? The prince did not need to speculate for long. Above the
painting a name had been inscribed: it was his own (**Plate 1**).

Bahrâm Gûr left the room but did not forget its prophecy. When he
duly became king, he sent his agents all over the world to seek out the
women he had been promised. Through bribery, blackmail, and con-
quest, he acquired—then married—the princesses of India, Byzantium,
Russia, Slavonia, North Africa, China, and Persia. Bahrâm then built
seven pavilions around his palace, dedicating each to a wife, her
homeland, a day of the week, a planet, and a color. Once his wives

had settled in their new homes, Bahrâm paid them a visit, spending a night with each over the course of a single hedonistic week. Each wife told him a story about love and virtue, before concluding with a plea for her own color. "There is no better hue than black," declared his raven-haired Indian bride. "Yellow is the source of joy," insisted his blonde Byzantine spouse. "Green is the soul's choice," claimed the emerald-eyed Russian. The flame-haired Slav sang the praises of life-affirming red; the African princess rhapsodized about the celestial nobility of blue; and his Chinese consort listed the health benefits of sandalwood brown. But in the end, the fair Persian princess won the day. "All hues with artifice are stained," she observed, "except for white, which pure remains." By the time Bahrâm Gûr had listened to her story, he too had been purified. His journey had taken him out of blackness, through the seven stages of life, and culminated in an apotheosis as white as snow.

The *Haft Paykar*, or *Seven Beauties*, is a masterpiece of Persian literature. Written by Nizâmî Ganjavî at the end of the twelfth century, it was inspired by Bahrâm V, ruler of the Sasanian Empire between 420 and 438 CE. But its other great protagonist is color. Nizâmî's hues blossom like flowers across the pages, so vivid that one can almost smell them. But their purpose is far from decorative. Nizâmî saw color as a microcosm of the universe—connected to the climes, days of the week, and celestial bodies, as well as the seven-stage path toward enlightenment. He believed color was a key to the hidden structures of the cosmos, one that could even unlock the mystery of life. This claim might strike us as implausible, but it wasn't at all unusual. People have always imputed such value to color—convinced that the hues around us are not only beautiful but saturated with meaning.[2]

This book asks that we do the same as Bahrâm Gûr. We too will make a journey, visiting seven colors in turn and listening to their stories. But before we embark on this adventure, we should answer a question.

WHAT IS IT TO BE A COLOR?

Augustine once wrote that he knew what *time* was—until he was asked to define it. The same might be said of color. Color, like time,

is our constant companion. It's with us from the moment we open our eyes in the morning to the moment we close them at night. It surrounds us in every direction, in inexhaustible variety. Just take a moment to inspect the colors around you right now: I guarantee there will be too many to count. We spend so much of our lives experiencing these apparitions that we rarely pause to understand them. Most of us know what red or blue looks like, just as we know what a minute or an hour feels like. But we are much less confident when it comes to explaining them. If you are completely honest with yourself, do you *really* know what color is?

Many people take the commonsense view that it is an objective property of things, or of the light that bounces off them. They say a tree's leaves are green because they reflect green light—a greenness that is just as real as the leaves. Others argue that color doesn't inhabit the physical world at all but exists only in the eye or mind of the beholder. They maintain that if a tree fell in a forest and no one was there to see it, its leaves would be colorless—and so would everything else. They say there is no such *thing* as color; there are only the people who see it. Both positions are, in a way, correct. Color is objective *and* subjective—"the place," as Paul Cézanne put it, "where our brain and the universe meet."[3] Color is created when light from the world is registered by the eyes and interpreted by the mind. It is a labyrinthine operation, arising from a long chain of physical, chemical, and biological events. This invites us to think of color not as a noun but as a *verb*, and to swap the "what is" question for a more useful alternative: *how does color happen?*

It begins with light, because without light there can be no color. Light belongs to a vast spectrum of electromagnetic radiation, which varies by wavelength and frequency. At one end of the spectrum gamma ray wavelengths are 100 million times shorter than a millimeter. At the other, extremely low-frequency radiation wavelengths are tens of thousands of kilometers long. The energy between them has many properties and functions. We use X-rays to photograph the insides of our bodies, microwaves to heat food, and radio waves to communicate across great distances. But about a third of the way along the spectrum—sandwiched between ultraviolet (which burns our skin) and infrared (which we feel as heat)—is a small band of

radiation visible to us. Though it makes up only 0.0035 percent of the electromagnetic spectrum, visible light is responsible for all the colors that every human has ever experienced. At a wavelength of about 400 nanometers (there are a million nanometers in a millimeter), ultraviolet blossoms into violet, then bleeds into blue (430–490 nm), then green (490–560 nm), yellow (560–590 nm), orange (590–630 nm), and red (610–700 nm), before slipping into infrared, and out of sight.

Light is made up of tiny packets of energy, known as photons, which are everywhere in astronomical numbers. If you are reading these words by a bedside lamp, its bulb is producing 100 billion billion photons every second—a million times the number of cells in your body. Some light sources are colored—a basic laser pointer emits only red light with a wavelength of 650 nanometers, and traditional sodium streetlamps emit only yellow light at 589 nanometers—but our leading photon emitter produces light of all visible wavelengths. The sun smashes hydrogen atoms together to form helium, creating unimaginable numbers of photons, which hurtle through the solar system at 300,000 kilometers per second. They reach our planet in just over eight minutes, where they clatter through the atmosphere, bounce off clouds, get lost in forests, and plunge into oceans. These violent interactions between energy and matter are the crucible of color.

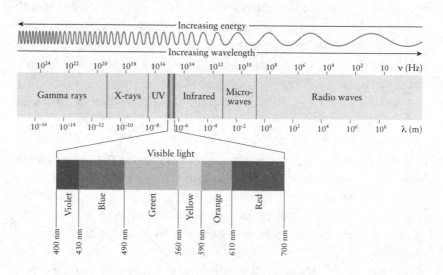

The electromagnetic spectrum

All materials have different structures, which interact with photons differently. Some reflect much of the light and thus appear white; others absorb much of it and appear black. Most substances, however, reflect or transmit some wavelengths of light and absorb others. This is what makes them colorful. Rubies appear red because their structures reflect only long, red, wavelengths of visible light. Grass looks green because it contains an elaborate pigment molecule called chlorophyll that absorbs blue and red wavelengths of light and reflects the greens and yellows between them. The morpho butterfly creates its exquisite blues with physical structures. Its wings are coated with microscopic scales that knock white light out of phase, scattering only blue wavelengths with iridescent intensity. In nearly all cases, objects paradoxically take on the color they *don't* possess—the one their surfaces reflect. But this reflected, refracted, and scattered light has not yet become color. That requires a perceiver.

Of the innumerable photons that bounce like pinballs around our planet, some find their way into our eyes, where 100 million photoreceptors lie in wait. The vast majority of these photoreceptors are rod cells, which aren't responsible for color vision, but four or five million of them are cone cells, which are. Most humans possess three classes of cones. S-cones are particularly sensitive to short (415–430 nm), M-cones to medium (530–570 nm), and L-cones to long (555–565 nm) wavelengths of visible light. All cones contain a pigment molecule consisting of a curved chain of amino acids. When this molecule absorbs a photon, a double bond snaps, causing the chain to straighten and the molecule to change shape. This seemingly trivial incident, lasting just 200 millionths of a billionth of a second, underpins all human vision.

Light absorption triggers a cascade of events. When photoreceptors change structure they activate a protein, which activates another protein, which converts the scattergun chaos of photon absorption into electrical messages that are transmitted across synapses to bipolar and then ganglion cells. These messages are then turned into binary signals—on-off voltage changes called "action potentials"—that exit the eyes through the optic nerves and careen along fluid-filled threads until they reach the primary visual cortex at the back of the brain. This part of the brain processes all kinds of visual material and sometimes sends it on to other areas in the occipital lobe for further

processing. The machinations of the cerebral cortex aren't well understood—but we do know that it is primarily responsible for converting the light information registered by the eyes into the dynamic and colorful world we see around us.

How, then, is color computed? Oddly enough, individual cone cells are color blind. They relay no information about the wavelengths they absorb; only whether they detect light or not. But each cone type, as we've seen, is particularly sensitive to a specific range of wavelengths: S-cones are more likely to absorb blue wavelengths of light than their counterparts, while L-cones are more likely to absorb red. This allows the brain to compare outputs from the three classes of cones to establish which wavelengths are striking different parts of the retina. It does this by sorting the data into three separate channels—red–green, blue–yellow, and black–white (this is why they are complementaries)—then measuring their differences by adding some signals and subtracting others. This exercise might seem bewilderingly abstract, but it is in fact both simple and efficient: from just three sets of comparisons, our brains are able to distinguish millions of hues and shades.[4]

This brief account has simplified many aspects of color vision, but has, I hope, revealed color as a *process*—a dance between subjects and objects, mind and matter. Different wavelengths of light exist independently of us, of course, but they don't truly become color

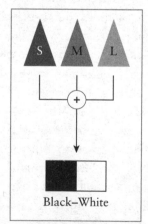
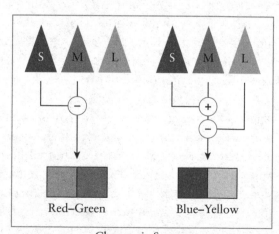

Achromatic System Chromatic System

The opponent process

until our brains have finished interpreting them. Or, to put it another way, color's ingredients exist outside of us, but its recipe resides within. The recipe, at least, is never the same. Like many largely subjective experiences, color perception hinges on a great deal of interpersonal variety. Roughly 8 percent of men lack one or more fully functional cone type and perceive fewer colors than others; a small number of women are thought to possess a fourth cone type, and thus an extra dimension of color experience (though whether they can actually distinguish more hues is unknown).[5] In fact, every person's visual system is unique. No two will interpret identical light information in the same way.

The artist Josef Albers, who spent much of his career trying to decipher the mysteries of the spectrum, acknowledged as much at the beginning of his magnificent book *Interaction of Color*:

> If one says "Red" (the name of a color) and there are 50 people listening, it can be expected that there will be 50 reds in their minds. And one can be sure that all these reds will be very different.
>
> Even when a certain color is specified which all listeners have seen innumerable times—such as the red of the Coca-Cola signs which is the same red all over the country—they will still think of many different reds.
>
> Even if all the listeners have hundreds of reds in front of them from which to choose the Coca-Cola red, they will again select quite different colors. And no one can be sure that he has found the precise red shade.
>
> And even if that round red Coca-Cola sign with the white name in the middle is actually shown so that everyone focuses on the same red, each will receive the same projection on his retina, but no one can be sure whether each has the same perception.[6]

Perception is only part of the story. Colors also help our brains understand when to wake up and go to sleep, what to eat and buy, who to find attractive, and what emotions to feel. They are constantly influencing our mood and behavior, though we're rarely conscious of them doing so. Red has been found to raise heart rates, increase electrical activity in the brain, contribute to sexual arousal, improve the body's speed, strength, and reaction times, and encourage risk-taking and competitive behaviors.[7] Blue is believed to reduce heart

rates and blood pressure, promote relaxation, and even reduce crime. These latter findings formed the basis of a famous initiative in Japan, where in 2006 several major railway operators installed blue LEDs on platforms and crossings around the country. They hoped that blue light would relax agitated people and discourage them from jumping in front of oncoming trains. The introduction of the LEDs duly coincided with an 84 percent decrease in suicides.[8]

Today's consumers are constantly being manipulated by logos, adverts, and packaging, which deploy colors to provoke specific emotional and physical responses. Up to 90 percent of our snap judgments are determined by color—decisions so immediate and subliminal as to be virtually irresistible. Shops use bright reds and yellows to catch our attention and arouse our interest, food and drink producers use reds and oranges because they are believed to stimulate appetites, and banks and insurers prefer blues because the public is said to associate them with honesty, loyalty, confidence, and stability. All businesses know that color is an essential component of a recognizable brand, and—in the case of BP's green or Cadbury's purple—they will go to court to keep control of it.[9]

THE MEANING OF COLOR

What do we mean by meaning? There are perhaps three types of meaning as it pertains to color. The first derives from the affective or psychological significance of hues and shades (red as energetic, brown as lethargic, light blue happier than dark blue). The second is created not by subjective responses but by codified social conventions (red signals indicating warnings, white flags denoting surrender). The third, and richest historically, is generated by association. Humans have been making this type of meaning for millennia. Philosophers, theologians, alchemists, and heralds have created byzantine systems of correspondence all over the world, connecting colors to the planets, days of the week, seasons, climates, directions, elements, metals, precious stones, flowers, herbs, musical notes, letters of the alphabet, ages of man, humors, organs, tissues, orifices, tastes, emotions, virtues, and vices. Some comparisons were logical; others less

so. In his heraldic "cullor" guide of 1610, Edmund Bolton identified yellow with topaz and chrysoberyl, Sundays and marigolds, faith and constancy, lions, the month of July, adolescence (specifically the ages of fourteen to twenty), air, springtime, sanguineness, and the numbers one, two, and three.[10]

Colors, of course, aren't inherently meaningful. Their meanings are created by the people who live with them. This is why a single color can mean different things in different places. In the West, white has long been identified with light, life, and purity, but in parts of Asia it is the color of death. In English green is the color of envy, but in French it is the color of fear, in Thai of rage, and in Russian, sadness or boredom.[11] In US politics, red is conservative and blue progressive; in Europe, it is the other way around. These kinds of color meanings also tend to change over time. Most people today think of blue as masculine and pink as feminine, and dress their offspring accordingly. But only a hundred years ago these metaphors were reversed. "The generally accepted rule is pink for the boy and blue for the girl," one parental guide instructed in 1918. "The reason is that pink being a more decided and stronger color is more suitable for the boy, while blue, which is more delicate and dainty, is prettier for the girl."[12]

All colors are ambiguous—even supposedly unambiguous ones. Black, which probably has more consistent connotations than any other, has been denigrated in virtually every part of the world through history, where it's been identified with darkness, despair, sin, and death. But even this apparently irredeemable color has its share of positive associations. In the last hundred years, it has become so synonymous with high fashion that all voguish products are invariably dubbed "the new black."[13] To Christian Dior, black was:

> The most popular and the most convenient and the most elegant of all colors. And I say color on purpose, because black may be sometimes just as striking as a color. It is the most slimming of all colors, and unless you have a bad complexion, it is one of the most flattering. You can wear black at any time. You can wear it at any age. You may wear it for almost any occasion. A "little black frock" is essential to a woman's wardrobe. I could write a book about black.[14]

Dior's "little black frock" reveals, in a very simple way, the instability of color meanings: if a woman wore a black dress to a funeral it would clearly symbolize mourning and death, but if she then jumped into a taxi and attended a nearby cocktail party, the same garment would signify stylish sophistication. Color's meanings—like all meanings—are rooted in context.

But they can also transcend context. Color preferences, for example, are startlingly consistent around the world. One recent study collected views from seventeen countries on five continents and found blue to be the most popular color in every one of them. More remarkable still was the extent of its popularity: in every country it received at least a third of the vote. In Germany it was favored by 47 percent of subjects, making it four times more popular than second-placed red.[15] This global consensus likewise applies to some color meanings—particularly on the first, affective, level. Most societies agree that red is "hot" and blue is "cold"; that yellow is "active" and green is "passive"; that white is "good" and black is "bad"; that bright colors are "happy" and dull colors are "sad."[16] The same is true of our second mode of color meaning. In an increasingly globalized world many color signs and symbols have by necessity become universal. The Vienna Convention on Road Traffic stipulates that in all jurisdictions red should mean "stop" and green mean "go." The International Organization for Standardization—which goes by the tagline "when the world agrees"—insists that all hazards should be indicated by yellow and black.

But what of the third type of meaning? Can color *associations* be truly global? The variations I've described indicate that they can't. Color metaphors are complex constructions, shaped by the landscapes, languages, habits, and beliefs of the communities in which they develop. Red—as we will see in Chapter 2—is a lucky color in China as a result of specifically Chinese circumstances, and green—as we'll see in Chapter 7—is a lucky color in the Middle East for Middle Eastern reasons. There are, however, a small number of color metaphors that have appeared repeatedly, and with striking similarities, around the world over the centuries. These associations are based on what we might call universals of human experience—a handful of simple and stable reference points that all people have encountered, wherever or whenever they have lived. They are:

Black	Night, darkness, dirt
White	Day, light, cleanliness
Yellow	Sun, fire, earth
Red	Blood, fire, earth
Green	Vegetation, water
Blue	Sky, water

At first sight they seem obvious to the point of cliché. But clichés are only clichés because there is some truth in them. The strength of these correlations, and the reason for their endurance, is their simplicity. They are grounded in resemblances so rudimentary that even crayon-wielding children can understand them. Over time this basic foundation of visual affinities has been built upon. Artworks, poems, treatises, rituals, and everyday idioms have slowly piled up into into vast edifices of multicolored meaning. This book explores how some of those edifices were constructed.

SEVEN BEAUTIES

Healthy humans perceive millions of different colors. In this respect our vision is superior to many other species. Most mammals don't possess the third class of cone cells sensitive to long wavelengths of light and are therefore red–green color blind. Bulls might be famous for their hatred of red capes, but the red itself is invisible to them; they are actually enraged by the fabric's movements. Many animals, however, are thought to have superior color vision to humans. Some reptiles, amphibians, insects, and birds possess *four* classes of cone receptors. Several species of butterfly and pigeon have *five*. Bees see ultraviolet light, discerning elaborate patterns in flowers that are wholly invisible to us, while snakes see infrared radiation, which allows them to detect the warm bodies of prey from a distance. The eyes of the mantis shrimp contain as many as *twenty-one* classes of photoreceptor, sensitive to ultraviolet as well as polarized light—though the extent to which its small brain can exploit such hardware is unclear.

Humans divide up these colors in various ways. The English language has eleven basic color terms—black, white, red, yellow, green, blue, purple, brown, gray, orange, and pink—but other languages do things differently. Russians possess two basic terms for blue—*goluboi* (голубой) for light blue, and *sinij* (синий) for dark blue—and think of them as entirely separate hues. A large number of languages don't have discrete words for pink, brown, and yellow, and some use one word for both green and blue. The Tiv people in west Africa possess only three basic color terms (black, white, red), and a few communities have no chromatic terms at all: the Burarra tribe in northern Australia divide the rainbow into *gungaltja* (light or bright) and *gungundja* (dark or dull). Color vocabulary, like color meaning, is largely cultural—it is dictated by context. Societies generally name only the colors they consider important. The Aztecs, who were enthusiastic farmers, possessed more than a dozen words for green.[17] The Mursi cattle-herders of Ethiopia have eleven color terms for cows and none for anything else.[18]

Theorists also divide color space into physical, perceptual, and philosophical primaries. Their formulations likewise vary wildly, rising from two (usually black and white) and three (like our primaries red, blue, and yellow) all the way up to the Optical Society of America's 2,755. No number, however, has proved more enduringly popular than seven. Aristotle believed there were seven "simple" colors, as did Nizâmî and Isaac Newton. These thinkers didn't arrive at this figure because there *were* seven colors, but because the number itself had special significance. To Aristotle it was a salient integer, corresponding with the seven tastes and seven ages of man. Nizâmî's seven colors correlated with the days of the week and the planets. Newton separated white light into seven hues because he believed in universal harmony and wanted them to dovetail with the seven notes of a musical scale.[19]

This book follows the modern equivalents of Aristotle's seven primaries: black, red, yellow, blue, white, purple, and green. I make no claim to be definitive—color is far too protean for that—but I have tried as far as possible to honor my subject's ubiquity. The book roams from prehistory to the present, from one side of the world to the other, and draws on art, literature, philosophy, science, and much else besides. My goal is to understand not only the physical properties of color but

the meanings it has been given. These meanings reveal a great deal about the societies that produced them, reflecting their hopes, fears, prejudices, and preoccupations. I have therefore arranged these seven colors in such a way as to tell another story, about humans and our place in the universe. Read it, if you like, as a cultural history of color; though I think of it as a history of the world, according to color.

I

Black

Out of Darkness

The Black beauty, which above that common light,
Whose Power can no colors here renew
But those which darkness can again subdue,
Do'st still remain unvary'd to the sight,
And like an object equal to the view,
Art neither chang'd with day, nor hid with night
When all these colors which the world call bright,
And which old Poetry doth so persue,
Are with the night so perished and gone,
That of their being there remains no mark,
Thou still abidest so intirely one,
That we may know thy blackness is a spark
Of light inaccessible, and alone
Our darkness which can make us think it dark.

Edward, Lord Herbert of Cherbury (1665)[1]

Let us begin with a simple black square (**Plate 2**). It appears unexpectedly in a leather-bound book, like a hole that's been waiting for a clumsy reader to lose balance and tumble in. It is made from hundreds of individually engraved lines, woven atop and across each other into a crisp, pixely blackness. The ink has peeled and puckered over the years, and been smudged in places by roving fingers, but still emits the astringent odor of linseed oil. The execution is far from perfect—the square's sides are unequal, its edges wobble, and its cumbersome corners bleed into the yellowing paper around

them—but the design is so boldly austere that it hits the eye with the force of a hammer. At first sight it looks like a pioneering piece of twentieth-century abstraction: perhaps a preparatory sketch dreamed up in revolutionary Moscow or postwar Greenwich Village. But this unforgettable image was actually conceived more than 300 years earlier, by an eccentric Englishman.

Robert Fludd was born in 1573 or 1574 into a distinguished family. His parents expected him to become a lawyer or gentleman farmer like his brothers, but he opted instead to study at Oxford, where he developed an interest—and apparently some expertise—in the occult. When his sword-belt and scabbard went missing from his college one day, Fludd drew up an astrological chart, deduced from the position of Mercury that they had been taken by a talkative man in the east, and recovered the stolen goods.[2] He later established a medical practice in London, where he combined conventional methods with magnetic treatments, horoscopy, and psychic healing. In his late thirties he embarked on another task: to seek out and compile the world's entire body of knowledge. With no time even to lose his virginity, he produced a series of treatises, on topics ranging from science, alchemy, and medicine to resurrection, music, and even a theory of wind. His masterpiece was unquestionably *The History of the Macrocosm and the Microcosm* (1617–1621), which chronicled the entire history of the universe, as well as the human place within it. Here, on page 26, the black square makes its appearance.

It is nothing less than a portrait of the universe before it existed. Surrounded on all sides by the words *"et sic in infinitum"* ("and so on, to infinity"), the square depicts the shapeless matter that God would later knead into the cosmos.

> This primal material is of a primordial, infinite, shapeless Existence, as suitable for something as for nothing; having no size or dimension, for it cannot be said to be either large or small; having no qualities, for it is neither thin, nor thick, nor perceptible; having no properties nor tendencies, neither moving nor still, without color, or any elementary property . . . [3]

How Fludd must have struggled to represent this unrepresentable subject. We can picture him at his desk in Fenchurch Street, quill in

one hand, head in the other, wondering how to illustrate something so thoroughly devoid of qualities. In the end, he plumped for blackness. In adjacent text he told readers that his "imaginary picture" envisioned the primordial void as "a black smoke, or vapor, or a dreadful gloom, or the darkness of an abyss."[4] He based his design on several ancient sources, including a third-century Egyptian-Greek creation myth from the *Corpus Hermeticum* that spoke of a darkness that coiled like a snake, belched plumes of black smoke, and emitted an "indescribable sound of lamentation."[5] He also drew on what is surely the most famous passage in the Bible:

> In the beginning God created the heaven and the earth. And the earth was without form, and void; and darkness was upon the face of the deep. And the Spirit of God moved upon the face of the waters. And God said, Let there be light: and there was light. And God saw the light, that it was good: and God divided the light from the darkness.[6]

This is of course Genesis 1:1, according to the King James version (first published just a few years before Fludd's own masterwork). This justly celebrated translation is poetic and portentous in all the right ways, but it gets something very wrong: "darkness" is far too elegant a word for the primeval gloom envisioned by its creators. The original Hebrew was *khoshekh* (חֹשֶׁךְ) —an ugly, guttural noun that had to be coughed out of the throat like phlegm. This darkness is violent, dissonant, feral.

Creation myths from all over the world begin in similar fashion. Here is the *Nasadiya Sukta*, sometimes known as "The Hymn of the Dark Beginning," from the Hindu *Rigveda* (*c.* 1500 BCE):

> There was neither nonexistence nor existence
> then; there was neither the realm of space nor the
> sky which is beyond.
> What stirred?
> Where?
> In whose protection?
> Was there water, bottomlessly deep?
> There was neither death nor immortality then.
> There was no distinguishing sign of night or day.

That one breathed, windless, by its own impulse.
Other than that there was nothing beyond.
Darkness was hidden by darkness in the
beginning . . . [7]

This is from the Chinese *Huainanzi* (139 BCE):

Of old, in the time before there was Heaven and Earth:
There were only images and no forms.
All was obscure and dark,
vague and unclear,
shapeless and formless,
and no one knows its gateway.
There were two spirits, born in murkiness, one that established
Heaven and the other that constructed Earth.
So vast! No one knows where they ultimately end.
So broad! No one knows where they finally stop. [8]

And this, from Polynesia—the ancient creation chant *Kumulipo*, whose title means "a source of darkness or origin":

At the time when the light of the sun was subdued
To cause light to break forth
At the time of the night of *Makalii*
Then began the slime which established the earth,
The source of deepest darkness.
Of the depth of darkness, of the depth of darkness,
Of the darkness of the sun, in the depth of night,
It is night,
So night was born. [9]

Why do so many universes begin in such a way? It is surely a product of our own cognitive shortcomings. Humans have never really got to grips with absences. It's difficult to imagine ourselves not existing, let alone everything else. So when ancient storytellers attempted to describe the void that preceded creation, they fell back on metaphors—endless oceans, divine wombs, cosmic eggs, and so on—though darkness was typically the closest thing to nothing they could conceive.

They turned out to be correct—as far as we know. Modern

cosmologists aren't certain how the universe started, but most agree it began in darkness. The Big Bang, often wrongly thought of as a sudden flash of light, actually generated an infinitely dense darkness that lasted hundreds of millennia. It took 380,000 years for the universe to slacken enough for the first photons to escape and to pierce the blackness with the very first light. As the universe expanded, this white light turned yellow, then saffron, then tangerine, then vermilion, until, around 200 million years after the beginning, it once again returned to darkness.[10] At roughly the same time, dense pockets of interstellar gas and dust imploded into the first stars. Pinpricks of light appeared, one after the other, across the blackness of space. Nine billion years later, in an unremarkable corner of the cosmos, one clump of particles curdled into our sun. It showered its surroundings with radiation, bathing light over debris that would eventually coagulate into the Earth. A billion years later, the first single-celled life-forms appeared on our planet. Three billion years after that, a small shrimp-like creature developed a pair of complex compound eyes—and saw the world for the first time.[11]

DARKNESS VISIBLE

Before LEDs and light bulbs and gas lamps and candles, and before even the discovery of fire, darkness was genuinely dark. Night then bore little resemblance to today's evenings, which over most of the world are bleached by streetlights and twinkle with charging electronic devices.[12] Darkness used to be close, thick, and impenetrable—unless the moon was out. This was far from ideal. As diurnal creatures, humans are optimized for bright conditions. Our eyes provide us with precise and vivid vision in daylight but are rather less useful after dark. This deficiency caused our ancestors to get lost, to fall and injure themselves, and rendered them defenseless against thieves, murderers, and nocturnal carnivores. To make matters worse, darkness could not be remedied. If people were cold, they could wrap themselves in another fur; if they were hungry, they could generally forage for food. But what could be done about the night? Their only solution was to wait until it was over—again and again and again.

We can now dispel darkness with a fingertip, but it remains a

stubborn adversary. Many children develop a fear of the dark at the age of two, and some never lose it.[13] Eleven percent of American adults are afflicted by scotophobia, making it the fourth most common fear after spiders, death, and—most paralyzing of all—public speaking.[14] Edmund Burke, who believed the phobia was a necessary tool for self-preservation, thought darkness even induced physical discomfort, stressing the "radial fibers of the iris" and producing a "very perceivable pain."[15] John Locke, by contrast, argued that it was little more than a superstition. "The ideas of goblins and sprites have really no more to do with darkness than light," he observed; "yet let but a foolish maid inculcate these often on the mind of a child, and . . . possibly he shall never be able to separate them again so long as he lives."[16]

The Bible contains nearly 200 references to darkness, many referring to the physical challenges posed by night. But its authors also invoke darkness as a metaphor. They connect it to misery and misfortune ("I cry aloud . . . he hath set darkness in my paths," Job 19:7–8), disease ("not for the pestilence that walks in darkness," Psalm 91:6), mortality ("in darkness and in the shadow of death," Luke 1:79), ignorance ("wisdom excelleth folly, as far as light excelleth darkness," Ecclesiastes 2:13), sin ("if thine eye be evil, thy whole body shall be full of darkness," Matthew 6:23), divine punishment ("God . . . cast them down to hell, and delivered them into chains of darkness," 2 Peter 2:4), and repeatedly contrast it with the goodness and godliness of light:

> When I looked for good, then evil came unto me: and when I waited for light, there came darkness. (Job 30:26)

> Woe unto them that call evil good, and good evil; that put darkness for light, and light for darkness; that put bitter for sweet, and sweet for bitter! (Isaiah 5:20)

> Then spake Jesus again unto them, saying, I am the light of the world: he that followeth me shall not walk in darkness, but shall have the light of life. (John 8:12)

Many ancient belief systems hinged on a dualism of light and darkness. Manichaeism, a Gnostic religion established by the Persian prophet Mani in the third century CE, maintained that the world and

its inhabitants were little more than battlefields on which light and darkness waged war. At first the two primordial principles—identified respectively with good and evil, spirit and matter—lived apart, in two separate territories. The Kingdom of Light was filled with sun, trees, flowers, and fresh air, while the Kingdom of Darkness was a lifeless terrain of ditches, bogs, and abysses, all choked by poisonous smoke. When the "Prince of Darkness" learned of this rival realm, he grew jealous and sent demons across the border to conquer it. In subsequent battles light and darkness penetrated each other, mixing virtue and vice, the spiritual and material—creating the conflicted world in which humans found themselves.[17] Manichaeans aspired to a future in which the two principles were once again divided and peace was reestablished, but, like most Gnostics, they were incorrigible pessimists. "There can be no salvation here, ever!" one of them grumbled. "All is darkness."[18]

What many of these metaphors share, and what they share with ancient creation stories, is the notion of darkness as *deprivation*. Four centuries after the death of Christ, Augustine—who had converted from Manichaeism to Christianity in his early thirties (much to his mother's relief)—argued that God had made everything, and everything he had made was good. It was a neat and reassuring syllogism, but it raised an inevitable question: if both propositions were true, whence came evil? If God had created everything, he had also made evil; if he hadn't, then the universe wasn't entirely of his making. To resolve the conundrum Augustine asserted that evil was simply an absence of goodness, before comparing it to other "privational" conditions such as silence and darkness:

> Yet we are familiar with darkness and silence, and we can only be aware of them by means of eyes and ears, but this not by perception but by absence of perception . . . For when with our bodily eyes, our glance travels over material forms, as they are presented to perception, we never see darkness except when we stop seeing.[19]

Augustine's argument, so deeply informed by his Manichaean inheritance, is significant because it identified darkness not with evil—that connection was established long before the Gospels were written— but with *absence*. This is relevant to us because the same argument

was, and is, used to denigrate the color with which darkness is always compared.

Black is the black sheep of color. It might not even be a color at all. Common sense suggests that it *is* one: we can buy black clothes, cars, and smartphones and use black paint just like red or blue. Yet physicists tell us that just as white is the sum of all colors, black is their absence. The disagreement is in part due to the word "color," which has two overlapping but nonidentical meanings: in the broader sense it describes everything that can be squeezed onto a painter's palette; in the narrower sense it refers only to specific wavelengths of visible light, and is more accurately known as "hue": black satisfies the first of these definitions but not the second. In order to resolve this inconsistency, we now categorize black (together with white and gray) as an "achromatic color"—a color without hue.[20]

It wasn't always so complicated. In some of the earliest color systems, from ancient Greece, black was a primary color from which all hues were made.[21] The kernel of this idea was repeated regularly for the best part of two millennia. "Nothing is more plaine," wrote the English herald Edmund Bolton in 1610, "that *blacke* is, as it were, the *basis* or *pedestal* of colors."[22] But he was by then a dissenting voice. From the second half of the Middle Ages a number of writers had begun to suspect that there was nothing "plaine" about black. In 1435, the Florentine artist, architect, and theorist Leon Battista Alberti concluded that there were "only four true colors"—red, blue, green, and (somewhat puzzlingly) ash—while black and white simply varied their value:

> The painter, therefore, may be reassured that white and black are not true colors but, one might say, moderators of colors, for the painter will find nothing but white to represent the brightest glow of light, and only black for the darkest shadows.[23]

Alberti was contributing to a change of perception that would ultimately separate black from color and relegate it to the shadows. The new formulation was famously confirmed in 1666, when Isaac Newton shone "white" light through a prism and refracted a rainbow of hues. He arranged them into a color circle containing red, orange, yellow, green, blue, indigo, and violet, with white at its center (marked

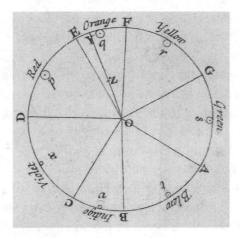

Newton's color wheel

by "O"). Black is nowhere to be seen. That's because in Newton's theory it didn't belong to the spectrum of light and therefore wasn't a genuine, prismatic, color. To Newton, black was perhaps even the *opposite* of color; where color was light, black was darkness.[24]

The assumption led later theorists to conclude that black wasn't even a sensation. They argued, like Augustine, that it was best compared not to other colors but to other privational experiences: as silence was the absence of sound, so black was the absence of light.[25] Here is a typical view, from 1924:

> When we look at a black object there is no light reflected back to the eye by that object, there is no activity set up in the rods and cones, and there is no message relayed to the brain by the optic nerve . . . Since black is thus the result of zero stimulation, it follows again that there is only one intensity of blackness. There can be but one degree of zero.[26]

This raises a question that has puzzled scientists for over a century: if black is indeed the absence of light, how are we able to see it? If it's the result of no photons stimulating our retinas, we should surely see *nothing*, just as when we hear nothing we experience silence. But black clearly isn't the same as nothing: enter a room, close the doors, tape up the windows, switch off the lights, and close your eyes. In this zero-light environment you won't be surrounded by blackness;

you will instead discern a swirling, achromatic midtone, often called "*eigengrau*" or "intrinsic light." Absolute darkness is not black: it is gray.[27]

Some scientists therefore began to differentiate darkness and blackness: where darkness was a *negative* sensation, they argued, blackness was a *positive* sensation. In the second half of the nineteenth century the German physiologist Ewald Hering claimed that human color vision was fundamentally relational, and that all visible hues were produced by two antagonistic pathways, two pairs of opposites: red versus green and blue versus yellow. The stimulation of one inhibited the other, and vice versa. This, he reasoned, is why we can't see reddish greens and bluish yellows but have no problems perceiving reddish blues and greenish yellows. Hering believed that there was also a third pathway, for black and white. He concluded that black was essentially a contrast effect, visible only when surrounded by a brighter area (simultaneous contrast) or following one (successive contrast).[28]

Hering's counterintuitive claim was controversial, but as rebuttals and refutations bounced between learned journals his theory was steadily verified. In 1929, the Russian-born Gestalt psychologist Adhémar Gelb suspended a black velvet disc in the doorway of a dark room and then illuminated it with a hidden light. Against the dark backdrop Gelb's observers saw the disc as white; but when he placed a sheet of white paper next to it the disc turned suddenly black. Here was simultaneous contrast in action: Gelb's experiment confirmed that black and white surfaces aren't produced by the absolute amount of light they reflect, but by their relationship.[29] The precise conditions of Gelb's experiments can't alas be reproduced on a printed page, but a similar effect can be seen in the following illustration. Five squares appear to take on five different shades, from pale gray on the left to near black on the right. All, however, are actually the same shade of gray; they have simply been driven down to black by the contrast with their lightening surroundings. The picture confirms that black is not an absence of light, as darkness is, but a *hole* in light. Just as we can only "feel" a hole by touching the edges around it, so we "see" black by observing the lightness that surrounds or precedes it. Black, in other words, is made by light.[30]

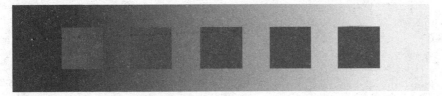

Simultaneous contrast

In a way, we've known this for tens of thousands of years—or at least since we first set eyes on fire. Our ancestors must have been captivated by the quicksilver colors that danced in the flames. As they watched smoke corkscrew into the air, it might have looked like darkness itself was being burned away. But when the fire subsided, they noticed the vegetation that fueled the inferno had been converted into a black, or near-black, residue. These stumps and twigs were later salvaged from firepits and used to draw patterns and images onto surfaces. Many of the earliest surviving artworks, which are located on the walls of pitch-dark caves, were made from black pigments that had themselves been born in flames. Before long, humans were burning materials deliberately for that purpose. They collected wood, bark, and vegetable matter, then fruit pits, bones, deer antlers, and mammoth tusks, and through controlled combustion transformed them into a range of pigments known collectively as "carbon black."

Almost all ancient blacks, and most modern ones, were produced by light and heat. The black pigment that filled Robert Fludd's primordial darkness was essentially soot, made by burning oil above an open flame. Many pigments' names are derived from fire: *lamp*black, *flame* black, *furnace* black, *thermal* black, *char*coal. The word "black" itself (like many other European words for the color) comes from the reconstructed Proto-Indo-European *bhleg*, *bhel*, or *bhelg*, a term originally used to describe the appearance of fire. It meant "burn," "gleam," "shine," or "flash" and evolved into a number of words we might think of as black's opposite—such as "bleach," "blank," "blond," and "blaze."[31] In ancient culture, just as in modern science, black was directly connected to that which illuminates. But over intervening centuries, we tore it away from the light and bundled it into the shadows.

THE BADGE OF HELL

The process wasn't inevitable. Many ancient societies thought black was no more sinister than any other color, and some even rather admired it. For ancient Egyptians, it was the color of the loamy soils of the Nile Delta, and thus of the fertile ground on which their crops, lives, indeed their entire civilization, depended. They called their kingdom "The Black Land" (*Kmt*), comparing it favorably with the barren reds of the surrounding desert. They also identified the color with the less obviously auspicious realm beneath the earth—the Egyptian underworld was "as black as the blackest night," and Osiris, who ruled over it, was "The Black One" (*kmjj*)—but these descriptions weren't necessarily negative.[32] Like the lands of rich soil above it, the underworld was a site of renewal, where plants germinated, the sun recharged, and the dead were reborn. Over the centuries Egyptians grew convinced that black therefore had magical powers, employing black amulets and statues to cure diseases and protect themselves from misfortune. In Egypt, black was a color of life.[33]

It wasn't until the first millenium BCE that a connection between black, darkness, and death began to crystallize. The ancient Greeks called it *melas* (μέλας), which also meant "dark," and consistently linked it to death. Their underworld was just as murky as its Egyptian predecessor but without the positive implications. Hades had black gates, trees, and rivers, and its chthonic gods were invariably dark or black. In the land of the living, black animals were sacrificed to the dead, and mourners often wore black fabrics. The Romans codified the connection between black garments and bereavement. If a relative or friend died (or was sentenced to death), one was expected to wear a black or near-black *toga pulla*, at least for a while. The conventions were sufficiently established in elite circles that those who disregarded them faced censure. When the statesman Publius Vatinius wore a *toga pulla* to a morale-boosting dinner following a funeral, his nemesis Cicero skewered him in a withering speech:

> I should also like to ask you what design or object you had in view
> when you took your place at my friend Quintus Arrius' banquet in a

toga pulla. Have you ever seen or heard of such a thing? . . . Tell me, who ever dined in a black gown? It was a funeral feast, true; but while the function of such a feast is to celebrate a death, the feast itself is an occasion of good cheer . . . Did you not know the custom?[34]

By the first century CE, black was such an explicit symbol of death that the mere sight of it filled Romans with fear. At one point Emperor Domitian attempted to intimidate his political opponents by inviting them to a banquet in which the walls, waiters, crockery, even food, were jet black. His guests' nerves were in tatters by the time they got home.[35]

For all its antipathy to darkness, the Bible has little to say about black. The two Testaments together mention it fewer than thirty times, and then simply to describe hair, clouds, skin, marble, and horses. It is neither conflated with darkness nor invested with negative meanings. In these texts black is still just a color, a physical rather than a moral quality. If any color is considered suspicious, it is red. "Though your sins be as scarlet," writes Isaiah, "they shall be as white as snow; though they be red like crimson, they shall be as white as wool" (1:18). White has already emerged as the color of virtue (more on that in Chapter 5), but interestingly red, not black, is its opposite. This duality did not survive long. In later centuries, the Church Fathers, all profoundly influenced by Greco-Roman culture, began to substitute iniquitous red for nefarious black.

St. Jerome was born in the Roman province of Dalmatia around 345 CE. After a thorough classical education he moved to Rome, where he immersed himself in Latin literature, mastered the art of rhetoric, and spent his free time womanizing. Jerome initially planned to become a lawyer or civil servant, but a Damascene conversion in his late twenties or early thirties convinced him to dedicate his life to God. He took an ascetic turn and lived for several years as a hermit in the Syrian desert, before returning to Rome in 382, where he became an adviser to Pope Damasus I. He devoted much of the next two decades to a new translation of the Bible, from Hebrew and Greek into Latin. Plagued by guilt for his youthful indiscretions, Jerome ruminated endlessly on sin—though he no longer thought it was red. In a Homily on Psalm 86, he wrote:

At one time we were Ethiopians in our vices and sins. How so? Because our sins had blackened us. But afterward we heard the words: "Wash yourselves clean!" and we said: "Wash me, and I shall be whiter than snow." We are Ethiopians, therefore, who have been transformed from blackness into whiteness.[36]

It was a flagrant piece of rewriting: Jerome had borrowed a metaphor from Isaiah almost verbatim, preserved its meaning in its entirety, but swapped its colors: black, not red, was now the color of sin.

The shift also crept into Jerome's translations. In a famous passage from the Song of Songs, sometimes attributed to the Queen of Sheba, Solomon's bride describes her dark skin to the daughters of Jerusalem. The original Hebrew had first been translated into Greek in about 270 BCE as "μέλαινά εἰμι καὶ καλή," and then into Latin in the third century CE as "nigra sum et formosa"—in both cases, "I am black and beautiful." Jerome, however, retranslated the line as "nigra sum, sed formosa": "I am black, *but* beautiful," swapping the "and" for "but." We don't know why. Though the original Hebrew is ambiguous (the conjunction in question, ו (*waw*), can mean "and," "so," "then," or "but"), Jerome's change probably betrayed a new prejudice. It also fundamentally altered the meaning of the text: blackness and beauty were now at odds with each other. The alteration had lasting consequences: Jerome's translation, known as the Vulgate, became the standard version in western Europe until the Reformation, passed into many vernacular languages, and remains the most famous form of the passage. In the many centuries in which it held sway, how many prejudices did it fuel?[37]

At around the same time, other Fathers of the Church converted the ancient clash of light and dark into a struggle between white (*candor*) and black (*niger*), establishing the white-good/black-evil polarity that still exists today. St. Augustine wrote of the "blackness of sin" (*nigritudo peccatorum*), while others used the term "The Black One" (ὁ μέλας) to describe Satan himself.[38] Black later became a defining feature of the "prince of darkness." In the *Livre de la Vigne nostre Seigneur*, a fifteenth-century treatise on Hell and the Antichrist, Lucifer stares out from the page with beady black eyes, his face crowned with two black horns, his body coated in grayish-black fur (**Plate 3**).

Above him hovers Christ, pale-skinned and robed in white. The image might remind us of the old Manichaean battle between light and darkness. But here that metaphor for the clash of good and evil has been condensed into physical form: as a contest between two figures—and two colors.

In the second half of the Middle Ages the prejudice against black spilled into everyday life. Women wearing black were increasingly believed to be witches. Black wolves, bears, dogs, wild boars, crows, owls, rats, cats, and roosters were Hell's earthly agents, if not Satan himself in disguise. Storytellers elaborated these superstitions into narratives, which they told in homes, around hearths, at children's bedtimes. In the mountains of Georgia one such folktale explained the origin of the raven's blackness. The bird was originally as white as Christ's robes but soon started telling fibs. "You have a nasty tongue, and there is no pity in your heart," God scolded. "You must not be white, but black as night, in the same way as your soul is black." God then pulled a charred log from a firepit—the source of so many ancient black pigments—and hurled it at the wicked bird, leaving a dark stain on its feathers that never washed off. Ravens have been black ever since.[39]

Though it isn't easy to trace exactly when and how these intolerances emerged, the evolution of language offers some clues. English, for instance, which is particularly well documented, once possessed not one but two words for black, reflecting the color's initially contradictory characteristics. Old and Middle English made a distinction between dull black (*sweart* or *swart*) and luminous black (*blaek*). But in the twelfth and thirteenth centuries *sweart* disappeared, and *blaek* lost its connections to brightness. At around the same time, the color began accruing negative connotations. According to the *Oxford English Dictionary*, it was associated with filth by 1300 ("in a poke ful and blac"), sin by 1303 (wrongdoers' souls being "black as pyk"), hardship by 1387 (in a reference to "blak dayes" of sorrow and bitterness), bereavement by 1400 ("mourning blak"), blood money by 1423 ("blakrente"), defamation by 1440 ("blakyn"), despair by 1500 ("blacke and ougly dredfull thoughts"), wickedness by 1547 ("their popes blacke curses"), disgrace by 1550 ("blacke blotte"), treachery by 1565 ("blacke treason"), necromancy by 1572 ("black art"), piracy by 1583 ("black flag"), and all manner of foul moods by 1590 ("black-browed"). And so, by the time

England's greatest writer reached maturity, black—in his language at least—was already thoroughly darkened.[40]

William Shakespeare had a vocabulary of between 17,000 and 20,000 words and is sometimes said to have invented a tenth of them. Of the 800,000-plus words in his collected works, about 800 describe colors. Shakespeare had ten basic color terms—one fewer than today ("pink" did not enter English until the 1660s)—but his most frequently used was black.[41] It accounts for more than a quarter of all his basic color terms.[42]

Basic Color Terms in Shakespeare

Black	202
White	169
Green	113
Red	107
Blue	35
Yellow	35
Brown	25
Purple	23
Grey	23

Shakespeare rarely thought of colors in their own terms, but as properties of objects. He used similes such as "black as ink" (*The Two Gentlemen of Verona*), "black as ebony" (*Love's Labour's Lost*), "black as jet" (*Titus Andronicus*), and "black as e'er was crow" (*The Winter's Tale*). He formed the compound adjectives "raven black" (Sonnet No. 127), "beetles black" (*A Midsummer Night's Dream*) and, on seven occasions, "coal-black" (*Henry VI, Part 2, Richard Duke of York, The Rape of Lucrece, Richard II, Titus Andronicus, Venus and Adonis*).[43] His blacks are earthy and quotidian; they smell foul and taste bitter; they squawk in trees and scuttle across floors; and like pitch—the tar with which the color had been compared since the fourteenth century—they stain everything they touch. But nothing in Shakespeare is consistently blacker than darkness. Night is "black-faced" (*Venus and Adonis*) or "black-brow'd" (*Romeo and Juliet, A Midsummer Night's Dream*), replete with a "black bosom" (*The Rape of Lucrece*) or "black contagious breath" (*King*

John), and wearing a "black mantle" (*Romeo and Juliet*) or a "black all-hiding cloak" (*The Rape of Lucrece*). Its blackness was even noted by slow-on-the-uptake Bottom: "O grim-look'd night! O night with hue so black! O night, which ever art when day is not! O night, O night! Alack, alack, alack" (*A Midsummer Night's Dream*).[44] The joke hinges, once again, on darkness as deprivation: an absence of day and light. But here Shakespeare goes further, transferring the same evaluation onto black. It was a happy coincidence that the color rhymed with "alack."[45]

If Shakespeare harbored a certain fondness for black—he began his famous sequence of sonnets to the "Dark Lady" by calling it "beauty's successive heir" (Sonnet No. 127)—he spent rather more time disparaging it. As the Bible had given unpleasant figurative meanings to darkness, so Shakespeare smeared them over black. Depression ("black-oppressing humor" (*Love's Labour's Lost*)), terror ("black and fearful" [*All's Well That Ends Well*]), covetousness ("black envy" [*Henry VIII*]), sexual transgression ("black as incest" [*Pericles*]), bad news ("black, fearful, comfortless and horrible" [*King John*]), criminality ("black villainy" [*Pericles*]), misery ("never was seen so black a day as this" [*Romeo and Juliet*]), mortality ("death's black veil" [*Henry VI, Part 3*]), violence ("black strife" [*Romeo and Juliet*]), damnation ("his soul may be as damn'd and black" [*Hamlet*]), and Satan ("the black prince" [*All's Well That Ends Well*]) were all so tarred. The color's status is perhaps best expressed in his phrase "hell-black night," first used in *King Lear*. In this gritty triad of Anglo-Saxon words, Shakespeare binds sin, darkness, and blackness together, trapping the color between a literal and figurative darkness.

Bad blacks bled through the pages of English literature like a pool of spilled ink, from John Milton's *Paradise Lost* (1667)—where Hell rages with "black fire" while excreting a "black bituminous gurge"—to Laurence Sterne's *The Life and Opinions of Tristram Shandy, Gentleman* (1759–1767)—where a character's death is marked by two striking black pages.[46] But the phenomenon wasn't confined to England. Similar (often almost identical) metaphors appeared in poems and plays all over Europe and America, becoming increasingly prevalent over time. The process seemed to peak in the middle of the nineteenth century, when writers used black in particularly vivid and unsettling ways. While hospitalized for a recurring mental illness in 1853, the

notoriously saturnine Gérard de Nerval composed "The Disinherited," linking blackness and depression in what became one of the most famous passages in French poetry:

> I am the brooding shadow,—the bereaved,—the unconsoled,
> Aquitaine's prince of the doomed tower;
> My only star is dead, and my astral lute
> Bears the Black Sun of Melancholy.[47]

Across the Atlantic, Nerval's contemporary Edgar Allan Poe revived and reinvented all kinds of medieval superstitions about black cats and birds. His best-known work, "The Raven," from 1845, is set in the darkness of a December night. Its lonely protagonist is dozing off by a fire when he is disturbed by tapping at his chamber door. It turns out to be a raven, which enters the room unbidden and perches on a bust. Believing it to be some kind of portent, the man bombards the creature with questions.

> "Prophet!" said I, "thing of evil!—prophet still, if bird or devil! –
> Whether Tempter sent, or whether tempest tossed thee here ashore,
> Desolate yet all undaunted, on this desert land enchanted –
> On this home by Horror haunted—tell me truly, I implore –
> Is there—*is* there balm in Gilead?—tell me—tell me, I implore!"

The raven answers all of his questions in the negative, with the immortal word "Nevermore."[48] Like black—the color by which it was supposedly stained—Poe's tormentor is a series of nos; a feathery figment of deprivation.

Such memorable phrases and associations couldn't fail but trickle back into the communities that spawned them, where they were absorbed by the public. Pejorative epithets steadily migrated from stage to audience, from page to mouth, and ultimately from mouth to mind. Today it is nigh impossible to use everyday language without expressing them. Here are just a few examples:

Black art: the art of performing supernatural or magical acts; magic, necromancy; witchcraft.

Blackball: to record an adverse vote against (a candidate) for membership of a club or other society by placing a black ball in the ballot

box; to exclude (a person) from a club, etc., as the result of such a ballot.

Black book: a record of the names of people liable to censure or punishment; a book containing this.

Black-browed: frowning, scowling.

Black dog: melancholy, depression.

Blacken: to defame (a person), to damage (a person's reputation, name, etc.).

Blackguard: a person, esp. a man, who behaves in a dishonorable or contemptible way; someone worthless or despicable; a villain.

Black-hearted: having evil intentions; malevolent.

Black list: a list of the names of people, groups, etc., who have incurred suspicion, censure or displeasure, and are typically therefore subject to a ban or other punishment.

Black magic: magic involving the invocation of evil spirits; harmful or malevolent magic.

Blackmail: originally: to extort money from (a person, etc.) by intimidation, by the unscrupulous use of an official or social position, or of political influence or vote. Now chiefly: to extort money from by threatening to reveal a damaging or incriminating secret.

Black mark: a (formal or official) record or notification of a person's misdemeanor, bad behavior, poor performance, etc.; (*fig.*) disapproval, (a mental note of) censure.

Black market: illegal traffic or trade in officially controlled goods or currencies, or in commodities in short supply; a place where this trade occurs.

Black mass: in Satanism: a ceremony which parodies the Roman Catholic Eucharist.

Black-mouthed: slanderous; foul-mouthed.

Black sheep: a disreputable or unsatisfactory member (of a family, etc.); a bad character.[49]

No longer confined to a handful of diabolical affiliations, black taints all that is unpleasant in modern life. In the last hundred years it has become the adjective par excellence for disaster: "Black Thursday" (October 24, 1929) and "Black Tuesday" (October 29, 1929) marked the beginnings of the Wall Street Crash and the subsequent Great Depression; "Black Wednesday" (September 16, 1992) was the ignominious day on which the United Kingdom was forced to withdraw from the European Exchange Rate Mechanism; and terrorist attacks in Brussels (in March 2016) and Paris (November 2016) were widely described as "black days" for Europe. We could dismiss these idioms as clichés, or say they reveal more about language than color. But language doesn't only reflect thought. It shapes our experiences of the world around us, as well as our thoughts and feelings about them. The words with which we assemble our sentences also infect our attitudes.

In 2014, three American psychologists undertook a large-scale study of color meaning. The investigators gathered 980 participants of various ages, genders, and races from around the country. The subjects were asked to sit in front of a computer and read the following instructions:

> This is a short study in which we want you to categorize words as negative or positive. If a word is negative, hit the 1 key at the top of the keyboard; if it is positive, hit the 9 key . . . The word itself will sometimes be presented in different colors. You should ignore this factor, making the classifications both quickly and as accurately as possible.

A hundred words flashed up against a gray background: fifty were white and fifty black; half were "positive" (i.e. brave, clean, love), and half "negative" (i.e. cancer, liar, poison). The system ensured complete randomization. If black and white had been neutral in the minds of the participants, they would have had no effect on the speed or accuracy of the identifications. But this wasn't the case. The results showed that almost everyone identified negative words more quickly when they were displayed in black and more slowly when they were in white.[50]

Other studies have shown how early the prejudice takes root. In the 1960s and '70s thousands of preschool children around the United States were subjected to "Color Meaning Tests." In one of them,

children in North Carolina aged from three to six were told stories about a series of good and bad animals. At the end of each story, investigators held up one drawing of a black animal and another of a white animal and then asked: "Which one is the *bad* doggy?" "Which one is the *nice* teddy bear?" "Which one is the *stupid* cow?" "Which one is the *pretty* kitty?" The children consistently linked negative characteristics with black animals: 83 percent considered black animals to be ugly, 83 percent thought them naughty or stupid, 84 percent said they were dirty, 86 percent declared them bad, and 90 percent concluded that they were mean; 41 percent of four-year-olds, 71 percent of five-year-olds, and 89 percent of six-year-olds, none of whom had read a dictionary, let alone tucked into Shakespeare, somehow knew that black could not be trusted.[51]

For many decades film- and television-program-makers applied the same bias to their protagonists. In serial westerns the heroes typically wore white and rode white horses while their antagonists wore black and rode black horses. These characters were often referred to within the industry as "white hats" or "black hats" (**Plate 4**). The convention was partly born of convenience: the two achromatic colors were easily distinguished on small black-and-white televisions and so helped viewers follow the narrative. But it also drew on something more fundamental, which is surely why, despite the advent of color film and television, the convention endured. In *Star Wars*—which consciously tapped into Manichaean ideas about light and darkness—the villains, who operate for "the Dark Side," are led by two men who dress exclusively in black. Would their cause seem as evil if it were called "the Light Side?" Would Darth Vader and Palpatine look as sinister if they were wearing white?[52]

These examples are just one small patch of masonry in a vast edifice of prejudice, but all are rooted in an old and simple conceit: that black is a mode of darkness. In recent centuries this assumption has been reinforced by modern science. Physicists still tell us that black surfaces are like black holes: they devour everything they touch. Black absorbs the entire visual spectrum, reflects none of it, and is therefore a total absence of light and color. It is once again the villain of the piece: the thief who steals light from the world. But this definition can easily support the opposite conclusion. If black absorbs all light, it is surely *full*

of light; and if it absorbs every visible wavelength, it is also *full of color*. Looked at this way, black assumes a very different personality.

BLACK BEAUTY

Next time you're tiptoeing through your home in the middle of the night, take a moment to examine your surroundings. If you are open-eyed and open-minded, you will experience not deprivation but transformation. Darkness abstracts and re-creates the world, making the familiar unfamiliar. It collapses space, bringing everything close. It softens edges, texturizes surfaces, and coats objects in fuzz—as if they have been drawn in conté crayon on coarse-grain paper. After several minutes, when your retinas have adjusted to the gloom, you will notice not one darkness but many, in shades of mottled and reticulated gray. You'll see dark-on-dark shadows drawing gravity-defying shapes against walls, and white phosphenes exploding across your visual field like half-seen fireworks. Perhaps the most satisfying aspect of darkness is that it makes us work. Our vision in bright conditions is too precise to be challenging, but scotopic vision demands we complete the picture for ourselves. In doing so darkness necessitates an unusually industrious mode of looking: interrogative, problem-solving, self-reflexive. In darkness, we see ourselves seeing. What a shame, then, that we rarely give the experience a chance. Whenever we're plunged into darkness we tend to panic, conclude that we can't see *anything*, and fumble for the light switch. But not all cultures think this way.

In his sublime essay *In Praise of Shadows*, written in 1933, the Japanese author Jun'ichirō Tanizaki argued that the "magic" of darkness was integral to eastern esthetics—and completely at odds with the misguided western obsession with light:

> We Orientals tend to seek our satisfactions in whatever surroundings we happen to find ourselves, to content ourselves with things as they are; and so darkness causes us no discontent, we resign ourselves to it as inevitable. If light is scarce then light is scarce; we will immerse ourselves in the darkness and there discover its own particular beauty. But

the progressive Westerner is determined always to better his lot. From candle to oil lamp, oil lamp to gaslight, gaslight to electric light—his quest for a bright light never ceases, he spares no pains to eradicate even the minutest shadow.[53]

These attitudes were part of a cluster of ideas originating in Buddhism, which led Japan to develop very different esthetic standards from those in the West—characterized in part by one evocative word: *yūgen*, imported from China during the Middle Ages, is made from two ideographs: *yū* (幽), meaning "deep," "dim," or "faint"; and *gen* (玄), meaning "mysterious," "dark," or "black." It refers to experiences that are veiled, not immediately apparent, and that can never be fully understood—their impenetrability being the source of their beauty. The thirteenth-century writer Kamo no Chōmei says that:

> *Yūgen* may be comprehended by the mind, but it cannot be expressed in words. Its quality may be suggested by the sight of thin cloud veiling the moon or by autumn mist swathing the scarlet leaves on a mountainside. If one is asked where in these sights lies the *Yūgen*, one cannot say, and it is not surprising that a man who does not understand this truth is likely to prefer the sight of a perfectly clear, cloudless sky. It is quite impossible to explain wherein lies the interest or the remarkable nature of *Yūgen*.[54]

In spite (or perhaps because) of its elusiveness, *yūgen* has been a lodestar of Japanese esthetics since the twelfth century, cultivating a preference for questions over answers, ambiguity over clarity, and shadows over light. Tanizaki believed this attraction to darkness persisted well into the twentieth century and informed much of Japan's material culture, from the dark, overhanging eaves of traditional houses to the black lacquerware inside them. It even underpinned the nation's partiality for soy sauce. "How rich in shadows is the viscous sheen of the liquid," he rhapsodized; "how beautifully it blends with the darkness."[55]

The admiration for darkness was joined by a taste for austerity. At roughly the same time as *yūgen* emerged, Japanese thinkers began to reject the extravagances of the medieval court in favor of a plain and simple esthetic. This required the streamlining of poetry, the

abandonment of ornament, and the "killing" of bright colors.[56] The renunciation of hue was perhaps informed by Taoist philosophy, which repeatedly warned that loud colors were superficial extravagances that could "confuse" or "blind" their observers.[57] One poem, written by Fujiwara no Teika in the thirteenth century, phrased similar guidance in more roundabout terms:

> As I look about,
> I see neither cherry blossoms
> Nor crimson leaves.
> A straw-thatched hut by the bay
> At evening in the autumn.[58]

It is about a beauty that fades: spring is but a memory, autumn leaves have fallen, and day is becoming night. But it is also about color. Teika invoked the warm hues of blossom and maple precisely in order to vanquish them. The reds and pinks of the past have been replaced by a bare wooden shack on a monochrome beach. It is in part a lesson: that life without color has a beauty all of its own.

Japan's growing admiration for ambiguity and austerity was perhaps best expressed in ink, first developed in Egypt thousands of years earlier but mastered later in Asia. In China, carbon-black ink (known, confusingly, as "India ink") was originally made by burning pinewood in a restricted air supply and then collecting the soot. The powder was strained, mixed with animal glue and up to a thousand other additives, kneaded, shaped, dried, and waxed. The process could not be hurried: according to one early recipe the mixture had to be pounded thirty thousand times.[59] At first the Chinese used this rich black fluid for writing, calligraphy, and printing, but by the T'ang dynasty (618–c. 907 CE) they were also using it to paint. Chinese painters began by pairing it with other colors but many later renounced everything except black. Not that they considered it to be a single color: they recognized at least five different blacks, including burned (*jiao* 焦), thick (*nong* 浓), heavy (*zhong* 重), pale (*dan* 淡), and clear (*qing* 清). According to Zhang Yanyuan, author of the world's first work of art history in 847 CE (700 years before Giorgio Vasari's *Lives of the Artists*), black ink was sufficiently versatile to make other colors quite unnecessary:

Anything in nature . . . can be depicted with the mysterious charm of ink and the painter's exquisite skills. Vegetation may display its lushness without using green pigments; clouds and snow may swirl and float aloft without using white color; mountains may show vivid verdure without blues and greens; and a phoenix may look flamboyant without luxuriant dyes. For this reason, a painter may use ink alone and yet all the five colors may seem present in his painting. If one's mind dwells only on colors, then the images of things might lose their essential charm.[60]

Inkwash painting—*sumi-e* or *suibokuga*—probably arrived in Japan in the twelfth century, around the same time as *yūgen*. The country's earliest practitioners were Zen priests who believed that ink painting—like calligraphy and gardening—stimulated, deepened, and expressed spiritual insights. Its visual asceticism might also have dovetailed with their abstemious lives (the Japanese word for color, *iro* (色), also means "physical form" and "sexual desire"; the renunciation of hue may therefore have reflected their quest to transcend the temptations of the flesh).[61] Ink painting spread throughout Japan in the thirteenth, fourteenth, and fifteenth centuries, but its center was a single temple in Kyoto. Shōkoku-ji was a veritable assembly line in pioneering painters, producing the early masters Josetsu, Shūbun, and, perhaps greatest of them all, Sesshū Tōyō.

Sesshū was born in a village near Okayama in 1420 and entered a small Buddhist monastery as a boy—although according to legend he was more interested in painting than meditation. One day he was so negligent that his exasperated masters tied him to a tree in punishment. At first Sesshū endured his detention with admirable stoicism, but gradually his fortitude was broken. After several hours, he began to weep. His tears were so abundant that they formed a puddle around his feet. Using his toe as a brush, Sesshū drew the outline of a rat in the tears. After completing his final stroke, the rat came to life, gnawed through the ropes, and liberated its creator.[62] Sesshū later moved to Kyoto, receiving Zen training at Shōkoku-ji, where he was taught by Shūbun. In 1467, he spent two years in China as part of an official trade delegation, where he was deeply influenced by its inkwash traditions. After returning to Japan, he established his reputation as the

country's preeminent painter and slowly mastered the art of blackness.

Sesshū painted the *Splashed-Ink Landscape* (1495) in his mid-seventies (**Plate 5**). It may only have taken a few minutes to make, but it is the fruit of a lifetime's expertise. What at first sight looks almost abstract soon coagulates into an image: in the foreground, a craggy outcrop of rock scattered with trees and bushes; in the background, towering peaks half-hidden by mist. We are watching *yūgen* in action. Look closer still: beneath the rocks the angular forms that initially looked like trees mutate into a small building: the angled eaves, the vertical posts of a fence, and a diagonal line that Sesshū's contemporaries identified as a wine tavern banner. At the bottom-right of the image half a dozen strokes denote the calm surface of a lake, with two figures rowing a boat across it. Are they heading to the tavern? Or are they trying to get off the water before the rain arrives? We must decide for ourselves. To look at this painting is not only to witness a process of becoming but to participate in bringing it to life. It would be 400 years before western artists made anything so stealthily suggestive.[63]

How did Sesshū create such a masterwork? He began by preparing his colors. He might have spent twenty or thirty minutes mixing his ink stick with water: patience not only ensured consistency of color but gave him time to prepare mentally for the job that lay ahead. The result was a dense, jet-black ink. He poured some of it into another bowl and mixed it, again patiently, with more water to produce a medium-black ink, before decanting it into a third bowl and diluting it again to produce a pale one. He was left with three bowls—three shades of black.[64] Sesshū was now ready to paint. He charged his brush with the lightest ink and applied it quickly, in a wash so pale as to be almost indistinguishable from the paper, creating the misty effects of distant mountains. Then he filled his brush with the middle black ink and in two dozen strokes outlined the structure of the rocks in the foreground. In certain places, where the previous layer was still wet, the inks bled together, creating a fourth shade of black between them. In other places he removed excess water from his brush and added to the wet blacks some dry ones, the strokes feathering at their ends as the hairs of the brush separated. Sesshū now turned to his

jet-black ink and added details of vegetation. The first of these marks, at the top, merged with the paler ink beneath it like a pattern of blood vessels, and so produced a fifth, medium-dark, black. When everything had dried, he added the final details: calligraphic marks for the tree, house, and boat. After sixty or seventy strokes, Sesshū was finished.

The *Splashed-Ink Landscape* is, among other things, an exercise in the generative capacity of black. Sesshū used this supposed noncolor to produce a rainbow of effects. There are light blacks and dark blacks, warm blacks and cool blacks, wet blacks and dry blacks, thick blacks and thin blacks, bleeding blacks and blotted blacks. Some stab, some caress, and others are so pale that they appear almost white. This painting proves that there is nothing monotonous about black. It is no less beautiful, and no less varied, than any other color.[65] The greatest virtue of monochrome painting, like darkness, is that it demands imagination; it allows its viewers to fill in the gaps. Austerity need not mean dullness. In the mind's eye, Sesshū's chameleonic blacks can become any color in the spectrum, in ever-changing combinations. But if he had used colored paint, they could only have been the hues he chose.

In its voracious quest to modernize and westernize Japan discarded many of its Zen traditions, but it still retains an unusually nuanced view of blackness. Unlike westerners, the Japanese rarely distinguish between black and color: black *is* color, as far as they are concerned. And so when color television came to the country in the 1960s, the Japanese couldn't call it "color television" because, as they saw it, black-and-white sets were already transmitting color images. After some deliberation they decided to call the new technology "natural television" (*tennenshoku terebi*).[66] The monochrome esthetic might also explain why so many Japanese artists and designers still restrict themselves to achromatic palettes. Hiroshi Sugimoto's black-and-white photographs of misty seascapes belong to a grayscale tradition that started with Josetsu, Shūbun, and Sesshū, while Comme des Garçons' celebrated all-black garments draw on old beliefs in black's generative capacity. During a rare interview in 1983, the brand's founder, Rei Kawakubo, revealed that she designed in "three shades of black": perhaps she was referring to the three bowls of ink that colored the country's greatest paintings.[67]

Western artists took longer to grasp the potential of black. While Sesshū and his contemporaries were busy constructing polychromatic worlds from ink, most painters of the Italian Renaissance still confined the color to their outlines and shadows. Alberti even declared that anyone who overused it deserved to be "strongly condemned."[68] Nevertheless, in the first half of the seventeenth century some European artists began to fill their pictures with black shadows. Their *tenebrism*, however, wasn't really about black. They had discovered that black lends intensity to everything it touches: long before Hering and Gelb, they understood that it makes its neighbors more vivid. Caravaggio's religious narratives derive much of their power from their pitch-black backgrounds (imagine how banal they would look in sunlit landscapes), while Velázquez's incomparable faces are brought to life, and sometimes imperiled, by the darkness around them. In one spellbinding portrait of an unknown man, the sitter's flesh tones fight for survival against an all-consuming blackness (**Plate 6**). I have returned to the painting many times over the years and am convinced the black is growing.

"I've really come to know Velázquez," Édouard Manet wrote to Charles Baudelaire during a visit to Spain in 1865, "and I tell you he's the greatest artist there has ever been."[69] Manet learned from Velázquez that black was the master key to a successful composition. His portrait of Berthe Morisot, painted in 1872, is, like Sesshū's *Splashed-Ink Landscape*, an object lesson in black's infinite versatility (**Plate 7**). By my count, it serves at least nine different functions: it is used wet and thick, to simulate velvet, fur, and satin, and dry and thin, to evoke the crisp edge of the taffeta bustle, mixed with brown and white, to represent the fabrics in the light, and with synthetic ultramarine to depict them in the shadows. It acts as an outline, and as the calligraphic residue of the artist's gestures. It frames and sets off the delicate flesh tones of Morisot's face, is used in tiny, almost invisible, quantities to modulate skin, eyes, and background, and, more legibly, in Manet's signature.[70]

Manet's successors embraced black with similar enthusiasm. Odilon Redon thought it "the most essential color,"[71] Picasso said it was "the only real color,"[72] and for Matisse it was not simply a pigment but "a force."[73] When toward the end of his life Auguste Renoir was told that black was a noncolor, he responded with incredulity. "Black a

non-color? Where on earth did you get that? Why, black is the queen of colors!"[74] Later in the century, it became a calling card of the Abstract Expressionists, with Franz Kline, Robert Rauschenberg, Barnett Newman, Frank Stella, Mark Rothko, Robert Motherwell, and Ad Reinhardt making all-black, off-black, or part-black pictures.[75] But their enthusiasm was still haunted by the old prejudice. Reinhardt in particular was keenly aware of the color's ignominious history. In an unpublished notebook he compiled an evocative inventory of its meanings under the heading "Black, symbol," many of which we have encountered before:

> Bible—"Good/Evil," "White/Black," "Light/Dark" . . .
> "Black as sin," evil, ignorance, wickedness . . .
> Black-hearted, black-list, black-mail, black-sheep, black-death, illness, hatred, morbidity, despair, sorrow, inferior, feminine . . .
> Chaucer, Milton, Shakespeare . . .
> Forces of darkness, formless, unformed, chaos
> Hell-void, "intolerable ache of absence, chill negation of love"
> Initial, germinal stage of all processes, primal, unconscious darkness . . .
> Profound mystery of the origin "primordial darkness" . . .
> Sucks time, space, identity into absolute of nothingness
> Inevitability of fate[76]

Reinhardt was a devotee of east Asian culture—he had studied the region's art at New York University in the 1940s, and attended D. T. Suzuki's celebrated lectures on Zen Buddhism in the early 1950s—and it seems likely that Chinese and Japanese inkwash traditions informed his own monochromes.[77] He created his first all-black paintings in the mid-1950s, and worked on them almost exclusively until his death in 1967. These unremittingly square canvases are uncannily similar to the primordial darkness that Robert Fludd conceived more than three centuries earlier. Like Fludd, Reinhardt chose the color for its absolutist negativity.

> Nonsensuous, formless, shapeless, colorless, soundless, odorless
> No sounds, sights, sensing,
> sensations
> No intensity

No images, mental copies of
Sensations, imagings
imaginings
No concepts, thinking, ideas, meaning, content.[78]

There was an important difference: where Fludd's black square was a portrait of the beginning, Reinhardt's depicted an end—the conclusion, in his own immodest opinion, of painting as an art form. He was deceiving himself.

Pierre Soulages was born six years after Reinhardt, in 1919—but also on Christmas Eve. He developed an affinity with black at an early age. When he was ten, a friend of his elder sister found him applying thick black lines to a sheet of paper and asked him what he was doing; young Pierre replied that he was drawing snow. "I can still see the amazed expression on her face," he recalled, "and yet I had not been trying to shock her or indulge a taste for paradox. I had simply told the truth." He continued:

> What I was drawing was a landscape under snow. I was trying to capture the brightness of light. The white paper began to shine like snow by contrast to the black lines I was drawing on it. In spite of, or rather because of the black, my drawing had for me the brilliance of a snow scene.[79]

Pierre, it seems, had intuitively grasped what physiologists and psychologists had taken many decades to understand: that black and white, like darkness and light, are indivisibly connected. He had discovered simultaneous contrast.

Soulages grew up to become a professional artist and never lost his love of black. People repeatedly told him it wasn't a color, but like Renoir before him he disagreed. "Black is a color!" he once retorted. "Black for me is an intense color, more intense than yellow, capable of giving rise to violent reactions and contrasts."[80] Soulages was also interested in the uses and meanings of black, going back tens of thousands of years. His lifelong home in Aveyron, France, is rich in prehistoric monuments, which he exhaustively explored as a youth. At the age of sixteen he even joined an archaeological dig, unearthing pottery and arrowheads in an ancient tomb. He grew fascinated by the cave paintings discovered at nearby Pech Merle, Lascaux, and Chauvet, which

provoked in him a flurry of questions. Why did Paleolithic humans travel to the darkest corners of their world to make pictures? And why, when they got there, did they paint so many of them in black, rather than in the bright white chalk that littered the ground? Did they see the color as a symbol of the darkness around them? Or did they see in it a kind of brilliance, derived from the fire that enkindled it, capable of illuminating places that daylight couldn't reach?

Soulages increasingly interrogated blackness in his own art. He smeared, scraped, and scratched it, blending one pigment with others, diluting it one day, piling it up in layers the next—stretching it to its limits, squeezing it until it gave up its secrets. He tested its effects on other colors, and theirs on it: how ivory black and ultramarine refuted but reinforced each other; how the meeting of mars black and chrome yellow detonated an optical explosion; and how mysterious things happened at the points where black became brown and brown became black. And yet it was only in his sixties that he finally discovered what Zhang Yanyuan and Sesshū had earlier realized: that most visual effects could be achieved with black alone.

> One day in 1979, I was in this studio working on a painting for hours and there was black paint everywhere. I was exhausted, and I couldn't understand why I had worked for so long on something I didn't like. I thought it must be a bad painting because it wasn't turning out like the others. I went to sleep for an hour, and when I woke up and looked at it again, I thought, "I don't paint with black anymore. I paint with the light reflected off the black surface."[81]

Soulages has worked almost exclusively in black pigments ever since, but from them fashions a rich and dazzling world. He calls this color *outrenoir*—"beyond black"—a name that evokes *outremer* (ultramarine), the most coveted pigment of the Renaissance. *Outremer* was also the name French crusaders gave to the Kingdom of Jerusalem, and thus to Heaven on Earth. The French still use the term *outre-Manche* (beyond the Channel) to refer to England and *outre-Rhin* (beyond the Rhine) for Germany. Soulages' *outrenoir* likewise evokes a territory whose porous borders are demarcated only on the retina.

Let us plunge into one such painting—a large triptych whose carbon-heavy surfaces smell like bonfires at night (**Plate 8**). Soulages

made it from two types of black acrylic—matte on the side canvases, glossy in the center—which he applied with expansive motions, the way a plasterer might skim a wall. But before the paint had time to dry, he attacked what he'd just created. He flipped the brush in his hands, using its handle to carve dozens of near-horizontal slashes into the paint, transforming the three rectangles of monolithic black into bands of light and shadow. The matte canvases alternate between shades of gray, while the glossy center is electrified by its light sources. Its indentations subside to a bottomless black, but its ridges ascend to the brink of whiteness, which shimmer and twinkle at their zeniths. In different states of illumination the lights and shadows swap places and change hues, while surface textures appear to switch between velvet, tar, and glass. Indeed, when you approach the picture, your reflection subtly alters it. Wear blue, and the black gets cooler; wear red, and it seems to blush.

Soulages' picture may be abstract, but it's impossible not to see something in it—just as we can't help but discern swirling shapes in darkness. Is it moonlight reflecting off rippling water? An ocean receding into the distance? We are in one sense gazing at the realm of *outrenoir*. But in another, we are looking back in time: past Hiroshi Sugimoto's monochrome photographs of seas, past the works of Reinhardt and Manet, past Shakespeare's "hell-black night," past the Japanese inkwash paintings, and past even the earliest carbon-black cave art, until finally we find ourselves at the beginning: when darkness stalked the face of the deep, and the spirit of God moved on the face of the waters. We have arrived at the primordial soup that Robert Fludd pictured in his own black quadrilateral. God, of course, went on to divide the light from the darkness, but Soulages brings these two old adversaries back together. This great painting, like so many of the artist's works, shows that black isn't empty or ugly or evil. It isn't even dark.

2

Red

Inventing Humanity

*Where I'm spread, I see eyes shine, passions increase, eye-
brows rise and heartbeats quicken. Behold how wonderful it
is to live! Behold how wonderful to see! Behold: living is see-
ing. I am everywhere. Life begins with and returns to me.*

Orhan Pamuk[1]

On a crisp Sunday afternoon in December 1994, three spelunkers were
exploring the limestone gorges of the Ardèche valley in southeastern
France when they caught sight of a small opening in a cliff wall. Their
passage was cut off by rockfall, but an updraft of cool air suggested a
large chamber lay beyond. They took turns removing loose rocks; by
early evening they had created an opening to another cavity, ten meters
beneath them. They considered giving up for the night and returning
the following weekend, but fearing someone might beat them to it, they
agreed to make a descent. An hour later they were inside a cave that
was as beautiful as it was vast: stalactites cascaded around them, and
mother-of-pearl glistened in the torchlight. They were about a hundred
meters into the chamber when a head torch alighted on two lines, faint
but unmistakably human, on the cave wall. Before they could digest
the discovery, they noticed drawings—a partly erased mammoth, a
bear, an abstracted butterfly, a rhinoceros with a giant horn, a pride of
lions—all scratched onto the rock with charcoal:

> The emotion that gripped us made us incapable of uttering a single
> word. Alone in that vastness, lit by the feeble beam of our lamps, we

were seized by a strange feeling. Everything was so beautiful, so fresh, almost too much so. Time was abolished, as if the tens of thousands of years that separated us from the producers of these paintings no longer existed. It seemed as if they had just created these masterpieces.[2]

The artists had also depicted themselves. A congregation of hands, outlined in red paint, waved out at their visitors like salutations from the past. Let us examine one of them (**Plate 9**). It appears halfway along the cave system, inside an abandoned charcoal outline of a mammoth. Its creator was probably left-handed (dominant hands typically produced the stencils and rarely appear on walls). The artist made it by mixing a red ochre pigment with blood or saliva. He or she then placed their right hand on the wall, taking care to position the fingers correctly, sucked the paint into their mouth with a small tube, and spat it onto the cave wall. They did this repeatedly, for up to forty-five minutes, until the entire perimeter of the hand was showered with pigment. It was then removed to reveal a scarlet silhouette—one made 300 centuries ago, but that looks only moments old. The thumb is still bent at the knuckle, the little finger stretched away from its neighbors. Preserved for thousands of years in darkness, the hazy red nimbus is bright and hot with life.[3]

Chauvet Cave contains more than 400 hand stencils, handprints, and palm prints, and unlike the drawings of animals—most of which are in charcoal—every one of them is red. Hands like these appear in dozens of prehistoric caves across France and Spain, as well as in India, southeast Asia, Africa, Australia, and in Patagonia, where some caves contain hundreds of hands (many of them again silhouetted in red) intertwined into a forest of gestures. The makers of these astonishingly direct and potent images were not copying each other—they didn't even know of each other's existence—but they were all somehow moved to place warm palms on cold stone and mark their presence with pigment. Why were these images made, and what did they mean? They could have been memorials or property markers, records of rites of passage, or even attempts to touch a spiritual realm believed to exist beyond the rock. We will never know for certain. But to us at least they are proof that modern humans—self-confident, self-conscious, and pulsating with imagination—had arrived.[4]

*

If we are to believe the ancient Babylonians, humans owe their existence to worker unrest. According to Mesopotamian myths, the Earth was originally inhabited only by gods—though not all of them were equal. While the senior deities lived in lazy majesty, their subordinates toiled on the land, digging canals and plowing fields until they could stand it no longer. One day, the junior gods went on strike and marched to the home of their master. Enlil was sleeping when the protesters arrived but was woken by a panicking servant. "My lord, your house is surrounded," he cried, "a rabble is running around your door!" Enlil sent a vizier into the street to find out who had organized the protest. The rebels answered as one.

> Every single one of us declared war!
> We have put a stop to the digging.
> The load is excessive, it is killing us!
> Our work is too hard, the trouble too much!
> So every single one of us gods
> Has agreed to complain to Enlil.

Enlil summoned Anu, god of the heavens, and Enki, god of the oceans, to help resolve the crisis. Enlil suggested punitive measures, but Enki urged conciliation. "Why are we blaming them?" he asked. "Their work was too hard, their trouble too much." Enki then made an audacious proposal. "*Create a mortal*. Let him bear the load of the gods!" After Enlil and Anu endorsed the scheme, Enki set to work. He sacrificed one of the rebels and mixed his flesh and blood with clay from the ocean bed. Each of the senior deities spat into the red mixture, which Enki then kneaded beneath his feet. The clay was divided into fourteen pieces and sent to fourteen birth goddesses for gestation. Nine months later, seven men and seven women were born who went on to populate the world.[5]

Dating back to 1800 or 1900 BCE, probably more than a thousand years before the Book of Genesis was composed, the ancient Akkadian poem *Atrahasis* is one of the oldest surviving accounts of the creation of our species. Later stories had different plots and characters, but they usually adhered to Enki's production methods. Most agreed that the first humans had been made from earth. The exact materials varied—many specified clay, some dust, others sand—but they

typically shared one conspicuous characteristic: almost all of them were red.[6] This is where the first human of the Old Testament, himself modeled from the "dust of the ground," got his name. "Adam" was derived from the Hebrew *âdham* (אדם), meaning "red," and related to *adhama* אדמה, meaning "ground," "earth," or "land" (and perhaps also to *dam* (דם), meaning "blood").

Homo sapiens comes in a sepia spectrum of skin colors—a superficial variation that, as we'll see in Chapter 5, has had profound and problematic consequences. But beneath the surface, all of us are red. The average adult body contains five liters of blood—about 7 or 8 percent of its total weight—while the bone marrow manufactures more than two million red blood cells every second. Blood contains more than 4,000 ingredients and has multiple functions: it distributes oxygen, nutrients, and hormones around the body, regulates internal temperature and pH levels, and fights invading microorganisms to help protect us from disease. Our tissues and organs would starve without it.[7]

Blood's distinctive color comes from hemoglobin, a protein molecule that makes up roughly a third of every red blood cell. Hemoglobin consists of a single iron atom surrounded by four five-pointed pyrolle rings that latch onto oxygen in the lungs and release it elsewhere in the body, then latch onto carbon dioxide and release it in the lungs. Hemoglobin's redness originates in its heme component (globin is colorless), which most chemists assume is produced by the iron at the heart of the molecule (as owners of aging cars will know, oxidized iron has an annoying tendency to turn red). Others, however, think iron is incidental to blood's color, and that its redness is actually created by the ligands (bonds) between the heme and oxygen, which absorb green light and reflect red. In both formulations, oxygen plays a decisive role. This is why oxygenated blood is redder than deoxygenated blood, which is sometimes described as blue but is really closer to burgundy.[8] Fresh oxygenated blood is disturbingly beautiful, so vivid that it seems almost fluorescent, viscous enough to form coherent shapes as it dribbles from any splash sites but glossy enough to reflect its surroundings. A single droplet can look yellow in its shallows (the color of the plasma in which blood cells are suspended) and black in its depths. In bright light, it tends to adopt two

Hemoglobin

principal tones: a deep granular claret that resembles the skins of just-washed cherries and a vermilion that looks like a ripe cayenne pepper. These intoxicating optical qualities are doubtless enhanced by their impermanence. As it dries, blood hardens into a ponderous dark brown.

The connection between blood and its color, the noun and its adjective, is both ancient and universal. It is why so many words for the hue originate in terms for the fluid. Red (English), *rouge* (French), *rosso* (Italian), *rojo* (Spanish), *rot* (German), *rood* (Dutch), *rød* (Danish), *röd* (Swedish), *rautt* (Icelandic), *rudý* (Czech), *ruber* (Latin), and ερυθρός (Greek) all probably derive from the Sanskrit word *rudhira*, "blood." As people compared red and blood, their characteristics rubbed off on each other, with red acquiring a correspondingly central place in human culture. Blood, after all, is present at the most decisive moments in our existence: during menstruation and childbirth, and when we are sick, injured, or dying. These complex and contradictory meanings made red a metaphor not just for blood but for the entire cycle of human life.[9]

HOMO RUBEUS

As far as we know, *Homo sapiens* emerged in Africa up to 300,000 years ago.[10] But when did our ancestors start behaving like us? When did they begin manufacturing tools, conducting trade, making art, performing rituals, inventing religions, telling stories, and creating symbols? This cluster of distinctly human activities—which is often called "behavioral modernity"—is traditionally believed to have

emerged suddenly in the Upper Paleolithic period in Europe about 40,000–50,000 years ago—not long before the paintings were made in Chauvet. Recent archaeological discoveries, however, offer compelling evidence that behavioral modernity evolved tens if not hundreds of thousands of years earlier, in Africa—and that these profound changes were inextricably connected to a particular red pigment.[11]

Ochre is a broad term for a group of iron-rich earth materials formed over time by chemical weathering, with a range of hues depending on the mineral compounds it contains. Red ochre, the most culturally important of them, comes from the mineral hematite.[12] Its verbal resemblance to hemoglobin is no coincidence: both words share the Greek root *haima* (αἷμα), for blood. When ancient creation myths spoke of humans being fashioned from "red earth," they were likely referring to hematite. Red ochre might have been used by *Homo erectus* as much as 1.5 million years ago, and certainly was by Neanderthals 250,000 years ago (though they generally preferred black pigments).[13] Modern humans were also avid devotees and used it throughout the Middle Stone Age (c. 300,000–40,000 BCE) all over Africa. Archaeologists have found it on the slopes of Kenya's Rift Valley, on Zambian hilltops, on remote islands in the Sudanese Nile, and all along the coast of South Africa.[14] By 100,000 BCE ochre use was a widespread feature of most human communities, though it was no casual undertaking. The raw material was laboriously excavated, transported to processing centers, then traded. It would only be a small exaggeration to describe red ochre as the gold of the Stone Age. It was almost certainly humanity's first color commodity.[15]

Blombos Cave, which is nestled in coastal cliffs 200 miles east of Cape Town, was one part of this extensive ancient industry. A hundred thousand years ago it was an ochre-producing workshop. Since its discovery in 1991, thousands of pieces of red ochre have been found there, together with tools once used to process it. Raw ochre was brought to the cave from a quarry twenty miles away, hacked into small chunks, and rubbed on a slab to produce a powder. Mammal bones were heated, crushed, and their marrow extracted; the animal fat was then placed with the ochre in two abalone shells taken from the beach and stirred until they became a thick red fluid. This process was repeated innumerable times in the cave, over many

years, until the tools were for some reason abruptly abandoned. Aeolian sand later blew into the cave and buried its contents for millennia.[16]

In 1999 and 2000, two unusual pieces of ochre were found on the site. One of the fragments is decorated with rows of cross-hatching, meticulously divided by three parallel lines into almost equilateral triangles (**Plate 10**). Its creator worked systematically across the surface, beginning with the oblique lines and finishing with the three horizontal incisions, engraved from left to right. Made an astonishing 70,000 years ago, it is the earliest surviving design created by humans—and more than twice as old as the paintings in Chauvet. But what was its significance? It couldn't have been an absentminded doodle: the effort required would have been too great, and the pattern seems too purposeful. Nor was it some form of notation: the markings aren't discrete enough to order information. The design, and the medium, were surely symbolic.[17]

What was the purpose of the red ochre at Blombos and elsewhere? And why did our ancestors go to such lengths to extract and process it? There are few more fiercely debated questions in archaeology and anthropology. One school holds that ochre was a largely functional material, used to make adhesives and varnishes, to assist in the knapping and hafting of stone implements, or to prepare and preserve animal hides.[18] Others have speculated that it was applied to the skin to protect its wearers against the sun, cold, and insect bites, to insulate the body when diving for seafood and to cauterize or clean injuries.[19] Some even think it was a dietary supplement.[20] All of these theories, however, share a common problem: there is little evidence that red ochre was more effective at such tasks than other, more accessible, materials. It seems more likely, then, that the material was chosen not for its utility but for its appearance. Analysis of several sites has shown that redder substances were much more likely to be extracted from quarries and processed in workshops—indeed, a staggering 94 percent of all surviving pigments from the African Middle Stone Age are red.[21]

In one sense, this shouldn't be surprising. Occupying one end of the visible spectrum, "red" contains a wider range of light wavelengths than any other hue. It is the only color that remains fully saturated

in peripheral vision, so it would have been particularly conspicuous amid the greens and yellows of the savannas in which early humans lived. There is a good deal of circumstantial evidence to show that it was used as some kind of signal. At Blombos, the animal fat with which ochre was mixed surely functioned as a binder, to form a simple red paint that was then applied to people, places, or objects.[22] But this answers only part of our question. If red ochre was indeed used to signal something, what did it signal? The most influential theory is that it symbolized blood.

Many mammals use red colors to alert potential mates to their sexual state. Female baboons and chimpanzees advertise their estrous cycle with reddening and swelling skin around the genitals. Humans don't possess such overt signs of ovulation; menstrual bleeding is perhaps the only visual evidence of potential fertility. In 1995, a group of anthropologists argued that females once used their own menstrual blood to attract the attention of males, but this had the disadvantage that females only had access to such fluids at certain times of the month. The signal therefore risked encouraging males to abandon nonmenstruating females in favor of those who were. Faced with potential desertion, the females had two options: they could compete or cooperate. This was the origin of what the anthropologists called "female cosmetic coalitions": a community of females would all apply red paint to their bodies in order to confuse males and so prevent them from devoting resources only to those who were menstruating. Initially these coalitions might have shared the blood of cycling females. But as the groups grew in size and the signals became increasingly elaborate, they sought out blood-like substitutes. This was where red ochre came in: hematite became a proxy for hemoglobin.[23]

The anthropologists corroborated their theory with ethnographic evidence drawn from contemporary hunter-gatherer populations. Women all across Africa—the Fang in Cameroon, the Nuba and Nuer in Sudan, the Maasai in Kenya and Tanzania, the Bemba in Zambia, the Venda in South Africa and Zimbabwe, and the click-speaking inhabitants of the Kalahari—still cover their bodies with red paint.[24] In northwestern Namibia, Himba women have excavated red ochre from one particular quarry for centuries. They grind it into a powder and mix it with clarified butter and aromatic resins until a fragrant

red paste called *otjize* is produced, which they apply to their skin and hair every morning. *Otjize* probably confers some health benefits on its wearers, including protection from the harsh Namibian sun, but most Himba women claim that its main function is to make them more beautiful.[25]

Many tribal communities also use red pigments to mark out female rites of passage. The Yombe, who live in the southern part of the Republic of Congo, practice a ritual called *Kumbi* that announces the onset of female fertility. It usually takes place either after a girl has reached puberty or before she is due to be married. The girl is led to a "red house," where her body and clothes are covered in a red paint called *tukula*, made from crushed camwood, palm oil, and sand. The girl may spend as little as a month or as much as a year in the small building, where she is visited by women who reapply the *tukula* to the upper half of her body—but they too must cover themselves in the pigment if they are to be admitted. At the end of her seclusion, the girl is taken to a nearby river and the layers of *tukula* are washed off her body. As this is happening, her clan prepares a lavish feast that celebrates the girl's transformation into a woman.[26]

The cosmetic coalitions theory isn't universally accepted.[27] But it has at least three fascinating implications: that the first pioneers of the human pigment industry were not men, but women; that body-painting was an early, if not the earliest, form of image-making, predating cave painting by hundreds of thousands of years; and, most relevant here, that red pigments were very early *symbols*.

Symbols are arbitrary signs. They refer to objects and ideas not because they are directly or causally connected to them, but because people have decided that they should. These words are symbols, meaningful only because English speakers have agreed that they are. When this book is translated into other languages, these words will be replaced by other symbols that have been chosen by other communities to mean similar things. No modern society could function without symbols. Complex communication would become impossible, governments would grind to a halt, money would become worthless, and this book would be gibberish.

According to the female cosmetic coalitions hypothesis, red ochre was symbolic because it was a complex collective fiction. For the

substance to become a symbol of fertility, a conceptual chain was required. First, people had to interpret menstrual blood as a symptom, and potential signal, of fertility. Then, groups of women had to realize that it was in their interests for all members to advertise the signal whether they were fertile or not. Finally, they had to see red ochre as an effective proxy for blood and therefore fertility. This sequence of cognitive leaps triggered a series of cultural practices that involved locating, extracting, and processing hematite, applying it to bodies, and displaying it in now-lost rituals. Over time, entire societies came to agree that red pigments *meant* something. It is quite possible that this symbol—red/blood/fertility—was humanity's first.

When *Homo sapiens* migrated from Africa and settled in the Middle East (c. 200,000 years ago), Asia (c. 100,000 years ago), Australia (c. 65,000 years ago), Europe (c. 40,000 years ago), and the Americas (c. 15,000 years ago), they took their predilection for red ochre with them. Humans applied it to their bodies in almost every part of the world. Aboriginal Australians had little contact with the outside world for tens of thousands of years but used hematite much like everyone else. The Maori, who identified red ochre with the blood of their earth goddess, mixed it with shark oil to make a paint called *kokowai* and applied it to their faces, homes, and possessions to invoke power, or *mana*. The indigenous tribes of North America coated their hair, bodies, clothes, and utensils with hematite, prompting some Europeans to call them "Red Indians."[28] As the red pigments spread, so did their meanings. They continued to symbolize female fertility, but they also became linked to hunting and burial rituals; were used to please gods and deter demons; to summon rainfall and communicate with ancestors; and to mark out things, spaces, and states that were considered auspicious or inauspicious. This towering edifice of connotations was built on one simple observation: that blood was red, and red therefore was blood.

BLOOD OFFERINGS

The metallic smell of blood was heavy in the air as a young warrior, captured on the field of battle, was led up a set of stone steps. When

he reached its summit, four temple assistants each grabbed a limb, bundled him backward onto an altar, and held him as still as they could. An executioner then plunged an obsidian knife into the flesh just below the left nipple. He hacked through the pulmonary trunk, the ascending aorta, and the superior vena cava, then ripped out the victim's heart. The young man, who was conscious throughout the excision, gazed up at the still-beating organ above him. He might even have seen it being rubbed against the temple's statues before he was thrown off the altar and back down the steps. A second group of officials then set to work on the body. When they had finished skinning the corpse, a priest dressed himself in the victim's hide and danced with the rapturous spectators. The warrior's remains were later eaten.[29]

Few societies were more obsessed with blood than the Mesoamericans. Gruesome sacrifices like the one above have captured western imaginations since the first Spanish conquerors witnessed them, but they were only a small, even unrepresentative, part of a much broader cult of bloodletting, in which all participated. Some pricked holes in their earlobes and decorated their faces with blood. Others skewered their tongues or genitals with stingray spines. Many pulled studded cords back and forth through their wounds hundreds of times a day. These people were motivated neither by sadism nor masochism: they were simply paying a debt. Most Mesoamericans believed that the gods had given blood to create the universe, so it was their duty to give it back. Blood was their sacred offering—not a symbol of death, but of life. For the Aztecs, it was a miraculous substance that imbued matter with energy. "Our gushing forth, or growth, our life is blood," they said; "thick, fat, animating, our life; it reddens, moistens, drenches, fills all the flesh with mud, it gives it growth, surges to the surfaces . . . It strengthens people, it fortifies people greatly."[30]

"Mesoamerica" is a wide geographical area, covering the southern half of modern-day Mexico, all of Belize, Guatemala, and El Salvador, and parts of Honduras, Nicaragua, and Costa Rica. Many societies thrived in this fertile land until the Spanish conquests of the sixteenth century. They developed their own languages, rituals, and color systems, but in all of them red was preeminent. It was no coincidence that the Aztec word for red—*tlapalli*—was also their term for "color,"

while the Maya word for red—*chak*—also meant "great."[31] Like their early African ancestors, the Aztecs, Maya, and Zapotecs mined hematite and other red earth pigments, applied them to their bodies, and buried them with their dead. But they also adorned objects, sculptures, floors, walls, temples, palaces, streets, and plazas with them. All Mesoamerican cities were brilliantly colored, and some were strikingly red. The first Spaniards to enter them, being accustomed to the muted hues of European architecture, were stunned. When Bernal Díaz del Castillo arrived in the Aztec capital, Tenochtitlán, with Hernán Cortés in 1519, he felt he had stepped into a dream. "Gazing on such wonderful sights, we did not know what to say, or whether what appeared before us was real."[32]

Why did Mesoamericans surround themselves with so much red? They might have chosen it because it was plentiful: hematite was abundant and accessible in the region, and thus easier to use in large quantities than other pigments. But their initial motivation was surely symbolic: red for them was profoundly *meaningful*. Some Mesoamerican societies identified it with the East, and so with dawn, light, warmth, and new life; to paint a statue or temple red was thus to smother it with auspicious significance. Moreover, in many parts of Mesoamerica blood was an integral component not only of sacrifice but status. It was the scarlet liquid of lineage, flowing from ancestors into rulers and on to their descendants. When a chief decorated a building in red ochre he was drenching it in royal—even divine—blood, and thus advertising his dynastic legitimacy.[33]

Mesoamerica was filled with bright red things. Its inhabitants were surrounded by vermilion flycatchers, red-capped manakins, red-legged honeycreepers, summer tanagers, and scarlet macaws, whose feathers they plucked and wore. They were also blessed with innumerable red or orange-red flowers, including poinsettia, dahlia, strelitzia, Mexican sunflower, Mexican honeysuckle, Belize sage, and the wonderfully named chocolate cosmos.[34] They converted many of these organisms into red colorants, most of which became proxies for blood. One, *achiotl* or *annatto*, was derived from the short evergreen shrub *Bixa orellana L* that was grown around houses and in kitchen gardens. In one sense the plant resembles a body: its leaves are interspersed with red veins, which in the spring are joined by crimson

fruits that look like miniature human hearts. The pods contained up to a hundred seeds coated in a sticky orange-red resin, which were ground into a powder and mixed with animal fat and water to produce a highly saturated colorant. *Achiotl* was employed as a writing ink and a paint pigment, a dye for fabrics and foods, applied to the face and hair as a cosmetic, sprinkled over ceremonial implements, and ingested or offered to the gods as a substitute for blood.[35]

Mesoamericans obtained a similar red colorant from the sap of the croton tree. The Maya used *kaqche'* to cure wounds, coughs, infections, diarrhea, inflammation, stomach ulcers, tumors, and rheumatism.[36] A sharp knife was hacked into the tree's trunk until a viscous red resin bled from the bark and coagulated into burgundy scabs. The Spanish called it *sangre de grado* ("blood of the tree") or *sangre de drago* ("dragon's blood"). Native Americans likewise identified croton sap with blood. One traditional Maya story even hinges on their indistinguishability. The *Popol Vuh* tells the tale of an unlucky young girl called Blood Moon, who during a visit to a calabash tree is unwittingly impregnated by a saliva-spitting skull. When her father discovers her secret, he instructs four executioners to kill her and deliver her heart in a bowl to the gods. Blood Moon pleads with her executioners to spare her. They want to help but feel bound to obey their orders. "What shall we deliver in the bowl?" they ask. After thinking for a moment Blood Moon makes her way to a nearby croton tree, extracts its sap, molds it into the shape of a heart, and places it inside the bowl. The executioners nervously hand this "duplicate" heart to the gods, who, after examining it closely, accept the offering. Blood Moon escapes with her life.[37]

The most widely used American red was a genuine body fluid— though not a human one. *Dactylopius coccus* (cochineal) is a soft-bodied, oval-shaped scale insect that grows to about 5 mm in length. It lives off the *nopal*, a prickly pear cactus native to Central and South America. Mexican farmers have cultivated these hapless parasites for thousands of years, and many still employ traditional methods. Young pads are typically removed from mature cacti and planted in protected greenhouses. When female insects are about to spawn they are placed in a basket or nest suspended from the plant. Over a couple of weeks their offspring latch onto the pad and feed off its nutrients.

When the insects are fully grown, farmers carefully remove them from the surface of the plant, usually with a brush or animal tail, and collect them in a container. They are killed by boiling, heating, or suffocating, then ideally left to dry in the sun. By the end of the process the insects have shrunk to a third of their former size, and look like ash-colored grain. When the Spanish first arrived in Mexico they presumed that cochineal was indeed a cereal crop and called it *grana*— "small seed."

Though they are ostensibly unassuming, these organisms contain a crimson fluid that makes up roughly 20 percent of their total body weight. It is made from an anthraquinone pigment called carminic acid, probably designed to deter predators.[38] More than any other colorant, carminic acid looks and feels like blood. It has the sharp redness of oxygenated hemoglobin, forms blood-like puddles in the palm, stains with the same stubbornness, and dries in dendritic patterns along the skin's creases. If you hold it in your hands you feel almost certain that you have cut yourself. The two substances were predictably compared: the Aztecs called cochineal the "blood of the nopal" (*nocheztli*). But cochineal was more than a blood substitute. It became a writing ink, a lake pigment, a popular cosmetic, and a medicine (used for healing wounds, cleaning teeth, alleviating headaches, and soothing stomach problems).[39] If the dried insects were pulverized and submerged within water, they also furnished a peerless crimson dye. Up to 150,000 insects were needed to make just one kilogram of cochineal, which was duly coveted by the rich and powerful.[40] According to a sixteenth-century Aztec tribute list later copied by the Spanish, Moctezuma II demanded regular deliveries as a tribute. One group of Mixtec towns in southern Mexico was every year expected to send the emperor 2,400 mantles, 800 blouses and skirts, 800 loincloths, 800 bundles of quetzal feathers, two feathered warrior costumes with shields, one feather headpiece, two strings of jade beads, twenty bowls of gold dust, and forty sacks of cochineal (**Plate 12**).

After conquering Mexico in 1521, the Spanish commandeered the cochineal industry. By the middle of the sixteenth century, their galleons were exporting tons of it to Spain every year. From there it was sold, at a healthy profit, to the rest of Europe and the world. By the end of the century Mexico's wingless parasites could be found as far

afield as Indonesia. Wherever it went, cochineal outperformed its rivals. It was redder than madder, more lightfast than orchil, and ten times more potent than its closest insect-based competitor, kermes. The crimson colorant went on to dye Britain's army uniforms, adorn Old Master paintings, and was even embraced by discriminating Chinese silk-makers, who enviously dubbed it "foreign red." After gold and silver, cochineal remained Central America's most coveted commodity for 300 years, generating vast revenues for the Spanish crown. It remained the world's finest red dyestuff until the mid-nineteenth century, when synthetic reds finally displaced it.[41]

Cochineal might have lost its place as the world's preeminent red dye, but it hasn't completely disappeared. Hundreds of tons are produced every year in Peru, Mexico, Bolivia, Chile, and the Canary Islands and distributed around the globe. It is now sold under the less poetic names "natural red 4," "E120," and "C.I. 75470" and is used by food processing and catering companies to create or enhance red colors in soups, sauces, milkshakes, ice creams, condiments, conserves, confectionary, and cakes. Like many red pigments, cochineal also functions as a body paint. Today's vast global cosmetics industry turns out billions of dollars' worth of cochineal-carrying blushers and lipsticks every year. Our lives might have little in common with those of our ochre-gathering ancestors, but our predilection for red evidently endures.[42]

KING HONG

The Paleolithic inhabitants of modern-day China were burying red ochre with their dead at least 18,000 years ago, scattering it into burial pits, sprinkling it onto grave goods, and smothering it over corpses.[43] The material was likely intended to breathe life back into the dead, providing them with vitalizing energy in the afterlife. Human bodies change color when they die. As oxygenated blood stops reaching the capillaries, the surface of the skin loses redness and grows pale. Reversing this color change was therefore a way of reversing death: to cover a pallid corpse with blood-like material was to give some semblance of life back to the dead. Bronze Age women were even interred with red

"cosmetic sticks," made from hematite and cattle hearts, to help them revive (or at least beautify) themselves in the afterlife.[44]

Red ochre remained an important colorant in ancient China for many centuries, but it was gradually superseded by a superior alternative. Cinnabar is a naturally occurring mineral made from mercury and sulfur. It is typically produced in areas of volcanic activity, when hot waters or vapors surge through layers of fractured rock. In its natural state cinnabar is strikingly beautiful. Its cherry-red crystals sparkle like dropped jewels, carpeting entire rockfaces in shimmering scarlet. Large deposits of cinnabar in Szechuan and Hunan provinces have been mined since prehistory. At first it was treated like hematite, ground into powder and scattered into tombs. But cinnabar had two major advantages over its cheaper and more accessible counterpart. First, cinnabar was more vividly red, and thus better resembled human blood. Second, it was a genuinely effective preservative. Mercury inhibits the activity of destructive microorganisms, helps sterilize materials, and ultimately slows down decomposition.[45]

Why, then, reserve it only for the dead? Ancient Chinese philosophers believed that cinnabar's compounds embodied the two fundamental principles of the universe—*yin* (associated with mercury) and *yang* (associated with sulfur)—that were essential for a long and healthy life (they didn't know, as we do, that mercury is highly toxic). By the end of the Han dynasty (206 BCE–220 CE) it was used (ineffectually) to clear the eyes, shrink tumors, cure scabies, and treat burns. Seen as a proxy for healthy blood, it was ingested, placed in wounds, and deployed in transfusions to revive those whose own blood was diseased.[46] Alchemists argued that cinnabar even conferred invincibility. In his fourth-century treatise *Bào pǔ zi* ("Master who embraces simplicity"), the philosopher Ge Hong included cinnabar as an ingredient in twenty-one of his twenty-seven elixirs of immortality. Others claimed that eating a grain of cinnabar every day for 100 days would transform one's bones into metal and provide "limitless longevity."[47] All the while, stories circulated about cinnabar-based miracles, including the famous soldier Huang An, who had eaten it until his body turned red, and lived for 10,000 years.[48]

At some point in antiquity—we don't know precisely when— Chinese chemists found a way to manufacture cinnabar artificially. In

this method, known as the "dry process," liquid mercury and molten sulfur were combined, heated to sublimation at 570°C, and condensed until they turned red. The result was a brilliant pigment that was all but identical to pulverized cinnabar.[49] "Vermilion"—the wonderful name by which we know it—was used to paint houses and decorate furniture, made into seal paste that colored the signatures of emperors, and inevitably became a desirable cosmetic. Mixed with wax, suet, and perfume, vermilion powder was applied to the face as a rouge or lipstick, becoming a touchstone of female beauty. When the ancient Chinese poet Song Yu (298–263 BCE) met an irresistible goddess in a dream, he was particularly enchanted by her "vermilion lips," which shone as "bright as cinnabar."[50]

Vermilion is perhaps best known for its role in Chinese lacquerware. The Chinese have lacquered objects for more than 6,000 years. The substance originates in poisonous sap from the bark of the lacquer tree (*Toxicodendron vernicifluum*), indigenous to the Yangtze Valley. Its resin is filtered and heated, then applied, in as many as 200 or 300 layers, to a wooden surface. Each coat has to be dried and polished before the next can be applied. Only one layer can be added per day, with craftsmen taking up to a year to lacquer a single object. Their patience is rewarded with an almost invincible natural plastic, resistant to water, heat, pests, and acids, which can preserve the wood it encases for centuries.[51] The resin can be mixed with iron oxide or carbon to produce blacks and orpiment to produce yellows, but the most celebrated Chinese lacquerware was made with vermilion. The Metropolitan Museum of Art in New York possesses a pinnacle of the form: an octagonal dish that at first glance might be mistaken for a stop sign (Plate 11). Its surface crawls with carvings, cut into the lacquer with exquisite precision. Around the inner octagon is a group of auspicious Taoist emblems known collectively as the "Eight Treasures." They include rhinoceros horns (denoting happiness), books (learning), a double lozenge (victory), a coin (wealth), a piece of coral (good health), and a pair of flaming pearls (fulfilled wishes). These symbols alternate with eight ruyi heads that resemble the so-called fungus of immortality. The center of the dish is dominated by the Chinese character *shou* (寿), meaning "longevity": whoever was fortunate enough to own this bloodred dish would lead a charmed life.[52]

By this stage, red's beneficial connotations were long established. Beginning in the Shang dynasty (1600–1046 BCE) and developing fully in the Han, philosophers codified the *Wuxing*, or "Five Phases Theory." This conceptual framework sought to explain the whole world and its processes by reference to the five principal elements: wood, fire, earth, metal, and water. These elements were connected to corresponding phenomena, including directions, seasons, organs, emotions, and colors. It was one of the first systematic attempts to tabulate the meanings of color.

Five Phases Theory

		Green	Red	Yellow	White	Black
Nature	Elements	Wood	Fire	Earth	Metal	Water
	Seasons	Spring	Summer	Late Summer	Autumn	Winter
	Directions	East	South	Center	West	North
	Climates	Wind	Heat	Damp	Dryness	Cold
	States	Birth	Growth	Change	Harvest	Store
Body	Zang Organs	Liver	Heart	Spleen	Lung	Kidney
	Fu Organs	Gall bladder	Small intestine	Stomach	Large intestine	Bladder
	Orifices	Eyes	Tongue	Mouth	Nose	Ears
	Tissues	Tendon	Vessel	Muscle	Skin	Bone
	Emotion	Anger	Joy	Anxiety	Grief	Fear

Red, unsurprisingly, was identified with blood: both with the heart, which pumps it, and with the vessels that carry it around the body. But it also had other associations, derived from Chinese attitudes toward the cosmos. All members of the *Wuxing*, including its colors, were characterized as *yin* (the negative, passive, feminine, cold, dark principle of the universe), *yang* (the positive, active, male, hot, light principle of the universe), or both. Red was nearly always *yang*. As a hot, bright,

active color, it was accordingly linked to other vibrant or positive phenomena—fire, heat, summer, growth, and joy. These connotations would prove immensely important to Chinese evaluations of red.

In medieval and early modern China color symbolism wasn't only meticulously codified but rigorously enforced. A succession of sumptuary laws correlated colors with rank, specifying in exhaustive detail what could and could not be worn. To don the wrong-colored robe, to line a hat with the wrong-colored silk, to wear even the wrong-colored tassel, was to contravene the entire social order and thus to commit a serious offense. These regulations, though draconian, produced a society unusually alive to the nuances and meanings of color, best expressed in China's attitudes toward red. The Chinese did not have one red but several, each with different connotations. *Dan* (丹) was the pale red of cinnabar, and thus associated with health and immortality (it was also the word for "elixir"). *Zhu* (朱) was the splendid red of vermilion, linked to status and wealth. *Chi* (赤) was closer to crimson, identified with honesty and loyalty, and often worn at weddings. And *hong* (紅)—pronounced long and soft like a distant echo—was a deep, rich scarlet, equated with power, fame, happiness, and good fortune.

The highest-status color in China was yellow, as we shall see in the next chapter. But red was a dominant dynastic color during parts of the Zhou (1046–256 BCE), Han (206 BCE–220 CE), Jin (265–420 CE), Sui (581–618 CE), Tang (618–906 CE), and Song (960–1279 CE) eras, and also acquired specific regal connotations during the Ming dynasty (1368–1644 CE), whose founder's family name happened to be *Zhu*. Red was a consistent presence in imperial life, adorning the gates, doors, windows, and walls of palaces, appearing on clothes, banners, and royal goods, and dominating wedding and funeral processions. In official contexts it not only represented but embodied imperial authority. After drafting edicts or directives, civil servants sent their documents to the emperor, who read and discussed each proposal with his aides. When a decision had been reached, he dipped his brush into a bowl of red ink and annotated the text. These "vermilion endorsements" (*zhupi*)—were, of course, all but infallible.

When the Communist Party assumed power in China in 1949, they made red the symbol of their revolution. They had borrowed it from

Europe, where the color had been identified with political revolutions since at least the eighteenth century. The sansculotte of 1789 had advertised their radical affiliations by wearing red and blue cockades, because those were the traditional colors of Paris (they were then combined with Bourbon white to form the famous French tricolor). In subsequent years, French Jacobins and socialists wore red caps and marched under red flags, evoking the blood spilled for their cause. The color retained its left-wing connotations into the twentieth century. During the Russian Revolution of 1917 and the ensuing civil war, it became the emblem of the Bolsheviks, and their struggle against their opponents, "the Whites." The association was firmly established by the time Mao Zedong founded the People's Republic of China. If he was lucky that his revolution's color happened to be a firm Chinese favorite, he exploited such good fortune brilliantly. In the 1950s and '60s the Communist Party drenched the country in red. Red flags were hoisted atop buildings, red posters filled the streets, *Little Red Books* poured into people's homes, and little red pins graced their lapels. In the summer of 1966, one group of Red Guards even proposed reversing the colors of traffic lights, making the green signal "stop" and the red signal "go."[53]

The interaction of this imported symbol with native traditions is a fascinating case study in the meanings of color and their exploitation. Mao himself was called *hong tai-yang*, "the red sun," and repeatedly depicted against a red orb emitting red and yellow rays. The metaphor was pressed home in dozens of eulogies, broadcast on state radio stations, and sung by millions of citizens daily.

> Beloved Chairman Mao,
> You are the red sun in our hearts.
> We have so much to tell you and
> We have so many songs to sing to you.
> Hundreds and thousands of red hearts are pumping excitedly;
> Hundreds and thousands of smiling faces face the red sun.
> We wish you, our leader Chairman Mao, a long long life,
> Long long life![54]

The propagandists were drawing not on red's European associations with political violence but rather on an older cluster of meanings in

Chinese history. Communist red was clearly *yang*: hot, light, active, the color of hope, change, and good fortune. It also invoked the elixir cinnabar, and so guaranteed a "long long life" not only to Mao but to the revolution he had brought about. Just as it heralded a glorious future for the People's Republic, it also connected the regime to those of the past: swapping revolutionary red for imperial yellow, the solar iconography borrowed from China's emperors makes Mao their inheritor.

More than four decades after Mao's death, and with the market economy now well established, red retains a profound power in China. It is used to avert tragedy, bring luck, and celebrate triumph. Red underwear or waistbands ward off the devil; red lanterns are strung up to herald the New Year; front doors are decorated with strips of red paper inscribed with propitious verses; birthday invitations are red, as are traditional matrimonial dresses; wedding gifts are presented in red envelopes or wrapped in red ribbons; the birth of a new child is celebrated by eating red sugar; newborn babies are given red clothing and painted eggshells; award ceremonies are marked with red silk and honors rolls are written on red paper. Its meanings are so positive that China's stock market shows rising stocks in red rather than black, the opposite of almost every other country.[55]

LIKE A RED RED ROSE

Not long into Act Two of *Macbeth*, husband and wife become obsessed with color. Lady Macbeth, who examines her hands with the tireless diligence of an obsessive-compulsive, is seen scrubbing away for up to fifteen minutes at a time. Her husband is less convinced by the merits of washing. "No," he laments, "my hand will rather the multitudinous seas in incarnadine, making the green one red." This stubborn and potentially oceanic stain is, of course, blood, which originally belonged to the King of Fife and his two servants, whom Macbeth had murdered in a ruthless bid for power. And yet it is not so much a literal mark of blood as a metaphor for the crime he has just committed and his spouse abetted. After all, the couple can easily wash away the hemoglobin with soap and water, but their souls—as Lady Macbeth begins to realize—will "ne'er be clean" again.

Red is an abiding marker of transgression. The metaphor, as we saw in Chapter 1, dates back at least to the Old Testament and is still embedded in everyday language: to be caught "red-handed" is to be discovered committing a crime. But red is also a metaphor for all kinds of psychological states. It is commonly identified with lust, love, embarrassment, and anger—even emotion itself. There is a logic to the connection. We often think of emotion as a kind of heat: we speak of "burning resentments," "smoldering desires," and "fiery tempers"; and if they get the better of us, we are sometimes told to "cool down."[56] In most societies red is likewise believed to be hot, so corresponds neatly with the flaming passions of the soul.[57] Both the hotness and redness of emotion are causally connected to blood. When we are enraged, aroused, or embarrassed, small capillaries around the face, neck, and thorax dilate, increasing oxygenated blood flow to those areas and making us warmer and redder.

Red, as the artist Anish Kapoor puts it, is an "inside-out color."[58] Like our emotions, and like our blood, it wells up within us, speaking *of* and *to* the body. Macbeth's undulating name for the color—"incarnadine"—came from the Latin word *caro*, for meat, or flesh, and is related to "incarnation." Red is the body made color, and at times color made body. Over the centuries it has been ascribed a taste (usually fruity), a smell (normally floral), a sound (often trumpets), a texture (typically wet), and a temperature (invariably hot).[59] In his novel *My Name Is Red*, published in 1998, Orhan Pamuk describes some of red's synaesthetic qualities:

> If we touched it with the tip of a finger, it would feel like something between iron and copper. If we took it into our palm, it would burn. If we tasted it, it would be full-bodied, like salted meat. If we took it between our lips, it would fill our mouths. If we smelled it, it'd have the scent of a horse. If it were a flower, it would smell like a daisy, not a red rose.[60]

In Pamuk's book, red actually becomes a flesh-and-blood character. It speaks for itself, recounts its autobiography, and even possesses a discernible personality: self-important, ostentatious, occasionally ticklish. "I'm so fortunate to be red!" it exclaims. "I'm fiery. I'm strong. I know men take notice of me and that I cannot be resisted."[61]

Hans Christian Andersen's fairy tale "The Red Shoes," from 1845, is a parable about such power. It describes the fate of a young girl called Karen, who one day acquires a pair of red leather shoes. She falls instantly in love with her new possessions, but they soon exert a sinister hold over her. Karen's behavior begins to change. One evening, as her foster mother lies prone on her deathbed, the once dutiful girl straps on her shoes, sneaks out of the house, and attends a grand ball in town. Karen starts to dance, but then discovers that she can't stop. The red shoes dance her out of the ballroom, down the staircase, along the street, through the town gates, and into a dark forest. Karen tries to remove the shoes but fails. She is forced to dance on, through day and night, through thorny fields and meadows, until her face is covered in tears and her legs stained with blood. Eventually she arrives at the executioner's house and begs him to chop off her feet. He obliges, and the red shoes dance off into the forest.[62]

There was a germ of truth in Andersen's otherwise implausible fable. Over the last few decades we have begun to understand the extent of red's extraordinary psychophysical impact on us. It has been found to increase systolic blood pressure, skin conductance, eye-blink frequency, and electrical activity in the brain; and to make us stronger, improve sporting performance, and encourage us to take more risks. It even contributes to romantic and sexual arousal: studies show that men are more likely to approach women in bars, to contact them on dating websites, to ask them more intimate questions, and to tip waitresses more generously if they are wearing red clothes or lipstick. All of us, like Karen, live under the influence of red.[63]

Some color meanings, as we are discovering, are stubbornly persistent. Like the ochre quarries mined by one generation after another, they are symbolic resources that never seem to run dry. Though hundreds of thousands of years have elapsed since our ancestors first started using hematite, red's oldest associations—with blood, love, life, danger, anger, sin, and death—are still intact. They have become so commonplace that they sound like the color psychology clichés turned out by brand consultants and tabloid astrologers. But this doesn't mean they've lost their cultural power. In the twentieth century many great image-makers mined this rich seam of meaning and reinvented them in thrilling new ways—not least in the defining medium of our era.

Cinema was colorful from the beginning. From as early as the 1890s, monochrome films were hand-painted, tinted, toned, or stenciled. The application of color was a laborious exercise that required teams of workers, typically women, to paint each frame individually. If the colors were initially decorative, they soon became a storytelling tool. We must remember that at this stage cinema was a novel medium of sometimes vertiginous dynamism that left many viewers confused. Color helped audiences understand when and where scenes were taking place. Blue tints (such as "nocturne") suggested night; yellow or orange ("afterglow") simulated sunrise or sunset; and green ("verdante") was often employed to depict forests. Hues were also used symbolically. Red, which American tint manufacturers called "Inferno," not only stood for burning buildings, furnaces, forest fires, and the flames of Hell, but—according to one industry insider in the 1920s— indicated "riot, panic, anarchy, mobs, turmoil, strife, war, battle, and unrestrained passion."[64]

The growth of natural color cinematography in the 1930s provoked renewed debates about the value and meaning of color. The most influential voice belonged to Natalie Kalmus, who had come to the industry through her husband, Herbert, a cofounder of Technicolor. When the couple secretly divorced in the early 1920s (they continued cohabiting until the mid-1940s), Natalie was given control of Technicolor's Color Advisory Service as part of the settlement. Her unit instructed productions how best to exploit the company's technology, devising detailed color schemes that covered every aspect of a film's appearance, from sets and costumes to background props—and even plants in dummy gardens. Kalmus worked on virtually every major Technicolor feature in the 1930s and '40s, including *The Wizard of Oz* (1939) and *Gone with the Wind* (1939), where she was typically credited as "color director." Her robust views (and, of course, her gender) made her enemies. While the press dubbed her the "Queen of Color," many filmmakers nicknamed her the "Wicked Witch of the West."[65] And yet Kalmus did more than anyone to develop a theory of cinematic color.[66]

She set out her stall in an essay called "Color Consciousness," published in 1935 and read by almost everyone in the industry. The essay opened in prehistory, discussing the use of red ochre and carbon black

in Paleolithic cave paintings. Kalmus saw these early masterpieces as proof that the desire to "show motion in color" had existed in human culture for thousands of years. As early artists created imagery from a limited palette, so modern filmmakers had to demonstrate similar discipline. Throughout her manifesto Kalmus argued for chromatic restraint, permitting bright colors only when they served the narrative. "Just as every scene has some definite dramatic mood—some definite emotional response which it seeks to arouse within the minds of the audience," she explained, "so too has each scene, each type of action, its definitely indicated color which harmonizes with that emotion."[67] Kalmus went on to discuss all the major hues, but granted red a singular power.

> Red recalls to mind a feeling of danger, a warning. It also suggests blood, life, and love. It is materialistic, stimulating. It suffuses the face of anger, it led the Roman soldiers into battle. Different shades of red can suggest various phases of life, such as love, happiness, physical strength, wine, passion, power, excitement, anger, turmoil, tragedy, cruelty, revenge, war, sin, and shame. These are all different, yet in certain respects they are the same. Red may be the color of the revolutionist's flag, and streets may run red with the blood of rioters, yet red may be used in a church ritual for Pentecost as a symbol of sacrifice. Whether blood is spilled upon the battlefield in an approved cause or whether it drips from the assassin's dagger, blood still runs red . . . Love gently warms the blood. The delicacy or strength of a shade of red will suggest the type of love. By introducing the colors of licentiousness, deceit, selfish ambition, or passion, it will be possible to classify the type of love portrayed with considerable accuracy.[68]

How many meanings can a color possess before it ceases to have meaning? If Kalmus' red seems suspiciously polyvalent, later filmmakers duly used it to denote all kinds of intense emotions. It is the color of fatal obsession in Powell and Pressburger's *The Red Shoes* (1948), on which Kalmus herself worked. It stands for leather-jacketed transgression in *Rebel Without a Cause* (1955), raincoated grief in *Don't Look Now* (1973), a moral epiphany in *Schindler's List* (1993), and repressed suburban passions in *Pleasantville* (1998) and *American Beauty* (1999). If these meanings are diverse and contradictory, that is because red itself has diverse and contradictory connotations. Most of them, however, are grounded in the nexus of meaning that

binds the color with its body fluid—a connection so strong that its two components are often indistinguishable. When Jean-Luc Godard was asked why there was so much blood in his 1965 film *Pierrot le Fou,* he responded: "Not blood, red."[69]

Alfred Hitchcock's psychological thriller *Marnie* (1964), based on Winston Graham's novel of the same name, hinges on such a slippage. Red is in some respects the story's "MacGuffin": when its meaning is deciphered, the mystery is unlocked. Marnie Edgar (Tippi Hedren) is a beautiful but miserable loner who spends her life migrating from one identity to the next, stealing money as she goes. We learn that her behavior is motivated by a deep-rooted anxiety triggered by red objects. Marnie is sent into paroxysms of terror by a vase of gladioli, a blob of vermilion ink on her blouse, a jockey's crimson silks, and a foxhunter's scarlet blazer. Each sighting is accompanied by an aggressive theme (composed by Hitchcock's longtime collaborator Bernard Herrmann) that builds as fast as panic before exploding with a violent snap. Hitchcock leaves us in no doubt that these episodes are psychological. They all conclude with a red suffusion that fills the screen and engulfs Marnie's face.

After learning of her crimes, an affluent widower called Mark Rutland (Sean Connery) blackmails Marnie into marrying him, and later identifies her erythrophobia with a word association game. He says "water," she says "bath"; he says "air," she says "stare"; he says "needles," she says "pins"; he says "black," she says "white." With his trap laid, Rutland leans forward, points at his new wife, and shouts "red!" Herrmann's spiky theme rattles back into life, and Marnie duly panics. "White! White! White! White!" she screams, before collapsing into a sobbing heap. Rutland grows determined to diagnose the etiology of Marnie's phobia. His subsequent investigation leads the couple back to Marnie's childhood home in Baltimore. Here, at the end of the film, she finally relives a formative moment from her youth. It is a stormy night, and her mother, who works as a prostitute, evicts the six-year-old Marnie from her bed so she can use it with her latest client. When a struggle breaks out between the two adults, Marnie leaps to her mother's defense. She picks up a fireplace poker and beats the man to death. Blood runs down the side of his face and drenches his white clothes. The screen is once again suffused with scarlet, Herrmann's

brasses shriek like police sirens, and Marnie screams us back into the present.[70] In the end Marnie Edgar, like Lady Macbeth, has blood on her hands and red on her mind.[71]

Ana Mendieta was twelve years old when she was taken from her parents. She and her sister were among the 14,000 children who, under the auspices of Operation Peter Pan, were extracted from Fidel Castro's Cuba and given a new life in the United States. The two girls arrived in Florida in September 1961—the same year as the novel *Marnie* was published—and were sent to a refugee camp just south of Miami. Three weeks later, they were relocated to Dubuque, Iowa, where they were placed in an orphanage run by the Catholic Church. For the next few years, they were shunted from one foster home to the next. They did not see their mother for five years; their father, who had been imprisoned in Cuba, was unable to join them until 1979. Estranged from her home and family, and a target of repeated racism, Ana felt as isolated and rootless as Marnie Edgar. But unlike Hitchcock's antiheroine she channeled her unresolved emotions into art. "To me art has been my salvation," she once wrote; "my art comes out of rage and displacement."[72]

In 1969 Mendieta began a postgraduate qualification in painting at the University of Iowa but was soon drawn to more avant-garde practices. She became fascinated by the controversial work of the Vienna Actionists, who throughout the 1960s had staged rituals involving blood, animal carcasses, and sex that often resulted in prison sentences. The Actionists were responding to specifically Austrian circumstances, using quasi-Catholic imagery to unsettle a nation that had hardly come to terms with its Nazi past. Mendieta, however, saw parallels between their blood-filled ceremonies and those of the ancient and indigenous cultures of her native Central America. She spent the summer of 1971 conducting archaeological research at Teotihuacán, about thirty miles northeast of Mexico City. Over the next few years, she read about the role that self-lacerations, blood offerings, and heart extractions played in Maya and Aztec life.

Mendieta first used blood in her work in November 1972. During one student session she removed her clothes and stood naked before the class. A friend then decapitated a white chicken with an axe. Ana

grabbed the bird by its feet and held it upside down in front of her. Its wings thrashed violently for several minutes, spraying warm blood onto her body and across the room. Mendieta's performance piece clearly drew on Latin American traditions. In her native Cuba the syncretic religion Santería, which originated among the Yoruba people of west Africa, involved strikingly similar rituals. Santería is underpinned by the concept of *ashé*, a primal energy that surges through reality like blood through a body. Blood itself is an important source of *ashé*. To offer *ashé* to the gods, and to increase one's own reserves of it, sacrifice (*ebbó*) is often necessary. Animals—usually chickens—are killed, and their blood sometimes drizzled over sacred stones to feed the deities. Mendieta understood that in Santería, just as in ancient Mesoamerican societies, blood was propitious. "I started immediately using blood," she recalled in 1980, "because I think it's a very powerful magic thing. I don't see it as a negative force."[73]

One night in March 1973, however, Sarah Ann Ottens, a part-time nursing student at the same university as Mendieta, was stripped half-naked, beaten with a broom handle, and strangled to death in her dormitory. Mendieta was unsettled by the brutality and proximity of the murder (the perpetrator was never identified) and made a series of performance pieces on the subject. A month after Ottens' death, she even re-created the crime scene, as reported by the local press. Fellow students were invited to her home in Iowa City. Finding the front door ajar, they stepped into the dark and dingy interior. The floor was littered with broken crockery and half-smoked cigarette butts. In the middle of the apartment they saw Mendieta, bent over a table, hands tied together, underpants pulled down to the ankles, with blood smeared across her legs—the victim of a crime that had never occurred.

Mendieta continued her exploration of blood in subsequent works. In May 1973, she ran a trail of the fluid from beneath her front door to the pavement outside, then filmed and photographed members of the public as they noticed it (most looked down but walked on). In the autumn she piled up mattresses in an abandoned farmhouse, drenched them in red paint, and waited for the installation to be discovered by chance. The following March she dipped her arms in cow's blood and slowly dragged them down a plain white wall. Her movements created two ragged red lines, each crowned with a crimson handprint.

That piece in particular was rich with historical resonances—it alluded to the millennia-old practice of women applying red pigments to their bodies, as well as to the red handprints and stencils found in prehistoric caves. "My work," she once admitted, "is basically in the tradition of a Neolithic artist."[74]

In retrospect, Mendieta's art's intimations of violence against women seem sadly prescient. By 1985, she was living in New York with her new husband, the celebrated sculptor Carl Andre. On the evening of Saturday, September 7, the couple decided to order a Chinese takeaway and watch a Spencer Tracy film at home. At some point, however, an argument broke out. At about 5:30 a.m. Mendieta fell from the thirty-fourth floor of her apartment building, landed on the roof of an all-night deli, and died on impact. Andre, the only other person in the apartment

Mendieta's *Body Tracks*

at the time, was charged with her murder, but was acquitted three years later. The events surrounding her death have never been fully explained.[75]

Today, Ana Mendieta's reputation rests principally on her *Siluetas*, a series of roughly 200 artworks made between 1973 and 1980. In each of them she created a stylized effigy of her body in the landscape, adorned it with mud, snow, grass, moss, flowers, fire, or blood, and then filmed or photographed it before it vanished. One of her *Siluetas* was made on land once inhabited by the Zapotecs. In the summer of 1976, she traveled to Oaxaca in southern Mexico and walked along the windswept beaches near Salina Cruz. When she found a suitable spot she dug, scraped, and shaped the sand until she had fashioned a simple silhouette of a female body, its arms raised in rapture, and filled the form with powdered red pigment (**Plate 13**). She was channeling the old tradition, once practiced all over the world, of scattering red pigments into graves. She was also invoking the many ancient myths, from *Atrahasis* onward, that described the genesis of humans from red earth.

> My art is the way I re-establish the bonds that unite me to the universe. It is a return to the maternal source. Through my earth/body sculptures I become one with the earth . . . I become an extension of nature and nature becomes an extension of my body. This obsessive act of reasserting my ties with the earth is really the reactivation of primaeval beliefs . . . [76]

For a short time Mendieta's figure was hot and red with life. But as the tide crawled up the beach, the sea began to destroy it. Waves bombarded the sculpture's contours until its human features crumbled and dissolved. As they tumbled into the figure's center they clashed and mixed with the pigment, transforming dry red powder into writhing wet blood. The color, now suspended in water, dispersed in all directions, diluting with every swell until, before long, it vanished into the gray-blue undulations of the Pacific.

Mendieta's *Silueta* is a wordless essay on life and its fragility; how a person's trace on this planet can disappear so quickly and completely that it seems as if it never existed at all. Her choice of pigment was an integral part of that message. Pulsating within us every second of every day of our lives, red is the hue with which we most consistently identify. The story of red is in many respects the story of our

species: the first red pigments emerged at the same time as modern human behavior but they also undoubtedly contributed to it—supplying our first symbols, nourishing our first rituals, starring in our foundational myths. From prehistory, and for millennia afterward, we used red to make sense of the perilous journey we had to make between birth and death, and the many rites of passage that lay between them. In the process, this symbol of love, lust, rage, and sin became a metaphor for the human condition all over the world—one we show no signs of discarding.

3

Yellow

Twilight of the Idols

Some painters transform the sun into a yellow spot, others transform a yellow spot into the sun.

Pablo Picasso[1]

One evening in October 2003 the sun rose in Southwark. It continued shining through the winter, when more than two million pilgrims went to see it. As they entered its subterranean residence, the anemic London light gave way to a blistering rapture of yellow. The air was sweet with glycol haze, which left them licking their lips and fighting hallucinations. They had come to look at a vast yellow orb, which floated above them like a solar deity. Some stood frozen in wonder, mouths open with incredulity; others waved, danced, or took photographs. Wiry men sat down to meditate, young lovers laid blankets on the floor and slept in each others' arms, and groups of laughing schoolchildren arranged their bodies into intricate geometrical shapes. One hardened atheist called it the first religious experience of his life.[2]

This intoxicating illusion, created by the Danish-born Icelandic artist Olafur Eliasson, was the fourth installation to grace Tate Modern's Turbine Hall since the museum's opening three years earlier (**Plate 14**). Eliasson made it by coating the entire ceiling in reflective foil, doubling the apparent height of the hall, then mounting a semi-circular screen at the top of the east wall, which under the mirrored ceiling looked like a sphere suspended halfway up the space. The screen was backlit by two hundred low-pressure sodium lamps—the kind used to illuminate streets around the world—which emitted only

yellow light with a wavelength of 589 nanometers. The overall effect was overwhelming. As the light advanced into the corners of the room it devoured all other hues: white shirts turned yellow, red dresses went orange, blue jeans subsided to black. The whole room, and everyone in it, became monochrome—built entirely from shades of yellow.

It is one of life's self-evident color truths—along with the grass being green and the sky blue—that the sun is yellow. Children know as much before they can even read, scrawling yellow circles surrounded by yellow rays of light onto drawing paper. But the sun isn't actually yellow. On a chromaticity diagram (a chart that measures and plots colors according to their hue, saturation, and luminance), it is peachy-pink; measured by dominant visible wavelength, it is green; while theoretically it is the epitome of whiteness because it emits all wavelengths of visible light. So why do we persist with the misapprehension? It might be because we rarely look. For most of the day the sun is too bright to behold. It spatters our visual field with lens flares and afterimages, burns red-hot oranges into the undersides of our eyelids, and can cause solar retinopathy or blindness. We can only safely look at the sun when it is low in the sky, just after dawn or before sunset. Then it does acquire an illusory yellow complexion, as its blue wavelengths are scattered away by the atmosphere. But as it sets, that yellowness is also scattered. The sun turns orange, then magenta, then disappears beneath the horizon.[3]

Astronomers classify the sun as a yellow dwarf star, though it is neither yellow nor by any estimation small: 1.3 million times larger than the Earth, it accounts for 99.86 percent of the total mass of the solar system. It has been burning for around 4.6 billion years, the result of a miraculous equilibrium of centrifugal and centripetal forces; the sun is an explosion that never quite explodes. Like other G-type main-sequence stars, it produces energy through nuclear fusion, converting 600 million tons of hydrogen into helium every second and discharging vast quantities of light and heat as a result.[4] Though it's almost 93 million miles away from us, the impact of this energy on our planet is considerable. It bombards every square meter of the part of the Earth that faces it with 100 billion billion photons per second. They create light, color, and life, turning ice into water, feeding plants that then produce oxygen, and making this planet habitable.[5]

"Was not the Sunrise to [man] the first wonder, the first beginning of

all reflection, all thought, all philosophy?" asked the nineteenth-century philologist Max Müller. "Was it not to him the first revelation, the first beginning of all trust, of all religion?"[6] Müller thought the sun was the Rosetta stone of human civilization, underpinning virtually every myth ever told. He claimed that Odysseus and Orpheus (who both descended beyond its reach to the underworld and then rose again), Jason (who searched for a sun-like golden fleece), and Hercules (whose twelve labors took him, like the sun, through all the signs of the zodiac) were all essentially solar deities—or at least on solar missions. Müller's assertions, though grandiloquent, contained a germ of truth. Most ancient societies *did* view the sun as divine. Why would they not? It was a perfect circle that burned across the sky each day, bringing light and warmth; and for much of the time it was too powerful to even gaze upon—not unlike the God in Exodus: "Thou canst not see my face: for there shall no man see me, and live" (33:20). The sun can inspire piety even in those resistant to the tug of faith. At the age of eighty-one, Voltaire—who had spent much of his life attacking religion—hiked into the mountains above Geneva before dawn. When the sun crept over the horizon, he fell to his knees and exclaimed (admittedly with some tongue in cheek): "I believe, I believe in you! Powerful God! I believe!"[7]

For the Maya, the sun was a giant rattlesnake. For the Aboriginal Australians it was an emu's egg. For the Hopi Indians it was a buck-skin shield with a parrot's tail attached. The sun had as many names as it did guises, inspiring adoration and terror in those who uttered them: Varuna, Mitra, Surya, Amaterasu, Xihe, Huitzilopochtli, Tona-tiuh, Inti, Shapash, Koyash, Tama-nui-te-rā, Helios, Apollo. The ancient Egyptians were perhaps the most committed sun worshippers of all, with not one solar deity but several. The dominant form was Re or Ra, who was often combined with the sky god Horakhty. The morning sun was sometimes called Khepri, depicted as a scarab beetle pushing a ball of dung across the sand as the sun rolled through the sky; the evening sun was the ram-headed Atum; and the solar disc itself was the Aten. The Egyptians had other gods, of course—perhaps as many as 2,000—but from the Middle Kingdom onward sun wor-ship became central to Egyptian religion. By the Eighteenth Dynasty the sun god was the most powerful deity in the pantheon. And for a brief period in the fourteenth century BCE, it was the only one.

We will never know what provoked Amenhotep IV to establish the world's first monotheistic religion. It has been ascribed to a chip on his shoulder, born of physical deformity or sibling rivalry, as well as to boredom, stupidity, and lunacy. In the fifth or sixth year of his reign, Amenhotep changed his name to Akhenaten ("He who is devoted to Aten"), built a new capital called Akhetaten ("Horizon of Aten"), closed temples devoted to other deities, erased the plural noun "gods" from inscriptions, and declared the sun disc to be the only Egyptian god.[8] The pharaoh was so devoted to his new overlord that he composed a hymn in the Aten's honor:

> You shine forth in beauty on the horizon of heaven,
> O living Aten, the creator of life!
> When you rise on the eastern horizon,
> You fill every land with your beauty.
> Beautiful, great, dazzling,
> High over every land,
> Your rays encompass the land
> To the limit of all that you have made.
> The earth is bright when you rise on the horizon,
> And shine as Aten of the daytime.
> You dispel the darkness
> When you send out your rays.
> The Two Lands are in festival . . .
> All the herds are at peace in their pastures,
> Trees and plants grow green,
> Birds fly up from their nests . . .
> Fish in the river leap in your presence,
> Your rays are in the midst of the sea . . . [9]

One image, carved in limestone relief around 1350 BCE, shows the potbellied pharaoh and his wife, Nefertiti, in an intimate scene. The royal couple play with their three spirited daughters, one of whom reaches for her mother's earring, while above them floats Aten. Light rays reach out in stick arms that terminate in tiny human hands, some of which grasp the *Ankh*, a symbol of life, and offer it to their devotees. It is difficult to think of a more perceptive representation of sunlight: 3,500 years before the discovery of electromagnetic radiation, this

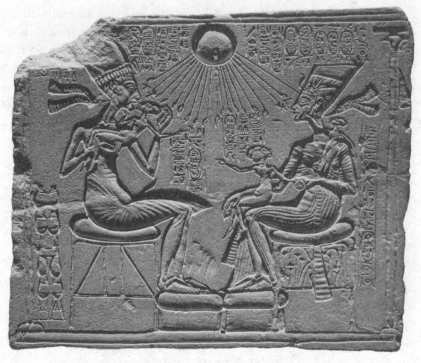

Akhenaten, Nefertiti, and their children

anonymous artist vividly conveys how photons shower our world with energy, animating everything they touch.

GOLD

Shortly after taking James Bond hostage, Auric Goldfinger does what all Bond villains do when in a position of incontestable power—he spills the beans:

> Mr. Bond, all my life I have been in love. I have been in love with gold. I love its color, its brilliance, its divine heaviness. I love the texture of gold, that soft sliminess that I have learned to gauge so accurately by touch that I can estimate the fineness of a bar to within one carat. And I love the warm tang it exudes when I melt it down into a true golden

syrup. But, above all, Mr. Bond, I love the power that gold alone gives to its owner — the magic of controlling energy, exacting labor, fulfilling one's every wish and whim and, when need be, purchasing bodies, minds, even souls . . . I ask you," Goldfinger gazed earnestly at Bond, "is there any other substance on earth that so rewards its owner?"[10]

You don't have to be a criminal mastermind to understand what he means. The hunger for gold is a staple of human civilization. As I write this, it's trading at almost $1,500 per ounce. The price of gold is dictated above all by scarcity: the element makes up just 1/500,000,000 of the Earth's crust. It has been estimated that all the gold mined in human history could fit comfortably into a 21 m³ box.[11] Gold is also miraculously ductile and malleable: one ounce can be drawn into a wire fifty miles long, or beaten into a sheet a hundred times thinner than this paper. It is also virtually invincible: unlike most other materials, gold doesn't corrode, rust, tarnish, or disintegrate: in thousands of years time, when all of us are gone and our planet is unrecognizable, it won't look a day older.[12] This makes the metal endlessly reusable. It's not impossible that a product stocked by a high-street jeweler could contain gold that once belonged to King Solomon or Cleopatra.

Humans were first attracted to gold not for its capabilities but for its appearance. When burnished, the surface of the metal becomes a symphony of yellows (its name derives from the Old English word *geolo*, and ultimately the Proto-Indo-European *ghel*, meaning "yellow"): the base hues are a combination of ochre, mustard, honey, and butterscotch that bleed into each other like ingredients in a mixing bowl.[13] As scratches and grooves catch the light, they rise to bumblebee and banana, lemon and canary, while shadowed areas subside to caramel and burned umber. In each case, this combination of colors is unique. Only one piece of metal, with its precise chemical composition, its own fingerprint of imperfections, will create this arrangement of yellows. And it will do so only in specific lighting conditions, when seen from a specific angle. We could spend years trying to re-create its exact colors; but even if we used the same piece of gold in the same room with the same camera, we would probably never succeed.

All metals are formed by a network of tightly packed ions surrounded by a free-flowing ocean of easily excitable electrons. When photons collide with metallic surfaces, these unchained electrons bounce up to higher levels or bands of energy. When the electrons fall back again, they emit the energy they have just absorbed as heat and light. This quasi-symmetrical process is why metals are efficient thermal and electrical conductors, and why they possess such lustrous reflectivity. Some metals are better reflectors of light than others. Silver reflects photons of light in all visible wavelengths, and therefore appears white or colorless, while gold absorbs more blue light, reflecting greens, yellows, oranges, and reds, which makes the metal golden. In one respect, then, gold appears yellowish for the same reason as the sun: both transmit light deprived of blueness.[14]

Gold, which we now know was first created by massive nuclear explosions inside or between stars like the sun, then carried to our planet on the backs of asteroids, has been identified with the sun since the beginnings of human civilization. The Incas called it the "sweat" or "tears" of the sun; the Aztecs, *teōcuitlatl*, "excrement of the sun." Modern terms are likewise informed by the association: the chemical symbol for gold, *Au*, comes from the Latin word *aurum*, which derives from *aurora*, meaning "dawn." The correlation was reinforced by alchemy and astrology. Philosophers had since Mesopotamian times compared what they considered to be the planets with metals, and by late antiquity these correspondences were widely accepted:

Planets	Metals	Colors
Sun	Gold	Yellow
Moon	Silver	White
Mercury	Quicksilver	Gray
Venus	Copper	Green
Mars	Iron	Red
Jupiter	Tin	Blue
Saturn	Lead	Black

As the slowest and dimmest planet, Saturn was linked to the heaviest metal and the darkest color. The sky god Jupiter was identified with

tin because the metal sounded like thunder when struck and had the same gray-blue tint as the firmament. Mars, the god of war, was associated with the metal of weapons and the color of the blood they shed. Venus (sometimes called *Cypris*) corresponded with copper (*cuprum*) because both were believed to originate in Cyprus. Mercury, the messenger of the gods, was agile and evasive like quicksilver. And the sun was connected to gold because, quite simply, it looked like it.[15]

The earliest surviving gold artifacts, made in modern-day Bulgaria more than 6,000 years ago, are thought to have once had solar significance. By 2000 BCE, similar objects were being manufactured all over northern Europe. Most of them were coin-sized discs decorated with dots, spirals, concentric rings, zigzags, spoked-wheel designs, and crosses—motifs that would go on to acquire considerable symbolic resonance. But the designs might also have alluded to the sun's physical properties: the way it moves or wheels across the sky, fulgurates on the retina, or explodes into solar flares. As their makers watched them glisten and glimmer in the daylight, they might have felt that they were holding the sun in their hands. We can't be sure how these objects were originally used, but perforations at their centers suggest they were sewn directly onto garments. Perhaps they were buried with the dead in hope that their owners, like the sun, would rise again.[16]

On September 7, 1902, a Danish farmer was working a peat moor on the island of Zealand when his plow brought up a bronze sculpture of a horse. Suspecting that it was an old children's toy, Niels Willumsen carried on plowing. When he later returned to the spot, however, he unearthed a set of wheels and a bronze disc covered in gold leaf. He searched for more fragments in the surrounding furrows, loaded his findings onto his cart, and went home. He gave the horse to his son and hid the gold pieces in his loft. But news of his discovery traveled fast: within a week a local administrator was at Willumsen's home inspecting the find. Recognizing its importance immediately, he cordoned off the field. An excavation soon turned up eleven more fragments of bronze and nineteen shards of gold. Over the next few months experts in Copenhagen carefully put the pieces back together, reassembling what is now Denmark's most famous ancient artifact (**Plate 15**).[17]

The Trundholm Sun Chariot (or Solvognen) was made in the early Danish Bronze Age, around 1400 BCE. It consists of a bright-eyed horse pulling a disc, both mounted on spoked wheels—which is surprising, given that two-wheeled chariots didn't yet exist in northern Europe. The disc itself is ornamented with concentric circles, spirals, and ribbons that shimmer in the light. The designs on both sides of the disc center on a single central spiral surrounded by eight spirals, which are accompanied by further rings of sixteen and twenty-seven on the gold side and twenty and twenty-five on the other. We don't know what these patterns mean, but they clearly aren't just decorative. They could illustrate a mathematical system, perhaps the rudimentary rules of multiplication (the number of spirals in each ring are multiples of one, two, three, four, and five). Or they could be calendrical: the four inner rows of the golden disc contain fifty-two spiral forms in total—the number of weeks in a year.[18]

To really understand the object, however, we need to explore its makers' beliefs. According to Norse mythology—compiled millennia after the Solvognen was made—the sun (Sol) made a fraught journey every day. Riding a chariot led by two heavenly horses, she was chased through the sky by snakes and wolves from the netherworld. At dusk they finally caught her, then dragged her beneath the horizon into the waters of the night. A battle ensued, in which her enemies were temporarily defeated. Sol's horses, now transformed into ships, sailed her toward dawn. As day began to break, they became horses again and rode her up to safety into the sky. Sol didn't get far before the monsters resumed their chase and dragged her back into the underworld. This torment she had to endure 365 times a year.[19] The Trundholm chariot didn't only depict Sol's diurnal voyage; it might have been used to re-create it. It is easy to imagine the scene: it is midwinter; the days are short, dark, and cold; food is scarce; and farmers are convinced the sun has abandoned them. So priests gather the community around a fire and promise them that Sol will indeed return. To prove it, they wheel the chariot left and right for all to see. When the gold disc explodes into light amid the flames, the community is reassured.

As monotheism eclipsed polytheism and paganism, new deities rose in the shadows of their solar predecessors. The first Christian images appeared in the second and third centuries, as many Romans embraced

a quasi-monotheism of their own. The Romans had venerated sun gods for centuries, but in the third century one of them—Sol Invictus (Invincible Sun)—came to prominence; in 274 CE Emperor Aurelian even united the ragbag of belief systems then present in the empire under the deity's rule. Early Christians consciously assimilated many of the solar cult's important dates, rituals, and personages, in part to broaden the appeal of their own religion, and in part because they had little else to work from. Deep beneath St. Peter's Basilica in Rome is a mausoleum from this formative period, when Christianity was still outlawed. Its vault is decorated with a yellow mosaic of a beardless young man on a chariot (**Plate 16**). His cloak flutters in the wind, and around his head a circular nimbus emits seven rays of light. The disc, the rays, the horses, and the golden-yellow background all suggest he is Sol Invictus. But this Apollonian youth probably belongs to the new faith: as the beams of light form a cross behind him, he is transformed from a sun god into the son of God. He may be one of the earliest surviving representations of Christ.

From the fourth century, Christian mosaicists substituted the modest yellow stone found in the catacombs for more splendid materials. They hammered gold leaf to a thickness of 0.005 of a millimeter, then sandwiched it between two pieces of glass. Backlit by the glass behind it and magnified by the glass in front, the metal's already formidable properties were amplified. It was then cut into small cubes—tesserae—and glued to the walls of religious buildings in vast quantities. At Hagia Sophia in Constantinople (constructed 532–537 CE)—then a center of Christian life—gold mosaic covered almost 10,000 square meters of the interior space, containing an estimated 76 kilograms of solid gold.[20] Artists deliberately affixed these tesserae unevenly. Gluing them at odd angles, mixing them up with yellow or silver pieces, and sometimes inserting them the wrong way around gave their colors unpredictable vitality. The insides of Byzantine buildings draw light in before bouncing it back like a constellation of golden stars, which sparkle as one passes them. Their makers were justly proud of their handiwork. On the wall of a sixth-century chapel in Ravenna an evocative inscription is written in tesserae: "Light either was born here, or, though imprisoned here, reigns free."[21]

Painters started encasing their own creations in gold, though they

employed rather different techniques. They typically began by covering wooden panels with a reddish clay, known as bole, then carefully picked up a beaten sheet of gold leaf with tweezers, moistened it with water, and suspended it just above the panel until it was sucked by capillary action onto the bole. After leaving it to dry, they burnished the gold leaf with agate, hematite, or animal teeth (those of dogs or other carnivores being preferred) until it glowed rich and dark. Sometimes they finished by punching or incising the gold with jewel-like patterns, producing a sparkle not unlike that of mosaic.[22] Gilding started to appear on Christian icons in the sixth century. It proved popular with patrons because it was both self-aggrandizing and self-effacing: ownership proved one was rich enough to afford luxuries but pious enough to spend money on religion. But the gold didn't only signify wealth and status; it possessed the deepest spiritual significance.[23]

To understand how, we must try to put ourselves into the mind of a medieval monk or merchant who possessed unshakable faith in the truth of the scriptures. For him, an icon of, say, Christ wasn't simply a depiction of divinity; it *was* divinity. He bowed down before it, prayed to it, kissed it, burned incense beneath it. He viewed the painting as an aperture through which he could see, and be seen by, his savior—and hopefully receive his blessing. Gold played a decisive role in this interaction. Christ, we should recall, was the light of the world, whose face shone as brilliantly as the sun after his transfiguration. Christian belief was pervaded with such divine light—a mysterious and ultimately inaccessible radiance that originated in God and bathed his followers in spiritual warmth. Gilded surfaces, which catch, reflect, and remake the light around them, helped represent this unrepresentable reality. As our medieval viewer scrutinized his icon in a dark, candlelit room, he might have witnessed a peculiar light emanating from within it, as if from another world beyond the threshold of the frame. As it did so, he could have imagined his prayers were being answered.

Later Christian artists represented divine light in action. Fra Angelico's wonderful *Annunciation* in the Prado, made for a monastery just outside Florence in the 1420s, depicts the moment a golden-winged Gabriel informs Mary that she will bear the son of God (**Plate 17**).

Above them hovers a refulgent orb that might be mistaken for the sun. But amid the golden glare we can make out two open hands, which gesture toward Mary. A beam of light, made of twenty-five parallel gilded lines (which must have been a nightmare to draw), exits the orb and hurtles diagonally downward, over Adam and Eve's heads, past the fruit-filled orchards of Eden, between the columns of a dainty portico, and through a white dove (symbol of the Holy Spirit), before tapering into golden fingers that are just about to make contact with the Virgin herself. It is an immaculate conception, both theologically and artistically, but it isn't the first of its kind. It's hard not to be reminded of Aten's outstretched fingers blessing Akhenaten and his family, depicted more than 2,000 years earlier.

Christian art had something else in common with the age of Akhenaten: it too was full of sun discs, though they were known by a different name. Halos aren't just found in Christianity—they appear in many if not most of the world's faiths—but Christian artists used them so prolifically that we often think them unique to the religion. In all creeds they had a similar meaning: they indicated that the figures they crowned were holy, or at least distinguished. The earliest Christian artists, working in the gloom of the Roman catacombs, gave them only to Christ, but their successors also bestowed them on the Virgin as well as the saints. Most early halos looked like circular golden plates, suspended vertically behind heads, though over time artists devised other ways of representing them: rings, spirals, squares, crosses, spoked wheels, gossamer nests, stars, flames, flares, and ghostly glows. Many of these decorative motifs, surely not coincidentally, bear a strong resemblance to the golden discs made thousands of years earlier by pagans. When a Christian artist placed a golden halo (the word derives from the Greek ἅλως, meaning "sun disc") above a biblical figure, he was quite literally overlaying one set of beliefs onto another. There is no clearer evidence of Christianity's debt to sun worship.

Attitudes toward gold changed in the fifteenth century. As naturalism became increasingly fashionable in art on both sides of the Alps, Renaissance theorists became concerned that the unrestrained use of gold was eclipsing the talents of the artists employing it. "There are those who utilize gold in a disproportionate way," wrote Leon Battista Alberti in the 1430s. "I do not approve of them at all."[24] He told artists

that it was far more impressive to mimic the appearance of gold with paint. For a few decades, painters tried and sometimes triumphantly succeeded in simulating golden objects in this way. In the 1470s Piero della Francesca was asked to complete an already heavily gilded altarpiece for a convent in Perugia. He crowned the principal characters with traditional plate halos but fashioned them from whites, browns, and yellows. And then, in an audacious outburst of naturalism, he showed the tops of the figures' heads—St. Anthony's bald pate, John the Baptist's unkempt mop of hair, and the Virgin's headcloth—reflected in the underside of their halos (**Plate 18**). He was demonstrating that he didn't need gold: his skill was sufficiently alchemical to convert base pigment into precious metal.

Gold itself was being evicted from mainstream European painting, and would return only intermittently thereafter. But in art's most pious backwaters it never went away. In the Eastern Orthodox Church, which is still the dominant form of Christianity in Russia, the Caucasus, and eastern and southeastern Europe (and has more than 200 million adherents around the world), icon painters are still working. Belonging to an almost unbroken tradition going back some 1,500 years, they make sacred images for churches, monasteries, and private homes, which are venerated in much the same way as they were centuries ago. Many of these pictures are still encrusted with burnished gold and continue to bathe their beholders in a soft yellow radiance.

GOLDEN SPICES

You might recall the charming childhood game that begins with a search for a buttercup. Once found, the flower is plucked from the ground and held just beneath the face: if its bearer's chin glows yellow, you know definitively that they like butter. It is a flawed method of diagnosis, not because most children love butter but because all chins glow yellow: buttercups have a glossy, dual-layered petal skin that reflects sunlight's yellow wavelengths as powerfully as mirrored glass.[25] There are tens of thousands of other yellow flower species— more than any other hue—though most are pigmented by one of just

two carbon-based molecules: flavonoids (from the Latin *flavus*, meaning "yellow") in lemons, dahlia, and snapdragons; and carotenoids in sunflowers, daffodils, and dandelions (which the French marvelously call *pissenlit*, "piss-in-bed"). Humans have used these plants to make yellow colorants for thousands of years. But the finest of them comes from a flower that isn't yellow at all.

At first sight, *Crocus sativus* is an unremarkable purple flower that barely grows higher than a blade of grass. But peer inside its unassuming corolla and you'll find three scarlet stigmas, which loll like indecent tongues. They are what make the plant so precious. In the autumn the stigmas are carefully plucked from the flower, dried, and sold as the world's most expensive spice. The best-quality saffron is currently trading at about £10 per gram—about a quarter of the price of gold. The price is primarily dictated by its labor-intensive harvesting: a kilogram of saffron might contain as many as 100,000 stigmas, each picked by heedful human hands. Today, saffron is mostly used in cooking, lending food a bittersweet flavor of mown hay, burned cinnamon, and after-dark jasmine. In the past it was also employed as a cure for kidney and heart complaints, an aphrodisiacal perfume, and, above all, a colorant. The saffron stigma contains a scarlet carotenoid pigment called *crocin* that can tint thousands of times its weight. And yet it doesn't produce a red dye. When the scarlet threads are placed in water, the liquid turns golden yellow.[26]

Saffron's name comes from the Arabic *za'faran* (زعفران), meaning "yellow." Ancient societies had other yellows, of course, but most leaned unsatisfactorily to green or brown. Saffron, by contrast, was deep, rich, and glowing hot—like gold seen by candlelight. The Greeks, who were probably the first to cultivate the plant four or five thousand years ago, frequently compared it with the flaxen metal— and also identified it with the sun. Homer's dawn (Eos) might be famous for her rosy fingers but she invariably dressed in yellow. This is one of the poet's most memorable sunrises, from the *Iliad*:

> At length as the Morning Star was beginning to herald the light which saffron-mantled Dawn was soon to suffuse over the sea, the flames fell and the fire began to die. The winds then went home beyond the Thracian sea, which roared and boiled as they swept over it.[27]

The Romans replaced Eos with Aurora but retained the saffron outfit. Here is Virgil's vision of dawn over the Mediterranean, from the *Aeneid*:

> And now the sea was reddening with the sun's rays, and saffron Aurora from the high heaven was shining in her rosy chariot, when the winds fell and every breath suddenly sank down and the oars struggle in the sluggish waters.[28]

Saffron's symbolic significance wasn't confined to Europe. It acquired greater importance in Asia—and in one country in particular.

Indian culture, which shares none of the West's ambivalence to color, is drenched in brilliant hues. What other society would devote a major annual festival to them? Holi, observed by the country's Hindu population every spring, is a celebration of love, joy, and renewal, but above all a carnival of color. Its kaleidoscopic character is rooted in mythology, with many putative origins. One story tells how Krishna, while courting his fair consort Radha, became ashamed of his dark-blue complexion. One day he smeared Radha's face with equally unnatural colors and cheered himself up in the process. Holi's celebrants have followed Krishna's lead for centuries, smearing pigments on their bodies, scattering them off rooftops, and firing them into crowds with water pistols. The revelers once made colors from many organic sources, including henna, sandalwood, indigo, annatto, neem, marigold, chrysanthemum, pomegranate, Indian Coral Tree, and Flame of the Forest. But amid this tsunami of hues, yellows have long been preeminent.

As far back as the *Rigveda*, Indians have associated yellow with sunlight and gold, and thus with brilliance, vitality, and divinity. Hindu deities are by definition incandescent—their collective name, Deva or Devi, comes from the verb *div*, "to shine"—and many have golden or yellow attributes. The sun god Surya has golden hair whose long strands resemble radiating beams of light. Savitr, a related deity, is also blond, wears tawny robes, and rides a golden chariot, while Indra has flaxen eyes and hands and dresses in yellow clothes and gold armor. Vishnu may be famous for his indigo-blue skin, but he is bedecked in yellow garments woven from the rays of the sun. Indian artists used several yellow materials to simulate the gleam of divinity, including gold. In the first panel of a triptych made in the 1820s, a

Rajasthani painter represented the absolute or ultimate reality as an uninterrupted field of shimmering gold leaf, antedating the first European abstractions by more than ninety years (**Plate 19**).

Indian artisans made other yellows and oranges from barberry, chamomile, colchinum, dolu, delphinium zalil, fenugreek, fustic, gamboge, kamala, marigold, myrobalan, osage, safflower, and weld. But their most prized yellow colorant was saffron. *Crocus sativus* was first cultivated in Kashmir up to 3,000 years ago and very soon acquired symbolic connotations. Hindus thought of it in much the same way as gold, associating it with sun, fire, and splendor, while Buddhists identified it with the humble colors of the earth, and thus with ascetic vestments. Gautama Buddha is said to have fashioned his robes from patches of discarded fabric in a haphazard range of colors. His followers likewise sourced scraps of cloth wherever they could find them, including rubbish dumps and cremation grounds. They too showed no preference for any one color—if anything, they favored an "impure" combination of hues—but after boiling them up in plants, roots, barks, and spices, their robes typically acquired a dusty orange-yellow complexion. Buddhist monks around Asia went on to wear different hues depending in part on their prevailing local dyes (they wear red in Myanmar and Tibet, brown, gray, and blue in China and Korea, and black and gray in Japan), but in India this hotchpotch of earthy yellows gradually cohered into saffron. Buddhist monks continue to wear saffron robes (named *kaṣāya*) today, though in most cases they are dyed with cheaper yellow substitutes such as ochre, gamboge, safflower, and turmeric.

In the twentieth century, saffron became an increasingly important, though controversial, component of Indian identity. In April 1931, the Indian authorities commissioned a panel to design a national flag to replace the unpopular red-white-and-green tricolor. After four months, its members unanimously concluded that the new Indian flag should be dominated by a single hue. "If there is one color that is more acceptable to Indians as a whole, even as it is more distinctive than another, one that is associated with this ancient country by long tradition," they wrote, "it is the *kesari* or saffron color."[29] The Working Committee to which the panel reported rejected the proposal but agreed that saffron should nevertheless be part of any future design.

Today's Indian flag contains horizontal stripes of saffron, white, and green, with a navy *chakra* in the center. Each band has specific significance: white symbolizes light and truth, green denotes the fertility of the Indian countryside, and, alluding to the nation's ancient ascetic traditions, saffron signifies "renunciation" and "disinterestedness."[30]

In recent decades, saffron has been appropriated by Hindu nationalists, who have revived its older meanings. The influential Hindu nationalist organization Rashtriya Swayamsevak Sangh (RSS) refused to accept the tricolor when it was adopted by the newly independent India in 1947. "The word three is in itself an evil," a spokesman wrote, "and a flag having three colors will certainly produce a very bad psychological effect and is injurious to a country."[31] Hindu nationalists instead proposed a swallow-tailed flag called the *bhagwa dhwaj* or *bhagwa jhanda*. With the exception of a black-blue "Om," the flag is entirely saffron and alludes not to asceticism but sun worship. In the words of Hindu Swayamsevak Sangh, a global nonprofit organization:

> The color of the flag embodies the glorious orange hue of the sun that dispels darkness and sheds light all around. It has the color of fire. The fire is a great purifier. The shape of rising flames and orange color tell us to shake off one's lethargy and do one's duty. The sun shines brilliantly throughout the day giving energy and life without demanding anything in return. So, we make sacrifices . . . without expectations.[32]

RSS and other radical Hindu nationalist groups still refuse to acknowledge the tricolor, pledging allegiance only to the *bhagwa dhwaj*. In recent years their increasing hostility to other communities has been dubbed "saffron terrorism."[33]

Not all Indian yellows are so divisive. The country's most widely used yellow colorant was—and is—turmeric. In the last decade turmeric has become a highly fashionable ingredient, appearing in flavored lattes and cold-pressed juices around the world. Nutritionists have rebranded this unprepossessing root a "super food"—one with anti-inflammatory and antioxidant properties that fights liver damage, diabetes, Alzheimer's, dementia, heart disease, and arthritis.[34] Many Indians still use it as a strong (and stubbornly staining) colorant, which they either grind into a powder and sprinkle as a pigment or dissolve in a solution and use as a dye. For thousands of years it

was an affordable substitute for saffron, though turmeric's yellow is thinner and colder than saffron's. But, like saffron, its hue provided a bridge of meaning to other yellow substances. Vedic authors called it both the "golden spice" and the "herb of the sun," while its many Sanskrit names include *bhadra* ("auspicious and lucky"), *pavitra* ("holy"), *hridayavilasini* ("giving delight to heart," or "charming"), and *shobhna* ("brilliant").[35]

The residents of Tamil Nadu and Andhra Pradesh identify turmeric specifically with Ganesh, carving effigies of the elephant-headed god from the rhizome or coating them with turmeric powder. According to the *Mugdala Purana*—a religious text dedicated to the deity—the Haridra Ganapati is the twenty-first of thirty-two forms of Ganesh, in which he also wears yellow clothes and is seated on a golden throne (**Plate 20**). Worship of him is completed by a prayer:

> I salute Lord Haridra Ganapati, who is radiant like turmeric yellow, whose face shines with yellow complexion, who has four hands, [three] carrying rope, hook, and sweet-meat and the [fourth] giving complete refuge to his devotees, destroying all their fears.[36]

Like the other thirty-one iterations of Ganesh, the Haridra Ganapati is an auspicious god. He grants wishes, dispenses good fortune, and improves life prospects. His worshippers typically pray to him when they are about to undertake activities for which luck might be needed, like starting a business, purchasing a car, or getting married.

Turmeric's bright and buoyant appearance was identified with other propitious events and used to mark the entire arc of life. It was smeared on mothers and their babies at birth, applied to the flesh of girls when they entered puberty, and buried with the dead, who in some cases were interred in fields of turmeric. It was most widely used in marriage rituals—and still is. In many parts of India turmeric is splashed liberally onto the bride, groom, matrimonial clothes, wedding invitations, guests, food, gifts, ceremonial spaces, and even the walls of a couple's future home. The newlyweds often exchange a betrothal wristband (*kankana*) dyed with or containing turmeric and sometimes remain in a "turmeric state" for the week following the wedding.[37]

Hindu traders exported turmeric to other parts of Asia and Oceania from as early as 200 BCE, and it reached remote Polynesian

islands such as Hawaii and Easter Island long before European explorers "discovered" them in the eighteenth century. These communities absorbed many Indian attitudes to the spice, with virtually all considering it quasi-sacred. They celebrated its cultivation, harvest, and preparation with rituals of singing, dancing, and prayer. Southeast Asians identified its yellow pigment with both the sun and the earth, and thus with their corresponding gods. The Mentawai people of West Sumatra commemorated violent deaths at communal buildings called *uma* that were then coated in turmeric. "This yellow is to make the spirit of the *uma* rejoice," priests would chant. "The spirits will then bless us and keep us from all that is evil." Some Malaysian tribes used the rhizome to protect them from the sunset. They believed the yellow flare that leaked across the horizon at dusk, which they called Mambang Kuning (the "Yellow Demon"), could invade their homes and imperil their families. Mothers therefore chewed chunks of turmeric and spat them around the perimeter of their properties. All over the eastern hemisphere people hung turmeric amulets around their necks, held roots in their hands, kept dyed fabrics in their pockets, and sprinkled its powder over beds and bodies. Their faith in this devil destroyer was ultimately grounded in its color. If turmeric's yellow wasn't as rich and deep as saffron's, it was bright enough to signify the illuminating, energizing power of sunlight.[38]

In most cases, yellow spoke to the forces that—like the sun—were beyond our control. But in one part of Asia it was used to promote a very human regime. China, as we saw in the previous chapter, had possessed a sophisticated appreciation of color meanings since antiquity. A succession of Chinese thinkers argued that yellow (like red) was bright, hot, and active, and thus charged with positive associations. Identifying it with the all-powerful sun, the fertile soil, and the great yellow river around which their civilization emerged, they established it as a natural symbol of the ruler who united Heaven and Earth and reigned over the Middle Kingdom. For thousands of years, China's emperors were duly marked out by yellow. They alone (and sometimes their wives) wore the brightest-yellow garments, with relatives and officials wearing lesser shades of yellow depending on their status. By the end of the Qing dynasty (1644–1912), the last imperial era, China's textile manufacturers were capable of making

140 different shades and hues of yellow, which were used to demarcate such hierarchies. But the color wasn't restricted to clothing. In his remarkable autobiography, China's last emperor, Puyi, claimed that it saturated the entire imperial court:

> Often I think about it, my childhood was as a dream full of the color yellow. Yellow tones overflowed everywhere, from the top of glazed tiles, the sedan chair, the lining of apparel, shoes and caps, waist-belts, porcelain bowls and plates, the cotton-padded covering for keeping rice gruel, the window curtains and reins, and so on. The bright yellow color was for the special use of the Chinese emperor, the consciousness of which was deeply carved in my young heart, and gave a sense of privilege and power.[39]

China's imperial treasures didn't mean the same thing or function the same way as India's saffron robes and southeast Asia's turmeric talismans. But all were informed by a simple association: in a continent where solar myths and rituals were widespread and deep-rooted, yellow, sun-like substances conveyed sanctity and power.

DARK AND LIGHT

"It is not obvious," wrote the English physician Havelock Ellis in 1906, "why we should have ceased to delight in a color that to the men of another age and of another continent has seemed so precious." Europeans had once exhibited no less love for yellow than other cultures, identifying it with warmth, gold, saffron, honey, butter, and wildflowers. But at some point during the Middle Ages attitudes changed. Yellow began to be viewed with suspicion, disapproval, at times even disgust. Havelock Ellis thought this volte-face had above all been driven by religion. "It is clearly the advent of Christianity that introduced a new feeling in regard to yellow," he wrote. "In very large measure, no doubt, this was merely the outcome of the whole of the Christian revulsion against the classic world and the rejection of everything which stood as the symbol of joy and pride." Christians, he said, would have similarly turned against red (another pagan favorite) had it not been "too firmly rooted in human nature" to stamp out.[40]

The emerging objection might also have been grounded in the color's physical properties. Yellow can be warm and bright like sunlight, but without warmth it looks shrill, and without brightness it looks leaden. It is powerful when pure and saturated but is also susceptible to corruption. Painters know yellow to be the least stable, and most easily vanquished, hue on the palette: an unclean brush will destroy its brilliance in an instant, and a speck of black or blue will transform it irreversibly into green. But this fragile and corruptible color is itself an insidious corruptor. Take its effect on white, for instance. All colors change white easily, but where ultramarine turns it sky blue and vermilion makes it pink, an equal mixture with yellow results only in off-white. Yellow doesn't transform white; it only spoils it.

For centuries (as we will see in Chapter 5), Europeans coveted whiteness. In this they were ultimately fighting against nature, for the simple reason that the world generally inclines to yellow. Organic matter tends to reflect more light in the middle range of the visible spectrum. White or pale substances therefore turn yellow when they age, fade, or go off. Paper yellows on exposure to air because oxygen breaks down its lignin into phenolic acid, which reflects yellow light. Cut apples go yellow then brown for similar reasons. These processes are catalyzed, somewhat fittingly, by sunlight. Ultraviolet radiation accelerates molecular mutations in many organic substances, causing the gradual yellowing of white paint, wool, silk, and cotton. We are ourselves victims of these transformations:

> Yellow is the color of aging, particularly conspicuous in pale-skinned peoples, especially of skin tissues that have lost their living suppleness, like calluses on feet and hands, or hardened tissue like teeth and nails, both of which yellow with age. As the predominating color of autumn in the arborial countries of Europe, yellow can easily signify the deciduous quality of life itself, as it dries out in age, moving from the taut and moist condition of the *cutis* to the sagging, parched condition of the *pelis* . . . Yellow is mortuary; the newly dead white often acquire a characteristic yellow hue. It is excremental too, being the color of many substances expelled or exuded from the body: earwax, mucous, pus, urine and feces.[41]

So perhaps it isn't surprising that Europeans have consistently identified yellow with the abject or unwanted. From the twelfth century onward, it was variously interpreted as a symbol of betrayal, jealousy, cowardice, avarice, and laziness, and increasingly used to designate and stigmatize outsiders.

"Disreputable" individuals had been marked by yellow since antiquity. Greek and Roman prostitutes were designated by yellow clothes, hairbands, and wigs. Medieval concubines, debtors, and sometimes lepers were required to wear it, while religious painters often reserved it for Judas. In the unforgettable *Betrayal of Christ* in the Arena Chapel in Padua, Giotto shrouds the turncoat apostle in a gaudy yellow robe that envelops Christ as he leans forward to embrace him. During the Spanish Inquisition, convicted heretics were ordered to wear a yellow cloak (known as a *sanbenito*) for the duration of their sentence, and sometimes even for life, while Elizabethan men who wore yellow risked advertising themselves as philanderers or adulterers. In one of the funniest scenes in *Twelfth Night*, the morose and pompous Malvolio straps on a pair of cross-gartered yellow stockings to woo Olivia but humiliates himself in the process.[42]

Malvolio's humiliation was nothing compared to that of Europe's longest-suffering victims of yellow shaming. In 1215, the Fourth Lateran Council decreed that Jews had to be "marked off in the eyes of the public from other peoples through the character of their dress."[43] Red capes, pointed hats, embroidered diagrams, or even bells attached to garments were all used to identify these outsiders within. Most jurisdictions subsequently required a colored circle, sometimes red but more often yellow, to be worn as a badge on the clothing. The choice of color could have been inspired by Islamic precedent, where Jews had been marked out by yellow badges since at least the ninth century.[44] Jews naturally resented wearing such conspicuous symbols, and many found ways to hide them. A number of laws were therefore passed to make them yet more obvious. The first, declared in Venice in 1496, mandated that Jews wear a yellow hat called a *baretta* in public, on penalty of a fifty-ducat fine and a month in prison. Other Italian states followed, and by the middle of the sixteenth century a patchwork of legislation covered much of Europe, though inconsistencies between legal systems made compliance difficult. In 1560, a Piedmontese Jew

called Leone Segele traveled to the Duchy of Milan to visit his sister. Unaware of the legislation, Segele arrived in the city sporting a splendid black hat. When he was told that he was breaking local law, Segele purchased a yellow *baretta* from a hatmaker, only to be arrested a few days later. At his trial the precise color of Segele's *baretta* was debated at length. One witness described it as "orange-golden" while another maintained that it was "silver and golden." Segele insisted throughout that it was yellow. Unable to resolve the dispute, the court eventually sent the hat to the Duke of Milan so that he could personally determine its color. Unfortunately, the duke's ruling on his realm's precise hue of anti-Semitism has been lost.[45]

The idea of a set of *principal* or *simple* colors dates back to antiquity, though the colors in question were far from consistent. Aristotle named five hues, in addition to black and white; Leonardo and Alberti plumped for four, linked to the four classical elements earth, water, air, and fire; and Newton, as we have seen, opted for seven hues that corresponded with the notes of the musical scale. It was only in the seventeenth century that theorists began to speak of the *three* primary hues we know today. Robert Boyle's *Experiments and Considerations Touching Color*, published in 1664, contains the earliest use of the term "primary color" in English:

> There are but few Simple and Primary Colors (if I may so call them) from whose Various Compositions all the rest do as it were Result. For though Painters can imitate the Hues (though not always the Splendor) of those almost Numberless differing Colors that are to be met with in the Works of Nature, and of Art, I have not yet found, that to exhibit this strange Variety they need to imploy any more than *White*, and *Black*, and *Red*, and *Blew*, and *Yellow*; these *five*, Variously *Compounded*, and (if I may so speak) *Decompounded*, being sufficient to exhibit a Variety and Number of Colors, such, as those that are altogether Strangers to the Painters Pallets, can hardly imagine.[46]

Boyle's ideas gained currency in the eighteenth century, and were reinforced by practical developments in color production. Color-makers had long been searching for an efficient means to produce a full rainbow of hues, but it was only in the third decade of the century that

their industry produced the first fully developed theory of trichromacy. In the late 1710s or early 1720s, the German artist and entrepreneur Jakob Christoph Le Blon discovered that by overprinting transparent layers of blue, yellow, and red ink on three separate mezzotint copperplates and then using a fourth plate of black ink for contrast, he could produce images that appeared to simulate "all visible objects."[47] He soon thereafter opened a "Picture Office" in London that printed reproductions of Old Master paintings in their "natural colors," selling them for between ten and twenty-one shillings apiece. Le Blon's technology was centuries ahead of its time, and its legacy was enormous: his principles still underpin CMYK printing techniques, which remain the industry standard today.[48] Le Blon had confirmed in practice what Boyle had proposed in theory: there were three primary colors, three building blocks from which the entire spectrum could be assembled—and yellow was among them. But one later author went still further.

Johann Wolfgang von Goethe was the greatest European polymath since Leonardo: a painter, novelist, poet, playwright, critic, essayist, antiquarian, philologist, philosopher, psychologist, botanist, geologist, meteorologist, anatomist, landscape designer, collector, lawyer, and, for ten years, minister of state for the Republic of Weimar. His contribution to most of these domains was considerable, but he considered his greatest achievement to be *Zur Farbenlehre* (*Theory of Colors*), first published in 1810. Like Newton, Goethe had been inspired by a prism. One day in 1790, he borrowed one from a friend, found a white room, and held the prism up to his eyes. He had expected the walls to fill with Newton's refracted prismatic hues, but found they didn't change appearance at all. The only noticeable colors materialized in the room's darkest corners and around the edges of the prism. "It required little thought to realize that a boundary was required to elicit the colors and, as if by instinct, I immediately said aloud to myself that the Newtonian doctrine must be erroneous."[49] After further experiments, Goethe concluded that color was not an exclusive property of white light, as Newton had claimed, but produced by the interaction of light and darkness at the surfaces on which they met. Within these two poles he identified two chromatic extremes: yellow being closest to light and blue to darkness. Goethe had replaced the established theory

of three primary hues with one that required just two. Moreover, he didn't simply make physical distinctions between yellow and blue, but contrasted their metaphorical characteristics.[50]

Plus	Minus
Yellow	Blue
Action	Negation
Light	Shadow
Brightness	Darkness
Force	Weakness
Warmth	Coldness
Proximity	Distance
Repulsion	Attraction
Affinity with acids	Affinity with alkalis

Over the course of 1,400 pages Goethe discussed the "moral associations" of all the major hues. He wrote of red's "gravity and dignity"; the "extreme excitement" precipitated by orange; the way lilac was "lively without gladness"; and why green was the most sensible color to paint one's home.[51]

Goethe's observations about yellow were particularly insightful, because they acknowledged the color's precarious position between the divine and disagreeable. "By a slight and scarcely perceptible change," he wrote, "the beautiful impression of fire and gold is transformed into one not undeserving the epithet foul; and the color of honor and joy reversed to that of ignominy and aversion." But at its brightest and purest, yellow was beyond compare.

> This is the color nearest the light. It appears on the slightest mitigation of light, whether by semi-transparent mediums or faint reflection from white surfaces . . .
>
> In its highest purity it always carries with it the nature of brightness, and has a serene, gay, softly exciting character.
>
> In this state, applied to dress, hangings, carpeting, &c., it is agreeable. Gold in its perfectly unmixed state, especially when the effect of polish is superadded, gives a new and high idea of this color; in like manner, a strong yellow, as it appears on satin, has a magnificent and noble effect.

We find from experience, again, that yellow excites a warm and agreeable impression. Hence in painting it belongs to the illumined and emphatic side.

This impression of warmth may be experienced in a very lively manner if we look at a landscape through a yellow glass, particularly on a gray winter's day. The eye is gladdened, the heart expanded and cheered, a glow seems at once to breathe toward us.[52]

Goethe was concluding a rehabilitation that had commenced 150 years earlier with Robert Boyle. His yellow is a positive, active force in the universe that brings joy to its beholders. Moreover, by identifying it with "brightness" and "warmth," and by calling it "the color nearest the light," Goethe was consciously reviving its old solar associations. He was not alone.

THE YELLOW DWARF

According to his own (unreliable) recollection, Joseph Mallord William Turner was born on St. George's Day—the same day as Shakespeare. The two had much else in common. Though both hailed from undistinguished backgrounds—Shakespeare's father made gloves, Turner's made wigs—they rapidly won fame even in the most rarefied circles. They were both artistic magpies, who crossbred the vigorous English vernacular with classical traditions and continental sensibilities. But where Shakespeare created his teeming worlds with words, Turner's toolbox was color. He loved the way it felt on his fingers, how it clung to his canvases, how it smelled in his studio. For Turner the world was a relentless rainbow, which he sought to re-create with maximum vividness. When asked why his paintings were filled with such lurid color, he replied: "Well, don't you see that yourself in Nature? Because, if you don't, Heaven help you!"[53]

Turner's favorite color was yellow. He spent hours studying its myriad iterations, using more yellow pigments than any other—so many, in fact, that scholars haven't yet finished cataloguing them.[54] He experimented with yellow ochre, orpiment, Mars yellow, Gamboge, Patent yellow (also known as Turner's yellow), Strontium yellow,

mid-chrome yellow, pale-lemon chrome, Barium chromate, Indian yellow, and flavonoid dyestuffs probably extracted from the petals of flowers.[55] Most of his contemporaries had seldom encountered, let alone used, most of these pigments. But he was always on the lookout for new yellows, and harassed shopkeepers, chemists, fellow artists, friends, and even strangers to obtain them. When one man bumped into Turner before making a trip to Italy, he politely asked if there was anything he could do for the artist while abroad. "No," Turner barked. "Unless you will bring me some Naples yellow."[56]

Turner was particularly partial to chrome yellow. The pigment had only been developed in his lifetime, after its main ingredient was discovered in a Siberian gold mine in 1770. This mineral was eventually named crocoite, after the Greek *krokos*, for saffron. In the late 1790s, the French chemist Nicolas Louis Vauquelin successfully isolated an element within it that he called chrome (from the Greek *chromos*, for color) on account of the brilliant compounds it produced. Vauquelin used it to make vivid greens, oranges, and reds, but it was his yellow that attracted attention. Chrome yellow came in a variety of shades and hues, depending on its lead chromate content. Its finest incarnations were exceptionally brilliant, with four times the covering power of most existing yellows, and so naturally fine that artists didn't even need to grind them. It became the most successful yellow pigment of the nineteenth century, used to paint houses, coaches, even to color confectionary,[57] and furnished the most famous yellows in modern art, including Gauguin's *Yellow Christ* and Van Gogh's *Sunflowers*.[58]

The chemist and colorman George Field, author of the influential *Chromatography; or, a Treatise on Colors and Pigments, and of Their Powers in Painting* (1835), was impressed by the "purity, beauty, and brilliancy" of chrome yellows but warned of their destabilizing power. "In general," he wrote, "they do not accord with the modest hues of nature, nor harmonize well with the sober beauty of other colors."[59] A number of artists experimented with the new colorant shortly after it became available but were so alarmed by its strength that they soon retreated to the familiar, softer hues of Naples and Patent yellow. Turner had a different reaction: he employed the pigment within weeks of its first manufacture in Britain in the 1810s and used it in almost everything he painted until his death.[60]

The public first noticed Turner's predilection for yellow in the 1820s. In 1826, he exhibited three paintings at the Royal Academy—*Cologne, Forum Romanum*, and *Mortlake Terrace*—all of which were covered with what one observer later called "a devil of a lot of chrome."[61] The critics did not approve. The *Literary Gazette* joked that Turner had "sworn fidelity to the Yellow Dwarf."[62] The *Morning Chronicle* concluded that he was "desperately afflicted with what we may call a yellow fever."[63] But the most vituperative critique appeared in the *British Press*:

> We find the same intolerable yellow hue pervading every thing; whether boats or buildings, water or water-men, houses or horses, all is yellow, yellow, nothing but yellow, violently contrasted with blue ... Mr. Turner has degenerated into such a detestable manner, that we cannot view his works without pain. He is old enough to remember Loutherbourg, whose red-hot burning skies were as repulsive as these saffron hues of his own. We mention this not unkindly, and would wish Mr. Turner to turn back to Nature, and worship her as the goddess of his idolatry, instead of this "yellow bronze" which haunts him.[64]

Turner took careful note of the review. We know this because after he had finished reading it, he carefully cut it out of the newspaper and posted it back to its author. The covering letter simply read "with J. M. W. Turner's thanks."[65]

Turner admired yellow's optical power. Bright and warm, it jumps out at us from a distance and forces itself on the retina: a brave painter can wield it like a weapon. He also understood its prismatic primacy. While preparing for a series of lectures at the Royal Academy in 1811, he read a good deal of color theory and learned that yellow was one of three primary colors. He even drew a series of color circles— among the first ever made by an artist—to illustrate the theory of trichromacy. He borrowed his design from Moses Harris' color diagrams in *The Natural System of Colors* (1770) but made one revealing change: he placed yellow rather than red at their apex (**Plate 21**). Turner believed that yellow was the foremost of the three primary colors because it was the closest to white, to light, and therefore to the sun. It was a realization of personal, perhaps even spiritual, importance. Though he wasn't a straightforwardly religious man, Turner was a lifelong worshipper of nature. The whole world, he thought, was

Turner at work

bathed in a divinity that originated in the sun. And if the sun was sacred, so too was yellow.

Some years later, Turner read Goethe's *Theory of Color*, which his friend Charles Eastlake had translated into English in 1840, but if his annotations are anything to go by, he was not impressed: "Prove it"; "Oh! Oh no"; "This doubtful"; "Will no do"; "Off again, G." When Goethe wrote that perfect colors "should not incline too much to yellow," Turner simply wrote "Oh."[66] But he was surely intrigued by Goethe's surprisingly accurate description of the sun:

> The highest degree of light, such as that of the sun . . . is for the most part colorless. This light, however, seen through a medium but very slightly thickened, appears to us yellow. If the density of such a medium be increased, or if its volume become greater, we shall see the light gradually assume a yellow-red hue, which at last deepens to a ruby color.[67]

Goethe's observations are echoed in several of Turner's works. *Ulysses Deriding Polyphemus* (1829) depicts the famous moment in the *Odyssey* when, after blinding the Cyclops, Ulysses ridicules his

defeated adversary (**Plate 22**). But Turner's protagonists are far less important than the sunrise that explodes behind them, setting the canvas alight. We can just decipher faint traces of solar horses galloping over the horizon—an allusion to the old belief that stallions carried the sun across the sky—but the debt to modern color science is far more conspicuous. The sky is built from dazzling rays of complementary colors that burn across half of the canvas: violet juxtaposed with orange, black with white, blue with volcanian yellow.[68] For the sun itself, Turner applied a thick disc of white paint to the canvas. When it was dry, he dragged a band of saturated chrome yellow across it. Here is Goethe's theory materialized in paint: the sun is white light turned yellow by the atmosphere.

Turner's depiction was grounded in close, even scientific, observation. He owned his own telescopes, drew schematic diagrams of the sun, and during a partial solar eclipse in London on February 11, 1804, excitedly sketched how it appeared to the naked eye.[69] He painted hundreds of sunrises and sunsets over the years, using almost as many methods to represent them. In a little watercolor known as *The Sun Rising over Water* (c. 1825–1830), he bathed the entire sheet in apricot yellows but left the sun empty, transforming a small circle of blank white paper into a spotlight. In *The Scarlet Sunset* (c. 1830–1840) he fashioned a bloodred cityscape out of vermilion, waited for it to dry, then deposited a chrome-yellow sun above its horizon. He then reloaded his brush, and in one deft move doodled a dazzling yellow reflection in the water. In his unfinished *Norham Castle, Sunrise* (c. 1845) Turner didn't paint a solar orb directly but invoked it with a cloud of lemon-posset yellow. For all its lyrical beauty, this painting has a curiously destabilizing effect on the eye, oscillating uncomfortably between visibility and invisibility. To understand why it does this, take a look at a black-and-white reproduction of the picture: in monochrome, the sun is virtually invisible (**Plates 24 and 25**). That is because Turner's sun and sky are isoluminant—they are equally bright, which creates mayhem in the visual system. To the part of the brain that mostly processes luminance the sun is invisible, but to the part of the brain that mostly processes color it is easily distinguished from the blue sky around it. Turner had achieved the effect instinctively, but the result is felicitous: his sun overwhelms our visual apparatus just like the real one.[70]

The most potent of all Turner's suns is in *Regulus*, made in 1828 and aggressively repainted in 1837 (**Plate 23**).[71] It tells the story of the Roman general Marcus Atilius Regulus, who, after being defeated at Tunis in 255 BCE, was captured by the Carthaginians and sent to Rome to negotiate a release of prisoners. Regulus advised the Roman Senate not to make the deal and then bravely returned to Carthage to break the news to his enemies. They did not take it well.

> Nothing could equal the fury and the disappointment of the Carthaginians, when they were informed by their ambassadors, that Regulus, instead of hastening a peace, had given his opinion for continuing the war. They accordingly prepared to punish his conduct with the most studied tortures. First, his eye-lids were cut off, and then he was remanded to prison. He was, after some days, again brought out and exposed with his face opposite the burning sun. At last, when malice was fatigued with studying all the arts of torture, he was put into a barrel stuck full of nails that pointed inward, and in this painful position he continued till he died.[72]

This passage, from Oliver Goldsmith's *Roman History* (1769), provided Turner's inspiration. It is the story of a man who stared directly into the sun. Turner once bragged that he could look at the midday sun without flinching, let alone suffering solar retinopathy. "It hurts my eyes no more than it would hurt yours to look at a candle," he once told a friend.[73] So perhaps we should think of *Regulus* not as a history painting, but a portrait of the artist as a sun worshipper. This might explain why the titular martyr is virtually absent, visible only as a tiny figure atop the steps in the distance. This is not about Marcus Atilius Regulus but about the terrible beauty of the sun.

More arson than artwork, *Regulus* is almost too incandescent to look at. When it originally went on display in London, critics advised the public to shield their eyes to avoid injury, or at least to stand well back. "Look at it from as great a distance as the width of the gallery will allow of," warned the *Spectator*, "and then you see nothing but a burst of sunlight."[74] In one sense Turner hadn't simply painted the sun but re-created it—not with hydrogen and helium but with lead white and chrome yellow. He, like Prometheus, had stolen fire from the gods and so become divine in his own right. This was certainly the view of

his most eloquent champion. In the first edition of *Modern Painters* (1843), John Ruskin wrote:

> Turner—glorious in conception—unfathomable in knowledge—solitary in power—with the elements waiting upon his will, and the night and the morning obedient to his call, sent as a prophet of God to reveal to men the mysteries of His universe, standing, like the great angel of the Apocalypse, clothed with a cloud, and with a rainbow upon his head, and with the sun and stars given into his hand.[75]

Ruskin's words proved deeply controversial. In a review published in *Blackwood's Edinburgh Magazine*, the Reverend John Eagles called it tantamount to blasphemy. "To keep up his idolatry to the sticking-point," Eagles concluded, "[Ruskin] terminates the volume with a prayer, and begs all the people of England to join in it—a prayer to Mr. Turner!" Ruskin quietly removed the offending passage from subsequent editions.[76]

Turner himself remained a sun worshipper to the end. In the final months of his life he was largely confined to his home in London. Though he suffered unrelenting pain and depression, the disc in the sky continued to bring him solace. He often asked to "see the sun again," and not long before his death he dragged himself out of bed and crawled to the window in order to set eyes on it.[77] He died on December 19, 1851, just two days before the winter solstice. If we are to believe his physician's account of the artist's final hours, the sun made an effort to say goodbye to its old devotee. "On the morning of his decease it was very dull and gloomy, but just before 9 a.m. the sun burst forth and shone directly on him with that brilliance which he loved to gaze on and transfer the likeness to his paintings." He died "without a groan" an hour later, his face turned toward the window.[78] Several years after Turner's death, Ruskin revealed that among the great artist's final words was a brief monosyllabic sentence: "the Sun is God."[79]

4

Blue

Beyond the Horizon

Why make so much of fragmentary blue
In here and there a bird, or butterfly,
Or flower, or wearing-stone, or open eye,
When heaven presents in sheets the solid hue?

Since earth is earth, perhaps, not heaven (as yet) –
Though some savants make earth include the sky;
And blue so far above us comes so high,
It only gives our wish for blue a whet.

"*Fragmentary Blue*"
Robert Frost[1]

At the beginning of May 1898, a small sailing boat dropped anchor in the cerulean waters between Australia and Papua New Guinea. Aboard were seven British scientists who had traveled more than 10,000 miles to study the indigenous communities of the Torres Strait. Their two-month voyage had not been easy. They had made the final leg of their journey lashed to the deck of a forty-seven-foot ketch in ferocious storms, and when they finally reached Murray Island they were soaked, seasick, and sunburned.[2] Among them was a young psychologist called William Rivers, whose fame now rests largely on his treatment of shell shock during the First World War. In 1898, however, he was preoccupied with the study of human vision, and had joined the expedition to investigate the eyesight of people who he believed were "sufficiently near their primitive condition to be thoroughly interesting."[3]

Over the next four months he examined more than 200 local inhab-
itants, assessing their visual acuity, spatial perception, sensibility to
light difference, and color vision. Rivers' tests indicated that though
the Torres Strait islanders possessed excellent vision—in some respects
superior to that of Europeans—they seemed incapable of identifying
certain hues. They had no difficulty spotting black, white, red, yellow,
and green, but consistently struggled when faced with blue samples.
Some respondents were struck dumb with uncertainty; others shouted
words for black and green; a few even mimicked their English visitors
by saying "bulu-bulu." He observed the responses with a fascination
bordering on bewilderment. How could a people with uncommonly
discerning eyesight be defeated by so straightforward a task? How
could a community surrounded by vast blue skies and deep-blue seas
be so insensitive to their color? He later described his findings as
"almost inexplicable."[4]

Rivers wasn't the only scientist to stumble on this mysterious phe-
nomenon. In the second half of the nineteenth century, Europeans
journeyed to the distant corners of the world to study what they con-
sidered to be primitive human societies, and many found a lacuna
where blue should have been. It was noticed by Philipp Strauch and
Otto Schellong in other parts of Melanesia; by Richard Andrée among
the Mpongwe people in Gabon and the indigenous Caribs of South
America; by Otto Keller in Ethiopia and Sudan; by Ernst Almquist in
the Chukchi Peninsula at the eastern edge of Russia; and by Hugo
Magnus among the bushmen and Herero of southern Africa, the
Hovas of Madagascar, the natives of Borneo, and the tribes of the
Nilgiri mountains in southern India. There were, it seemed, a signifi-
cant number of people around the world who were blind to blue.[5]

The affliction went back millennia. Four decades before Rivers' visit
to the Torres Strait, William Gladstone had noticed a similar phenome-
non in the epics of Homer. After repeated rereadings of the *Odyssey*
and the *Iliad*, Gladstone concluded that something was curiously awry
in the poet's descriptions of color. Homer hardly ever labeled blue
things with a secure and consistent adjective. He described the sea in
dozens of different ways (including "wine-dark" on at least nineteen
occasions) and labeled the sky "starry," "broad," "great," "iron," or "cop-
per," but not the azure for which they are famous. Homer did possess

two words for blue things—*kyaneos* (an ancestor of our "cyan") and *glaukos*—but these had much broader meanings: *kyaneos* denoted all kinds of dark colors, and *glaukos* all kinds of pale or desaturated colors. "Homer had before him the most perfect example of blue," a puzzled Gladstone remarked. "Yet he never once so describes the sky."[6] We might suppose that Homer was an oddity (he was, after all, allegedly blind), but as one German philologist later discovered, the poet was far from alone.

At the age of seven, Lazarus Geiger had set himself the challenge of mastering all the world's languages. He never completed the task—he died at the age of forty-one—but by his thirties he had made considerable progress through the canon of world literature.[7] He found, to his amazement, that basic color terms for "blue" were almost entirely absent from the *Rigveda*, the Zoroastrian *Avesta*, the Norse *Eddas*, the New Testament, ancient Chinese and Semitic writings, and many other classical Greek poems. Geiger's findings, first presented at a lecture in Frankfurt in 1867, were nothing short of astonishing: millions of lines of text and tens of millions of words, but virtually none of them devoted to one of the world's most ubiquitous colors. "You will grant," he concluded, "that such a series of agreements cannot well be deemed to chance."[8]

Geiger's work sent tremors through academia, and in the following decades Europe's philologists, philosophers, and physicians competed to explain the cause of the phenomenon. Many thought the answer was physiological: ancient people, like the communities Rivers and his peers went on to study, were afflicted with "acyanoblepsia": they were blue-blind. But how could a disability on so vast a scale be explained? German ophthalmologist Hugo Magnus claimed that the eye had changed over time: as humans evolved, the retina became more exposed to light and thus more sensitive to the visible spectrum. Blue, being a "low-intensity" color, took longer for us to see than most other hues. In ancient and "primitive" cultures, he argued, that evolution had not been completed. Magnus' theory acquired many distinguished supporters, Gladstone included.[9]

It was finally overturned in 1969 when anthropologist Brent Berlin and linguist Paul Kay published *Basic Color Terms*, which demonstrated that the widespread nonrecognition of blue was a result not

of perceptual but of *linguistic* variations. By examining twenty languages (they later expanded their study to more than a hundred), they showed that virtually every human language developed color terms in the same order. All began with a distinction between black and white; then created a word for red; then green followed by yellow (or sometimes yellow followed by green); and then—and *only* then—came blue.

BLACK			GREEN	→	YELLOW		
	→	RED	→			→	BLUE
WHITE			YELLOW	→	GREEN		

More complex colors (including brown, purple, pink, orange, and gray) followed. Nevertheless, Berlin and Kay described many languages—including the Papuan Dani, the Philippine Hanunóo, and the Central American Tzeltal—that even in 1969 lacked specific and stable terms for blue.[10] More recent studies have identified sixty-eight languages that fail to discriminate between blue and green, using one word—which linguists call "grue"—for both hues; seventeen languages that don't distinguish blue from black, green, or yellow; and two Australian Aboriginal languages—Murrinh-Patha and Kuku-Yalanji—that have no basic color terms for blue at all.[11]

Why has blue taken so long to be named? The answer, I suspect, has something to do with scarcity. Unlike most other hues, blue rarely adopts a tangible form in nature. There are few naturally occurring and easily accessible blue minerals in the world; the color accounts for less than 5 percent of plants and 8 percent of fruits; and though we might point to a number of blue birds, fish, and amphibians—some of which appear almost electrically blue—most merely create an illusion of the hue by modulating their surface structures. In fact, of the Earth's 64,000 vertebrate species, only two (the mandarinfish and the picturesque dragonet fish) are genuinely pigmented blue.[12] Early humans therefore interacted with blue *things* only intermittently. Indeed, before the invention of blue dyes and pigments, some might never have touched a blue object in their lives.

Berlin and Kay's theory is supported by William Rivers' findings in the Torres Strait. His subjects, as we have seen, had no difficulty identifying other basic colors. On Murray Island, they named black

(*golegole*) after the black ink of the cuttlefish (*gole*), white (*giaud-giaud*) after limestone (*giaud*), red (*mamamamam*) after blood (*mam*), green (*soskepusoskep*) after bile (*soskep*), and yellow (*bambam; siu-siu*) after turmeric (*bam*) or yellow ochre (*siu*). All these terms were derived from substances that could easily be collected, handled, or manipulated and were regularly used to distinguish between dark and light objects, red and yellow fruits, and different kinds of vegetation. This vocabulary played a valuable role in their daily lives, if not their survival. But the inhabitants of the Torres Strait couldn't collect, handle, or manipulate blue, so they didn't develop the adjective. As long as blue was absent from their material worlds, it didn't need to be named.[13]

Absent from the world: it is a good way to think about blue. Unlike most other hues, blue thrives only in the unearthly realms of sky, sea, and horizon. But even those fields of color are apparitions. Cloudless skies are blue because of a process called Rayleigh scattering: when sunlight travels through the Earth's atmosphere, shortwave blue photons are disrupted by molecules in the air, torn away from their counterparts, and scattered in all directions across the firmament. The sea is blue because it mirrors the sky, and because water tends to reflect short wavelengths of light, converting others into heat. Horizons are often blue because of a phenomenon related to Rayleigh scattering called aerial perspective: as objects recede from us, they are veiled by ever more scattered light, appearing progressively bluer, before terminating in a hazy cerulean horizon. All these blues reside not in surfaces but in depths, not in objects but in the spaces between them.[14] If we bottle the contents of a deep blue sea we will find it is largely colorless; if we travel toward a blue horizon we'll discover it isn't blue, and never was. Blue, in short, is the most elusive of colors. It slips through our fingers and retreats just as fast as we approach it. That may be why, as the poet Robert Frost once observed, we "wish for blue." We wish for it because we know we can't have it.[15]

This oscillation of presence and absence, this teasing existence at the margins of our world, is at the heart of blue's cultural significance. After all, how can one look at a blue sky or horizon and not fantasize about what lies beyond it? "As we readily follow an agreeable object that flies from us," wrote Goethe, "so we love to contemplate blue, not because it advances to us, but because it draws us after it."[16] To

contemplate blue is to be lured into an optical journey from here to there, from one world to another. Even to say "blue" is to plot such a journey on the palate: once the small consonantal threshold between "b" and "l" is negotiated, the word vanishes into the distance. Few other color terms behave that way: black, white, red, and green are circumscribed by consonants, yellow and purple are return trips; but blue is a one-way voyage toward the horizon.[17]

BEYOND THE SEA

When did humans first look at the horizon and decide to travel toward it? The urge to explore and discover inspired Paleolithic Asians to hike across an icy land bridge from Siberia to Alaska, Polynesian navigators to traverse vast swathes of the Pacific in little more than canoes, Renaissance explorers to travel so far around the globe that they returned to where they started, and astronauts to leave the Earth completely. Exploration was usually motivated by survival, profit, or politics, but also by our inveterate curiosity for the world around us, and our irresistible desire to test its frontiers. Those frontiers were very often blue. Explorers' journals contain descriptions of "misty blue islands" on horizons, "light-blue outlines" in the distance, mountains "feebly pencilled on the ethereal blue of heavens," and "regions far away hidden in a blue transparency of light vapors."[18] All of these blues evaporated as they were approached. But one of the first great adventurers stumbled on one that was ravishingly tangible.

In the summer of 1271, a Venetian teenager embarked on a journey that would last some twenty-four years and make him forever famous. Together with his father and uncle—who had made a similar trip before—Marco Polo boarded a small boat, sailed across the eastern Mediterranean to the Levant, traveled by camel through Persia, and from there journeyed northeast into the Hindu Kush. By the end of the year, the party had arrived in Badakhshan, now the border of northeastern Afghanistan and southeastern Tajikistan. Polo was astounded by what he found: a vast kingdom governed by the descendants of Alexander the Great, a range of exotic flora and fauna, and air "so pure and salubrious" that it felt medicinal. He wasn't enamored

of the region's weather—"it is a cold country," he grumbled—but such hardships were more than made up for by the beauty of its mountains. There, Polo learned that not far off his route was a group of ancient mines that contained a rock of astonishing beauty.[19]

Lapis lazuli is created by a violent geological process. It only occurs in areas where marble or limestone has been transformed by the extreme pressures and temperatures of intruding magma. These forces produce a cluster of minerals that form in lenses or veins around the area of contact, the most abundant being a blue crystal called lazurite. For many years, chemists believed lazurite's blueness was metallic in origin, derived from copper or iron oxide, but they now agree that it comes from a group of negatively charged radical sulfur ions that together absorb yellow-orange light and thus appear violet-blue.[20] Lapis lazuli's name derives from the Persian *lazward*, which denoted both the color of the stone and the area in which it was mined. The word, like the substance, first entered Europe at some point in the Middle Ages, and evolved into other words for blue, including *azur* (French), *azul* (Spanish and Portuguese), and *azzurro* (Italian).

By the time Polo arrived in Badakhshan, lapis lazuli had already been exported from the region for millennia, but to reach Europe required a journey no less remarkable than Polo's own. Mined lapis was loaded onto mules and transported along the Silk Road through Merv, west into the mountains of northern Persia, down into the Mesopotamian plains, and on to the ports of the Levant, where merchant mariners sailed it up the Adriatic to Venice, often concealing it in their personal effects to avoid import duties. Another route took it across land to the ports of the Black Sea, whence it sailed to Constantinople, and then around Greece to Italy. Both 4,000-mile voyages lasted months if not years, and involved a vast chain of traders, travelers, and sailors.[21] Distance was part of its allure: Europeans believed that the stone hailed from the edge of the world, if not the threshold of paradise.[22] In its raw state, the substance resembles a fragment of the firmament: the lazurite phosphoresces like a darkening sky, white calcite races across its surfaces like cirrocumulus clouds, and specks of golden pyrite sparkle like constellations (**Plate 26**).

Lapis lazuli was used (unsuccessfully) to heal warts, buboes, and ulcers; to manage menstruation and urinary tract infections; and to

treat fevers, cataracts, and depression.[23] It was also the sole source of an exceptional blue pigment—though extracting it was far from straightforward. In his *Craftsman's Handbook*, the fifteenth-century Florentine artist Cennino Cennini described a process so intricate that only the "dainty hands" of "pretty girls" could complete it. The convoluted recipe, possibly devised around 1200, involved grinding the stone into a powder, mixing it with resin, wax, gum, and linseed oil, kneading the dough for several days, submerging it in a lye solution, then working the substance until only its blue constituents saturated the liquid.[24] It was worth the effort: Cennini considered the pigment to be "illustrious, beautiful, and most perfect, beyond all other colors."[25] While most blue pigments were insipid, with unsatisfying green and gray tints, lapis blue was deep, rich, and resonant, with a sumptuous violet blush. The pigment was given the most evocative appellation in the history of color: *azzurro oltramarino*, from the Italian *oltremare*, meaning "from overseas."[26]

Most blue colorants needed to be imported. Indigo came from India, turquoise from Turkey, and Damascene blue from Damascus; even European azurite hailed from the inaccessible mountains that lay across the Alps and was often called "German blue."[27] All were therefore costly, but none was as expensive as ultramarine. In Renaissance Italy it cost between one and five florins per ounce, depending on its quality (a florin contained just over 3.5 grams of gold). In 1515, the Florentine artist Andrea del Sarto paid five florins for an ounce of high-quality ultramarine to use on a painting of the Madonna, equivalent to a month's salary for a minor civil servant, or five years' rent for a laborer living just outside the city.[28] The finest ultramarine cost up to a hundred times more than other pigments on the market, and even inferior grades were more expensive than the best blue alternatives. Many patrons nevertheless requested ultramarine for their pictures and willingly paid a surcharge for it. Others acquired it for themselves and dispensed it frugally: when Raphael's master Perugino was painting a fresco in a Tuscan convent, a penny-pinching prior offered him use of the institution's stock of ultramarine but closely monitored the artist as he used it. Irritated by such treatment, Perugino furtively deposited the excess pigment into a basin between brushstrokes, forcing his miserly patron to keep replacing it. When he was finished, Perugino returned the basin to the

prior: "Father, this is yours," he said. "Learn to trust honest men who never deceive those who trust in them, but know how to deceive, when they choose, suspicious men like you."[29]

If ultramarine's birthplace was Afghanistan, its spiritual home was Venice. A flourishing naval power with trading links to what Byron called the "exhaustless East," medieval Venice sparkled with exotic commodities.[30] It was in many ways a city-sized souk, more like the mercantile metropolises of Baghdad and Cairo than other cities in Europe.[31] Venice was the best place on the continent to buy Chinese silk, Egyptian cotton, Persian rugs, gold, frankincense, myrrh, caviar, ginger, pepper, cinnamon, cloves, nutmeg, and sugar, as well as a menagerie of exotic pets. The abundance was enough to send visitors into raptures. In the fifteenth century, the Milanese cleric Pietro Casola was astonished:

> So many cloths of every make—tapestry, brocades and hangings of every design, carpets of every sort, camlets of every color and texture, silks of every kind; and so many warehouses full of spices, groceries and drugs, and so much beautiful white wax! These things stupefy the beholder, and cannot be fully described to those who have not seen them. Though I wished to see everything, I saw only a part, and even that by forcing myself to see all I could.[32]

Venice, according to the diplomat Giovanni Botero, was nothing less than "a summary of the universe" because there was nothing in God's creation that couldn't be found there.[33] It was also the center of Europe's medieval pigment industry, and the birthplace of an entirely new color profession. Traditionally, artists purchased their paints from nonmedicinal apothecaries, who also sold paper, ink, candles, soap, string, spices, and sweets. That changed at the end of the fifteenth century, when the world's first "color shops" (*vendecolori*) opened around the Rialto, more than a century before anywhere else.[34]

Venice is an appropriate setting for a chromatic revolution. Floating in a nebulous body of water and doused in mists that ascend from the lagoon, the city is perpetually unmade and remade by color. Its buildings' flushed and crumbling hues are swallowed by the surrounding waterways and regurgitated as a kaleidoscope of reflections, reinventing them as an abstract pattern of ochres, umbers, vermilions,

and ceruleans. "No city built on land," one modern art historian has written, "can offer so brilliant and so strange an intermingling of the color of the sky and the color of the buildings on the surface of its thoroughfares."[35] To move through those thoroughfares is an intoxicating visual experience—now, as it was centuries ago. Could its fortunate residents have witnessed such eye-opening phenomena and remained immune to the charm of color? Could they have watched their city transform itself into countless chromatic images and not wanted to try it for themselves? They could not.

Venetian artists coveted color throughout the Middle Ages. They had inherited the craving from the Byzantine Empire, with which their city had long been associated. Many of Venice's medieval craftsmen originally came from the East, having mastered their trades in Constantinople and Damascus. By the time Marco Polo embarked on his travels in the thirteenth century, the city was already famed for its glass, enamel, and mosaics, all characterized by dazzling optical effects. When in the fifteenth century more restrained Renaissance tastes arrived from Tuscany, Venice's artists didn't abandon their old habits. They explored the Florentine principles of naturalism but combined them with the chromatic splendor to which they had grown accustomed. They continued to fill their pictures with exotic colors and Byzantine patterns. Not for nothing were the Venetians celebrated, and sometimes denigrated, for being both masters and servants of *colore*.

Of all Venice's color addicts, none was more incurable than Titian. Born some time between 1488 and 1490 in the small alpine village of Pieve di Cadore, 130 kilometers north of Venice, Titian grew up in a modest stone house that overlooked the spiky skyline of the Marmarole mountains. He would surely have noticed from his bedroom window how this jagged corner of the Dolomites receded in overlapping sheets of blue (it remains one of the best places in Italy to witness aerial perspective). He was, after all, already in love with color. According to one anecdote, the young Titian wandered into the pastures near his home one day and returned with a bouquet of flowers under his arm. He squeezed the colored juices from their petals and with them painted a vivid portrait of the Virgin on a wall in the street.[36] When he was nine (or ten, or perhaps twelve), his parents sent him to live with his uncle in Venice to train as an artist. After passing

through the workshops of several mentors (including probably Gentile Bellini, Giovanni Bellini, and Giorgione), he rapidly established himself as the city's preeminent painter.

Titian was, as a recent biographer has observed, "an explorer in paint."[37] He often dispensed with the tedious business of preparatory drawing, starting pictures with little sense of how they might look when finished, experimenting as he painted, changing his mind as he went, and devising compositions by trial and error. He used pigments generously, even recklessly. His early paintings are constructed from large fields of color, including white and crimson fabrics rich enough to make the mouth water (my undergraduate tutor likened them to strawberries and cream). Titian couldn't resist taking risks. At the bottom of one otherwise monochrome portrait he added a scarlet cuff so bright that it steals the thunder from its sitter; on the flesh of a large nude he deposited a blue blob of paint so incongruous that it looks like an accident. Titian continued to play with pigment throughout his long career. That much is clear from Marco Boschini's famous account of the octogenarian, which came directly from one of Titian's pupils:

> [Titian] prepared his canvas with a great deal of color that served as a bed or base for what he had to construct on it. I myself have seen the confident brush-strokes applying masses of color, sometimes a streak of pure red earth which served . . . for the mid-tones; other times with a stroke of lead white. Then with the same brush dipped in reds, black or yellow he would produce a highlight and with these principles of construction he would produce the outlines of a beautiful figure with four strokes of the brush. After he had finished this foundation, he would turn the paintings to the wall for up to several months without so much as looking at them. And when he felt the urge to go back to them, he would examine them closely, as though they were his mortal enemies, looking for the slightest defect . . . Gradually here and there he would cover these quintessences with living flesh, refining them through many trials, until they lacked only the capacity to breathe . . . The seasoning of the final touches [consisted in] going from place to place rubbing the highlights with his fingers, thereby blending them with the mid-tones and harmonizing one color with another. At other times,

with a stroke of his finger he would add a dark touch in a corner to give it emphasis, or apply a streak of red, like drops of blood, to enliven an area, and thus refined his living figures until they reached perfection. Palma told me for a fact that, for the finishing touches, Titian painted more with his fingers than his brush.[38]

It is a vivid description of a great master at work. And though we shouldn't trust the passage too wholeheartedly, Boschini brilliantly conveys Titian's relish in his pigments. Color was his art's genetic code, and everything in his oeuvre was spun from it.

Let us turn to one of Titian's most famous works. *Bacchus and Ariadne* was commissioned in 1520 by Alfonso d'Este, the Duke of Ferrara, to accompany other exotic, erotic mythologies in his private study. It captures the moment Bacchus and his ragbag of revelers first set eyes on a heartbroken Ariadne. She has just been abandoned by her rakish suitor Theseus, who on the left of the picture can just be seen sailing across the horizon without her. Bacchus falls instantly in love with the young Cretan princess, marries her on the spot, and transforms her into a deity like himself (**Plate 29**). Titian appears to have conceived this complex composition on the hoof: infrared analysis has failed to detect a single significant underdrawing, which might explain why he spent a good part of two frustrating years reworking the figure of Ariadne alone. By 1523, Alfonso's patience was exhausted. The picture was rolled up, stuffed into a tube, sailed to Ferrara, and carried eight miles to the duke's castle, where Titian was forced to complete it in his patron's company.[39]

Bacchus and Ariadne didn't age well. By the twentieth century it was encrusted with amber varnish that grew darker with every year. In the late 1960s, the National Gallery decided to restore it. Many specialists, including the art historians Ernst Gombrich and Erwin Panofsky, opposed the cleaning, but I suspect Titian would almost have emphatically supported it.[40] He went to great lengths to intensify his colors, purchasing Venice's most expensive pigments (including azurite, malachite, realgar, orpiment, crimson, and vermilion) and deploying them in large quantities at maximum purity. He applied them in semi-translucent glazes, dark over light, to make them look backlit, and avoided mixing his hues with anything other than lead white, for fear

that other combinations would subdue them. It is impossible to stand in front of the cleaned painting and not be thrilled: Ariadne's scarlet sash is so bright that the eye struggles to adjust to it; Bacchus' crimson cape crackles with energy; and the lead-tin yellow fabric in the foreground is as rich and velvety as whipped butter. It is by any measure a breathtaking achievement. Colors can be as unruly as children, and in most artists' hands this canvas would have degenerated into chaos. But Titian somehow brought his cacophony into harmony. Not for nothing has he been called "the prince of colorists."[41]

The prince of *Bacchus and Ariadne*'s colors is ultramarine, which is among the purest examples of the pigment in the history of art. It covers nearly a third of the canvas and probably cost more than all the other pigments put together.[42] Titian used it on Ariadne's robe, in the dress of the cymbal-brandishing bacchante, and in the outrageously eventful sky. But the painting's most revealing blue is also the most easily overlooked: it resides in the mountainous background behind Bacchus. Without ever having heard of Rayleigh scattering, Titian was representing aerial perspective—though amplifying its effects dramatically. The mountains are not hazy cerulean but resonant ultramarine. Centuries later, John Ruskin was fascinated by this unnaturalistic passage of painting. "It is difficult to imagine anything more magnificently impossible than the blue of the distant landscape," he wrote. "It would be impossible to tell the mountains (intended to be ten miles off) from the robe of Ariadne close to the spectator."[43] Why did Titian exaggerate the blueness of distance in this way? Perhaps he was creating pictorial balance. Perhaps he was being exuberant. Either way, by using the same pigment for both foreground and background, he was lassoing the distance and hauling the horizon within reach.

L'AZUR! L'AZUR! L'AZUR! L'AZUR!

It was late at night, and the German town of Eisenach was doused in deep-blue darkness. Wind whistled past walls and windows, and moonlight slithered through the streets. Most of the town's residents were fast asleep, but in one house a young poet lay restless in bed, kept awake by an overwhelming obsession:

I yearn to get a glimpse of the blue flower. It is perpetually in my mind, and I can write or think of nothing else. I have never felt like this before; it seems as if I had a dream just then, or as if slumber had carried me into another world. For in the world where I had always lived, who ever bothered about flowers?[44]

At last, Heinrich fell asleep and into a dream. He traveled through a forest, a rocky gorge, a passageway cut through cliffs, and a lake quivering with colors, until eventually he alighted at a sweet-smelling meadow beneath an indigo sky. It was here that Heinrich first caught sight of the blue flower for which he had longed. It stood, pale and delicate, in the long grass. As he approached it, a delicate female face appeared in its corolla. But before he could grasp it, he was woken by his mother.

So began the bildungsroman *Heinrich von Ofterdingen*, composed in 1801 by the German writer Friedrich von Hardenberg (better known by his pseudonym, Novalis), which went on to become a defining text of Romanticism. In one respect its hero's phantasmagorical quest had much in common with the great voyages of Polo and others before him; like them, Heinrich coveted the things and places that lay beyond the horizon. But the territory he was exploring was *internal*. Novalis believed the world's most exotic realms were produced by the imagination, and the ultimate journey was one of self-discovery. "We dream of travel through the universe," he wrote, "but isn't the universe within us? We don't know the depths of our minds—the secret path leads inward."[45]

Novalis' own path was cut short when he died of tuberculosis, aged twenty-nine, before he could finish his novel. As a consequence, *Heinrich von Ofterdingen*'s first part, "Die Ewartung" (The Expectation), wasn't resolved by its second part, "Die Erfüllung" (The Fulfillment), and its hero never got his hands on the enigmatic blue flower (*blaue Blume*). Perhaps this is as it should be. Blue flowers are rare in nature because very few genuine blue pigments are available to them. Those that do exist use reddish-purple anthocyanin pigments before mixing them with ions, molecules, or other pigments, and perhaps subjecting them to pH shifts, in order to produce the hue. It is a complicated and biologically expensive process that few plants have evolved to undertake.[46] Scientists have spent decades trying to cultivate blue roses and tulips

but have consistently failed to overcome nature's recalcitrance.[47] *Heinrich von Ofterdingen* is a novel about longing, and longing ceases to be such when it is satisfied. No hue embodies this bittersweet sensation quite like blue.

Why is blue so infuriatingly unattainable? It is, as we've established, somewhat scarce in nature, and even then prefers to keep its distance. But there is another reason—one much closer to home. Human color vision is produced by three types of cone cells, each particularly receptive to long, medium, and short wavelengths of visible light. Shortwave cones, which are often called "blue" cones even though they are most sensitive to violet, represent only 5 percent of all color receptors in the retina, and unlike their counterparts don't appear in the very center of the fovea, where our most precise vision is created, but around its edges. This often makes blue objects appear hazy and indistinct and even leads to a blue blind spot at the center of our visual field that is only rectified by neural filling-in processes.[48] In one respect, then, Hugo Magnus and his disciples were right: blue is harder for us to see than other hues (though not so hard that ancient societies couldn't perceive it). Blue tends to elude perception; like Heinrich's flower, it dissolves when we look at it.

The one condition in which our eyes are more sensitive to blue light is semidarkness, when rod cells take over from cone cells and scotopic vision replaces photopic vision. Though rod cells are unable to distinguish color, they are unusually sensitive to blue light. Blue objects therefore appear comparatively bright in darker conditions. This phenomenon was first noticed by the Czech physiologist Jan Evangelista Purkinje. Sitting in his garden one night in 1819, he realized that his delphiniums were more visible than his poppies, when in daylight the opposite was the case.[49] The Purkinje Effect, as it is now known, is the reason why most countries' emergency vehicles are fitted with blue flashing lights, and why filmmakers simulate nocturnal scenes actually filmed during daytime by using lavender-blue filters.[50] The realities of human vision are therefore responsible, at least in part, for creating some of our most resonant cultural assumptions about blue.

Novalis wasn't the first to connect the unattainable hue with the longings of the Romantic imagination. Thirty years earlier, Goethe's

debut novel, *The Sorrows of Young Werther* (1774), had done something similar. A semiautobiographical parable of self-destructive desire, it has been called Europe's "first psychological novel."[51] Through epistolary fragments it tells the story of its hero's doomed love for a woman called Charlotte. Werther is wearing a blue coat when he first meets her. When he learns that she is engaged to another man, the garment becomes a symbol of unrequited desire. Werther wears it every day for four months until it is threadbare:

> It cost me much to part with the blue coat which I wore the first time I danced with Charlotte. But I could not possibly wear it any longer. But I have ordered a new one, precisely similar, even to the collar and sleeves, as well as a new waistcoat and pantaloons. But it does not produce the same effect upon me. I know not how it is, but I hope in time I shall like it better.[52]

At the novel's melodramatic conclusion Werther dons the original blue coat for a final time, writes a valedictory note to Charlotte, and at the stroke of midnight shoots himself dead.

It was a literary sensation. After publication in Germany, *The Sorrows of Young Werther* was translated into French (1775), English (1779), Italian (1781), and Russian (1788) and became a bestseller across the continent (Napoleon claimed to have read it seven times). In the 1770s and '80s thousands of impressionable young men around Europe started wearing blue frock coats—a fashion craze perhaps only surpassed by the impact of James Dean's blue jeans in *Rebel Without a Cause*—and some even followed Werther to the grave.[53] The spate of suicides was sufficiently concerning that a number of German cities outlawed it, and in later editions Goethe was forced to add a line spoken by Werther's ghost: "Be a man, and do not follow me."[54]

Werther's bittersweet frock coat and Heinrich's impossible flower helped transform blue into the quintessential Romantic color. The era's poets were determined not to be left behind. Poetry had been getting bluer since the late Middle Ages. In a painstaking analysis of major English writers' lexicons in 1898, Alice Edwards Pratt found that blue's prevalence rose tenfold between Chaucer and Keats. She also discovered that by the early nineteenth century—the heroic

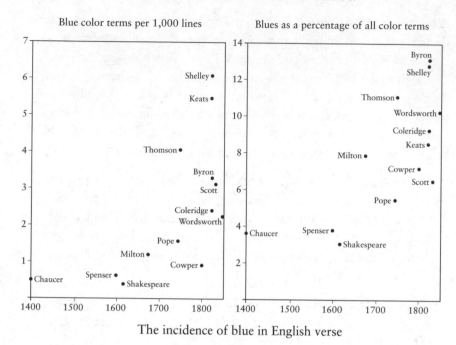

The incidence of blue in English verse

period of English Romantic poetry—blue's popularity increased relative to other colors: in Shelley and Byron it accounted for 12 or 13 percent of all color references—roughly four times higher than in Shakespeare and Spenser.[55]

Most of these Romantic blues invoked high, deep, or dark natural phenomena: Coleridge, Wordsworth, Byron, Shelley, and Keats repeatedly linked skies ("heaven's blue firmament"), bodies of water ("blue and moveless depth"), the atmosphere ("ethereal blue"), and night ("dark, silent blue, with all its diamonds trembling through and through") to it. Distances received the same treatment. Shelley wrote of "blue mountains, shapes which seem like wrecks of childhood's sunny dream' on the horizon. During a visit to Loch Lomond in the summer of 1818, Keats, so enthralled by the area's distant blue hills, even made a sketch of them in a letter to his brother.[56] Keats' closer blues were similarly evasive. Shortly after returning from Scotland he encountered J. H. Reynolds' sonnet praising dark eyes and rebutted it with a paean to blue eyes.

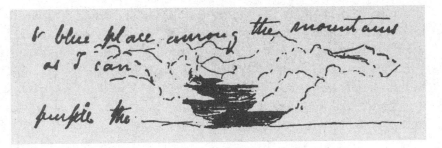

Keats' sketch of the hills around Loch Lomond

BLUE! 'Tis the life of heaven,—the domain
Of Cynthia,—the wide palace of the sun, –
The tent of Hesperus, and all his train, –
The bosom of clouds, gold, gray, and dun.
Blue! 'Tis the life of waters—ocean
And all its vassal streams: pools numberless
May rage, and foam, and fret, but never can
Subside, if not to dark-blue nativeness.
Blue! Gentle cousin of the forest-green,
Married to green in all the sweetest flowers, –
Forget-me-not,—the blue-bell,—and, that queen
Of secrecy, the violet: what strange powers
Hast thou, as a mere shadow! But how great,
When in an Eye thou art alive with fate![57]

Keats' sonnet is not so much about a pair of irises as their elusive color. The poem turns on the abiding paradox of blue—that it is everywhere and nowhere. If it fills skies, oceans, and forests, it does so only indirectly—as a spouse, a cousin, and ultimately a "mere shadow." Keats seems to have suspected, quite correctly, that eyes don't actually possess the color. Blue eyes don't contain a scintilla of blue pigment; the color is an optical illusion, produced by the same scattering effects that tint the sky and horizon.

By the middle of the nineteenth century blue's oscillation between presence and absence made it the symbol of a generation's futile strivings for the ideal. It found its most memorable expression in Stéphane Mallarmé's 1864 poem "L'Azur," which invokes the blueness of the

sky as an emblem of eternal and transcendental perfection. The word lends itself to such portentous connotations: its first two letters, "az," are the all-encompassing bookends of the alphabet, while its second two, "ur," are the German word for "original."[58] But unlike the blue faithful before him, Mallarmé is not captivated by the beauty above; he is tormented by it and berates it with impotent frustration. How can anything he writes compare to the unattainable ideal?

> The eternal Azure's serene irony
> Burdens, with the indolent grace of flowers,
> The impotent poet who damns his genius
> Across a sterile desert of sorrows.

Mallarmé tries to conquer his nemesis by smothering it with fog, smoke, and darkness. But he does not succeed.

> In vain! The Azure triumphs, and I can hear it sing
> In the bells. My soul, it becomes voice,
> The better to scare us with its mean success,
> And from the living metal bluely rings the angelus!

The young poet signs off with a shriek of despair. "It haunts me. Azure! Azure! Azure! Azure!"[59]

Not everyone was quite so tormented. Wassily Kandinsky, born two years after Mallarmé's poem was written, was convinced of blue's immense spiritual potential. As a young boy growing up in Russia, Kandinsky was so engrossed by his "inner life" that he sometimes failed to notice the world around him.[60] And though by his late twenties he had already built the foundations of an impressive academic career in law and economics in Moscow, he abandoned it in 1896 in favor of art school in Munich. Kandinsky was convinced that art could transport him "beyond time and space"—an ambition he realized in an important early painting.[61] *The Blue Rider* (1903) depicts a blue-cloaked horseman galloping across a verdant meadow toward a deep-blue horizon. The rider might be Kandinsky, the landscape a metaphor for his emotions. It is a crude, even *jejune*, picture—it's hard to believe it was made by a thirty-seven-year-old intellectual—but by using the same shade of ultramarine on both the rider's cloak and the

horizon, Kandinsky—like Titian before him—connects explorer and explored, origin and destination: if blue is the color of distances, those distances are created within us.

Kandinsky wasn't monogamously devoted to blue. His earliest chromatic memories, from the age of three, were of "light juicy green, white, carmine red, black, and yellow ochre."[62] He was fascinated by the entire spectrum and believed that color, like music, was a conduit between external and internal, physical and psychological, worlds. In his treatise *On the Spiritual in Art*, from 1911, he wrote that:

> Color is a means of exerting a direct influence upon the soul. Color is the keyboard. The eye is the hammer. The soul is the piano, with its many strings. The artist is the hand that purposefully sets the soul vibrating by means of this or that key.[63]

No color granted more intimate access to the soul than blue. In a Goethe-inspired diagram comparing blue with its opposite, yellow, Kandinsky argued that as the latter advances toward the spectator, the former recedes "like a snail disappearing into its shell." While yellow is external and "bodily," blue is internal and "spiritual."[64] He continues, in an extraordinarily vivid passage:

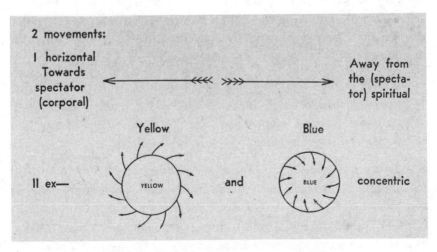

Kandinsky's comparison of blue and yellow

The inclination of blue toward depth is so great that it becomes more intense the darker the tone, and has a more characteristic inner effect. The deeper the blue becomes, the more strongly it calls man toward the infinite, awakening in him a desire for the pure and, finally, for the supernatural. It is the color of the heavens, the same color we picture to ourselves when we hear the sound of the word "heaven." Blue is the typically heavenly color. Blue unfolds in its lowest depths the element of tranquility. As it deepens toward black, it assumes overtones of a superhuman sorrow. It becomes like an infinite self-absorption into that profound state of seriousness which has, and can have, no end. As it tends toward the bright, to which blue is, however, less suited, it takes on a more indifferent character and appears to the spectator remote and impersonal, like the high, pale-blue sky. The brighter it becomes, the more it loses in sound, until it turns into silent stillness and becomes white. Represented in musical terms, light blue resembles the flute, dark blue the 'cello, darker still the wonderful sounds of the double bass; while in a deep, solemn form the sound of blue can be compared to that of the deep notes of the organ.[65]

That same year Kandinsky formed an artistic group and named it in the color's honor. *Der Blaue Reiter* (The Blue Rider) consisted of a cluster of young Munich artists (including Franz Marc, Paul Klee, August Macke, and Kandinsky's future partner Gabriele Münter) committed to expressing their inner worlds in paint. Kandinsky later claimed that the group's name had resulted from a casual conversation with Franz Marc in Bavaria's Blue Mountains:

> We made up the name "The Blue Rider" around a coffee table in the garden at Sindelsdorf. Both of us loved blue, Marc horses, I riders. So the name more or less invented itself. And the fantastic coffee of Marc's wife Maria tasted even better.[66]

Kandinsky was being disingenuous—he understood blue's history as well as anyone. He had read Goethe and Novalis. He had marveled at the ultramarines of the Renaissance. He knew of blue's utopian connotations, and hoped it would transport an increasingly materialistic society into a more spiritual future.

In 1911 he also painted *Improvisation 19*, sometimes known as *Blue Sound* (**Plate 28**). To look at it is to feel trapped inside a rainbow. The

canvas is lavished with swirling hues of lollypop orange, fir-tree green, and a blast of squashed-raspberry crimson, but it is dominated by an agitated blue cloud that Kandinsky clearly took great efforts to create. He began by charging his brush with a dark, dry, and slightly green Prussian-blue paint and applied it near the bottom-left. He worked his way up and right toward the center. As the paint left the brush, the blue became thin and scratchy. But he kept going, enjoying the way the pigment scattered unpredictably across the canvas weave. He then mixed the remaining blue with a small amount of the crimson above and painted an ethereal fringe of violet around the left of the cloud. When virtually nothing was left, he loaded his brush with a rich cerulean paint and applied it thicker, wetter, and lighter over the first blue, in violent vertical and diagonal zigzags. He then returned to his palette, mixed this second blue with white, and smeared it over both previous blues near the middle of the image. By combining pigments and techniques, Kandinsky produced a whole range of blues—wet and dry, thin and thick, light and dark, greenish and reddish—in a dizzying thatch of strokes. It was as close to a "blue sound" as Kandinsky could create in physical form.

After this carnival of color had dried, Kandinsky drew, in wet black paint, the outline of a narrative on top of it. Two groups of figures stand either side of the blue cloud. On the left, people appear to be queuing for an important event; one of them even seems to be pointing toward it. On the right, others—presumably having experienced the event—file off out of the canvas. The nature of the occasion is unknown, but its effect on its participants is clear. The first group is short, disorganized, and earth-colored, the second is tall and disciplined, shown in sacred blues and violets and surmounted by what could be a halo. The painting seems to depict a transition from material to spiritual, from natural to supernatural, from Earth to Heaven. We are looking at a rite of passage for humanity itself—a transfiguration brought about by blue.

SPACE MEN

In the beginning, the sky and earth were one. That, at least, is what many of the world's ancient myths claimed. For the Maori, the sky father (Rangi) and earth mother (Papa) began life locked in an erotic

embrace; for the Japanese, they were mixed together within the shell of a single egg; and according to many communities in southeast Asia the sky was originally so low that women bumped up against it when they raised their pestles to grind rice. What followed in all of those stories was a cosmic separation. Rangi and Papa were torn apart by their resentful children; the Japanese egg curdled into a celestial white and a terrestrial yolk; and the frustrated rice-eaters of Asia pushed the sky high above them so it would no longer get in their way. One world thus became two: sky and Earth were forever divided, their frontiers demarcated by an impermeable horizon. From that point on, the earth's inhabitants saw the sky as a realm apart.[67]

Unlike the rumpled quilt of earth colors that lies beneath the horizon, a clear sky is an intense, uninterrupted, flawlessly modulated blue. It is perhaps the only color in nature that seems liberated from objecthood. When we look up at a cloudless sky, we are seeing no *thing* but blue. In the late 1780s, the Swiss adventurer Horace Bénédict de Saussure fashioned a device to measure this special color (**Plate 27**). He carefully painted a series of papers in many shades of blue, arranged them in a scale running from white to black, glued them to a piece of cardboard, and gave each a number or degree. He then held his "cyanometer" to the sky and matched up the hues. Saussure did this repeatedly, even obsessively. He measured the sky throughout the day and compared it in different places, finding that higher altitudes produced deeper blues. He was so determined to test the color's limits that in August 1787 he climbed to the summit of Mont Blanc—at 4,800 meters the highest point in western Europe—and recorded a blue so dark that it was almost black.[68]

Saussure's climb coincided with a new era of vertical exploration that pierced the ancient barrier between earth and sky. The first manned balloon flights had taken place across the Alps in France just four years before his ascent. Though they initially achieved only modest altitudes, by the early nineteenth century they had taken humans higher than Saussure. By the beginning of the twentieth century, they had exceeded the Earth's tallest peaks. And by the middle of the century, they had carried their passengers to the upper limits of the sky.

On the evening of August 18, 1957, a thirty-five-year-old scientist squeezed himself into a small capsule and had the door sealed behind

him. David Simons was loaded onto the back of a flatbed truck and driven 150 miles north to a remote iron pit in Minnesota. He was part of the US Air Force's "Project Manhigh," which sent pilots up in balloons to test the physical and psychological effects of extreme altitude.[69] At 8 a.m. the following day, Simons' helium-filled balloon was cut loose from the Earth. Two hours later, he reached an altitude of 31,212 meters—higher than any human had gone in a balloon. From his position in the stratosphere, above 99 percent of the Earth's atmosphere, he could see half a million square miles beneath him. He was staggered by the view, but above all overwhelmed by the color.

> The Earth's familiar blue atmosphere was easily discernible around the entire horizon . . . beginning at the horizon with a washed out whiteness and gradually changing to pale blue that grew ever deeper until it merged with the intensely deep but dark bluish purple of space . . . With a finely calculated color chart I tried to match the colors of the atmosphere as seen from its outer rim. The color samples . . . included every perceived shade of color man can reproduce in pigment. But not one of them could match the strange blue-purple color my eyes beheld . . . The sky was so heavily saturated with this blue-purple color that it was inescapable, yet its intensity was so low that it was hard to comprehend, like a musical note which is beautifully vibrant but so high that it lies almost beyond the ear's ability to hear, leaving you certain of its brilliance but unsure whether you actually heard it or dreamed of its beauty.[70]

Hovering high above the Earth, on the threshold of space itself, Simons achieved what for many had been a fantasy. He had reached the blue beyond—and been surrounded by color triumphant.

Simons had spent more than forty-three hours in his aluminum cell when he landed in the soft soil of South Dakota. News of his successful mission was received with excitement, and for a brief period he was a minor American celebrity.[71] But Simons' historic feat would soon be eclipsed. In 1958—the year of Dean Martin's cover of "Volare," a song about an ecstatic lover who paints his body blue then ascends into the sky—President Eisenhower formed the National Aeronautics and Space Administration.[72] The decision was primarily a response to the Soviet Union's rapidly developing space program

but was also surely shaped by the old human obsession with the other side of the horizon. As an official White House pamphlet put it (in words later popularized by *Star Trek*):

> The first of these factors is the compelling urge of man to explore and to discover, the thrust of curiosity that leads men to try to go where no one has gone before. Most of the surface of the earth has now been explored and men now turn to the exploration of outer space as their next objective.[73]

A decade before NASA had been established, before the Soviet Union had built its first Sputnik, and before even David Simons had ascended into the stratosphere, an idealistic French teenager initiated his own space program. One day in 1946 or 1947, Yves Klein stretched out on the beach at Nice, raised his right hand into the air, and signed his nine-letter name across the firmament. It was above all a gesture of ownership: Klein was so possessive of the sky that he resented even the birds that flew across it.[74] Klein, like Kandinsky, was searching for transcendence, experimenting with Rosicrucianism, Zen, and judo. In the early 1950s, he funneled his prodigious energies toward art and concluded that color was the answer to his questions.[75] "Colors alone inhabit space," he wrote, "whereas line only travels through it and furrows it. The line travels through infinity, where color is infinity. Through color, I experience total identification with space; I am truly free."[76] Klein made a series of monochrome canvases in yellow, pink, scarlet, burgundy, orange, green, black, and white, but then recalled the sky into which he had stared as a teenager. By the end of 1954, he realized that only one color could satisfy his agoraphilia:

> Blue has no dimensions, it is beyond dimensions, whereas the other colors are not . . . All colors arouse specific associative ideas, psychologically, material or tangible, while blue suggests at most the sea and sky, and they, after all, are in actual, visible nature, what is most abstract.[77]

Klein felt that none of art's existing blues truly captured the dematerializing effects of space. The problem wasn't so much the pigments as the mediums that bound them, which invariably weakened the colors they contained. To develop a blue that satisfied his imagination, Klein enlisted the assistance of the celebrated Parisian color

merchant Édouard Adam, who had supplied paint to many modern masters, including Picasso, Braque, and Matisse. After more than a year of work, Adam came across a synthetic resin called *Rhodopas M*, normally used in the production of glue, which possessed a refractive index low enough to bind pigments without compromising their luminosity. When he mixed the medium with ultramarine, Klein was so impressed with the results that he trademarked the discovery. His patent for "International Klein Blue" (IKB) reads as follows:

> International Klein Blue has been perfected by Yves Klein le monochrome in the course of the years 1954–55–56–57–58. The current chemical formula is exactly:
> FIXATIVE MEDIUM of I.K.B.
> 1.2 kilos Rhodopas (paste product)
> M A (Rhône Poulenc) (vinyl chloride)
> 2.2 kilos ethyl alcohol. 95% industrial, denatured.
> 6 kilos Ethyl acetate.
> A total of 4 kilos.
> Mix cold while energetically agitating and never heat uncovered!
> Then, mix cold the pure ultramarine blue 1311 in powder with the fixative medium . . . [78]

Klein premiered the new paint in January 1957 at his exhibition "Monochrome Proposition: Blue Period' in Milan's Galleria Apollinaire. The show included eleven 78×56 cm paintings in nothing but IKB. Klein used a number of techniques to amplify the power of his color: he primed the linen canvases with a milk protein called casein, applied the paint with a lambskin roller to ensure a consistent finish, and then hung the paintings 20 cm away from the walls on brackets. The results were—and are—breathtaking. By transforming a color of space and depth into one of mass and surface, an IKB monochrome unsettles the retina. Suspended in the gap between wall and viewer, the canvas appears to advance, retreat and advance again, while its immaculate facture invites but confounds close inspection (**Plate 30**). This relentless optical vibration can induce a kind of out-of-body experience, leading observers to feel as untethered as the artworks they scrutinize. This is surely why Klein called his blue monochromes "open windows to freedom."[79]

Klein went on to liberate his pigment from the canvas. In subsequent exhibitions he applied IKB to screens, sponges, tapestries, reliefs, and even naked bodies of models. This was only the beginning of his so-called blue revolution.[80] In the late 1950s, Klein wrote letters to the United Nations, requesting permission to dye an entire lake in IKB and rename it "The Blue Sea," and to the International Atomic Energy Agency (copying in the Dalai Lama, Pope Pius XII, and Bertrand Russell), proposing that future atomic weapons produce IKB-tinted explosions.[81] In May 1957, just three months before David Simons ascended into the air above Minnesota, Klein released 1,001 helium-filled blue balloons into the night sky above Saint-Germain-des-Prés, inspiring hundreds of Parisians to look upward. Its real audience, however, was its creator—the twenty-nine-year-old teenager who still longed to go into space.

Three years later, Klein made his dream a reality. On October 19, 1960, he drove to an unexciting suburb of Paris, climbed onto the roof of 5 rue Gentil-Bernard, and jumped off. A photograph of the incident was published the following month, under the title *Un Homme dans l'espace*: a man in space (**Plate 31**). Though his position looks precarious, even fatal, Klein had in reality been caught by ten friends with a tarpaulin, who had been spliced out of the image before publication. But his picture isn't about landing; it is about liftoff. It captures Klein, his eyes trained above him, achieving his life's goal of conquering the blue empyrean. The photograph, *Leap into the Void*, was also a twentieth-century homage to Icarus, the background cyclist a nod to the uninterested men in Brueghel's famous *Landscape with the Fall of Icarus* (c. 1558).[82] Like Icarus, Klein crashed to a premature end. Eighteen months after leaping into the void, he suffered a heart attack. He was dead at the age of thirty-four.

Yves Klein is famous today for his blue, but he would probably most want to be thought of as the first man in space.[83] He wasn't, of course. On April 12, 1961, six months after Klein's audacious leap, Yury Gagarin became the first human to escape the Earth's atmosphere and complete a full orbit of the planet. Klein pored over reports of Gagarin's historic achievement, feeling a special bond with his Soviet counterpart (who would also die at thirty-four).[84] Gagarin's flight marked the real beginning of another golden age in human

exploration. In the following decade missions took cosmonauts and astronauts into undiscovered territory. As the public gazed up at the rockets that hurtled into the firmament, it seemed that other worlds had finally come within reach. It was ironic, then, that arguably the greatest discovery of the space race was the Earth itself.

What color is our planet? For centuries most people presumed, not illogically, that it was a tapestry of leaf-greens, sand-yellows, earth-browns, sea-blues, and snow-whites. This was how cartographers had traditionally depicted it, and it was what aviators saw when they looked down from their aircraft.[85] But the space explorers of the 1960s noticed these colors were overwhelmed by another hue. "The Earth," Gagarin told mission control from *Vostok 1*, "has a very characteristic and very beautiful blue halo."[86] Shortly after landing, journalists asked him to describe the planet again. "Bluish, like a big ball," he responded, smiling. "A wonderful sight!"[87] Gagarin's successors made similar observations. Gherman Titov and Alexei Leonov both called the Earth *goluboi* (голубой)—sky blue.[88] When Pete Conrad embarked on a space walk from *Gemini 11* in September 1966, he too was struck by the intensity of the color. "I'll tell you one thing," he informed Houston. "It really is blue. The water really stands out, and everything is blue."[89]

In 1965 and 1966, these personal revelations became public when the first color photographs from space appeared on the pages of *Life*, *Time*, and *National Geographic* magazines. Readers doubtless focused on the white-suited men in the foregrounds, but they couldn't fail to be struck by the blue sphere floating behind them. This wasn't how the Earth was supposed to look. Where were the dark-green forests, pale-green prairies, and ochre deserts? Everyone understood that the planet's surface was dominated by water, but that didn't explain why the land was tinted blue. Nor did it account for the sapphire nimbus that surrounded the globe like a glimmering gas flame. These colors were in fact the products of the same Rayleigh scattering that on Earth made the sky and horizon appear blue; the planet's atmosphere scattered blue light in all directions, not just downward.

Two years later, NASA was preparing its most ambitious mission to date. It planned to send a three-man crew—Commander Frank Borman, Command Module Pilot James Lovell, and Lunar Module

Pilot William Anders—all the way to the Moon, making them the first humans to completely sever their bonds with the Earth. At 7:51 in the morning on December 21, 1968, the men were propelled into the air by the most powerful rocket ever built. They shot upward, through azure, cerulean, royal blue, ultramarine, midnight blue, and into the blackness of space. Within eleven minutes *Apollo 8* had left the Earth's atmosphere; after sixty-nine hours it had traveled a quarter of a million miles to the Moon.[90] As the crew orbited their destination, they studied its surface, photographing possible landing sites for future missions. But when they emerged from the dark side of the Moon on their fourth orbit, Frank Borman saw something:

> I happened to glance out of one of the still-clear windows just at the moment the Earth appeared over the lunar horizon. It was the most beautiful, heart-catching sight of my life, one that sent a torrent of nostalgia, of sheer homesickness, surging through me. It was the only thing in space that had any color to it. Everything was either black or white, but not the Earth.[91]

He picked up a 70 mm Hasselblad camera that had been specially modified for the mission and took a black-and-white photograph of the view. Bill Anders initially berated Borman for his indulgence but then he too looked out of the window. He grabbed the camera and demanded some color film. As Jim Lovell searched the cabin, Anders barked: "Hurry. Quick." "Hurry up!" "Anything, quick!" Eventually, Lovell handed his colleague a roll of SO-368 Ektachrome color film, but by the time it was loaded the shot had disappeared. Lovell then spotted the Earth from another window. According to the official mission transcripts, another argument ensued.

> LOVELL: Bill, I got it framed; it's very clear right here. You got it?
> ANDERS: Yes.
> BORMAN: Well, take several of the–
> LOVELL: Take several of them! Here, give it to me.
> ANDERS: Wait a minute, let's get the right setting. Here now, just calm down.
> BORMAN: Calm down, Lovell.
> LOVELL: Well, I got it ri—oh, that's a beautiful shot.[92]

In that handful of clumsy seconds, Bill Anders took several photographs at a variety of f-stops. One of them became one of the most famous images of the century.[93]

Earthrise shows our world from a distance of 250,000 miles (**Plate 32**). The planet, a third of which is shrouded in shadow, ascends from the gray lunar horizon into the void of space. Amid the monochrome cosmos around it, the Earth is a radiant droplet of color, a symphony of blue seas and white clouds, like a polished sphere of lapis lazuli. Never before had the planet looked so small and fragile. Never before had it been shown, in full color, from the perspective of another astronomical body. Like all great images, *Earthrise* changed its viewers' perspectives. The photograph decentered and diminished the Earth and so humbled its inhabitants. It portrayed a world without borders, nations, and ideologies, which some interpreted as a vision of a more united future.[94] When *Life* reproduced *Earthrise* on January 10, 1969, (in an issue apparently read by a quarter of all Americans), it also published a poem by the US Poet Laureate James Dickey, which ends:

> And behold
> The blue planet steeped in its dream
> Of reality, its calculated vision shaking with
> The only love.

The Earth had been christened a "blue planet."[95]

For many observers, *Apollo 8* was the climax of an age of exploration that had started centuries earlier. In just six days Borman, Lovell, and Anders had traveled forty times farther than Marco Polo, transcending the obdurate planetary limits that had contained even their most adventurous predecessors. "The boundless frontier has been opened," exclaimed the *Evening Star*. "Man's horizon now reaches to infinity."[96] *Apollo 8* had blasted humans off the Earth and delivered them to the threshold of another world. But as well as looking forward to the new horizon, they looked backward to the old. Two decades later, Bill Anders recalled the mission:

> We'd spent all our time on Earth training about how to study the moon,
> how to go to the moon . . . And yet when I looked up and saw the Earth
> coming up on this very stark, beat up lunar horizon, an Earth that was

the only color that we could see, a very fragile looking Earth, a very delicate looking Earth, I was immediately almost overcome by the thought that here we came all this way to see the moon, and yet the most significant thing we're seeing is our own home planet, the Earth.[97]

For most of history, blue was the quintessential color of other worlds: distant mountains, unfathomable oceans, unreachable skies, the uncharted territory of the soul. But when we finally escaped our world and voyaged beyond its horizons, we discovered that all along blue was the color of home.

5
White
Poisonous Purity

> *But not yet have we solved the incantation of this whiteness,*
> *and learned why it appeals with such power to the soul; and*
> *more strange and far more portentous—why as we have seen,*
> *it is at once the most meaning symbol of spiritual things, nay,*
> *the very veil of the Christian's Deity; and yet should be as it is,*
> *the intensifying agent in things the most appalling to*
> *mankind.*
>
> Herman Melville, Moby-Dick (1851)[1]

A woman wakes up one morning in a cocoon of white sheets. She climbs out of bed, wraps herself in a white dressing gown, and walks to the bathroom. The walls are coated in white tiles that shimmer in the early light. She sits on her white porcelain toilet, expels the waste from her body, wipes herself with a roll of white paper, and washes her hands with a bar of white soap. She steps into the shower, squeezes a blob of white liquid onto her palm, and massages it into her hair. After rinsing away the white foam she dries herself with a white towel, smears some white paste onto her toothbrush and brushes her teeth, then moisturizes with another globule of white cream. Back in her bedroom, she gets dressed: white underpants, white bra, a crisp white shirt. She ambles into her kitchen for breakfast, scoops up her cereal from a white bowl, wipes her mouth with a square of white kitchen paper, and leaves for work.

I am exaggerating—but only a little. Many morning *levées* are almost as monochrome as the one I've described. This isn't an accident. We

deliberately surround ourselves with whiteness. We coat our homes in white or off-white paint, fill them with white linens and crockery, and even grant the color intimate access to our bodies—we rub it into our skin, scrub it into our teeth, and when we feel unwell we swallow white tablets in the hope they'll make us better. That is because, in one sense, we believe in white. We believe that this most pure and perfect color will eradicate the world's imperfections, remove even the most stubborn stains, and make us immaculate again.

Our demand for white is so widespread, and so persistent, that some shops exist simply to supply it. The White Company, which specializes in muted domestic products for middle-class consumers, describes access to the color as a human right. "Whoever we are,

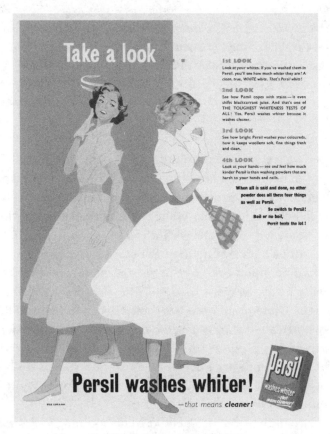

Persil advert from the 1950s

whatever our style, wherever we are from—there's a place in everyone's life for white."[2] Other companies stake their reputations on making things yet whiter. Soap and detergent firms present the world as a battle between bad (dirt) and good (white). Their advertisements typically begin with the etiology of a stain—the dropped chocolate ice cream, the slip in the mud—before vanquishing it with a powerful detergent. They usually end with hands stroking pristine white shirts or children cantering through drying laundry, to the sound of buoyant catchphrases: "Adds brightness to cleanness and whiteness"; "Not just white, Persil white"; "Blindingly white and clean in just one wash"; "Brings back true whiteness"; "I've seen the white."[3]

We strive to make all kinds of organic materials, which naturally incline to yellow, look whiter. Flour is bleached; brown sugar is passed through decolorization filters; golden paddy rice is hulled and polished into brilliant white seeds; and white pigments are added to poultry, fish, dairy products, baked goods, and confectionary to make them more appealing.[4] Though these whitened foods are no more nutritious than their colorful counterparts, consumers consistently prefer them, perhaps because the name for these processes— "refining"—suggests the products are being purified or improved when really they are being disfigured and denatured. The paper you are currently holding has likewise required a great deal of refining to become so white. It started as brown wood pulp before being bleached with chlorine dioxide, then treated with an optical brightening agent, which lends it a subtle fluorescent glow. We even apply such processes to our own bodies, using sprays and foams that "restore natural whiteness" to teeth, eye drops that whiten the sclerae of the eyes, and skin creams that promise complexions as pristine as alabaster.[5]

Our faith in white is almost as old as faith itself. The Bible repeatedly identifies the color with moral and spiritual purification. After committing adultery with Bathsheba and arranging her husband's murder in order to cover up his transgression, King David even prays for it. "Purge me with hyssop, and I shall be clean," he pleads. "Wash me, and I shall be whiter than snow" (Psalm 51:7). The New Testament's most virtuous characters are distinguished by their spotless clothes. Saints and angels dress in "pure and white linen" (Revelation 15:7), while martyrs are given robes washed white by the blood of Christ (Revelation 7:14).

When Christ himself is transfigured on a remote mountaintop, his clothes become glisteningly, intensely white—whiter than any human could dye them (Mark 9:3). White garments are now worn on every continent to symbolize and solicit redemption—by the Pope, monks, and rabbis, by pilgrims journeying across the deserts of the Middle East and through the forests of Japan, by participants in rituals of initiation, sacrifice, and atonement—and of course by western brides, in homage to a chastity that few actually practice.

Why do we think of white as pure? The reason, I think, is *absence*. Like purity, white is defined by what it excludes. Where black objects absorb most of the light that reaches them, white objects shrug it off. Where colored objects absorb some wavelengths of light, white objects make no exceptions. White surfaces are optical detergents: they deter anything that threatens their whiteness. As purity is an absence of contamination, so white is an absence of color. This might seem counterintuitive. Since Isaac Newton's famous prism experiment showed white light to be a "confused aggregate of Rays indued with all sorts of Colors," we have understood white as the sum of all colors.[6] Few know what happened when Newton attempted to put this theory into practice. When he tried to manufacture a tangible white by mixing paints of all colors on a palette, he instead produced a murky hue that he compared to "the Colors of a Man's Nail, of a Mouse, of Ashes, of ordinary Stones, of Mortar, of Dust and Dirt in High-ways, and the like."[7]

Newton had stumbled on a paradox of white: it is both colorful and colorless. In the realm of light it is made from all the hues, but in the realm of matter it is made from none of them. We might even think of it as a *destroyer* of color. You can demonstrate this quite easily with an experiment not unlike Newton's. Begin by squeezing any brightly colored paint onto a palette. But then, instead of adding every other color, mix it only with increasing amounts of white. You will see the original color's intensity slowly fade, as if obscured by a gathering mist, until eventually all traces of it vanish. The white paint has done something remarkable: it has removed the color from color. Other pigments will alter hue, but not annihilate it. Black, it is true, can also obliterate other colors, but where it smothers them in shades of darkness, white makes them fade away.

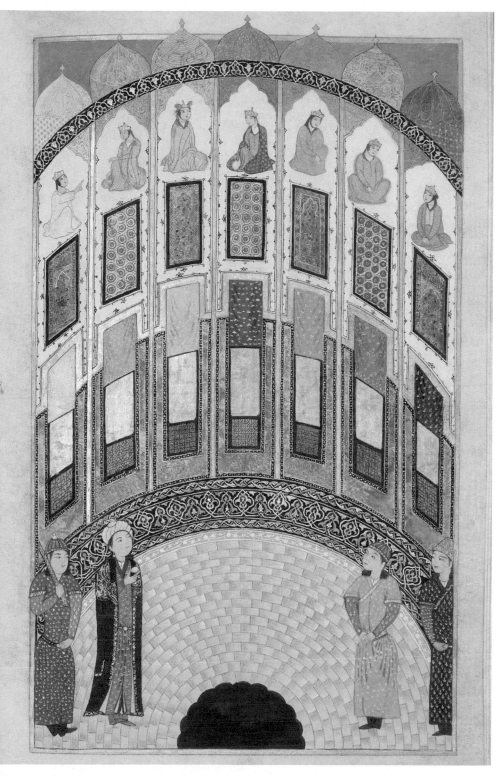

1. Bahrâm Gûr in the room of the seven portraits, from a fifteenth-century Persian manuscript. Above the princesses are the colorful domes he will build for them

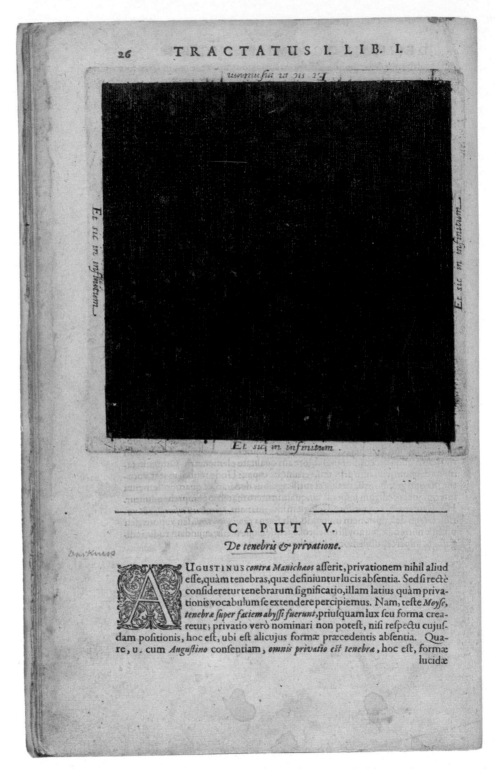

Et sic in infinitum.

Et sic in infinitum. *Et sic in infinitum.*

Et sic in infinitum.

CAPUT V.
De tenebris & privatione.

AUGUSTINUS *contra Manichæos* afferit, privationem nihil aliud effe, quàm tenebras, quæ definiuntur lucis abfentia. Sed fi rectè confideretur tenebrarum fignificatio, illam latius quàm privationis vocabulum fe extendere percipiemus. Nam, tefte *Moyfe*, *tenebræ fuper faciem abyffi fuerunt*, priufquam lux feu forma crearetur; privatio verò nominari non poteft, nifi refpectu cujufdam pofitionis, hoc eft, ubi eft alicujus formæ præcedentis abfentia. Quare, v. cum *Auguftino* confentiam, *omnis privatio eft tenebra*, hoc eft, formæ lucidæ

2. In the beginning there was darkness: in this remarkably modern image, the seventeenth-century cosmologist Robert Fludd depicted the primordial void as a simple black square

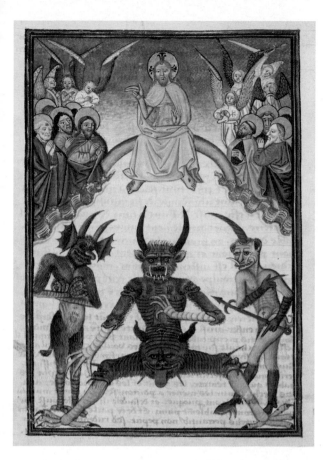

3. Throughout the Middle Ages, the Devil was repeatedly represented as a black or dark creature. In this illuminated French manuscript he is contrasted with the white-robed Christ above him

4. The heroes of film and television traditionally wore white, while their antagonists dressed in black. Here, Marshal Matt Dillon takes on a baddie in the 1950s CBS series *Gunsmoke*

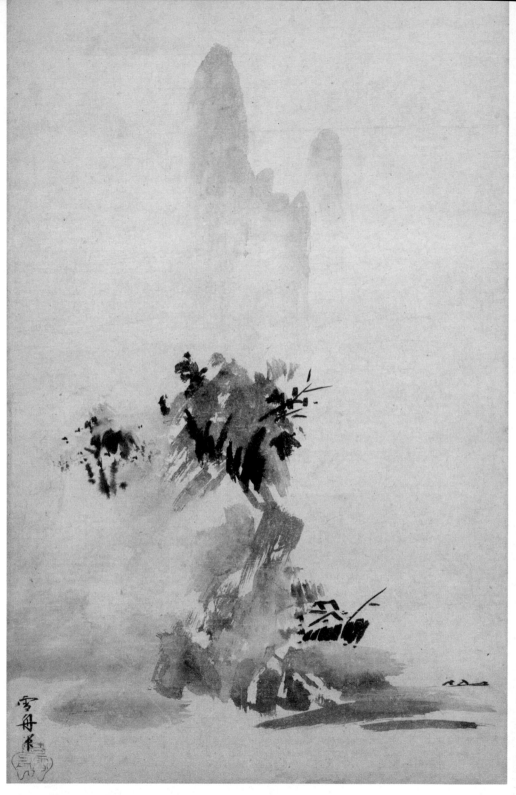

5. Sesshū's *Splashed-Ink Landscape*, made in 1495. From one ink, variously diluted and masterfully applied, springs an evocative mountain scene: a wine tavern by a lake, complete with two boaters at the bottom right

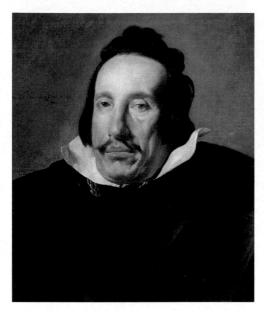

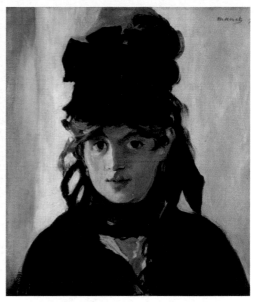

6. Diego Velázquez was one of the first European painters to recognize the power of black. Here the cloak almost seems to be devouring its wearer

7. Édouard Manet, who revered Velázquez, also saw the potential of black. This portrait of his friend Berthe Morisot is largely fashioned from the color

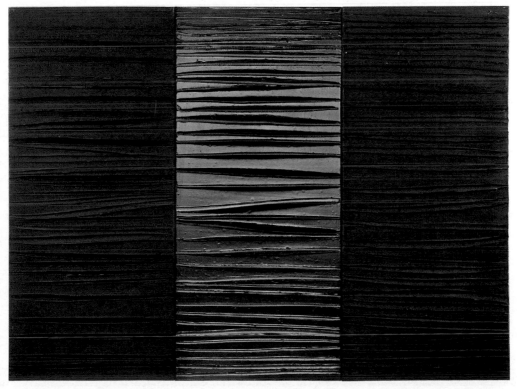

8. *Outrenoir*: light and color dance across this tryptych by Pierre Soulages—an effect produced by cutting dozens of scars into its matte and glossy black surfaces

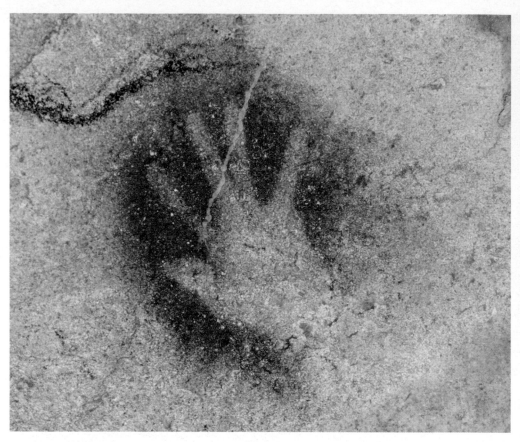

9. A stencil of a hand, in red ochre, on the wall of Chauvet Cave. In prehistoric art, human forms are consistently represented with red pigments

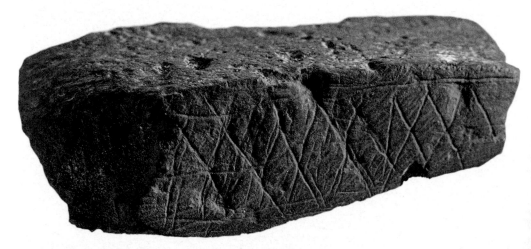

10. Sixty-five thousand years ago, on the southern coast of Africa, a pattern was carved into this block of red hematite. It is one of the earliest surviving abstract designs made by humans

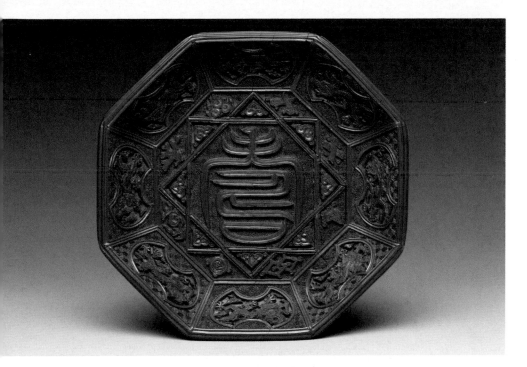

11. A Ming dynasty dish, in carved red lacquer. The auspicious color is complemented by other propitious symbols, all surrounding the character for longevity

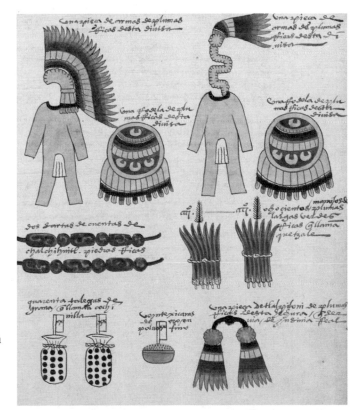

12. A tribute list, showing offerings given by the Province of Coayxtlahuacan to the Aztec emperor Moctezuma. The red dots represent sacks of cochineal dye

13. One of Ana Mendieta's *Siluetas*, made in Mexico in 1976. Here she carved a female
form into the beach, filled it with a bloodred pigment, and watched as the rising tide
washed the color, and figure, away

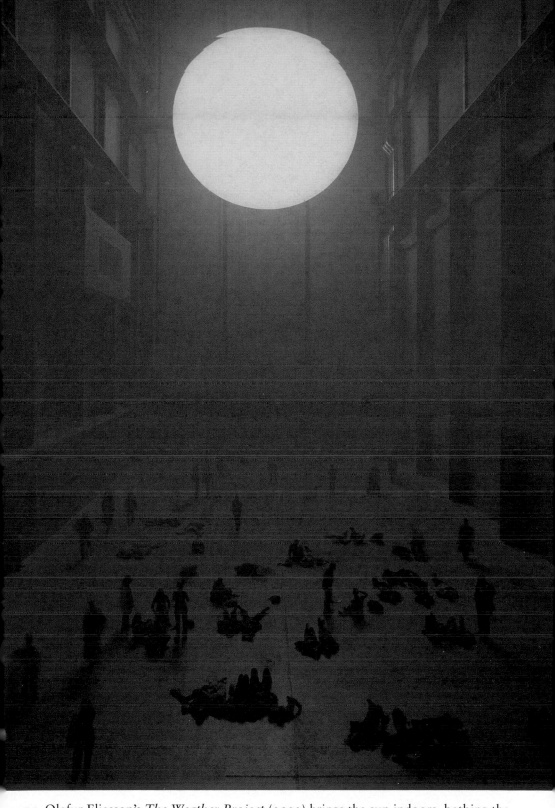

14. Olafur Eliasson's *The Weather Project* (2003) brings the sun indoors, bathing the Tate Modern's turbine hall in the warm yellow light of 200 low-pressure sodium lamps

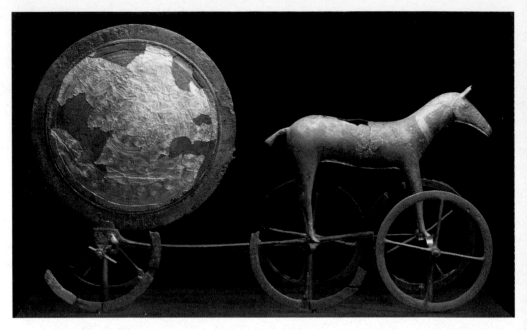

15. The Trundholm Sun Chariot, made in Bronze Age Denmark, uses gold leaf to capture the brilliance of the solar deity Sol

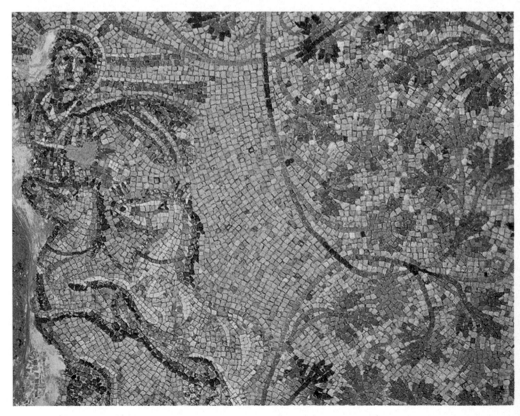

16. This fourth-century mosaic in Rome's catacombs is often thought to be an early image of Christ, with the attributes of the pagan sun deities Helios and Sol Invictus

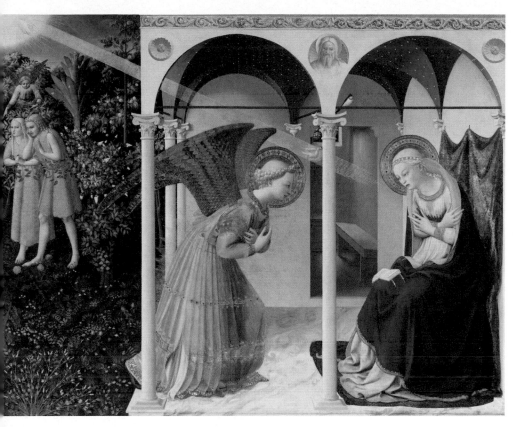

17. In this *Annunciation*, by Fra Angelico in the 1420s, God is a golden sun, and his divine message a beam of light

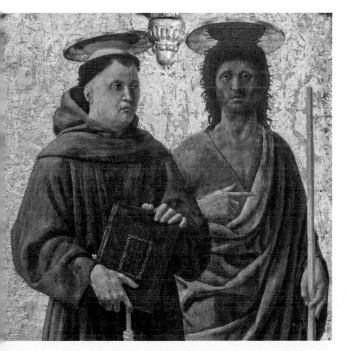

18. Piero della Francesca simulated the luster of these halos with white, brown, and yellow paint rather than traditional gold leaf, enhancing the illusion by showing the tops of his saints' heads reflected in their undersides

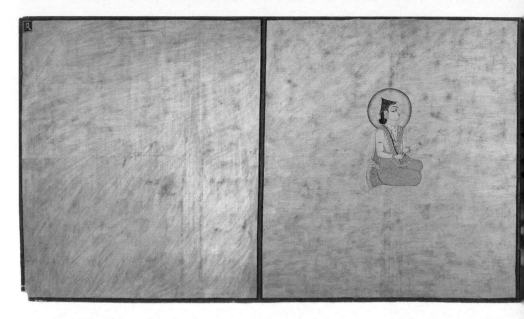

19. Detail from a strikingly abstract painting, made by the Rajasthani artist Bulaki in the 1820s, that imagines absolute reality as a shimmering field of gold

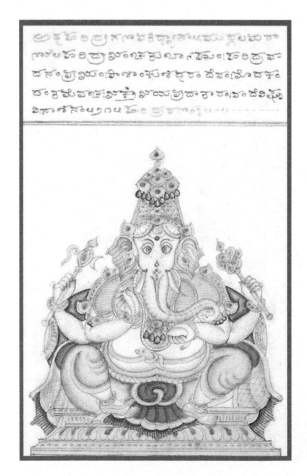

20. A nineteenth-century illustration shows Ganesh with turmeric yellow flesh, wearing yellow clothes, and seated on a golden throne

21. Turner's color charts, which show the interaction of three primary colors, are among the first ever made by an artist

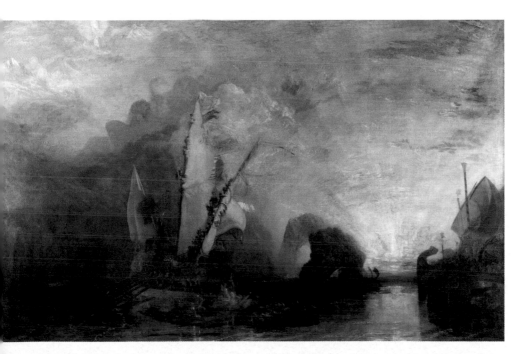

22. Turner's *Ulysses Deriding Polyphemus* is dominated by a vast and heroic sunset. The faint outlines of stallions carrying the sun over the horizon can just be made out

23. (*Over*) In *Regulus,* Turner used chrome yellow and lead white to re-create the intense experience of staring directly into the sun. Contemporary critics advised viewers to keep a safe distance

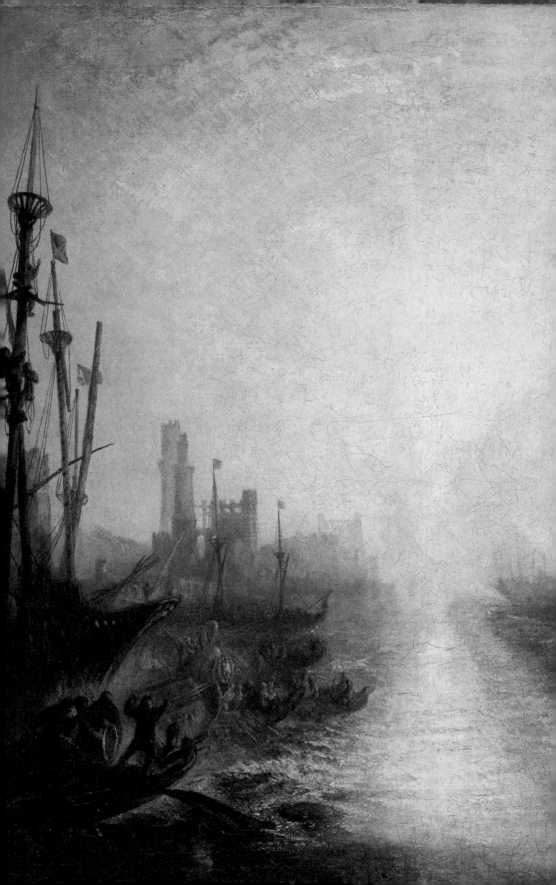

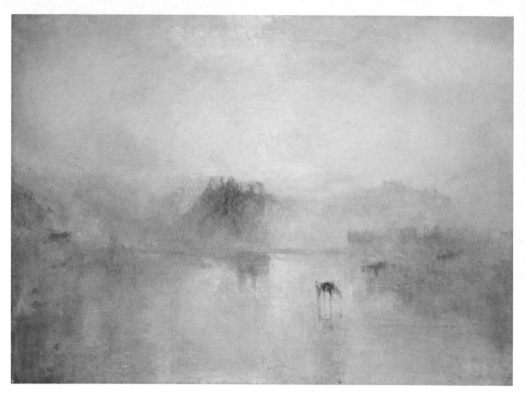

24–25. The evanescent sunrise behind Norham Castle depends on a phenomenon called isoluminance. In black and white, we can see the sun's yellow haze is exactly the same brightness as the blue sky around it

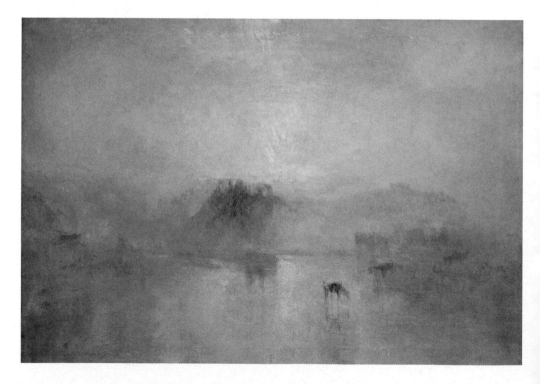

Add black, and color is hidden; add white, and it's like it never existed.

No wonder we often confuse the white and the colorless. We consistently call colorless things white (white vinegar, white spirit, white liquor, white diamonds, white light) and white things (paper, screens, walls) "blank" or "empty"—when actually they are full of white. This conflation renders us partially blind to white. Like the walls of our homes or the paper on which these words are printed, the color hides in plain sight: neutral, natural, original. White, we conclude, is what things looked like before their purity was polluted by color, and is therefore the condition to which they should return. This is the idea behind the detergent that "brings back true whiteness" to clothes, the toothpaste that "restores natural whiteness" to teeth, and the skin cream that promises a "natural white" complexion. None of those substances is naturally or originally white, but we repeatedly convince ourselves otherwise.

Together with black and red, white is one of the three most persistently meaningful colors in human culture. Long before humans even had words for other colors, they formed a symbolic triad that governed every aspect of life. If black was connected to darkness and red to human blood, white emerged as a metaphor for physical and moral purity all over the world.[8] No population, however, loaded it with more symbolic baggage than the peoples of Europe. From at least the beginning of the sixteenth century, they elevated it to a paradigm of esthetic, intellectual, and social perfection. They came to see it as an emblem not only of their own civilization, but even their own bodies. And yet the foundation for this peculiar attachment was laid long before humans even walked the Earth, in a violent geological accident.

NOBLE SIMPLICITY AND CALM GRANDEUR

One hundred and fifty million years ago, the land that eventually became Europe was submerged beneath a large tropical ocean. The Tethys was abundant in marine life, with molluscs, planktons, coral,

and algae thriving in its warm shallow waters. When these tiny organisms died—as they did, daily, in their billions—their bodies sank to the seabed and formed a calcium carbonate graveyard of shells and skeletons. Over time and under pressure, the sediment was transformed: in some regions into oil; in others, into carbonate rocks. Europe is particularly blessed with the latter. When the landmass finally emerged from the Tethys' receding waters it was generously coated in limestone, some of which then underwent a further transformation.[9] The southern edge of Europe sits above a contact zone between two massive tectonic plates, which about 100 million years ago began to collide. This formed the great European mountain ranges, extending from the Pyrenees in the west to the Carpathians in the east, creating immense temperatures and pressures that recrystallized the limestone into another, more splendid, substance.

Marble is the bedrock of Mediterranean civilization in more ways than one. Many of the region's most celebrated cultural achievements occurred when and where it was plentiful and wouldn't have been the same without it. The pioneering Cycladic societies started carving pots and figurines out of marble from Naxos and Paros more than 5,000 years ago. The Parthenon was built from a newly opened quarry at Mount Pentelikos near Athens in the early fifth century BCE. The first substantial marble monuments of the Roman Empire also followed the opening of a quarry, at Luna in the Apuan Alps, 400 years later. Emperor Augustus, who regarded marble as tangible proof of his empire's greatness, rebuilt much of his capital in it. "I found Rome a city of bricks and left it a city of marble," he boasted.[10] The Italian revival of antiquity that began in the thirteenth century was also a revival of marble. The celebrated churches and statues of the Renaissance were made from stone originating in Luna (by then renamed Carrara), just reopened after centuries in abeyance. Without these vast quantities of calcium carbonate, western culture would look very different.

The stone has many attractions. Marble is weak enough to be quarried but strong enough to last centuries, soft enough to be carved but hard enough to take polish. This sheen gives it its name, from the Greek *marmaros* (μάρμαρος), meaning "shining stone." Marble sparkles in many different colors depending on its impurities, which dance

through it in veins, streaks, stripes, circles, rings, spirals, corrugations, starbursts, brocades, rhomboids, and arabesques. Some resemble slabs of fatty meat; others, lithic Jackson Pollocks. The purest marble is white—though not all white marble is equally pure. While Carraran stone contains up to 99.9 percent calcite and has a brilliant bluish-white cast, Pentelic stone has a warm, buttery hue that browns on exposure to air (**Plates 33–34**). If the Parthenon had been constructed from cold white Carraran marble, or Michelangelo's *David* had been carved from golden Pentelic stone, they would make very different impressions.

The Greeks and Romans didn't leave their marbles white. They inlaid their surfaces with enamel and gemstones, ornamented them with gilding and metalwork, and painted them in bright colors.[11] Over the centuries these pigments disintegrated, faded, or washed away, and their adornments were lost or stolen. By the time ancient monuments were rediscovered during the Renaissance, the marble was naked once again. Most people assumed it had always been that way. The presumption had been informed by one of the major debates about the visual arts of the fifteenth century, called the *paragone* by Leonardo, in which artists and writers compared painting and sculpture to define their respective essence. Many held that sculpture was primarily a spatial medium: sculptors were advised to focus on line, form, contour, surface, and depth, while steering clear of color, which belonged instead on the painter's palette. Leonardo was insistent that sculptors should have "no concern at all" with color.[12]

The case was strengthened when a totemic series of classical sculptures came to light in Rome. The *Belvedere Torso* (by the 1430s), *Apollo Belvedere* (by 1489), *Laocoön* (in 1506), *Belvedere Hermes* (early 1540s), and the *Farnese Hercules* (1556/7) were superior to anything hitherto known from antiquity—and all were made from supposedly unadorned marble. Michelangelo was himself present, on January 14, 1506, when the *Laocoön* was unearthed in a vineyard on the Esquiline. According to one account, he was so excited that he started sketching the sculpture before it had even fully emerged from the ground.[13] It was not Michelangelo's first brush with antiquity. He had studied Roman statues in Lorenzo de' Medici's garden in Florence as a boy, and in the 1490s carved a marble sculpture that he

artificially aged and sold as a genuine piece of antiquity.[14] Classical forms reappear repeatedly throughout his career, as does their lack of color. From the early *Madonna of the Steps* (1491) to the *Rondanini Pietà* (1564), which he left unfinished on his death seventy-three years later, Michelangelo sculpted almost exclusively in Carraran marble.

Michelangelo cared deeply about the purity of his materials and spent months in the Carraran mountains, sun-scorched by dazzling rockfaces, in pursuit of immaculate *statuario*. According to his long-suffering stonecutter Topolino, he demanded marble that was "white and without veins, marks and hairlines." He rejected even the slightest imperfection, discarding a material the moment his chisel alighted on a vein.[15] Thinking of himself as the liberator of subjects incarcerated within the stone, Michelangelo saw carving as an act of purification. "By sculpture," he wrote, "I understand an art which is operated by taking away superfluous material."[16] There is surely no more moving illustration of this than his four *Prisoners* in Florence's Galleria dell'Accademia, originally conceived as part of Pope Julius II's elaborate tomb commissioned in 1505. Michelangelo abandoned the pieces when the project was scaled back in the 1530s, leaving them unfinished in his studio. Half-trapped for half a millenium, they appear to be engaged in an eternal struggle for freedom (**Plate 35**).

Monochrome marble statuary derives its uncanny power from the fact that it looks both unnatural and natural. No human body is as white as Carraran marble, but the material possesses the soft luminescence of living tissue. Perhaps this is because of marble's wonderful translucency: as with skin and other organic substances, light doesn't bounce off its surfaces but penetrates its depths, often as far as several centimeters, before ricocheting off its calcite crystals and reemerging in different directions. Gian Lorenzo Bernini, possibly the greatest sculptor of the seventeenth century, had an incomparable ability to turn mineral into animal, carving flesh that looks supple enough to bruise (**Plate 36**). He understood marble's paradoxical qualities better than anyone, pontificating about it so often that his assistants must have grown tired of listening. He liked to say that if a man were depicted in a white marble bust the whiteness would go unnoticed. But if that same man were to cover his own face with white powder, his friends wouldn't only struggle to recognize him; they would be horrified.[17]

By the time Bernini died in 1680, white marble was Europe's pre-eminent sculptural material. But though this taste had undoubtedly been shaped by classical sculpture, few explicitly said so. The whiteness of antiquity was assumed, implied, occasionally mentioned in passing, but rarely addressed directly. That changed in the following century, when the movement we call Neoclassicism was triggered by a second burst of archaeological activity. As excavations at Herculaneum (beginning in 1738), Pompeii (from 1748), and Paestum (around 1750) unearthed a string of wondrous artifacts, people naturally concluded that western culture had peaked in Greece and Rome. No one argued this more effectively than Johann Joachim Winckelmann.

Born the son of a cobbler in a small Prussian village, Winckelmann drew on considerable resources of talent, charm and ambition to transform himself into one of the century's most influential thinkers. By the time of his murder in 1768 (by a petty thief called Francesco Arcangeli), he was one of the household names of the Enlightenment. He had started his career as a teacher in Seehausen, became a librarian in Nothnitz, then secured a well-connected role at the royal court in Dresden. In 1754, a pragmatic (some say cynical) conversion to Catholicism rewarded him with a route to Rome, where he established himself as the city's leading antiquarian. By 1763, he was the prefect of papal antiquities, a position once held by Raphael. In a series of wildly successful publications, including *On the Imitation of the Greeks* (1755) and *History of the Art of Antiquity* (1764), Winckelmann argued that ancient Greece wasn't simply a golden age in history but a model on which modern values could be based. "The only way for us to become great, or, if this be possible, inimitable," he advised his readers, "is to imitate the ancients."[18]

In Rome Winckelmann came face to face with sculptures that had inspired Michelangelo and Bernini before him, responding with an enthusiasm that at times bordered on hysteria. This is his rhapsodic reaction to the *Apollo Belvedere*:

> His build is sublimely superhuman, and his stance bears witness to the fullness of his grandeur. An eternal springtime, as if in blissful Elysium, clothes the charming manliness of maturity with graceful youthfulness, and plays with soft tenderness on the proud build of his limbs . . . I become

oblivious to everything else as I look at this masterwork of art, and I myself take on an elevated stance, so as to be worthy of gazing at it. My chest seems to expand with veneration and to rise and heave, as happens with those I have seen who seem swollen with the spirit of prophecy, and I feel myself taken back to Delos and the Lycean fields, places that Apollo honored with his presence; for my image seems to take on life and movement, like Pygmalion's beauty. I place the idea which I have given of this image at its feet, like the wreaths offered by those who could not reach the head of the divinity that they wished to crown.[19]

Winckelmann regarded the *Apollo Belvedere* as the quintessence of Greek art, when in reality it was a second-century Roman copy of a lost Greek bronze (**Plate 37**). A more significant misapprehension, however, concerned its color. The *Apollo* was carved from Parian marble that had yellowed over time. Its surfaces have the hues of aged paper or the unbleached ecru of linen and cotton, while the arms and legs are so mottled that Apollo seems to be suffering from vitiligo. He isn't the only ancient statue so afflicted: *Hermes* (whom Winckelmann wrongly identified as Antinous) has an unmistakable yellow tint, the *Laocoön* is ghostly gray, and the *Belvedere Torso* is stippled with rust-colored spots. But Winckelmann didn't see the yellows, grays, beiges, browns, and reds; nor did he notice the veins, stains, blemishes, and blotches—he saw only white. That's because whiteness, he believed, was a necessary condition of classical beauty; a point he supported with some half-remembered Newtonian remarks about light.

> Since white is the color that reflects the most rays of light, and thus is most easily perceived, a beautiful body will be all the more beautiful the whiter it is, and nude it will thereby appear larger than it actually is, just as the newly formed gypsum figures seem larger than the statues from which they were cast.[20]

It is a simple argument: white statues are superior in part because they are easier to see: a puzzling assertion, perhaps, but one that Winckelmann gamely elaborated. Picking up the *paragone* debates of the Renaissance, he maintained that sculpture was a spatial rather than pictorial medium: plain white surfaces didn't distract from the more significant features of line, contour, and depth. His argument hinges on

the enduring elision of whiteness and colorlessness: that white is sufficiently neutral to go unnoticed. In Winckelmann's view, the viewer doesn't look *at* white but *through* it, to things of greater importance.

Like Michelangelo before him, Winckelmann identified white with purity. He revered Greek art above all because it visualized an ideal beauty that was absent of contamination. At one point he likened it to the purest spring water: "The less taste it has, the more healthy it is seen to be, because it is cleansed of all foreign elements."[21] The carved bodies of antiquity had likewise been purged of the superficial, ephemeral, distinctive, and particular. Their creators had extrapolated from flesh-and-blood models a universal and eternal type that transcended any one individual; they had distilled (pure) *ideal* form from (impure) *real* form. These men and women do not sweat or excrete; their skin is without blood vessels, freckles, birthmarks, spots, or body hair. All corporeal blemishes have been subsumed beneath a wipe-clean surface.

Winckelmann summarized his ascetic esthetic with the phrase "Eine edle Einfalt und eine stille Grösse," which over the years has been translated in too many ways to count (I shall opt for "noble simplicity and calm grandeur").[22] He was referring specifically to the restrained poses and expressions in so much Greek sculpture, but his words came to mean much more. In the century after his death, they reverberated around the learned world, were recited in books and letters, lectures and speeches, at courts and academies, encapsulating a particular attitude toward antiquity that, as we shall see, helped to shape modern taste. Above all, Winckelmann exhorted his readers to appreciate the virtues of simplicity. The Greeks, he told them, knew they didn't need to gild the lily; they understood that a plain surface was finer than an ornamented one; that less was nearly always more.

Winckelmann's preferences were part of a larger intellectual framework. In the seventeenth and eighteenth centuries philosophers increasingly divided reality into two principal categories: "primary qualities," which existed objectively in the world, and "secondary qualities," which were rooted in subjective experiences. The first meant reliable and measurable properties such as size, shape, and motion; the second included sensations such as taste, smell, and sound. Color was increasingly seen as a secondary quality—and so relegated, in David Hume's words, to being "merely a phantasm of the senses."[23] Other philosophers

even excluded it from canons of beauty. "In painting, sculpture, and in all the formative arts . . . delineation is the essential thing," announced Immanuel Kant in 1790. "The colors which light up the sketch belong to the charm; they may indeed enliven the object for sensation, but they cannot make it worthy of contemplation and beauty."[24] Kant's repudiation of color belonged to a more fundamental intellectual purification—an exclusion of pleasure from esthetic judgments, and therefore from philosophical scrutiny. Like Winckelmann, Kant maintained that serious people had to resist the temptations of color. The principle became such a hallmark of Enlightened thought that even a chromophile like Goethe, who had studied Kant and idolized Winckelmann, freely espoused it:

> It is also worthy of remark that savage nations, uneducated people, and children have a great predilection for vivid colors; that animals are excited to rage by certain colors; that people of refinement avoid vivid colors in their dress and the objects that are about them, and seem inclined to banish them altogether from their presence.[25]

These dubious assertions were lent credence by ancient precedent. If the infallible Greeks had chosen to renounce color then that was evidently the correct thing to do. But evidence was slowly accumulating to the contrary. Traces of painted marble had been discovered at several archaeological sites in the eighteenth century. Winckelmann himself was aware of the practice but dismissed it as a "barbaric custom" unrepresentative of wider classical culture and spoke no more of the matter.[26] Others tried to suppress the information (there's an old anecdote about two archaeologists studying a Greek temple; when one climbed a ladder and found signs of paint on the pediment, his colleague shouted: "Come down instantly!"). But as more colorful fragments came to light, researchers concluded that Winckelmann was wrong. In his 1814 book, *Le Jupiter Olympien*, the French antiquarian Antoine-Chrysostome Quatremère de Quincy didn't simply describe the colors of ancient monuments but reconstructed their original hues in nineteen gaudy plates (**Plate 38**). Its frontispiece showed Phidias' monumental statue of Zeus at Olympia as few had seen antiquity before: blanketed with gold, sparkling with precious stones and inlaid glass, and painted in vivid greens, pinks, blues, and crimsons. The news didn't go down well. Polychromists such as Quatremère

were ridiculed and rebutted throughout the nineteenth century. Gesturing to his heart, Auguste Rodin is said to have declared: "I feel *here* that they were never colored."[27]

Many Greco-Roman carvings were adjusted to match such misconceptions.[28] The Parthenon Sculptures, better known as the Elgin Marbles, are surely the most famous victims. From the moment they entered the British Museum in 1817, visitors had complained about their glossy orange-brown patina that had in places turned black with soot and fungi.[29] The museum washed the objects several times over the decades, but without much success. In the late 1930s, however, the construction of a new Parthenon gallery precipitated a more vigorous refurbishment. The project had been funded by the influential art dealer Joseph Duveen on one condition: that the carvings were thoroughly cleaned before going back on display. "Wait until you see them with the London grime removed and in their first purity," he bragged to *The Times*. "They will be luminous. To me there was never any loveliness in dirt."[30] Over fifteen months between 1937 and 1938, workers scraped, scoured, and scrubbed the sculptures' epidermises away to reveal the pale stone beneath (**Plate 39**). By the time the project was halted by the museum's director, roughly 10 percent of the east pediment, 40 percent of the frieze, and 60 percent of the metopes had been irreparably damaged.[31]

News of the cleaning broke in February 1939 and triggered six months of national debate, including questions in Parliament. Most connoisseurs were convinced that the Elgin Marbles had been ruined. In a letter to the *Sunday Times*, the art historian and traveler Robert Byron described the restoration as cultural homicide:

> Anyone who knows the patina of Pentelic marble, who has run his hands over the knife-like edges of the Parthenon or the objects in the Acropolis and felt those innumerable tiny asperities and translucencies which make that stone the most vivid material that ever rewarded a carver's skill, can see at once that the marbles in Lord Duveen's new gallery have lost this patina. The luster and the gentleness have vanished. The lumps of stone remain, robbed of life, dead as casts.[32]

Duveen's determination to make the Parthenon sculptures "as clean and white as possible" wasn't motivated only by an old misunderstanding of antiquity. It was informed by another, broader, fallacy:

that white was the color of a pure, original, *natural* state that had been lost and needed to be regained.[33]

As these old assumptions intermingled with Winckelmannian visions of antiquity, they helped shape modern taste. A preference for plainness and whiteness emerged in late eighteenth-century material culture and grew progressively stronger thereafter. Modern artists increasingly saw the renunciation of color as a kind of cleansing process: an attempt to strip their disciplines of the filth and clutter that had accumulated over the centuries, so they could create artworks purer even than those made by the Greeks. For James Whistler, Kazimir Malevich, Ben Nicholson, Piet Mondrian, and many others, white was a means to this end. Some lionized it with a zeal bordering on worship. Here is Theo van Does-burg, of the Dutch avant-garde group De Stijl, writing in 1929:

> WHITE This is the spiritual color of our times, the clearness of which directs all our actions. It is neither gray nor ivory white, but pure white.
>
> WHITE This is the color of modern times, the color which dissipates a whole era; our era is one of perfection, purity and certitude.
>
> WHITE It includes everything.
>
> We have superseded both the "brown" of decadence and classicism and the "blue" of divisionism, the cult of the blue sky, the gods with green beards and the spectrum.
>
> White pure white.[34]

Others extended their aspiration to the built environment. In the 1920s, the Swiss architect Le Corbusier even imagined painting the world white by decree:

> Imagine the results of the Law of Ripolin. Every citizen is required to replace his hangings, his damasks, his wall-papers, his stencils, with a plain coat of white ripolin. His *home* is made clean. There are no more dirty, dark corners. *Everything is shown as it is.* Then comes *inner* cleanness, for the course adopted leads to a refusal to allow anything at all which is not correct, authorized, intended, desired, thought-out: no action before thought . . . Once you have put ripolin on your walls you will be *master of yourself* . . . Without the Law of Ripolin we accumulate, we make our houses into museums or temples filled with votive offerings, turning our mind into a concierge or *custodian* . . . On white

ripolin walls these accretions of dead things from the past would be intolerable: they would leave a mark.[35]

We could ridicule the enthusiasm of Le Corbusier and his contemporaries, just as we can Winckelmann's. But their esthetic standards live on. Cultivated types still identify "refined" taste with the understated and muted, whether it takes the form of a fashionable "white cube" art gallery or a designer product made by Apple. It is no longer even radical to whitewash our homes; most of us cover our walls with white or "off-white" paints because it is the conventional thing to do.

But the rediscovery of antiquity left another, more important, legacy. Winckelmann and his successors encouraged Europe's disparate communities to think of themselves as a single ethnic group with a shared cultural heritage, stretching all the way back to Homer. The achievements of the Greeks allowed Europeans to imagine themselves as the inheritors of a civilization greater than any other, and thus to assert the superiority of their own. We now know their forebears were nowhere near as "European" as their imagined descendants believed, but their artworks at least suggested otherwise.[36] As antiquarians examined these beautiful stone figures, they compared the pale marble with their own skin. This growing self-awareness was reinforced by increasingly frequent interactions with darker-skinned populations around the world that were taking place at the same time. These two processes gradually convinced Europeans that they themselves were white.

WHITE SUPREME

In March 1455, a Venetian trader called Alvise Ca' da Mosto set out to make his fortune. He sailed down the Adriatic and turned west into the Atlantic, then headed south past the Canary Islands toward what he called "the land of the Blacks."[37] Several weeks later Ca' da Mosto's ship arrived in modern-day Senegal, where he successfully traded Spanish horses and Italian textiles for 100 African slaves. To celebrate the deal, Ca' da Mosto traveled inland with the local ruler. He wrote excitedly of bizarre animals, unusual food, and evenings spent with a twelve-year-old "negress" who had been given to his bedchamber.

One day he decided to leave the royal complex and visit a local market. His presence caused quite the commotion:

> These negroes, men and women, crowded to see me as though I were a marvel. It seemed to be a new experience to them to see Christians, which they had not previously seen. They marveled no less at my clothing than at my white skin . . . Some touched my hands and limbs, and rubbed me with their spittle to discover whether my whiteness was dye or flesh. Finding that it was flesh they were astounded.[38]

In Ca' da Mosto's lifetime and for years after his death, Europeans did not consider themselves white. More often they used the adjective to describe *non*-Europeans, such as Persians, Asians, and Native Americans—primarily to distinguish them from Africans. Christopher Columbus applied the term to the inhabitants of Trinidad. "These people," he reportedly said when he reached the island in July 1498, "are white, with long hair, and of yellow color."[39] But as trading posts were established along the coast of west Africa in the fifteenth and sixteenth centuries, Europeans increasingly encountered peoples who, like Ca' da Mosto's interlocutors, described their visitors as "white." By the early 1600s, some western travelers were applying the adjective to themselves. The usage soon made its way back from the frontiers. In October 1613, a pageant was staged for the newly appointed mayor of London, which included Thomas Middleton's play *The Triumphs of Truth*. Halfway through the performance, the King of the Moors arrived onstage in a ship, looked at his audience, and declared:

> I see in amazement set upon the faces
> Of these white people, wanderings and strange gazes;
> Is it at me? Does my complexion draw
> So many Christian eyes that never saw
> A King so black before?[40]

In the middle of the seventeenth century, the distinction became a legal status. In the colonies of the New World, where European settlers and African slaves lived side by side, colonial governments feared that their multiethnic workforce would unite in protest against their exploitation, so they used legislation to divide European laborers from African servants and slaves. English lawmakers had a widely

accepted term for those of African descent—"Negro"—but no equivalent for those from Europe. In the first half of the seventeenth century, they tried "Christian" and "English," but both presented difficulties: "Christian" was too broad (because many Africans had already converted to Christianity), while "English" was too narrow (because the colonies were also home to Irish, Scottish, Danish, and Dutch settlers). The only term that overcame these difficulties, and which also was clear, simple, and widely understood, was "white."[41]

Between 1644 and 1691, "white" entered the statute books in thirteen colonies, starting in Antigua and Barbados then spreading north to the American mainland. These regulations typically granted rights to those deemed white while removing them from those who weren't. All the texts are pervaded with the old fear of contamination. In April 1691, the Virginia Assembly prohibited interracial marriage for precisely this reason:

> For prevention of that abominable mixture and spurious issue which hereafter may increase in this dominion, as well as by negroes, mulattos, and Indians intermarrying with English, or other white women, as by their unlawful accompanying with one another, Be it enacted . . . that . . . whatsoever English or other white man or woman being free, shall intermarry with a negro, mulatto or Indian man or woman bond or free shall within three months after such marriage be banished and removed from this dominion forever . . . [42]

It once again came down to purity. Like biblical prophets, Enlightenment antiquarians, and modern minimalists, Virginia's legislators feared their immaculate whiteness was about to be polluted by the "abominable mixture" of color.

America's lawmakers policed the fragile purity of whiteness long after the Revolution and Independence. Many states adopted the "one-drop rule," which asserted that a citizen with a single drop of "black blood"—one African ancestor in an otherwise white family tree—counted as black. There were no shades of gray here: a "tainted" white was not white at all.[43]

Race, like all other categorizations, is a human invention. Genomics has confirmed that humans belong to a single and remarkably

homogenous species, and that genetic variety is greater within ethnic groups than between them. Yet there *are* physical differences between populations, which, though superficial, are unmistakable. In the eighteenth century, skin color in particular was used to divide humans into what were increasingly defined as races. One of the first to do this systematically was Carl Linnaeus. He separated the world into animal, vegetable, and mineral kingdoms, and then into a scheme of increasingly specific classes, orders, genera, and species. In *Systema naturae* (first published in 1735), he subjected humans to similar taxonomical scrutiny, outlining four principal varieties of what he named *Homo sapiens*, which he then linked to the humors, elements, corners of the earth, continents, and (of course) colors. In his definitive tenth edition (published in 1758–1759), he described Americans as red (*rufus*), Asians as yellow (*luridus*), Africans as black (*niger*), and Europeans as white (*albus*).[44]

These classifications inevitably raised the question of whether the different races belonged to the same species. Some were certain that they didn't. "The negro race," wrote Voltaire, "is a species of men as different from ours as the breed of spaniels is from that of greyhounds."[45] Others contended that all races had a shared origin but gradually differed over time. By the second half of the eighteenth century a growing body of evidence vindicated the latter: philosophers reported that African babies had pale skin when they left the womb, which darkened over subsequent days; physicians conducting dissections noted that the subcutaneous tissue of Africans was identical to that of Europeans; and journalists wrote of "negroes" whose black skin had mysteriously turned white. In the 1790s, this condition (probably vitiligo) made Henry Moss one of the most famous men in America.[46] All of these cases appeared to suggest—as the Parthenon sculptures had to Joseph Duveen—that beneath the dark epidermis lay a pure white body.

The idea had some pedigree. By the time Pliny wrote his *Natural History* in the first century CE, it was well established that the inhabitants of the hot lands of "Ethiopia" (a catchall term for sub-Saharan Africa) had been "scorched with the heat thereof, like them that be burned."[47] Indeed, the term "Ethiopian," which came from the Greek αἴθω and ὄψ, literally meant "burned-face." The theory was elaborated

by the Comte de Buffon in the middle of the eighteenth century, who contended that humans originated in and around Europe, attaining physical perfection in the temperate climates that prevailed between the latitudes of forty and fifty degrees. The "most beautiful, the whitest, the best-formed people" flourished in a horizontal stretch of land that began in northern Spain, passed through the Mediterranean, extended into the Caucasus, and terminated in northern India. When they settled outside this temperate zone, less amenable climates altered their complexions. As they migrated south toward the Equator, the sun turned their bodies darker, until eventually it burned them black. Over time this "germ of blackness" was transmitted from parents to children, before being permanently inscribed on the body.[48]

Buffon's theory picked up some illustrious supporters. In 1775, Johann Friedrich Blumenbach, often considered the father of modern anthropology, agreed that the pale-skinned people of the Caucasus (whom he named Caucasians) possessed "the primitive color of mankind," because it was "very easy for [white] to degenerate into brown, but very much more difficult for dark to become white."[49] Both authors' ideas were shaped by assumptions about ancient statues as well as modern beauty products: that whiteness is *original*; that it is how things look at the beginning. In evolutionary terms, of course, the opposite was the case. The earliest *Homo sapiens*—who emerged in Africa, not Europe—had dark skin, to protect against ultraviolet radiation from the tropical sun and to preserve their bodies' reserves of nutrients. It was only tens of thousands of years later, when some of them migrated to cooler parts of Africa and Eurasia, that they lost some of their melanin, possibly to maximize absorption of vitamin D from the less plentiful sunlight, and became paler.[50]

Other writers elaborated Buffon's theory. In America the cleric and philosopher Samuel Stanhope Smith—whose *Essay on the Causes of the Variety of Complexion and Figure in the Human Species* (1787) was the first major American study of race—argued that dark skin had social as well as climatic causes.[51] Stagnant air, rotting matter, smoke, poor food, unsatisfactory accommodation, an absence of clothes, and "filthiness in their whole manner of living" all enhanced the "disagreeable duskiness" of Africans' complexions and rendered their features "coarse and deformed."[52] Smith explained the underlying

biological processes in some detail. Extreme temperatures and unhealthy lifestyles caused the body to produce an excess of yellow bile, which was secreted into the cellular membrane of the skin, giving the complexion a "dull yellow tinge." When skin thus infected was exposed to torrid conditions, the hydrogen within it evaporated, leaving the remaining carbon component to take on a "very dark hue." This process was repeated through the generations until the African body developed what Smith called a permanent "universal freckle."[53]

Five years later, another American author posited an alternative explanation. Benjamin Rush was an accomplished physician, an outspoken opponent of capital punishment, a campaigner for women's education, a founder of public schools and free dispensaries for the poor, one of the fifty-six signatories of the Declaration of Independence, and a prominent abolitionist.[54] But this otherwise enlightened man was nevertheless convinced that blackness was a disease. In a paper given to the American Philosophical Society on July 14, 1792, Rush argued that Africans were unusually susceptible to leprosy because of their voracious sexual desires. "After whole days, spent in hard labor in a hot sun in the West Indies," he wrote, "the black men often walk five or six miles to comply with a venereal assignation."[55] He explained that this malady expanded the lips, flattened the nose, curled the hair, and blackened the skin. Rush was sure that a cure could be found, and suggested that fear, abstinence, friction, hydrochloric acid, even the juice of unripe peaches, might reverse the damage. "Is the color of the negroes a disease?" he asked. "Then let science and humanity combine their efforts, and endeavor to discover a remedy for it."[56]

I have described these theories at length in order to demonstrate what they had in common: all saw blackness as pathology and color as contagion. Whether it was stained, burned, infected, or deformed, black skin was white skin that had been ruined. Many reinforced their claims to superiority with reference to classical antiquity. In his *Account of Regular Gradation in Man* (1799), the aptly named English physician Charles White produced a chart of "facial angles" in humans and other animals that established a scale of ascending beauty based on the verticality of the skull's profile. Beginning with birds, crocodiles, dogs, monkeys (42°), and orangutans (58°), the chart then

proceeded to the "Negro" (70°), the "American Savage" (73.5°), the "Asiatic" (75°), and then the "European" (80–90°). The pinnacle of the chart was reserved for the "Grecian Antique" (100°).[57] The debt to Winckelmann was even more explicit in the work of the Swiss physiognomist Johann Kaspar Lavater. One edition of his essays, published in 1803, featured a twenty-four-part engraving that illustrated the evolution of a frog into a human and then, finally, into Apollo—an image that uncannily resembled the *Apollo Belvedere* that Winckelmann had extolled a few decades earlier.

But racial theorists made a more fundamental claim based on the meanings of white. "White," wrote Stanhope Smith, "may be regarded as the colorless state of skin, and all the shades of the dark colors as different stains inserted into its substance."[58] The white and the colorless are once again being elided. White people, of course, are neither white nor colorless. But Stanhope Smith and the others didn't see the spectrum of pinks, yellows, beiges, and browns that really blushed across their skin.[59] They, like Winckelmann, saw only a white that wasn't there. Their collective blindness would have a momentous impact on the history of race relations. By describing their bodies as colorless, they were able to mark themselves out as different from every other ethnic group, creating a distinction between "white people" and "people of color" that still persists today. And by aligning themselves with the color of purity, they could also claim to be the cleanest

The evolution of a frog into Apollo

and most virtuous people on the planet.[60] It is this that brings us back to where we began this chapter: to cleanliness.

For much of the seventeenth and eighteenth centuries, Europeans were among the world's filthiest people—certainly dirtier than most Asians, Africans, and Polynesians. They avoided baths like the plague (partly because they believed them to be carriers of plague) and were reluctant to make even the slightest physical contact with water. The wealthier classes instead advertised their cleanliness through a display of whiteness: covering their hair and skin in white powder, and clothing their soiled bodies in immaculate white undershirts. "We do not make baths," bragged Charles Perrault at the end of the seventeenth century, "but the cleanliness of our linen and its abundance are worth more than all the baths in the world."[61] In the second half of the nineteenth century, however, western attitudes toward personal hygiene changed. From the 1860s onward, scientists began to suspect that diseases weren't caused by toxic vapors (the dominant theory since Galen) but by pathogenic microorganisms. Their suspicions were confirmed by the discoveries of the bacilli of leprosy (1874), septicemia (1878), gonorrhea (1879), typhoid (1880), pneumonia (1881), tuberculosis (1882), cholera (1883), tetanus (1884), and bubonic plague (1894).

"Germ theory" had far-reaching social consequences. It created an unprecedented obsession with cleanliness in all its forms, prompting massive investment in municipal sanitation and running water, an epidemic of hand-scrubbing, body-washing, and tooth-brushing, and a raft of newfangled cleaning products to supply the ever-growing demand. It also lent scientific credibility to the old assumption that whiteness equaled cleanliness. With germs now understood as an "invisible enemy," white became a weapon with which to fight them. Germ theorists argued that white surfaces denied dirt the camouflage of darkness, making bacteria visible even to the naked eye, and easier therefore to remove. As a result, "hygienic" spaces, such as hospitals and laboratories, became whiter. The process also extended to the home, as the dark, ornate surfaces of Victorian water closets were steadily replaced by wipe-clean linoleum floors, white-tiled walls, and white enamel or porcelain sanitary ware—establishing the principles of the bathroom esthetic with which we began this chapter.[62]

Victorian thinkers invested their hygienic aspirations, as they did everything else, with moral and social meanings. They identified cleanliness with personal virtue and national progress and repeatedly mapped hygiene onto race, where—predictably—they equated white people with cleanliness and black people with filth. They weren't by any means the first to do so. Long before the modern racial terms "white" and "black" were understood, Europeans had fantasized about washing African skin whiter. Some had even attempted it—with little success.[63] The dream had already crystallized into a series of fables in antiquity. Here is one of them, composed by Aphthonius of Antioch in the fourth century CE:

> A man bought an Ethiopian slave with the idea that his color was the way it was because of the negligence of the previous owner. When he took him home he applied every kind of soap and tried to clean him in every sort of bath. Yet not only was he unable to change his color, he made the man ill from what he had been through. The fable shows that people's natures remain exactly as they first presented themselves.[64]

In the sixteenth century Erasmus condensed the story into three pithy Latin adages—*Aethiopem dealbare* ("to whiten an Ethiopian"), *Aethiopem lavas* ("you are washing an Ethiopian"), and *Aethiops non albescit* ("the Ethiopian does not whiten")—which gradually entered common parlance in most European languages to describe any futile labor or impossible task: if you were disciplining an intractable child, rehabilitating an inveterate criminal, or trying to repair an irreparable watch, you were said to be "washing the Ethiopian." The idioms remained popular well into modern times, acquiring renewed significance in the nineteenth century thanks to a controversial political process.[65]

As the hygiene movement colonized western societies, western societies colonized Africa. Between 1870 and 1900, European powers increased their direct control over the continent from 10 percent to 90 percent. They regularly used notions of hygiene to justify their conquests. Imperialists saw their standards of cleanliness—their double whiteness, if you will—as evidence of their superiority to their colonial subjects, as well as a potential gift to them. The idea was epitomized by one of the preeminent imperial commodities: soap. In

a Pears' Soap advert from the late 1890s a white-uniformed admiral washes his hands in a white basin. Around him, a montage illustrates the global reach of soap: cargo ships sail the seas, boxes are unloaded ashore, and a missionary offers the product to a grateful native. Beneath the images, the copy reads:

> The first step toward lightening the White Man's Burden is through teaching the virtues of cleanliness. Pears' Soap is a potent factor in brightening the dark corners of the earth as civilization advances, while among the cultured of all nations it holds the highest place—it is the ideal toilet soap.[66]

A. & F. Pears was run by Thomas Barratt, a businessman renowned for audacious and controversial advertising. He once imported a quarter of a million centimes from France, stamped "Pears" on them, then sent them back into circulation, forcing the British government to make foreign coins illegal tender.[67] Barratt's most notorious advert, which appeared in December 1884, as European powers gathered in Berlin to agree on a strategy for the conquest and partitioning of Africa, revisited an ancient obsession. It presented two illustrations demonstrating the miraculous power of Pears' Soap. The "before" image shows a young black boy in a bathtub while a British boy, wearing the white apron of the modern scientist, proffers a bar of soap. The "after" image depicts the outcome of the washing: from the neck down the black boy has turned as pale as his companion. Pears' Soap has accomplished the impossible: it has washed the Ethiopian white.

We might dismiss Pears' cheerful racism and heavy-handed marketing as the product of an earlier, more prejudiced age. But prejudices don't disappear quickly, and nor do cultural tropes. Western society continues to elide white skin and cleanliness, either consciously or unconsciously. Barely a year goes by without a major body care company channeling the spirit of Pears'. In October 2017, the American soap manufacturer Dove—now owned by the same company as Pears'—released an advert online in the United States: a black woman stands in a spotless white bathroom next to a white tub of Dove body wash; when she pulls off her T-shirt she is magically transformed into a white woman, who grins from ear to ear. Though she goes on to remove her shirt and become an Asian woman, it was the initial

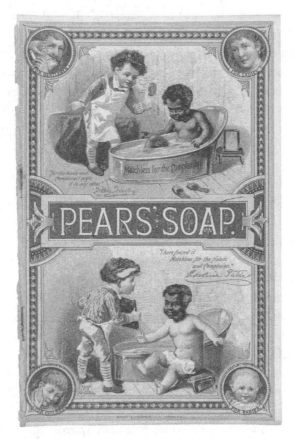

Pears' Soap advert from the 1880s

mutation that caught people's attention. The public and press decried the advert as racist, with many comparing it to its Victorian predecessors. It didn't take long for Dove's parent company, Unilever, to take down the video and issue an unreserved apology.[68]

A few months earlier, the German brand Nivea had made a more revealing error of judgment. In April they unveiled an advert for their latest nonstaining deodorant, "Invisible." It showed a woman in an immaculate white shirt gazing past a vase of white orchids to a view through a window. Beneath her, in capital letters, ran the sentence: "WHITE IS PURITY." Nivea posted the image online with the caption "Keep it clean, keep bright. Don't let anything ruin it. #Invisible." In one

simple image and a handful of words, the ad's makers alluded to some of white's most complex meanings: its interchangeability with invisibility, its susceptibility to corruption, and its enduring identification with physical and moral purity. But the public response also exposed the darker meanings that now clung to this brightest of colors. Though Nivea was widely condemned for flagrant racism, a minority rather liked what they saw. White supremacists shared the advert widely and approvingly, with one alt-right group posting the following on Nivea's Facebook page: "We enthusiastically support this new direction your company is taking. I'm glad we can all agree that #WhiteIsPurity."[69]

If white was ever pure, it surely isn't anymore. Over the last five centuries, and certainly since the Enlightenment, western thinkers have filled this supposedly empty color with so much esthetic, scientific, social, and racial meaning as to transform it into an ideology. Their preoccupation with whiteness was grounded in a desire to purify themselves and the world around them. But absolute white, like absolute purity, is an ideal that will never be realized, and whose pursuit can lead to confusion and catastrophe. We need only recall Captain Ahab's hunt for the great white whale in *Moby-Dick*—a creature whose pale skin evoked memories of marble statues and religious vestments, but whose ferocious jaws had left Ahab without a leg. Ahab dedicated the rest of his life to finding and killing his nemesis, but his quest concluded with his own death beneath a weltering sea. The only surviving member of Ahab's crew could never again think of white as pure. "There yet lurks an elusive something in the innermost idea of this hue," Ishmael reflects, "which strikes more of a panic to the soul than that redness which affrights in blood."[70]

6

Purple

The Synthetic Rainbow

As I look out of my window ... purple hands wave from open carriages—purple hands shake each other at street doors—purple hands threaten each other from opposite sides of the street; purple striped gowns cram barouches, jam up cabs, throng steamers, fill railway stations: all flying countryward, like so many purple birds of migrating Paradise; purple ribbons fill the windows, purple gowns circle out at shop entrances, purple feather fans beckon you in windows. We shall soon have purple omnibuses and purple houses ...

All the Year Round (1859)[1]

One day in the 1850s, a Prussian schoolboy conducted an experiment. He stretched a sheet of blotting paper across a table, filled a pipette with a solution of manganese and zinc sulfate, and carefully released a drop onto the page. Once it was dry, he deposited blue copper sulfate at the same spot, then repeated the process with iron oxide phosphoric acid, ammonia phosphoric acid, and cyanide calendium. As they bled into each other, the chemicals formed an image of exquisite complexity. Through squinted eyes this constellation of ripples and rivulets might be a supernova, a flower, or even the inside of a human body. It is made from three basic colors, which proliferate into every hue in the spectrum: yellows bubble up into lemons, apricots, and gold-oranges; blues wash between ultramarine and cerulean, turning oak-leaf green when they meet their neighbors; and at the center, an explosion of crimson metastasizes

into flesh-colored fingers, which on touching the blues become a palimpsest of purples (**Plate 40**).

The boy was working under the instructions of an eccentric German scientist with plenty of time on his hands. After being sacked from his job as an industrial chemist four years earlier, Friedlieb Ferdinand Runge had converted his small home in Oranienburg into a makeshift laboratory, where he began conducting experiments on blotting paper.[2] He became captivated by the resulting images, and grew convinced that they were of profound importance. "After everything, I think I can now assert," he wrote, "that in the formation of these pictures, a new, hitherto unknown force is active. It has nothing in common with magnetism, electricity or galvanism. It is not excited or aroused by something external, but lives inside the elements from the very beginning."[3] Runge's largely forgotten images, many of which were made by local schoolchildren, mark a significant moment in our history: they demonstrate that, after millennia, the "unknown force" of color was finally being deciphered.[4] Like other scientists of his generation, Runge realized that colors were grounded "inside the elements"—in the structure of chemicals and their interactions. These discoveries made it possible not only to extract and manipulate nature's hues, but to manufacture them from scratch.

The period between 1774 and 1849 is often called "The Age of Revolution," after the swarm of uprisings that began with the American War of Independence and concluded seven decades later with revolts all over Europe. These upheavals coincided with a series of intellectual and technological advances that together contributed to another revolution: a revolution in color. At the start of this period, the color industry was resolutely traditional. Most pigment and dye manufacturers relied on recipes passed down by their forefathers, unchanged for centuries if not millennia. But in the eighteenth century their colorific complacency was shaken to its core by the emerging discipline of chemistry. Working in laboratories around Europe, chemists discovered new elements and experimented with old ones, inventing one synthetic color after another.

The era arguably began in the first decade of the century, when Johann Jacob Diesbach accidently discovered a bright, stable pigment later

named Prussian blue, but it was only later that the breakthroughs came thick and fast.[5] The 1770s and 1780s produced emerald green and Scheele's green, both made from arsenic. In the 1790s, as mentioned in Chapter 3, the French chemist Louis Nicolas Vauquelin isolated chrome, making the powerful yellow that so bewitched Turner. In the years around 1802, Vauquelin's student Louis-Jacques Thénard invented cobalt blue. In 1817, another of his students, Friedrich Stromeyer, discovered cadmium, which gave rise to yellows, oranges, and reds of blazing intensity. And in 1828, three chemists working separately claimed the greatest prize of all: a synthetic version of ultramarine, chemically identical to the natural pigment but up to ten times cheaper.[6] By the middle of the century, European chemists had remade virtually every hue in the spectrum, creating pigments and dyes that were brighter, purer, and often much less expensive than their preindustrial equivalents. But one color would encapsulate this age like no other.

Purple is a chameleon of color. A mixture of red and blue, it is made when two ends of the spectrum come together. This might make it the most versatile color on the palette: it can rove from all-but-red to all-but-blue and never cease to be purple. It can be light and dark, hot and cold, belligerent and bashful—occasionally all at the same time. In spite of these many moods, purple is rare in nature. Few organic compounds can pull off the precarious balancing act on which it depends, reflecting short and long wavelengths of light while absorbing the narrow range between them. For both of these reasons purple doesn't have a clear, elemental analog like black (darkness) or red (blood) or yellow (the sun). Its most persistent meanings originate instead in our long struggle to possess it. Purple's natural scarcity forced people to develop ingenious and elaborate manufacturing methods, lending the resulting colorants an aura of mystery and luxury. Over time, purple itself acquired associations with both technology and decadence—associations that began in antiquity but, as we shall see, were thrillingly reinvented in the nineteenth century.

History's most illustrious purple was so splendid, and so revered, that civilizations were built around it. Tyrian purple was manufactured on the Syro-Phoenician coast from as early as the fifteenth century BCE and became so closely identified with the area that the region's names—"Canaan" and "Phoenicia"—might originally have

meant "land of purple" in ancient Mesopotamian.[7] The dye was made from a group of shellfish, primarily *Hexaplex trunculus* and *Bolinas brandaris*. The molluscs' shells were crushed, and the hypobranchial gland, which secreted a small quantity of toxic mucus, extracted. This unpleasant fluid was steeped in saltwater for three days then gently simmered in lead vats for a further nine. By all accounts the process released an unbearable stench—a mix of rotting flesh, asafetida, and garlic breath—but it also produced a spectrum of seductive hues, from sky blue to deep scarlet.[8] The most desirable of them was an unfathomably deep purple that Pliny compared to a "dark rose," "clotted blood," and "the hue of darkness."[9]

Production was labor-intensive: 9,000–10,000 molluscs were required to make just a single gram of the dye. This made the product exorbitantly expensive.[10] In the Roman Emperor Domitian's *Edict on Maximum Prices* (301 CE), which catalogued and costed more than a thousand commodities, a pound of the finest Tyrian purple silk was priced at up to 150,000 denarii—seventy-five times more expensive than saffron, more than twice as expensive as gold, and five times the price of a healthy male slave. The only item on the list to match its astronomical cost was a "first-class" male lion. Let us put these eye-opening figures into another perspective: a typical fourth-century farm laborer earned roughly 25 denarii per day; in the unlikely event of his aspiring to purchase even a handful of purple silk (and assuming he saved every denarius), he would have needed to work flat out for twenty-four years.[11]

Tyrian purple was worn by the rich and powerful in the Near East from the fourteenth century BCE, and later in Persia and Greece.[12] For the status-obsessed Romans it occupied the zenith of a sartorial system in which the quantity and quality of the color was an index of rank. While ordinary citizens made do with an off-white *toga pura*, magistrates and high priests wore the purple-hemmed *toga praetexta*, equestrians' garments were decorated with a thin purple stripe (*angustus clavus*), senators were permitted to wear wide purple stripes (*latus clavus*), while triumphal generals and emperors donned an all-purple *toga picta*. The Romans developed what Pliny called such a "mad lust" for the color that the authorities felt compelled to regulate it.[13] Nero closed shops that sold it, Caligula sequestered it for official purposes,

and Diocletian commandeered the dye workshops at Tyre. In the eastern part of the empire, known as Byzantium, the color was renamed "imperial" or "royal purple" and became an exclusive symbol of the emperor. Under Theodosius II anyone found making, buying, wearing, or even owning Tyrian purple fabrics could be charged with treason—a crime punishable by death.[14] But here purple's imperial connotations weren't confined to silk. Byzantine rulers were equally covetous of purple marble: their children were born in a sacred chamber of the Great Palace of Constantinople that was entirely decorated in porphyry. From the tenth century, some were even given a suffix that is still used, in a different context, today: *porphyrogenitus*—"born in the purple."[15]

Large-scale production of Tyrian purple ceased after the fall of Constantinople in 1453, and the recipe was lost soon thereafter. But its associations endured. In later centuries, the product acquired almost legendary status, establishing a connection with luxury that still survives. To speak of a writer's "purple prose" or a sportsman's "purple patch" is to refer—albeit unconsciously—to a lavish dye that hasn't been made for 600 years.[16] In the 1850s, however, a cluster of European chemists produced a series of dyes that equaled the purple of Tyre in both richness and fame, and in doing so updated its ancient meanings for the modern, industrial world.

PERKIN PORPHYROGENITUS

Though recognized today as a benign substance—used, among other things, to treat dry scalps—coal tar in the nineteenth century was a menace. A waste product of coal gas combustion (one of the primary fuels of the industrial revolution), this pungent black slime clogged up pipes, leaked into streets, and stuck to shoes. Victorians went to great lengths to dispose of it: burning it, burying it, dumping it into rivers, and giving it to anyone willing to take it. Its only admirers, it seems, were chemists, some of whom were rightly convinced of its potential. Coal tar contains thousands of beautifully complex hydrocarbon compounds, many of which remain unidentified, but one of which is aniline. Since first isolating it in the 1820s, chemists knew

that aniline possessed formidable color-making properties (Friedlieb Runge himself had used it to make a vivid violet-blue liquid), naming it after the Porturguese (*anil*) and Spanish (*añil*) words for "indigo."[17] None, however, had converted it into a feasible dyestuff—until Henry Perkin.[18]

Perkin was born in London in 1838 to a family of builders. He was expected to follow a similar path, but a chance discovery led him to a quite different trade. He was twelve years old when a friend showed him a rudimentary chemistry set, and in a series of simple experiments demonstrated "the wonderful power of substances to crystallize into definite forms."[19] Young Henry was bewitched. Over the next few years, he amassed a collection of chemicals and spent his spare time investigating their properties. He attended twice-weekly chemistry lectures during the dinner interval at school, and at fifteen joined the Royal College of Chemistry, where he was taught by the distinguished German chemist August Wilhelm von Hofmann (a man who, in a rare unguarded moment, had called aniline his "first love").[20] Within two years, he was Hofmann's honorary assistant. But his curiosity couldn't be contained by his institution. He built himself a primitive laboratory on the top floor of his parents' home in Shadwell and made combustions in the garden shed.

Perkin was eighteen when he conducted the experiment that changed his life. It was the Easter vacation of 1856, and he was attempting the holy grail of organic synthesis. Quinine, at that time the only effective treatment for malaria, had been extracted from the bark of the South American cinchona tree for centuries, but the cinchona's scarcity made it extremely expensive. Chemists had attempted to synthesize it for decades, but without success.[21] Knowing quinine's formula to be $C_{20}H_{24}N_2O_2$, and naively believing that chemical synthesis was a simple numbers game, Perkin assumed that he could create the compound by adding oxygen to two molecules of allyltoluidine ($C_{10}H_{13}N$). When this failed, he tried again with a different ingredient. He grabbed a beaker of aniline, given to him a few days earlier by Hofmann, and treated the colorless oily fluid with sulfate of potassium dichromate. Again he failed, producing only an ugly black precipitate. At this point many chemists might have shrugged their shoulders and moved on. But Perkin was intrigued by the sediment at the bottom of his test tube.

When he dissolved the black sludge in methylated spirit, it blossomed into a rich and radiant purple.[22]

Working with his brother, Perkin spent the spring and early summer refining his method. Within a couple of weeks, he had prepared a few ounces of the product. He dyed several samples of silk and sent them to a respected dye-house in Perth. Robert Pullar, who ran the firm, was impressed. "This color is one which has been very much wanted in all classes of goods," he replied in June 1856. "If your discovery does not make the goods too expensive, it is decidedly one of the most valuable that has come out for a very long time."[23] It's not hard to understand Pullar's enthusiasm: the earliest surviving samples are perfectly poised between red and blue, reverberatingly intense, and possess a uniformity of hue that is rare in natural dyes (**Plate 41**). Some of these swatches are more than 150 years old but look as vivid as the brightest textiles found today.

After verifying with a solicitor that he was old enough to do so, Perkin submitted a patent for his new dye on August 26 and by October felt sufficiently confident to withdraw from the Royal College of Chemistry.[24] Hofmann warned the young man that he was throwing away a promising scientific career, but Perkin was not to be discouraged. In the spring of 1857, he persuaded his father—whose faith in his son's abilities never erred—to lend him his lifetime's savings, which he used to purchase a site at Greenford Green near Harrow. In June, despite never having set foot inside a chemical works before, the Perkins began constructing their dye factory. It was completed six months later. By December the first cases of aniline purple were being distributed to textile manufacturers under the trade name "Tyrian Purple."[25]

Perkin's timing couldn't have been better. In the years immediately before the release of his product, other new purples had appeared in Britain, whetting public appetites for the exotic hue. The most successful of them, made with uric acid extracted from guano (accumulated bird droppings gathered on islands off the coast of Peru), was manufactured in Manchester from 1855. Called Murexide or Roman Purple, it too was compared to the great dye from Tyre.[26] Demand for lilacs, violets, heliotropes, amaranths, and pinks grew in the first half of 1857, and by August they were apparently "quite the rage."[27] The colors were promoted in Paris by Empress Eugénie—widely dubbed the

"Empress of fashion"—who wore a lilac silk dress and a bonnet trimmed with lilac tufts at an event that summer; the garments were dyed with a lichen-based product with the brand name French Purple. The following January, Queen Victoria followed suit, wearing a lilac velvet dress with a violet and silver petticoat to her daughter's wedding.[28] She wore the color several times over the next few months, which the press later labeled "Queen's Lilac."[29] Like the ancient ones before it, modern purples had already acquired regal connotations.

In France these new colors were called *mauve*, after the lilac mallow flower, which blossomed across Europe between March and June in such uncontrollable quantities that it was widely considered a weed.[30] Perkin couldn't speak French, but as he scoured newspapers and magazines for information about his competitors he must have encountered, and admired, the word. In the first half of 1858 he decided to capitalize on its continental cachet and rebrand "Tyrian Purple" as "Mauve," invoking not the distant past but the modish present.[31] Within a few months it had eclipsed all other lilac dyes on the market, attracting rhapsodic praise in the press.

> It is rich and pure, and fit for anything; be it fan, slipper, gown, ribbon, handkerchief, tie, or glove. It will lend luster to the soft changeless twilight of ladies' eyes—it will take any shape to find an excuse to flutter round her neck—to cling (as the wind blows it) up to her lips—to kiss her foot—to whisper at her ear. O Perkins's [*sic*] purple, thou are a lucky and a favored color![32]

When the dye became affordable enough to be purchased by the middle classes, "Mauve mania" spread through the country like wildflowers. The Epsom races in May 1858 were awash with it, as were London's summer balls.[33] By early 1859 it was being likened to a contagious disease. In its first edition of the year, *Punch*—which nicknamed the dye *mauvais*—claimed the British Isles had been infected with "mauve measles."

> Lovely woman is just now afflicted with a malady which apparently is spreading to so serious an extent that it is high time to consider by what means it may be checked. As the complaint is quite a new one, doctors disagree of course as to its origin and nature. There are many

who regard it as of purely English growth, and from the effect which it produces on the mind contend it must be treated as a form of mild insanity. Other learned men, however, including Dr. Punch, are disposed rather to view it as a kind of epidemic, and to ascribe its origin entirely to the French. Although the mind is certainly affected by the malady, it is chiefly on the body that its effects are noticeable: and having most maturely considered the complaint, Dr. Punch is of opinion that it is not so much a mania as a species of measles. The main reason which inclines Dr. Punch to this opinion is, that one of the first symptoms by which the malady declares itself consists in the eruption of a measly rash of ribbons, about the head and neck of the person who has caught it. The eruption, which is of a *mauve* color, soon spreads, until in some cases the sufferer becomes completely covered with it. Arms, hands, and even feet are rapidly disfigured by the one prevailing hue, and, strange as it may seem, the face even looks tinted with it. Like the other form of measles, the *mauve* complaint is very catching: indeed, cases might be cited, where the lady of the house having taken the infection, all the family have caught it before the week was out.[34]

In the 1860s, mauve migrated from dresses, ribbons, and bonnets to morning suits, school uniforms, wallpapers, leather-bound books, household appliances, even confectionary. In 1867 the British Post Office made it the color of sixpenny postage stamps, which appeared in their billions until 1880. In doing so, they made it possible for any member of the public to purchase, for the cost of a few pints of beer, a piece of their own imperial purple, complete with a portrait of the Queen. A color once almost impossible to acquire had become almost impossible to avoid.[35]

By 1860, Perkin's purple was a global sensation, appearing everywhere from San Francisco to Hong Kong and making the young chemist from Shadwell sufficiently wealthy to retire from business at the age of thirty-six and devote the rest of his career to chemical research. He was immortalized by the British press as a hero of the industrial age, the boy genius who had used modern science to unlock the secrets of Tyrian Purple. Journalists likened him to Hector, to Agamemnon, even the Roman emperors. "We hail thee, Perkins [*sic*], Prince, Imperator!" declared *Vanity Fair*. "Thou might have had a

more musical name, but 'twill pass. 'Twill do to swear by King Per-
kins the first. Not so bad, after all, PERKINS Porphyrogenitus."[36]

THE BATTLE FOR MAGENTA

As soon as Perkin published his method, European chemists began
subjecting aniline to every oxidizing agent known to the nineteenth
century in a quest for their own coal tar gold mine. The first to achieve
anything of significance was the Lyon-based schoolteacher François-
Emmanuel Verguin. At some point in early 1859, he combined aniline
with stannic chloride to produce a dye that was perhaps even more
beautiful than Perkin's. Verguin's colorant was warmer than mauve—in
fact, almost crimson—but shared its predecessor's shrill synthetic tim-
bre. With franc signs flashing before his eyes, Verguin partnered with a
local silk-dyeing firm called Renard Frères, obtaining a patent for his
invention in April.[37] The firm started manufacturing the dye in Novem-
ber, which, following Perkin, they named after a flowering plant.
Fuchsine was a fitting moniker: the fuchsia's red-purple sepals closely
resembled the color of their dye (its petals, by wonderful coincidence,
are mauve), and *Fuchs*—which meant "fox" in German—translated to
renard in French.[38]

Across the Channel, Edward Chambers Nicholson—another of Hof-
mann's students—was also attempting to climb aboard the aniline
bandwagon, and in early 1859 requested from Perkin a license to man-
ufacture mauve. After Perkin refused, he and a friend decided to develop
their own purple dyes, though none proved commercially viable.[39] That
winter, however, Nicholson, made a breakthrough. Combining aniline
with arsenic acid, he synthesized a crimson that was virtually identical
to Verguin's. He named it Roseine. On January 25, 1860, he hurried to
Chancery Lane to apply for a patent, only to discover that yet another
of Hofmann's students, Henry Medlock, had taken out a similar license
only seven days earlier. Nicholson withdrew his application, tracked
down Medlock, and resentfully purchased the rights to his rival's recipe
for £2,000.[40]

Within months, Nicholson's company (Simpson, Maule & Nichol-
son) was manufacturing the dye under the trade name "Magenta."

26. A combination of deep blue lazurite, streaks of white calcite, and specks of golden pyrite, lapis lazuli resembles a fragment of the firmament

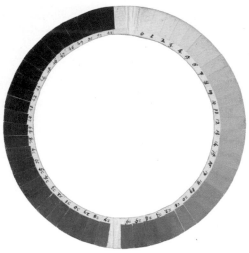

27. Horace-Bénédict de Saussure's cyanometer, used by the explorer to measure the blueness of the sky

28. Wassily Kandinsky's *Improvisation 19* (also known as *Blue Sound*) is dominated by an exuberant blue haze that seems to transfigure the figures who pass through it

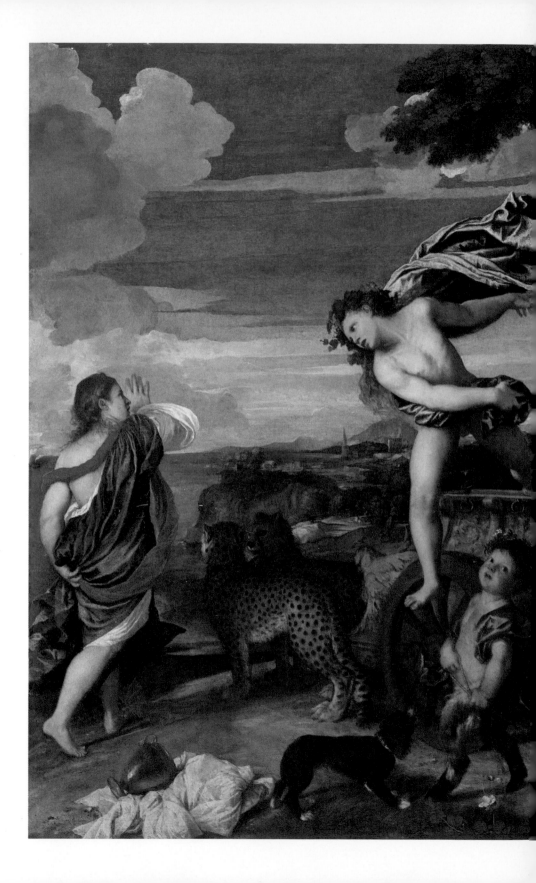

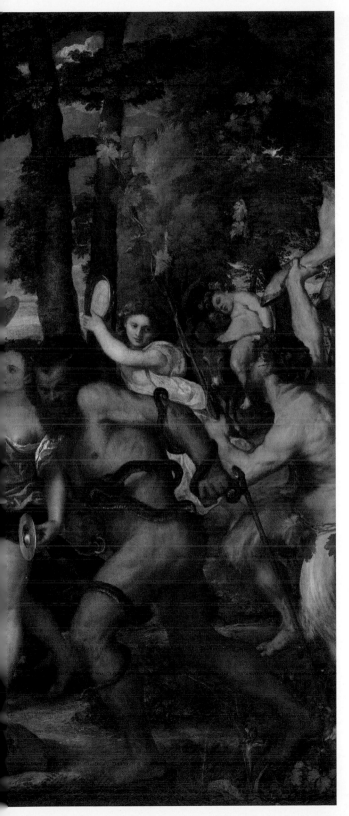

29. Titian's *Bacchus and Ariadne* was made from the most exotic and expensive pigments available in sixteenth-century Venice. It features some of the purest ultramarine ever identified in the history of art

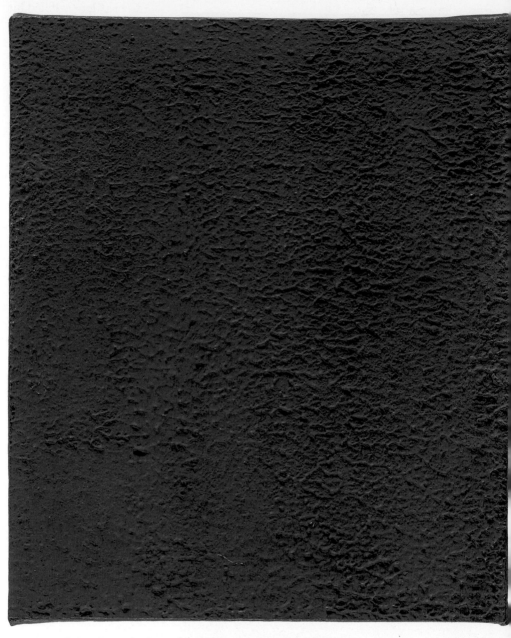

30. Yves Klein's monochromes, in his signature IKB pigment, are so intense that they seem to vibrate on the retina

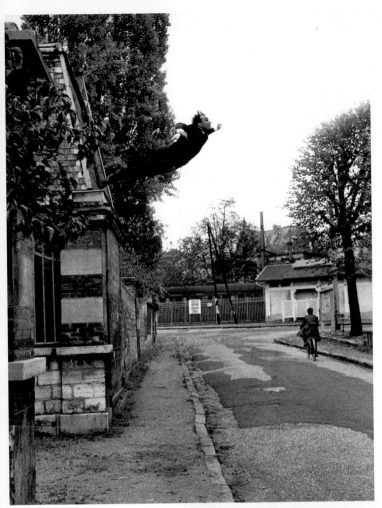

31. Klein fulfilled his dream of venturing into empty space in October 1960 by jumping off a building in the suburbs of Paris. He called his performance *Leap into the Void*

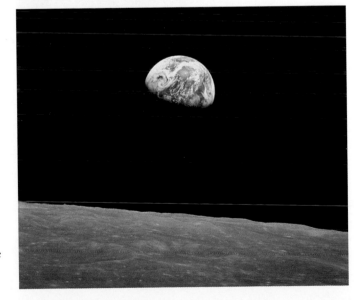

32. As they orbited the moon in December 1968, the crew of Apollo 8 photographed their own blue planet emerging from behind the lunar surface. *Earthrise* is now one of the most celebrated images of the twentieth century

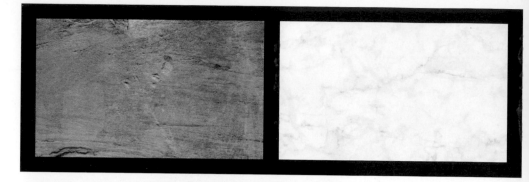

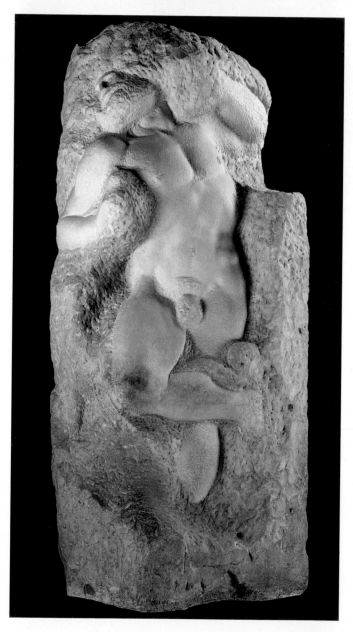

33–34. Seen side by side, the two defining marbles of antiquity look very different. Pentelic stone, used in ancient Greece, is brown with impurities, while Carraran stone, used in ancient Rome and during the Italian Renaissance, is white with faint gray veins

35. Michelangelo was obsessed with the purity of Carraran marble and believed that by cutting away its imperfections he could release the figures within—though in this unfinished work the slave will never be free

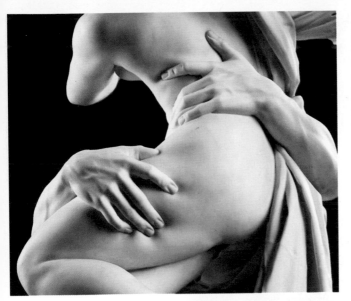

36. Bernini had a special talent for transforming hard stone into supple flesh. In this sculpture, of the rape or kidnap of Proserpina, the victim's skin seems delicate enough to bruise

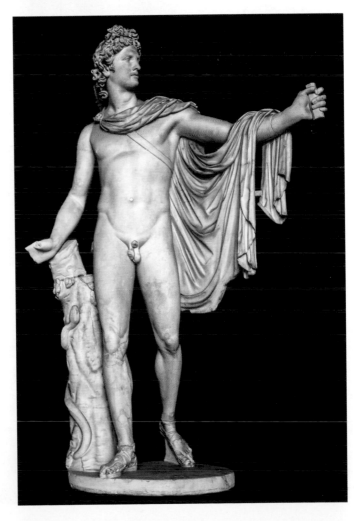

37. Johann Joachim Winckelmann saw the *Apollo Belvedere*, and its purported whiteness, as a paragon of ancient Greek civilization

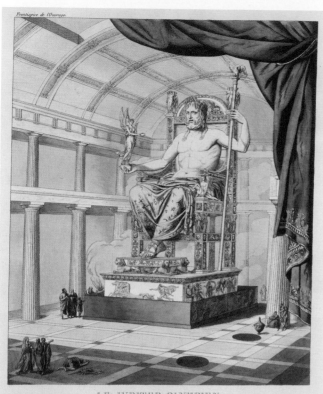

LE JUPITER OLYMPIEN,
VU DANS SON TRÔNE ET DANS L'INTERIEUR DE SON TEMPLE.

38. Antoine-Chrysostome Quatremère de Quincy reimagined the many lost colors that once adorned the monuments of antiquity: this is Phidias' statue of Zeus at Olympia

39. One of the Parthenon marbles at the British Museum after an attempt to restore its supposed original whiteness. One critic described the sculpture as having been "skinned"

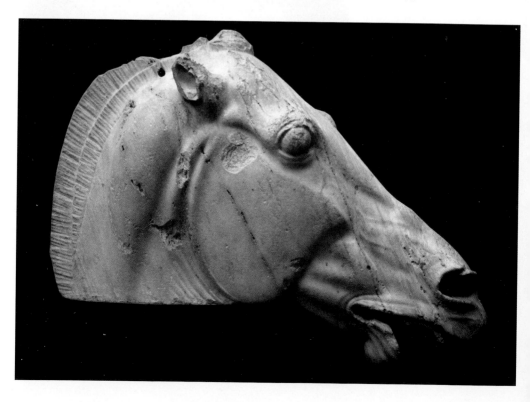

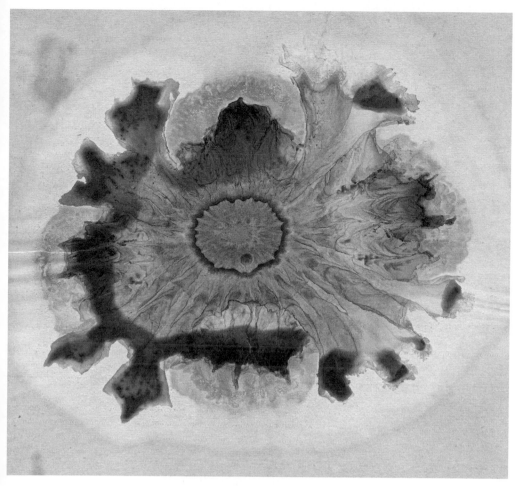

40. In the 1850s, Friedlieb Runge interrogated the hidden causes of color by mixing chemicals on blotting paper

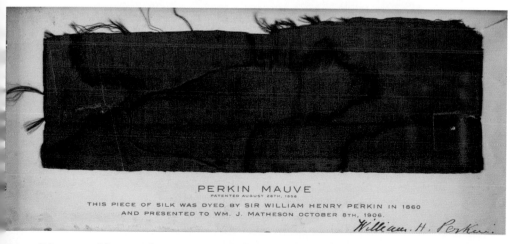

PERKIN MAUVE
PATENTED AUGUST 26TH, 1856
THIS PIECE OF SILK WAS DYED BY SIR WILLIAM HENRY PERKIN IN 1860
AND PRESENTED TO WM. J. MATHESON OCTOBER 8TH, 1906.

William. H. Perkin

41. Discovered by accident in 1856, William Henry Perkin's mauve triggered a new era in synthetic dyestuffs

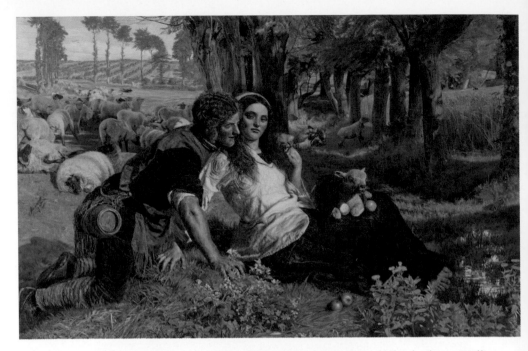

42. One of the first modern paintings with violet, rather than dark, shadows, William Holman Hunt's *The Hireling Shepherd* (1851) fizzes with "all the color of luscious summer"

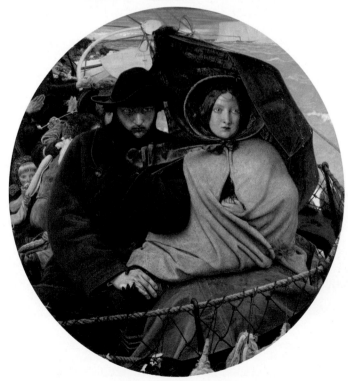

43. The most striking feature of Ford Madox Brown's *The Last of England* (1852–1855) is a magenta ribbon that alone took him four weeks to paint

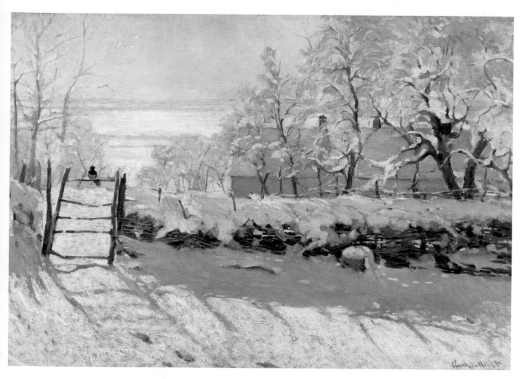

44. Claude Monet's early masterpiece *The Magpie* (1868–1869) transforms an ostensibly white landscape into a playground of blues, pinks, and purples

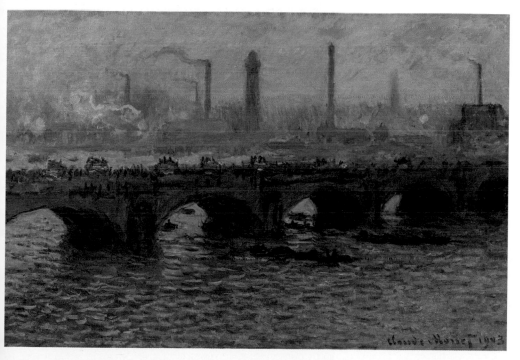

45. Monet was captivated by the optical effects of London smog. In this view of Waterloo Bridge he smothers the city's industrial skyline with synthetic purple emissions

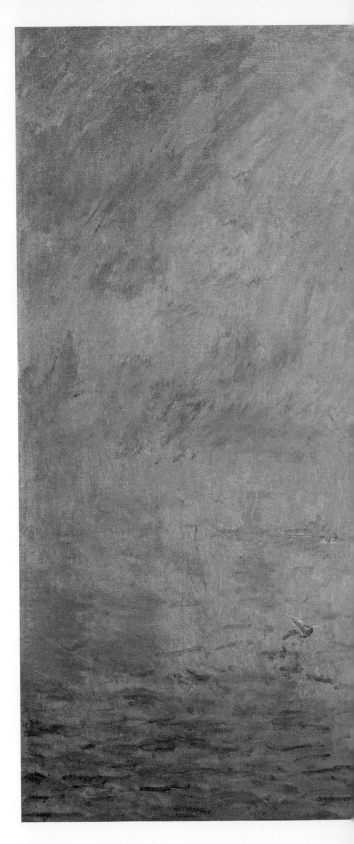

46. Monet's *The Houses of Parliament, Seagulls* is a pageant of purples. Near the center, two mysterious mauve blobs float like ghosts above the water

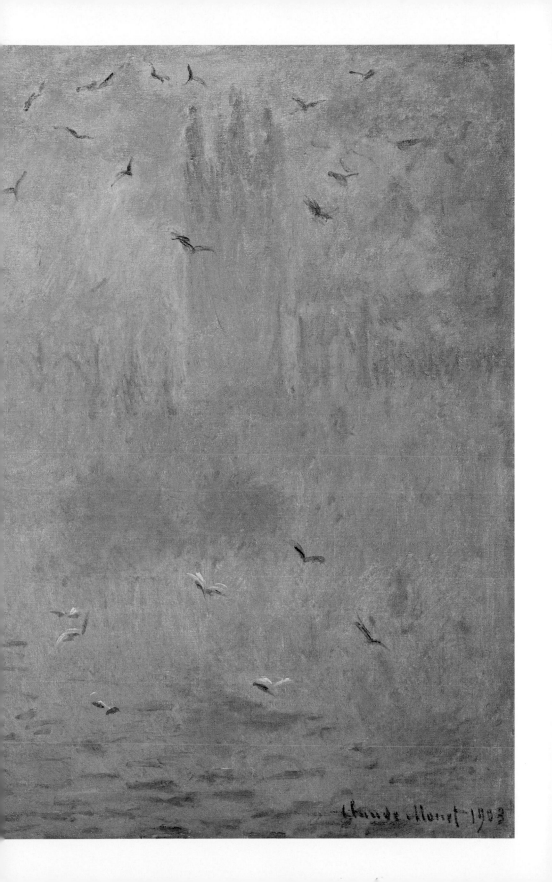

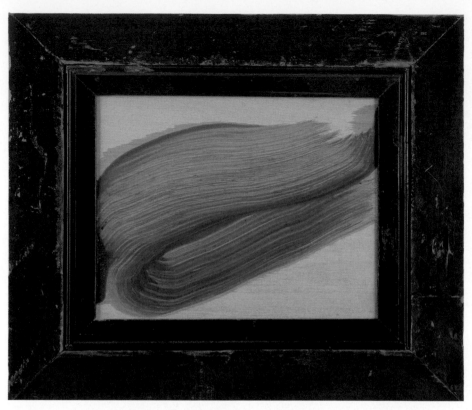

47. Howard Hodgkin's *Leaf* distills one of the most enduring color associations—between green and vegetation—to its essentials

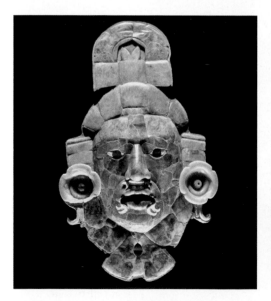

48. A Maya death mask, fashioned between 660 and 750 CE from plant-green jade, teems with agricultural symbolism

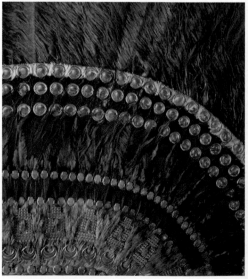

49. A replica of Moctezuma's Headdress, made from the feathers of lovely cotingas, roseate spoonbills, squirrel cuckoos, and crowned by 450 green quetzal plumes

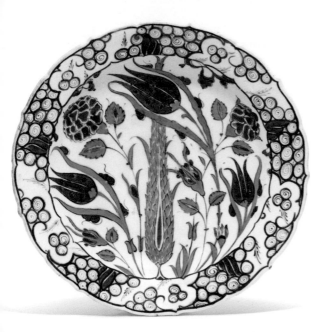

50. Islamic artists were masters of greens and blues. This Iznik dish, from about 1570, features a vivid emerald-green glaze invented only a few years earlier

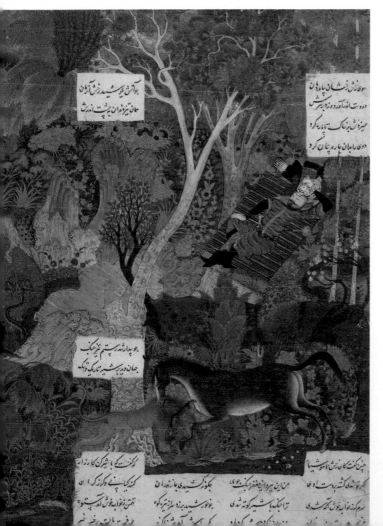

51. A sixteenth-century miniature showing the Persian hero Rostam asleep in a landscape while his horse fights a lion. The artist has taken great care to depict the many greens of the forest

52. David Nash's *Oak Leaves Through May* (2016) likewise captures the myriad colors of nature—in this case the changing hues of young oak leaves toward the end of spring

53. An act of faith amid a growing environmental crisis: twenty-two ash trees planted by Nash in Wales in 1977, and patiently trained over the decades into the form of a dome

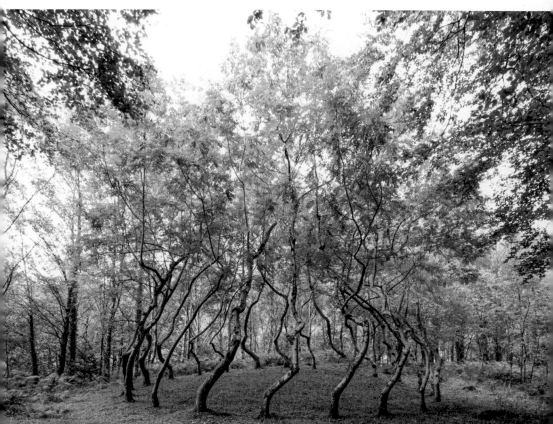

This might now seem like an obvious designation for a color—it is the "M" in every CMYK printing process—but at that point the word had rather different connotations. In 1860, its most famous reference point was a bloody battle from the previous year, when French and Sardinian troops defeated the Austrian army at the northern Italian town of Magenta.[41] "You never saw such a frightful scene of carnage," wrote a traumatized correspondent for *The Times* in its aftermath. "It is like the remains of a great rag fair; shakoes, knapsacks, muskets, shoes, cloaks, tunics, linen, all stained with blood."[42] Some historians have assumed that Nicholson and his colleagues wanted to identify their reddish dye with the bloodstained battlefield. It seems more likely that they were simply capitalizing on a vogue. Most British people supported the Italian struggle for independence. After that famous victory over the Habsburg Empire, the name "Magenta" briefly became fashionable—and was also applied to country houses, lipsticks, even newborn babies.[43]

For a few years, magenta was even more ubiquitous than mauve. By the end of 1860, there were magenta books, carpets, ties, opera cloaks, and shirts (though shirtmakers advised customers to mitigate its vividness with blacks and grays), and the dye was being sold for "universal use" by the bottle.[44] At London's International Exhibition in 1862 Nicholson's firm displayed a crown made from crystallized salts of aniline that was reportedly worth upward of £8,000. Hofmann, a man not prone to hyperbole, proclaimed that "no mortal eye" had ever seen anything so splendid.[45] A rumor began to circulate that the crown, which flashed between deep crimson and metallic green, could dye the entire length of the Thames magenta.[46] The exhibition certainly established the color as a common term. When a Londoner lost his pet parrot in October of that year, he issued a notice in *The Times* that offered a ten-shilling reward for anyone who found it. The bird's distinguishing features? It was "green, with magenta colored wings."[47]

Today, when colors are both plentiful and affordable, it is difficult to imagine a simple dye being controversial. But in the Victorian world, colorants were fiercely contested—and magenta provoked a commercial battle that was almost as ferocious as its namesake. At the peak of its success, Nicholson learned that other companies were violating the

patent he had acquired at such expense from Medlock. He spent much of 1863 and 1864 issuing threats to his enemies in the press. "Notice is hereby given," ran one in *The Times*, "that all persons manufacturing, selling, or using such dyes will be PROSECUTED to the utmost rigor of the law."[48] The seeds of the dispute had been sown a few years earlier when two French chemists obtained a patent for an arsenic-based aniline crimson that seeemed uncannily similar to Nicholson's. Their recipe made its way to England, where it was manufactured by a company called Read Holliday. Nicholson sued, and over five days in June and July 1864 "the Magenta Dye Case" was heard by the vice-chancellor's court.

The dispute hinged on the meaning of one word—"dry"—in Medlock's original patent, which described the raw ingredients of his "rich purple color" as "aniline" and "dry arsenic acid."[49] This was significant because truly "dry" arsenic acid couldn't actually produce the necessary dye. Simpson, Maule & Nicholson used an arsenic acid solution, as did Read Holliday. Read Holliday therefore argued that Medlock's patent didn't cover their own method. The trial degenerated into a protracted debate about the meaning of an adjective: Holliday's barristers claimed that "dry" meant dry, Nicholson's that it could actually contain up to 13 percent water. The vice-chancellor ruled in favor of Nicholson, but in January 1865 the lord chancellor judged Medlock's patent too inaccurate to be binding and overturned the verdict.[50] The defeat must have been immensely galling, not least because Nicholson's own original method, which he had discarded to purchase Medlock's patent, would have protected him all along.[51]

In the meantime, a similar dispute was raging in France. The Renard brothers, who held Verguin's original 1859 patent, had grown immensely rich from Fuchsine: between 1860 and 1863 they made 2.5 million francs simply by licensing it to Nicholson's rivals. But as in England, other companies had started to manufacture similar products without permission. The ensuing legal proceedings lasted more than three years, reaching Paris' Imperial Court in March 1863, where a favorable ruling effectively granted Renard Frères a monopoly.[52] The Renards didn't hesitate to exploit their victory: in December they set up a joint-stock company called La Fuchsine, snapped up factories in France and England, bought huge stockpiles of aniline, and took over any company they considered to be a competitor. The strategy was

ill-judged. La Fuchsine lost a million francs in its first year, and its stakeholders couldn't agree on a recovery plan. By 1868, the company was almost bankrupt.[53]

The pioneers had in a way become victims of their own success. In the decade following Henry Perkin's serendipitous discovery, so many aniline colors entered the market that a monopoly on just one of them counted for little. By the end of the 1860s, consumers could choose between Regina Purple, Parma Violet, Britannia Violet, Imperial Violet, Phoenicine, Violaniline, Chrystoluidine, Geranosine, Safranine, Indisine, and Harmaline, as well as a range of violet dyes invented by Hofmann himself (which Perkin called "the most brilliant color of any which had been produced").[54] These trade names (and there were many more) are extremely revealing. They suggest that purple's most stable meanings, with their roots in antiquity, were beginning to change. The luxurious, imperial, oriental associations of Tyrian purple were still there, but they were now joined by a new set of qualities—expressed by chemical nomenclatures and "ine" suffixes—drawn from a modern age of synthetic chemistry and industrial manufacturing.

We often think the past is less colorful than the present, perhaps because we're accustomed to seeing it through sepia photographs and black-and-white films. And yet the inventions of the 1850s and '60s give the lie to such assumptions. In those decades, organic chemists created from coal tar a spectrum of colorants that were no less brilliant than our own. The nineteenth-century world was in fact so saturated with color that some people couldn't cope. When the conservative French critic Hippolyte Taine visited England in the 1860s, he was appalled by the "outrageously crude" colors of people's clothes, and on a Sunday stroll through Hyde Park, struggled even to keep his eyes open. "The glare and glitter is brutal."[55] To the Victorian public, though, the genesis of these dyes was little short of miraculous. Coal tar's transformation from a black nuisance into a radiant rainbow seemed to them a triumph of industrial alchemy. This is how Thomas Salter in his 1869 revision of George Field's *Chromatography* described it:

> Previous to the year 1856 the coloring matters derived from coal-tar were practically unknown. Until then, that black evil-smelling substance was looked upon as almost worthless; but gradually the unsightly grub

emerged into a beautiful butterfly, clothed first in mauve and next in magenta. After its long winter of neglect, there sprung from coal-tar the most vivid and varied hues like flowers from the earth at spring. At a touch of the fairy wand of science, the waste land became a garden of tropic tints, and color succeeded color, until the whole gamut had been gone through. Never was transformation more dazzling or more complete . . . The world rubbed its eyes with astonishment; and truly it seemed almost as wonderful to produce the colors of the rainbow from a lump of coal, as to extract sunshine from cucumbers.[56]

Over the next fifty years, the cucumber-sunshine business increased in value by 3,800 percent. By 1913, there were as many as 2,000 synthetic dyes on the market, all originating in just nine coal tar compounds.[57]

VIOLETTOMANIA

Purple isn't plentiful in the history of art. A recent study, examining almost 140,000 artworks, found it in only 0.06 percent of paintings before the middle of the nineteenth century.[58] The reason is partly practical. For most of history, as we have seen, pure purple pigments were rare, and painters were reluctant to mix valuable blues and reds to simulate them. Artists also learned that purple aged badly: most varnishes slowly turn yellow, desaturating the complementaries they protect. Nineteenth-century artists had a handful of adequate purples at their disposal, but none was perfect: Mars violet inclined to maroon, purple madder was difficult to acquire in useful quantities, and cobalt violet—invented in France in 1859—was prohibitively expensive, so rarely used.[59] Some colormen converted coal tar dyes into usable paints, but their experiments typically resulted in unpleasant brown stains (not for nothing did James McNeill Whistler dub them "*analine*").[60] But in spite of these many challenges, the proliferation of purple fabrics in the 1850s coincided with an unprecedented craze for the hue in European art.

The Pre-Raphaelite Brotherhood's interest in purple was initially part of a wider rebellion. The founding members of the group—William Holman Hunt, John Everett Millais, and Dante Gabriel Rossetti

(middle names, it seems, were mandatory)—had studied at the Royal Academy, where its first president's principles still held sway. In his *Discourses* (1769–1790), Sir Joshua Reynolds had repeatedly insisted that artists not only subordinate individual hues to overall harmonies of light and shade but prioritize warm tones over cold. "The masses of light in a picture be always of a warm mellow color, yellow, red, or a yellowish-white," he insisted, while cold colors should be "kept almost entirely out of these masses, and be used only to support and set off these warm colors."[61] Reynolds' advice inspired a century of paintings—called "slosh" by the Pre-Raphaelites—that generally eschewed purple. "With all this subserviency to early example," Millais asked, "when the turn of violet comes, why does the courage of the modern imitator fail? If you notice, a clean purple is scarcely ever given these days."[62]

The Pre-Raphaelites aimed to remedy this chromatic deficit. Formally establishing their group in the revolutionary year of 1848, they abandoned the common practice of working on midtoned surfaces, opting instead for bright white grounds.[63] They chose the most vivid modern pigments: cadmiums, chromes, and cobalts, emerald green and viridian, strontium yellow, zinc white, and French ultramarine. They blended them not with linseed oil (which yellowed the colors) but with poppy or nut oil, and added a copal resin that brought the oil's refractive index close to that of the pigments, maximizing their power. Hunt applied his paint in such thin and translucent glazes that the ground shone through them like light through stained glass. He avoided mixing colors, knowing that every mixture reduced intensity, and studiously avoided black. In defiance of Reynolds' notion of tonal harmonies, he placed pure pigments next to each other—where possible in jarring combinations.[64]

These innovations are clear in Hunt's *The Hireling Shepherd*, which he started in the summer of 1851 and exhibited at the Royal Academy the following year (**Plate 42**). The painting depicts a lusty shepherd who is so busy seducing a farm girl that he forgets about his flock. As he shows her a death's-head hawkmoth he has just captured, his unsupervised sheep misbehave: one is already eating its way through a field of wheat. The image is traditionally interpreted as an allegorical attack on the Victorian clergy (the shepherd) for neglecting their congregation

(the sheep) and so bringing the nation (the countryside) into disre-pair.[65] But its real power lies in its optical intensity. Hunt's picture is so brilliant that it burns. Aiming to capture "all the color of luscious sum-mer," he amassed an orchestra of high-keyed hues. Irradiating yellows and humming blues jostle for attention with near-fluorescent crimsons and indigestibly unripe greens.[66] Hunt intended this firecracker of a painting to shock, and the critics duly obliged him. One called it "ludi-crous and repulsive"; another condemned its "rainbow sheep"; another wrote that its red-faced protagonists appeared to have been "fed on madder or been busy with raspberries."[67]

At first glance, the one hue missing from Hunt's painting is purple. Look closer, however, and you will see it creeping up tree trunks, extend-ing across harvested fields, alighting in thatches of muddy grass, hiding in white flower petals, and twinkling in the plumage of birds. The clouds are fringed with purple; the distant haystacks are made of softened magenta and faded indigo; violets hem the sheep like coal tar halos and explode into a starburst of lines beneath the shepherd's amorous eyelashes. Whenever I look at this painting, I think of Alice Walker's novel *The Color Purple*. About two-thirds of the way into the book, the blues singer Shug Avery is discussing her Creator with the down-trodden narrator Celie. "I think it pisses off God," she says, "if you walk by the color purple in a field somewhere and don't notice it."[68] William Holman Hunt could never have been accused of such inat-tention: he saw purple everywhere.

Hunt's purples are noteworthy because they inhabit the shadows. Before Hunt—and for a long time after him—most European artists thought shadows were simply dark. In most cases they therefore added varying quantities of black paint to a given local color (the color of an object in normal light conditions) to drive it down to darkness. It was a straightforward and effective technique, and when used well (as it had been by Rembrandt, Velázquez, and Caravaggio), produced believ-able illusions of light and shade. But from the seventeenth century natural philosophers noticed that shadows had colors of their own—and often acquired the complementary hues of their objects and light sources. To avoid the deadening effect of blacks and browns, Hunt filled his shadows with such colors. Because sunlight—as he believed—was slightly yellow, he made his shadows violet.

As the 1850s progressed, purple crawled out of the shadows, crept in from the peripheries, and found itself at the center of the canvas, where it became a signature hue of the Pre-Raphaelites and their followers. In some of their most celebrated paintings—John Everett Millais' *A Huguenot on St. Bartholomew's Day* (1852), Arthur Hughes' *April Love* (1855–1856), and Henry Wallis's *Chatterton* (1856)—the protagonists flaunt elaborate purple garments.[69] The real star of Ford Madox Brown's *The Last of England* (1852–1855) is not the rain-lashed couple sailing toward a new life in Australia but a magenta ribbon that took Brown some four weeks to paint (**Plate 43**). It pulsates in the damp silver light, bouncing reflections across its wearer's left cheek. As the fabric folds and wrinkles, pink highlights trade places with madder shadows; mauve dances beneath the woman's chin, and indigo twinkles around her forehead. One end rises into a gesture of farewell, while the other congeals into a spear that shoots ominously into the husband's chest. It is perhaps the finest thing that Brown ever painted.[70]

These pictures are puzzlingly prophetic. To us, their painted purple garments seem clearly inspired by aniline dyes. And yet in most cases they appeared several years *before* such colorants had even been invented. The coincidence cannot easily be explained. Did these artworks help stimulate the fashion for purple textiles? Or was there something purple in the air in the 1850s that all somehow inhaled? One thing isn't in doubt: artists happily embraced the fabrics when they arrived. For his part, Ford Madox Brown deeply admired the coal tar purples that went on to light up the Victorian era. On October 2, 1866, he invited friends for dinner at his house in Fitzroy Square. After eating, they played a parlor game called "Favorite Things." The rules were simple: each player was bombarded with a series of quick-fire questions and had to respond with the first answers that came to mind. Brown's answers from that night, written hastily in black ink, survive. Favorite poet? "Swinburne." Favorite costume? "Bathing dress." Favorite amusement? "Flirting." Favorite dish? "Thunder & Lightning: a Cornish dish prepared with pilchards, mutton, treacle & garlic." The questions kept coming. Favorite virtue? "Discretion." Favorite artist? "Afraid to say."

At one point Brown was asked to name his favorite color. It is a

question I have long fantasized asking of great artists and have spent many an idle hour ruminating on their likely responses: George de la Tour would surely have opted for red-hot orange, Hokusai for Prussian blue, Stanley Spencer for a rusty iron burgundy, and Michelangelo—if he had not been allowed to choose the stinging white of Carraran marble—would have plumped for candy-floss pink. Most, of course, would have refused to answer: a painter choosing one hue is like a composer choosing one chord. But Ford Madox Brown did not hesitate. As soon as the question had been asked, he wrote down a word that seven years earlier wasn't even a color: "Magenta."[71]

*

> When you go out to paint, try to forget what objects you have before you, a tree, a house, a field or whatever. Merely think, here is a little square of blue, here an oblong of pink, here a streak of yellow, and paint it just as it looks to you, the exact color and shape, until it gives your own naïve impression of the scene before you.[72]

Claude Monet's much emulated but never equaled technique was rooted in the simple act of observation. He scrutinized the world like a bird of prey, noticing much that others missed. "Monet is only an eye," declared an envious Paul Cézanne, "but, heavens, *what* an eye!"[73] Like William Holman Hunt, Monet saw purple everywhere. He was twenty-nine when he even spotted it in the snow. His early masterpiece *The Magpie* (1868–1869) transforms an ostensibly white landscape into a playground of blues, pinks, and purples (**Plate 44**). The picture's real subject is not the eponymous bird but the extraordinary shadow cast by the wattle fence in the foreground—a stream of lilacs and lavenders that explodes into splats of gelid indigo. Close examination suggests that these prismatic hues were applied late in the painting process, on top of more conventional grays and browns: the old overlaid with the new.

In later years purple spread across Monet's pictures like veins through a slab of Roquefort. It threaded through summer dresses, rippled in the waters of La Grenouillère, hid under the bridge at Argenteuil, billowed out of idling trains at the Gare Saint-Lazare, clambered up the cliffs at Étretat, flourished in the iris-filled water

meadows of Giverny, bounced off rowing boats onto his stepdaughters' faces, and shimmered on the horizon at Antibes. In the 1890s, it flooded grainstacks, cathedral facades, and early-morning hazes on the Seine. The water-lily paintings, which dominated his final decades, contain purples so extravagantly exaggerated that they can't possibly have existed in nature. His use of the color was primarily an esthetic preference, though some think it physiological in origin. Monet's exceptional vision deteriorated in his sixties, warping the colors that he had once seen with such clarity. In 1912, he was diagnosed with cataracts. He reluctantly agreed to surgery a decade later, having the lens removed from his right eye in 1923. It has been claimed (with little evidence) that this allowed him to perceive ultraviolet light.[74]

Like the Pre-Raphaelites before them, Impressionists wanted to represent the eviscerating radiance of natural light. They were handicapped, as all painters have been, by the fact that the dynamic range of paint—the difference between its lightest and darkest values—is barely a tenth that of sunlight and shadow. Realizing they could never get close to the natural contrast we see in the outside world by varying their tonal values, they sought to mimic its effects with hue. By the second half of the nineteenth century, artists knew that colors appeared stronger when juxtaposed with their complementaries. The Impressionists learned that by placing yellow patches of sunshine next to violet patches of shadow they could intensify both, simulating the pulsating brilliance of dappled light. Camille Pissarro took the approach to its logical conclusion by exhibiting some of his bright-yellow pictures in violet frames.[75]

Impressionist artists were also acquainted with the ongoing revolution in color production—some of them personally. Monet's brother, Léon, had been employed by the Swiss synthetic dye company Geigy since 1872 and gave the excited artist a tour of its factory near Rouen.[76] Like the Pre-Raphaelites before them, Monet and his peers embraced many recently invented artificial pigments, including cobalt violet, cadmium yellow, viridian green, cerulean blue, and alizarin crimson, which they used to represent their increasingly synthetic surroundings. Even Edgar Degas, the least enthusiastic colorist of the group, became captivated by aniline-dyed fabrics. In *The Jockeys* (c. 1882) he seems less interested in the forthcoming race than in the competition between its riders' silks. The picture is a clash

of glittering yellows, glossy mandarins, lurid teals, and alizarin polka dots—not to mention an exquisitely painted mauve sleeve that phosphoresces in the soft light. Most of these colors owed their existence to synthetic chemistry.

Criticism was inevitable. Though contemporaries condemned all of these lurid new hues, they reserved particular disdain for purple. Audiences accustomed to warm canvases dominated by medium- and long-wavelength colors saw the sudden shift to violet and indigo not as a small step toward naturalism but a giant leap away from it. One reviewer of the second Impressionist exhibition in 1876 wrote in *Le Figaro*:

> Make it clear to M. Pissarro that the trees are not violet, that the sky is not a fresh butter tone, that in no country can we see the things he paints, and that no intelligence can adopt such foolishness! . . . Try to explain to M. Renoir that the torso of a woman is not a mass of flesh in decomposition with violaceous green spots which denote the state of complete putrefaction of a corpse![77]

There were it seemed only three explanations for such mistakes: the Impressionists were mischievous, incompetent, or unwell. Diagnoses followed, all of them fanciful. Some authors called them color blind, others thought them insane.[78] "Are they mad? Yes. Indeed they are!" observed August Strindberg after encountering a series of "reddish blue" paintings in Paris in 1876.[79] In 1880, J. K. Huysmans dubbed their condition "indigomania":

> I do not wish to name names. It suffices to say that in most cases their vision has become monomaniacal. One of them saw wigmaker's blue in all of nature and so turned a river into a washerwoman's bucket. Another saw her as purple: land, skies, water, flesh; everything between lilac and aubergine. Most of them could have confirmed Dr. Charcot's experiments on distorted color perception he has observed in the many hysterics at Salpêtrière [Hospital], and in other people suffering from diseases of the nervous system.[80]

For some, the phenomenon was symptomatic of a wider malaise. In his profoundly pessimistic book *Entartung* (*Degeneration*), from 1892, the German physician Max Nordau compiled a withering

diagnosis of fin de siècle culture. Taking a "long and sorrowful wandering through the hospital" that was modern Europe, he saw despair, madness, and criminality in every direction. "We stand now in the midst of a severe mental epidemic," he concluded, "of a sort of black death of degeneration and hysteria."[81] Nordau believed that the decaying civilization was clearly embodied by its painters, many of whom were themselves deviants. Their predilection for purple was particularly pathological.

> If red is dynamogenous, violet is conversely enervating and inhibitive. It was not by accident that violet was chosen by many nations as the exclusive color for mourning, and by us also for half-mourning. The sight of this color has a depressing effect, and the unpleasant feeling awakened by it induces dejection in a sorrowfully-disposed mind. This suggests that painters suffering from hysteria and neurasthenia will be inclined to cover their pictures uniformly with the color most in accordance with their condition of lassitude and exhaustion. Thus originate the violet pictures of Manet and his school, which spring from no actually observable aspect of nature, but from a subjective view due to the condition of the nerves. When the entire surface of walls in salons and art exhibitions of the day appears veiled in uniform half-mourning, this predilection for violet is simply an expression of the nervous debility of the painter.[82]

Nordau was right about one thing. Purple *did* capture the spirit of the age. In the 1880s and '90s, a new sensibility spread through western culture like an infectious disease. Its victims, who sometimes referred to themselves as "Decadents," shared the apocalypticism of Nordau but embraced it with masochistic glee. Decadent writers and artists reveled in the purposeless profligacy and social transgressions that tend to flourish in collapsing societies. Their movement is traditionally affiliated with yellow (after the periodical *The Yellow Book*, which did much to promote its cause), but its affiliates were equally enamored of purple. "I love this word *decadence*," wrote Paul Verlaine, "all shimmering in purple and gold."[83] They admired the color because its two principal meanings—one ancient, the other modern—neatly encapsulated their guiding principles. The first was extravagance: purple recalled the expensive and exclusive dye of Rome—the color of an earlier

society poisoned by excess—so Decadents used it to describe their own indulgences. Oscar Wilde connected it to the carnal pleasures he enjoyed with men. "How evil it is to buy Love, and how evil to sell it!" he wrote to Robert Ross in 1900. "And yet what purple hours one can snatch from that gray slowly-moving thing we call Time!"[84]

The second relevant meaning had more recent origins, emerging from the synthetic revolution. Decadents were for the most part indifferent, if not hostile, to nature, which they viewed as too normative to be interesting. "Nature has had her day," proclaims the degenerate anti-hero Jean Des Esseintes in J. K. Huysmans' *À rebours* (1884). "There is not one of her inventions, no matter how subtle or imposing it may be, which human genius cannot create . . . The moment has come to replace her with artifice."[85] What hue better fulfilled this imperative than purple? A color once locked away in flowers and shellfish, but now liberated by human ingenuity. The chemists of the industrial age hadn't only concocted their own purples but made them brighter, stronger, and more plentiful than any furnished by nature. But these new synthetic purples weren't necessarily auspicious. Artifice might have been ingenious, but it was also dangerous. By the end of the 1890s, many believed the synthetic revolution wasn't just eclipsing nature but destroying it.

THE PURPLE CLOUD

I have finally discovered the true color of the atmosphere. It's violet. Fresh air is violet. Three years from now, everything will be violet.[86]

Édouard Manet

Progress is always accompanied by anxiety, particularly when it is rapid. Concerns had surrounded synthetic colorants since they first appeared in the 1850s. Traditionalists thought them cheap and vulgar and advised people of taste to avoid them, while others feared that the new chemical products were literally toxic. Reports appeared in the 1860s of dyed fabrics causing rashes and ulcers on skin and of aniline-dyed postage stamps leading to cancerous growths on tongues. As

chemical dye-works proliferated, the public became increasingly convinced that poisonous waste was entering water supplies, killing crops, and contaminating local areas. La Fuchsine's ignominious collapse had been hastened in 1864, when a woman living near its factory in Lyon died in unexplained circumstances. The coroner found arsenic—a principal ingredient of magenta dyes—in the well next to her home.[87]

This might explain why fin de siècle literature is so full of toxic purples, which in the years around 1900 poisoned, drowned, suffocated, and transformed many fictional characters. H. G. Wells' *The Purple Pileus* (1896) describes a browbeaten husband who eats a hallucinogenic purple toadstool that fundamentally changes his personality.[88] Fred White's *The Purple Terror* (1898) follows a group of American soldiers into rural Cuba, where they are attacked by man-eating purple orchids.[89] Fred Jane's *The Violet Flame* (1899) tells the story of a maniacal scientist (surely based on the chemists of the synthetic revolution) who concocts a violet substance in his laboratory that blazes, spins, and bursts into flames. It is not a dye but a death ray, which he uses to vaporize Waterloo Station. He later conquers and terrorizes the world, before killing himself by accident. A comet of violet flame then crashes into the Earth, fills the sky with lilac mist, and wipes out most of the world's population.[90]

The most extended reflection on poisonous purples came from a man on the peripheries of the Decadent movement whose life of fraudulence, promiscuity, and pedophilia would have appalled even Huysmans.[91] M. P. Shiel's novel *The Purple Cloud* appeared in 1901 with the striking cover of a man being swallowed by a mauve fog. It tells the tale of a ruthless Arctic explorer called Adam Jeffson. When his team is ten miles from its destination, Jeffson leaves his colleagues for dead and treks on by himself. He eventually arrives at a lake of writhing liquid and notices an icy pillar covered in enigmatic inscriptions. He is the first person in history to reach the North Pole. Overwhelmed, Jeffson loses consciousness. When he recovers, he begins the long journey home. He has been hiking for more than a week when he sees something ominous in the distance:

> On the eighth day I noticed, stretched right across the southeastern horizon, a region of purple vapor which luridly obscured the face of

the sun: and day after day I saw it steadily brooding there. But what it could be I did not understand.[92]

It takes him fifteen months to find his ship, but his elation is short-lived. All the crew members are dead. Every surface of the vessel is coated in a fine purple ash and pervaded with an aroma of peach blossom. Jeffson takes the ship and sails south past Norway—whose empty coast is "rapt in a trance of rose and purple"—toward the land of his birth.[93] He arrives in Dover three years after leaving and staggers through its lifeless streets. He finds a copy of a newspaper, which he reads with horror. The purple cloud he had seen in the Arctic had spread slowly but unstoppably around the world, killing all who stood in its path. His predicament finally dawns on him. "If now a wave from the Deep has washed over this planetary ship of earth," he asks, "and I am the sole survivor of that crew? . . . What then, my God, shall I do?"[94]

He decides to travel to London. The Thames is empty, the factories silent, the streets littered with the dead. He looks up at the Houses of Parliament, the navel of a once great empire, and notices that Big Ben's clock has stopped at 3:10 p.m.: the moment the world ended. He makes his way to the newsroom at *The Times*, where an unpublished article reveals the cause of the disaster. A massive volcanic eruption somewhere in Indonesia had released vast quantities of hydrogen cyanide into the air, poisoning everyone who inhaled it. Jeffson alone had been spared by the extreme temperatures of the North Pole, which froze the gas into a harmless purple dust. Jeffson slides into a state of maniacal decadence, traveling the empty planet in a vicious circle of consumption and destruction. He loots the world's museums and archaeological sites, builds his own palace, and lives like a purple-robed emperor of earlier centuries. He copulates with female corpses and defiles what is left of them. He burns London, Paris, Calcutta, Beijing, and San Francisco to the ground simply because he can. His behavior is only curtailed when he finds another, female, survivor in Istanbul, with whom he attempts to repopulate the world. But they live in constant fear of another purple cloud that might wipe out humanity again.

The Purple Cloud is an odd but important book. An early example

of science fiction and "last man" literature, it helped establish a genre that is now ubiquitous. If its unsavory prose is as purple as its subject matter, the larger themes are cannily calibrated. Shiel's novel absorbed, exaggerated and dramatized many fin de siècle preoccupations: the obsession with reaching the North Pole, the fears of volcanic eruptions (Krakatoa had exploded in 1883), and all manner of eschatological anxieties surrounding the turn of the century. Even his toxic cloud had contemporary resonance. Some people, in fact, were convinced that it had already arrived.

*

A foggy smoke penetrated with light envelopes them; the sun there sifts its golden rain, and the brackish, tawny, half-green, half-violet water, balances in its undulations striking and strange reflections. It might be said that this was the heavy and smoky air of a large hothouse. Nothing is natural here, everything is transformed, artificially wrought from the toil of man, up to the light and the air.[95]

In September 1899, Claude Monet, now fifty-eight, checked into London's recently opened Savoy Hotel. His sixth-floor corner suite was the epitome of luxury: it even boasted its own bathroom, with hot and cold running water. The balcony offered panoramic views of the British capital, extending from Waterloo Bridge in the east to the Houses of Parliament in the west. The ostensible purpose of Monet's visit—at least the one he had told his wife, Alice—was to inspect the lodgings of his son Michel, who had recently moved to the city to improve his English. But the artist had an ulterior motive. He planned to paint an atmospheric effect that was unique to London, and already notorious around the world. It led him to stay on at the Savoy for two further months, to return the following year, and to visit again in the spring of 1901.

London at the time wasn't just the largest city in the world but the most polluted. The Thames was surrounded by a dense forest of chimneys, emitting millions of tons of coal smoke every year. When these emissions intermingled with the still, damp air above the capital, they created a dense blend of smoke and fog that in 1905 was christened "smog." If the city's endlessly recurring smogs weren't quite as

apocalyptic as Shiel's purple cloud (the story was first serialized during Monet's third visit) they were certainly dangerous. They made the place virtually invisible, coated everything in grime, stank of rotten eggs, and caused all manner of health problems—often with fatal consequences. The great fog of December 1892 killed nearly a thousand people in just three days.[96]

Monet, however, was captivated by the optical effects generated by the smog and developed a strict routine to record them: in the morning he painted Waterloo Bridge against the rising sun, at noon he turned to Charing Cross Bridge, before crossing the river to capture the Houses of Parliament at dusk. His subject was so ephemeral that it was impossible to work on one picture at a time, so he kept dozens of half-finished canvases in his hotel room; when the weather changed, he rummaged around for the one that best matched it and picked up where he had left off. The toxic air took a toll on his health—he developed symptoms of pleurisy in March 1901—but he was too enchanted to care. "I can't begin to describe a day as wonderful as this," he wrote to Alice. "One marvel after another, each lasting less than five minutes, it was enough to drive one mad. No country could be more extraordinary for a painter."[97] Sometimes the conditions even cut short his letters. "Now, my darling, I must leave you. The effect will not wait."[98]

London fogs became famous in the second half of the twentieth century for being the yellow-green hue of pea soup, but in reality their colors were constantly changing. Charles Dickens even thought they varied by neighborhood. In *Our Mutual Friend* (1864–1865) they are dark yellow in the suburbs, grow browner as they approach the center, and become a feculent rusty black at the heart of the City.[99] A number of Victorians saw them as purple. One author in 1884 labeled them a "purple haze," the better part of a century before Jimi Hendrix made the phrase famous.[100] These observations may not have been as whimsical as they first appear. When particles of coal smoke interact with acids emitted by commercial chimneys, they can, in the right conditions, form coal tar dyes that change the color of water droplets in the air. It may be that billions of microscopic aniline dyes were being created in the skies above London just as they were being manufactured in the factories below.[101]

Monet painted almost a hundred canvases of London. *Waterloo*

Bridge, Gray Weather (1903), set on an overcast morning as the city's factories burp the day's first emissions into the air, is a classic of the series (**Plate 45**). The foreground is dominated by blacks, browns, and peaches in the dirty water of the Thames and on the bridge. This part of the picture is enlivened only by the yellow and red flashes of commuter traffic that chugs over the crossing. Beyond the bridge, on the south bank of the river, is Waterloo's industrial skyline: its factories are depicted with thick, aggressive strokes of synthetic-looking purple, and their smoke rises, snakelike, out of chimneys, before reaching across the sky. Was Monet commenting on purple's industrial provenance? Did he know that aniline colors sprang from the same coal as smoke?

London looked very different after a full day of emissions. If the conditions were right, a vast purple cloud slobbered over the city. Monet captured this uncanny effect in a series of paintings based on sketches made from the terrace of St. Thomas' Hospital. They look west across the Thames toward the Houses of Parliament, as the sinking sun backlights the architecture. One of them, *The Houses of Parliament, Seagulls* (1903), is a pageant of purples (**Plate 46**). Monet began with a soft base hue of desaturated lavender and periwinkle. He then covered it recklessly with the color's full range of hues, letting warm and cold purples dance and fight with each other. The buildings are virtually blue, blushing at their Gothic edges into the indigo of bluebells. The crepuscular sky bristles with magenta that erupts into lurid purity at the left by the waterline. A flock of multicolored seagulls claps itself across the canvas, the only vestige of nature in an otherwise artificial world. To look at the painting is to feel smothered, even suffocated, by color. It is breathtaking in both senses of the word.

Occasionally, great painters do something so audacious that they send the stomach churning. Near the center of the picture, just below the Victoria Tower, Monet placed two formless blobs: two smears of perfectly calibrated purple, thatched into a nest of calculatedly careless strokes. We don't know what they are. They could be ghostly shadows of barges on the water, or floaters in the artist's eyes. Monet might even have invented them in Giverny while finishing the picture in his studio. What's certain is they transform a good picture into a great one. They wobble back and forth on the canvas, destabilizing

the composition, thickening its textures, complicating its contents. They are so diaphanous that one wants to rub one's eyes to confirm they are real. The two little patches also seem to complete Monet's lesson in purple. Though the canvas illustrates the hue's full range, this small area captures it at its most exquisite: halfway between red and blue, the color of Perkin's mauve.

If purple had started the nineteenth century as a symbol of antiquity, it ended it a metaphor for modernity. At first it was rare and precious, invoking the legendary extravagances of ancient and exotic empires. But in the 1850s and '60s a cavalcade of synthetic purples poured out of factories around western Europe, making the scarce common and the expensive cheap. These new hues inherited some connotations from the past but increasingly acquired meanings from their own industrial age. As they entered shops, filled homes, bedecked people, and populated streets, they colored the world that produced them in rampant and resonant ways. And by the time Monet arrived in London—the home of Henry Perkin and Edward Nicholson, and the birthplace of so many synthetic dyes—the entire city was dressed in purple.

7

Green

Paradise Lost

And the Lord God planted a garden eastward in Eden; and there he put the man whom he had formed.

And out of the ground made the Lord God to grow every tree that is pleasant to the sight, and good for food; the tree of life also in the midst of the garden, and the tree of knowledge of good and evil . . .

. . . And the Lord God took the man, and put him into the garden of Eden to dress it and to keep it.

Genesis (2:8–15)

A small wooden panel, no larger than a standard sheet of paper. On it, a painting distilled to the barest essentials: one pigment, one stroke. A thick smear of emerald green surges diagonally downward and leftward, loops back on itself, slips off the edge of the panel, skids on to the ebonized frame, then vanishes with an upward thrust. This is art-making as joyriding. The brush's bristles separate as they go, transforming one color into many. The green paint divaricates into a spectrum of stripes— jungle-dark in its depths, sun-kissed yellow in its shallows. On the left, it wells up against the frame edge into a near-black puddle, with silver-green bubbles held in suspended animation. The liquin used to thin the pigment bleeds out onto the unprimed panel, encircling the green shape like a greasy nimbus.

This deceptively simple artwork was made by Howard Hodgkin in the twilight of his career. Though the gesture that produced it lasted just a couple of breath-held seconds, it was the result of two years of

mental and physical preparation. If at first glance it looks like a work of abstraction, the color soon condenses into a likeness. Hodgkin called the picture *Leaf* (**Plate 47**). The principal fold might be a midrib, its paint striations the frenetic patterns of veins. We can't identify the leaf's species, let alone its status or location: it might be lying flat on a table, budding into life on a branch, or dancing dead in the wind. In this respect it recalls those meticulous botanical drawings made in the eighteenth and nineteenth centuries, which likewise depicted natural specimens prone, magnified, shorn of context.

Hodgkin loved colors like a father loves his children. They delighted him, inspired him, infuriated him, sometimes made his life a misery—and he never wished to be free of them. "Color is color," Hodgkin once said. "You can't control it."[1] Green was a tireless tormentor. His pictures teem with teal zigzags, viridescent curves, mossy smears, olive polka dots, and two-toned stripes of freshly mown lawns, all wriggling around within their frames. The green in *Leaf* is profoundly leaflike: organic enough to seem rooted but weightless enough to fly away. Watch it seesaw between paint and plant, color and content: first it is green, then a leaf, then green again. It is performing one of the world's most obvious and enduring color associations—between green and vegetation.

To find the origin of this connection, we must travel back in time 1.5 billion years. The land is barren and lifeless, but the Earth's oceans, lakes, and rivers teem with microscopic organisms. Many of them feed off each other, but some create energy by harvesting light from the sun. We have arrived at a turning point in the history of life. Somewhere in the shallows, one organism (probably a eukaryote) devours another (probably a light-consuming bacterium). It has enjoyed similar meals before, but this time its dinner survives ingestion and lives on inside its host. The arrangement turns out to be mutually advantageous. The victim is protected from other predators in a nutrient-rich environment, while its host benefits from the energy made by its sunlight-harvesting tenant. Their bond grows progressively stronger. In later generations they swap genetic material and merge into one. Over the next billion years the resulting fusion grows larger and more complex, evolving first into algae and then into plants.[2]

Every plant today stems from that ancient partnership. Examine a leaf through a microscope and you'll see the descendants of that first meal packed inside like prisoners. These pea-shaped, pea-green organelles are called plastids or chloroplasts. They are the engine room of plants, producing the most famous chemical process in biology—learned at school as a simple word equation:

$$\text{Carbon dioxide + water} \xrightarrow{\text{light energy}} \text{glucose + oxygen}$$

Photosynthesis is actually much more complicated than this, involving not one process but at least two. Stage one begins when sunlight penetrates the chloroplast and is converted into energy storage molecules. These power a second reaction, which splits water into hydrogen and oxygen. The hydrogen is then forced onto carbon dioxide to create carbohydrates, which go on to feed the plant, while the oxygen is released into the atmosphere. The reaction is integral to life on Earth. All animals live off the energy harvested by chloroplasts, either by consuming plants directly or by eating animals that have themselves consumed plants.

At the heart of photosynthesis is the world's most abundant pigment. Chlorophyll—from the Greek χλωρός (green) and φύλλο (leaf)—colors 85 percent of the Earth's ice-free land, as well as much of its water.[3] This marvel of microscopic architecture, often compared to a spider's web, consists of four pentagons, each containing four carbon atoms and one nitrogen atom, strung together into a spiky ring. At its center sits a solitary magnesium ion, the spider in the

Chlorophyll

center of its creation. Structurally, chlorophyll bears a striking resemblance to our own life-giving pigment, hemoglobin. Apart from a minor variation in bonding, the only significant difference is that iron, instead of magnesium, occupies the ring's core. This tiny substitution has conspicuous visual consequences, making hemoglobin red and chlorophyll green.

Of all the world's colors, none seem more natural than the greens of vegetation. We are so accustomed to "greenery" (the term was coined by Coleridge) being green that it is difficult to contemplate it being anything else.[4] But this color really makes no sense at all. Plants are green because chlorophyll absorbs blue and red wavelengths of light and reflects the light between them. But if they evolved to harvest light energy, why do they reject green light? It would be more efficient to absorb all wavelengths of visible light and thus be black. This conundrum has baffled scientists for decades, prompting a number of competing explanations. Plants might reflect green light to prevent oversaturation and thus overheating; or their color could be the result of microbial competition. When chlorophyll first appeared on the earth, microorganisms were already using another light-sensitive molecule, called retinal, which absorbed only green light; chlorophyll had to make do with the red and blue that its rival rejected. No theory is universally accepted. It's quite possible the greenness of plants is entirely accidental.[5]

There are six types of chlorophyll, though most plants contain only sharp, teal-green Chlorophyll A or soft, yellow-green Chlorophyll B. Some variegated species combine both pigments, with half a dozen greens cohabiting in a single leaf.[6] Leaf color is also dictated by habitat, weather conditions, surface structure, plant health and, of course, the seasons.[7] In springtime, young leaves often appear yellow or burgundy until their chloroplasts start working and turn them green. When chlorophyll ceases to function in the autumn, other pigments—present in the leaf since the beginning but hitherto overpowered by green—slowly become visible. This is why some trees turn amber and vermilion at certain times of the year, setting entire landscapes ablaze. The annual death of chlorophyll is one of nature's great spectacles—and among its most popular tourist attractions: "leaf-peeping" contributes billions of dollars to New England's economy every autumn.

Humans, who evolved in arboreal conditions, are particularly adept at distinguishing these hues. It is quite possible that primate eyes developed their third, long-wave, cone type precisely to better navigate the chlorophyll around them. This additional photoreceptor granted our ancestors abilities denied to most other mammals: it enabled them to spot ripe red fruits against a backdrop of green foliage, and to distinguish different leaves from each other—young from old, nutritious from poisonous.[8] Our specific version of trichromacy means that in normal daylight conditions our eyes are most sensitive to light at a wavelength of 555 nanometers: a lime-like hue that hovers just on the threshold between green and yellow. It's surely no coincidence that this is the point at which most mature leaves are best differentiated.

To experience the myriad greens around us, we needn't enter the countryside: a trip to the supermarket will do. The herb shelves showcase the rippled greens of mint, the scalloped sheen of basil, two-toned rosemary, green fingers of tarragon and dill, and silver sage, which looks likes grass under frost. The fruit aisle offers dimpled limes (which aren't "lime green" at all), pears that flirt with brown, and translucent grape-greens that look like polished beads of nephrite. In the vegetable aisle, which contains what English-speakers call "greens," spring onions and leeks are lessons in saturation, extending from near-white bulbs to royal green ends, expressing every shade of green between. But perhaps the most exciting produce is the most underappreciated. Broccoli doesn't simply range from light-green root to dark-green floret: its flowers alternate unpredictably between yellow-green and blue-green, which in some varieties mutates into lavenders, violets, and indigos.

Everywhere people noticed the color of vegetation. How could they not? It was beneath their feet, above their heads, surrounding them on every side. They hunted in it and hid in it, harvested and consumed it, or traveled great distances to seek it out. Many societies did not possess a unique word for the hue, but those that did typically based them on existing terms for leaves, grass, and vegetal processes. Virtually all European greens originate in such a connection. In the Germanic languages, *green* (English), *grænn* (Icelandic), *grün* (German), *groen* (Dutch), *grøn* (Danish), *grön* (Swedish), and *grønn* (Norwegian) all derive from the Proto-Indo-European root *ghre*, meaning "grow." In the Romance languages, *vert* (French) and *verde* (Italian, Spanish, Portuguese, Romanian)

stem from the Latin verb *virere,* partly meaning "to sprout," and also giving rise to *virga* ("stem," "branch," "rod"), *ver* ("spring"), *vis* ("strength"), and even *vir* ("man").[9]

Once the seed had been sown, a connection took root. The green–nature nexus was grounded in a simple visual affinity that grew bigger and more complex over time. The associations proliferated in all directions, growing so intertwined that it is now difficult to disentangle the meanings of green from those of nature. Like the original partnership of the microorganisms that made plants possible in the first place, it was a story of two strangers slowly becoming inseparable.

THE GREEN REVOLUTION

About 11,700 years ago, the Earth underwent a major geological transformation. It left a 2.5-million-year Ice Age behind, shook off the frost, and entered an epoch we call the Holocene. Warmer and wetter than its predecessor, this era gave rise to rainforests, boreal woodlands, savannas, and steppes around the world. For its first 6,000 years, even the Sahara was green—with woods, grasslands, and lakes filled with crocodiles and hippopotamus.[10] These mild conditions had far-reaching consequences: they made it possible for humans, hitherto nomadic foragers, to start farming. The domestication of crops and livestock began independently in east Asia, South and Central America, and New Guinea, but the earliest secure evidence of farming comes from the Middle East. From about 11,000 years ago, Neolithic communities living in the Fertile Crescent (a sickle-shaped stretch of land that begins in the Nile valley, runs north along the Mediterranean coast, extends east into modern-day Syria and Iraq, and then follows the Tigris and Euphrates southeast toward the Persian Gulf) began cultivating wheat, barley, peas, lentils, and figs. It is surely no coincidence that this was also the fabled location of Eden. The agricultural revolution triggered a chain reaction of other transformations. It led to the first permanent human settlements, which produced ever-larger communities, which required social organization and administration, which in turn led to the creation of political, commercial, and cultural institutions, and what some call civilization.

It also changed attitudes toward color. Farming was, and is, a highly visual profession, and color is a reliable index of a crop's condition. Early farmers monitored the hues of their produce for evidence of health, ripeness, and readiness for harvest. They watched wheat turn gold in the summer sun, and figs slowly darken to plummy purple. Though they knew nothing of the carotenoid and anthocyanin pigments that caused such changes, they understood what they meant. But of all these natural hues, their first delight was surely chlorophyll. It's not difficult to imagine their excitement when, after a long hard winter, the first green shoots began to emerge from the soil. Green's arrival was the promise of a new year—a promise of the future.

The connection between green and agriculture was established early. A recent excavation in the Levant—in the northwestern apex of the Fertile Crescent—has unearthed a hoard of beads and pendants dating back some 10,000 years. The discovery of these objects, a third of which are green or greenish in color, surprised archaeologists, both because humans had demonstrated no preference for green before this point, and because great efforts had clearly been made to obtain them. Most of the green minerals had been sourced hundreds of miles away in Jordan, Israel, Saudi Arabia, Syria, perhaps even overseas in Cyprus. Why? The archaeologists responsible for the find argued that this new and probably expensive taste for green was related to the emergence of agriculture in the region. They believed the green stones had been chosen because they resembled young leaf blades and might have been used as talismans to provoke the germination of crops or invoke rainfall.[11]

Egyptians were among the first to farm on a vast, organized scale, growing wheat, papyrus, barley, beans, pulses, root vegetables, salad crops, and fruits on the fertile banks of the Nile from as early as 8000 BCE. They quickly identified these crops and their growth with green. Their term for the color was *wadj*, which also meant "flourish," and was represented in hieroglyph by the flowering stalk of a papyrus plant. Egyptian agriculture was overseen by Osiris, god of the afterlife. We don't know how Osiris came to be associated with agriculture, though one legend suggests an answer. While King of Egypt, he was murdered and his body dumped into the Nile. There he remained, as King of the Underworld, Lord of the River, and master of its annual

inundation. It was Osiris who flooded the Nile's banks and filled the soil with nutrients, who pushed the first green shoots up through the bare fields and who transformed them into crops capable of feeding Egypt for another year. This is surely why, though they regularly likened him to the blackness of the soil, Egyptian painters often depicted him as a green-skinned being.

Egyptians identified green with much broader notions of renewal and rebirth and went to great lengths to get their hands on it. Pharaohs sent quarrymen into the deserts to obtain malachite and chrysocolla, while chemists supplied vast quantities of blue-green faience ceramics to a voracious public. Egyptians were convinced that these vegetal hues had revitalizing capabilities. They applied them to their faces, wore them around their necks, and prayed to them as if they were gods. "Come chrysocolla, come chrysocolla," went one incantation, "the green one . . . ward off disease, blindness."[12] They left green amulets in the tombs of loved ones, placed green scarabs on the chests of mummies, and in later dynasties even painted coffins with green faces. They weren't just identifying the deceased with the ruler of the underworld, but eliciting a resurrection like the one that occurred every spring around the Nile. Their hope was to gain access to a paradise they sometimes called "the field of malachite."[13]

On the other side of the Atlantic, Mesoamerican farmers were growing gourds, pumpkins, avocados, potatoes, and chili peppers in the fertile Mexican highlands. By 2000 BCE, maize had become the region's staple crop—and a commodity of such importance that it inspired almost religious reverence. The locals identified this vivid-green plant, which bobbed about in fields like a drunken army, with a viridescent stone that is more famously identified with Asian culture. Jade hovered alluringly between green and blue, recalling both the color of vegetation and the water that nourished it.[14] The Olmecs—usually considered the first great Mesoamerican civilization—obtained the stone from the Motagua Valley in modern-day Guatemala. They carved from it symbolic axes, digging sticks, and mace heads—the same tools used to clear land, plant maize, and process its kernels. Indigenous Americans also deposited jade and other green stones into the graves of their loved ones, because they too believed green generated life. Noticing that the vegetation above such burial sites became unusually lush, the Aztecs

concluded that the green minerals were themselves alive, breathing a vapor into the soil that fertilized the people and plants that resided there (this vigorous growth is more likely to have been the result of the decomposition of the bodies beneath).[15]

The rich and powerful entered the underworld not with modest green pebbles but elaborate jade creations. The Calakmul Mask, discovered in a tomb in the Yucatán Peninsula in 1984, was made between 660 and 750 CE as a death mask for a local Maya ruler (**Plate 48**). The likeness remains hauntingly potent. Two obsidian irises eyeball us, unflinching and inscrutable. Seashell volutes corkscrew out of the mouth and nostrils, the breath of life from beyond the grave. The face is a gamut of green mosaic—soft and sharp, deep and light, mottled and striated—that seethes with symbolism, much of it drawn from plants. The king's face is flanked by two four-petaled flowers. His headdress swells into a verdant mountain, under which his body has been planted like a seed. At its center two sprouts of maize point toward the future. This dead ruler will, like Osiris, infuse the earth with fertility, ensuring that his living subjects thrive.

Mesoamericans had another maize substitute—one that was even more precious than jade. The quetzal is an almost impossibly beautiful local bird—a scintillating clash of green and vermilion that hurtles through tropical forests like a flying Fauvist palette. Indigenous people coveted the male's iridescent green tail feathers. Quetzal plumes were considered the epitome of luxury, far more expensive than gold, and were typically reserved only for gods or powerful mortals. They are unforgettably deployed in the sixteenth-century *quetzalapanecayotl*, better known as "Moctezuma's Headdress" (**Plate 49**). The exceptional object—which was probably never owned, let alone worn, by the Aztec emperor—is a cocktail of colored commodities, containing the feathers of lovely cotingas, roseate spoonbills, and squirrel cuckoos, as well as ornaments in brass and gold, all crowned by 450 supernaturally green quetzal plumes, plucked from the bottoms of hundreds of unfortunate birds. Standing on their ends, they resemble a row of maize stalks wiggling in the wind. The headdress might temporarily have converted its wearer into a maize god, his body nourishing the crop that fed his people.[16]

One Aztec legend, transcribed by the Spanish in the sixteenth century, tells of a Toltec leader called Huemac who one day dared to play ball with the rain gods. The game was for a prize of quetzal feathers and jade, but when Huemac emerged victorious he was presented with an ear of green maize instead. Huemac was indignant. "Is *this* what I won? Wasn't it jades? Wasn't it quetzal plumes? Well, bring them here!" he exclaimed. The rain gods acceded to his demand but resolved to punish the king for his arrogance and greed. That summer, heavy snow fell on the land around his capital until all the crops were destroyed. The city meanwhile suffered a drought so severe that its canals dried up and its orchards withered away. The ensuing famine, which lasted four long years, led to the downfall of the Toltecs. In choosing jade and quetzal feathers over the crop on which his people depended—choosing the symbol over the thing it symbolized—Huemac had been led astray by color.[17]

As agriculture proliferated, so did its links with green. Some pagan societies marked the two most important episodes in the agricultural calendar—spring and harvest—with rituals involving the wearing of green robes or the worship of sacred green objects, and, like the Egyptians and Mesoamericans, many communities pinned their agricultural hopes to verdant characters: the green-thumbed Chinese god of millet, Hou Ji; the Romano-Celtic earth god Viridios; and the foliage-fleshed Green Man, who lent his name to dozens of British pubs. Green, above all, was linked to the fertility on which a successful harvest depended. A number of medieval writers used the evocative term *viriditas* to describe the color of plants and their sap, viewed as a life force that turned seeds into sprouts, sprouts into buds, buds into leaves, and flowers into fruits. The twelfth-century abbess Hildegard of Bingen believed it also underpinned human fertility. "Just as a tree flowers and puts forth leaves by means of its *viriditas*," she wrote, "so a woman brings forth flowers and leaves in her womb by means of the *viriditas* of menstruation."[18]

The same agricultural fecundity made green the color of other life-giving concepts, including youth, growth, spring, and hope—and inspiring sometimes uncontrollable enthusiasm. In his fifteenth-century guide to heraldry, Jean Courtois—better known as the Sicily Herald—compiled an often tediously pedantic essay on the significance of

colors. But when the otherwise phlegmatic author arrived at green, his prose turned suddenly rhapsodic:

> Nothing is more beautiful, nothing so delights the eye and the heart . . . There is nothing in the world more pleasant than the beautiful verdure of fields in blossom, broad-leafed trees covered in foliage, banks of the rivers where the swallows come and bathe, stones that are green in color, like precious emeralds. What is it that makes April and May the most pleasant months of the year? It is the verdure of the fields, which prompts the small birds to sing and to praise Spring and its delightful gay green livery.[19]

Courtois wasn't the only enthusiast. By the time his text was published in 1495, the greens of nature were revered all over the world. And in one inauspiciously arid region they became the focus of almost religious zeal.

مُدْهَامَّتَانِ

Islamic culture has always been soaked in color. Arabic possesses an unusually large and sophisticated visual vocabulary that gave us many of our most evocative color terms—azure, carmine, crimson, lilac, orange, saffron, scarlet. The Qur'an, as revealed to the Prophet Muhammad in the seventh century, is so filled with color that it makes the Bible seem monochrome by comparison. It describes scarlet sunsets, black rain clouds, yellow camels, and saffron horses. The phrase "of diverse hues" (*mukhtalifan alwanuhu*) is repeated through the text like a mantra.[20] This is because color, according to Islam, was nothing less than a divine gift. "All the things on this earth which He has multiplied in diverse hues," the Qur'an declares, are "a sign for men who celebrate the praises of Allah" (16:13). Of all these myriad hues, none was more important than green. It isn't difficult to guess why.

At one point in David Lean's 1962 film, *Lawrence of Arabia*, Prince Faisal makes a perceptive observation. "I think you are another of these desert-loving English," he tells Lawrence. "No Arab loves the desert; we love water and green trees. There is nothing *in* the desert." The Prophet Muhammad would probably have agreed. He belonged

to a nomadic tribe that eked out a living in one of the world's driest places. Mecca is surrounded by a scorched ochre desert with barely a shrub in sight. The Qur'an, by contrast, is filled with descriptions of vegetation and rain—fantasies, perhaps, of a society in which both are scarce. We are told how torrents of water make the barren earth "quiver and swell" (22:5), causing "grain and grapes and herbage and olive trees and palm trees and gardens of dense shrubbery and fruit and grass" to erupt into life (80:30). "Do you not see," asks one verse, "that Allah has sent down rain from the sky and the earth becomes green?" (22:63). If rain was a gesture of divine mercy then green was a gift from paradise.

The notion of paradise as a garden is now so firmly established that it is hard to think of it as anything else. The idea dates back to the very earliest writings, imprinted on 5,000-year-old Sumerian clay tablets, which describe a verdant paradise at Dilmun. The Hebrew Bible replaced it with Eden, a fertile garden of fruit-filled trees nourished by four streams. The Qur'an in turn based its paradise on biblical precedent, though elaborated significantly. Using the term *jannah* (which means both "garden" and "paradise"), it describes four beautiful gardens, each irrigated by cascading springs fed by rivers of water, wine, milk, and honey. They are covered by trees that provide "shade long extended" and serve up an endless bounty of dates, pomegranates, and bananas. But unlike its predecessors, the Qur'an is explicit about the color of paradise. Its resident virgins recline on green cushions while male inhabitants wear exquisite green garments of silk and brocade, all sheltered from the sun by trees, which (as if there had ever been any doubt) are likewise green. But they aren't just any shade of green. The Qur'an deploys a unique adjective to denote this miraculous hue. *Madhamatan* (مُدْهَامَّتَان) is a rich dark viridian that pulsates with everlasting life. It has a very special status: it is the only word in the Qur'an's shortest verse.[21]

For Muhammad, green stood apart from all other colors. His famous, though perhaps apocryphal, saying—"three things of this world take away sadness: water, greenery and a beautiful face"—is still recited around the Islamic world.[22] From the Hadith, which compiled records of Muhammad's words and deeds roughly a century after his death, we know he regularly wore green garments and was

fond of verdant vegetation. He repeatedly identifies the faithful with green. The souls of martyrs are described as green birds suspended from the trees of paradise, and the devout likened to vegetation. "The example of a believer is like a green tree," he said, "the leaves of which do not fall."[23] Or: "The example of a believer is that of a fresh green plant the leaves of which move in whatever direction the wind forces it."[24] Muhammad even evokes the Qur'an's preoccupation with the effects of rainfall on vegetation—but here humans have become the crops, nurtured by divine gifts. "Allah will send down water from the sky and people will grow like green vegetables."[25]

In the centuries after Muhammad's death, green became even more closely identified with him. The Fatimid dynasty, which claimed descent from the Prophet through his daughter Fatimah and ruled large parts of north Africa, Sicily, and the Levant between the tenth and twelfth centuries, marched under a plain green banner in his honor, while Islamic intellectuals reinforced the hue's special place in his religion. The thirteenth-century Sufi mystic Najm al-Din Kubra wrote that green was not only sacred but satisfying: gazing at greenery, he wrote, inspired "a racing of the heart, an expansion of the breasts, a pleasing of the soul, a sweet taste for the spirit, and a refreshing sensation for the inner eye."[26] In the fourteenth century Ala'Uddaula Simnani—one of the great figures of Iranian Sufism—established a series of correspondences between organs, prophets, and colors that marked a seven-stage journey to enlightenment. The first involved the creation of a new body, linked to Adam and black. Next came the vital soul, identified with Noah and blue. Stage three saw the appearance of the heart, with Abraham and red. In stage four, the believer developed a superconsciousness related to Moses and white. In stage five he found the Spirit, which corresponded with David and yellow; and in stage six he penetrated the depths of the Arcanum and was confronted by Jesus, together with a luminous black light. The journey came to a climax in the seventh stage when the truly enlightened individual arrived at the Divine Center and met Muhammad. This ultimate reality was, according to Simnani, emerald green—"the most beautiful color of them all."[27]

How Islam proved this to be true. Travel from Granada to Isfahan, from Samarkand to Jaipur, and you'll find yourself besieged by the

colors of paradise. Muslim artists were masters of the crystalline hinterland between green and blue: a territory inhabited by aquamarine, eggshell, lovat, peacock, jade, teal, and turquoise. They covered domes, doorways, minarets, and mihrabs in glazed tiles that invoked the orchards and streams of the everlasting oasis. Many decorative schemes were constructed out of swirling vegetal patterns known as arabesques. Flora proliferate like triffids; they bud, shoot, grow, and flower in every direction; stems and leaves twist and turn, spiral back on themselves, and loop over and under each other, knotting, unraveling, retangling; some plunge into illusory depths while others explode into rosettes or palmettes of tulip, carnation, lily, and hyacinth. Every so often the arabesques give way to half-hidden mantras such as "God is most mighty" and "there is no God but God."

Islamic artisans made most of these greens from copper oxide. They learned over the centuries that by adjusting the ingredients and alkalinities of their glazes they could push blue into turquoise, turquoise into teal, and teal into sage. In the 1560s, the peerless Turkish ceramicists working in the town of Iznik near Istanbul perfected the greatest green of all. When this emerald hue first emerged from the kiln, the workshops must have been abuzz with excitement: here, at last, was a color commensurate with *madhamatan*. It soon appeared in mosques, Ottoman palaces, even domestic settings. One dish, made only a few years after the new glaze had been invented, already exhibits a mastery of the color (**Plate 50**). Tulips and roses dance around a scalloped cypress tree. Stems and leaves proliferate in every direction, contained only by spiral clusters on the rim. The pattern is so inventively exuberant that it wouldn't look out of place in a modern homeware store. The green is amplified in every possible way: stabilized by black outlines, backlit by white ground, rhyming with cobalt blue, jarring with coral red, it is as vital as the vegetation it depicts.

Islamic painters were similarly devoted. The British Museum possesses a superb Persian picture, made in Tabriz in the first half of the sixteenth century, that depicts the legendary hero Rostam asleep in a forest while his loyal steed Rakhsh fights off a lion (**Plate 51**). Though the figures are painted charmingly enough, they are nothing compared to the foliage that surrounds them. Every plant is flourishing, every flower blossoming, and every single leaf—of which there are

thousands—is individually delineated. The artist, very possibly the peerless miniaturist Sultan Muhammad, has taken particular care to differentiate the innumerable greens that inhabit the forest. There are dark mossy-green grasses, pale avocado-green fronds, and shrill teal rock formations that stretch and contort into just-visible monstrous faces. These hues are themselves subtly multiplied: the leaves become paler and yellower at their edges, bluer and browner in their shadows. Animated by their scalloping outlines, these colors seem to gurn and gush across the paper, bristling with sentient energy. We are looking at the work of an artist who has seen in the kingdom of plants nothing less than the fingerprints of Allah.[28]

Gardens had been cultivated in the Middle East for thousands of years before Muhammad, but his green-fingered followers established horticulture as a major imaginative endeavor. The earliest Islamic gardens were largely practical: either shaded courtyards offering respite from the sun or walled orchards providing fruit throughout the year. But as knowledge of the Qur'an spread, gardeners increasingly tried to replicate the paradise it had so memorably described. Following scriptural precedent, these creations were typically divided into four spaces, irrigated by streams, and thronged with verdant foliage. The *chahar bagh* ("four garden") motif probably originated in the eighth century at the Umayyad caliph's palace at Rusafa in northern Syria. From there it spread with Islam to north Africa and southern Spain, to Persia and central Asia. The form reached its apogee in Mughal Hindustan. Babur, the founder of the Mughal dynasty, constructed the first of his many gardens in Kabul in the early sixteenth century. His descendants, Humayun, Akbar, Jahangir, and Shah Jahan, all built elaborate *chahar baghs*, some of which still survive in Delhi (Humayun's Tomb, c. 1565–1572), Srinagar (Shalimar Bagh, 1619), Lahore (Shalimar Bagh, 1637), and Agra (Mehtab Bagh, c. 1652). Each of them is remarkable, but one stands out as both the most famous and the most overlooked.[29]

Ostensibly built as a memorial to his wife, Mumtaz Mahal, Shah Jahan's Taj Mahal (1632–1653) might be the most recognizable building in the world—a structure Rabindranath Tagore mawkishly likened to a "teardrop on the cheek of time."[30] If the mausoleum is the teardrop, the cheek must be its garden. And yet most visitors are so focused on

the white marble edifice that they ignore the garden completely, hurrying along its paths to beat the crowds. They rarely realize that the garden of the Taj Mahal was originally just as important as the building it surrounds. It was meant to be a replica of the Garden of Paradise, as evidenced by the Qur'anic inscription above its gateway. "O thou soul at peace, return thou unto thy Lord, well-pleased and well-pleasing unto Him! Enter thou among my servants—and enter thou My Paradise!"[31] Visitors are going to experience a taste of everlasting bliss.

The garden is divided into quarters by canals like the Qur'an's sacred rivers. The central waterway, running from the main entrance to the mausoleum, is studded with lotus-bud fountains that veil the edifice in an ethereal spray of water. The original planting was abundant. It is believed to have contained cypress, poplar, palm, chanar, willow, may, juniper, myrtle, and laurel trees; flowerbeds of roses, marigolds, poppies, and carnations; and extensive orchards of apples, oranges, lemons, limes, figs, mangoes, bananas, coconuts, pineapples, mulberries, peaches, and pomegranates. At times the vegetation was so dense that the mausoleum was virtually invisible. The Taj Mahal's garden is now, alas, a shadow of its former self, but greenery survives in the pale lawns of Bermuda grass trimmed into Islamic stars; in the green-black cypresses that line the pathways; and in the emerald plumage of barbets that scour the site for scraps. The best time to see the Taj Mahal is arguably in August—the month most tourists avoid—when the monsoon rains make the garden lush and lend the waterways an algal tint. Then, seen in reflection, the pearly white building looks almost green.

Green is now the signature hue of Islam. Muhammad's favorite color crowns mosques, is bound around heads, and brands Muslim organizations everywhere from Senegal to Indonesia. Several national flags of Islamic countries (Algeria, Mauritania, Pakistan, Saudi Arabia, Turkmenistan) are overwhelmingly green, as is the official flag of the Arab League, which represents twenty-two member states. Islamic cultures have come to view green as an auspicious, protective color in the way the Chinese see red and south Asians see yellow. Friends wish each other a "green year"; in Syria, lucky people are said to have "green hands"; in Morocco, those with "green stirrups" bring good fortune wherever they go.

Islamic doctrines also profoundly influenced Muslim attitudes to nature. The Qur'an repeatedly instructs Muslims not simply to revere the environment but to protect it. It describes humans as temporary stewards (*khalifa*) of their habitats, advising them not to disturb the fine balance of creation by unnecessary destruction or excessive consumption. In one admittedly polyvalent injunction it warns its readers: "Make not mischief on the earth" (2:11). During the golden age of Islamic scholarship, between the eighth and thirteenth centuries, philosophers and scientists transformed these evocative words into a comprehensive environmental ethics, writing treatises on sustainable agriculture, resource management, pollution, wildlife conservation, and even a bill of rights for animals. These concerns have never been more relevant—and not only to Muslims. In the last fifty years they have informed the latest—and most pervasive—meaning of green.

THE GREEN REBELLION

In September 1962, a moss-green hardback appeared in American bookshops. *Silent Spring*, written by the marine biologist Rachel Carson, opened with her own portrait of paradise: a small, prosperous American town surrounded by fields and orchards. Its woods are populated by oak and maple trees that become a "blaze of color" through the autumn mists, while ferns and wildflowers flourish along the roadsides. Birds pick on berries in the hedgerows, deer roam through the pastures, and trout bathe in shady streams. Gradually, however, blight spreads like "an evil spell." The flowers wither. The fish vanish. Farmers and their children fall sick. Even birds abandon the town, and take their songs with them. For the first time in living memory, spring falls silent. Carson concludes with an explanation:

> This town does not actually exist, but it might easily have a thousand counterparts in America or elsewhere in the world. I know of no community that has experienced all the misfortunes I describe. Yet everyone [*sic*] of these disasters has actually happened somewhere, and many real communities have already suffered a substantial number of them.

A grim specter has crept upon us almost unnoticed, and this imagined tragedy may easily become a stark reality we all shall know. What has already silenced the voices of spring in countless towns in America? This book is an attempt to explain.[32]

This parable of paradise lost is almost biblical in its trajectory, with humans once again the authors of their misfortune. The cause of their downfall is not the Tree of Knowledge but a cluster of agricultural products. What follows is a long and forensic analysis of the damaging effects of chemical pesticides on "the Earth's green mantle." Carson argues that these substances, some of which originated in the same synthetic revolution that invented mauve and magenta, kill many more species than intended, contaminate entire ecosystems, and even poison humans. If the methods were new, the pattern has been long established:

As man proceeds toward his announced goal of the conquest of nature, he has written a depressing record of destruction, directed not only against the earth he inhabits but against the life that shares it with him. The history of the recent centuries has its black passages—the slaughter of the buffalo on the western plains, the massacre of the shorebirds by the market gunners, the near-extermination of the egrets for their plumage. Now, to these and others like them, we are adding a new chapter and a new kind of havoc—the direct killing of birds, mammals, fishes, and indeed practically every form of wildlife by chemical insecticides indiscriminately sprayed on the land.[33]

Silent Spring sold more than half a million copies in hardback and stayed on the *New York Times* bestseller list for thirty-one weeks— but it also made Carson some enemies. The National Agricultural Chemicals Association spent over $250,000 on a campaign to discredit her, recruiting a string of scientists to dismiss, in often openly misogynistic ways, her "emotional" and "hysterical" arguments.[34] It did little to suppress the book's impact. *Silent Spring* opened public eyes to the environmental costs of modern agricultural methods and even contributed to changes in government policy. In 1972, the recently formed Environmental Protection Agency outlawed DDT and later banned or restricted other hazardous pesticides.[35]

From 1950, rapid increases in population, urbanization, and industrialization took an even-greater toll on the environment than pesticides, resulting in the early signs of global warming, the beginnings of mass deforestation, and the widespread destruction of wildlife. By 1962, 250 mammal species were threatened with extinction, including the rhinoceros, mountain gorilla, and blue whale.[36] This was compounded by a pollution pandemic, underscored by a succession of environmental disasters. The most notorious occurred in 1969 near Santa Barbara, when 10,000 tons of crude oil spilled into the Pacific, contaminating 230 kilometers of coastline.[37] As distressing images of black tides and dead seabirds leaked into America's collective conscience, the Santa Barbara disaster crystallized a process that had arguably begun with *Silent Spring*: it helped convert a growing ecological awareness into a nascent environmental movement. On April 22, 1970, twenty million Americans celebrated the first Earth Day. Around the country schoolchildren collected litter, academics conducted teach-ins, and students staged rallies. For the first time, environmentalism itself was headline news. In a special report televised that evening, CBS's Walter Cronkite described this watershed moment.

> A unique day in American history is ending. A day set aside for a nation-wide outpouring of mankind seeking its own survival: Earth Day. A day dedicated to enlisting all the citizens of a bountiful country in a common cause of saving life from the deadly byproducts of that bounty: the fouled skies, the filthy waters, the littered earth . . . Its demonstrators were predominantly young, predominantly white, predominantly anti-Nixon. Often its protests appeared frivolous, its protestors curiously carefree. Yet the gravity of the message of Earth Day still came through: act, or die.[38]

Environmentalism belonged to an archipelago of countercultural movements that rose to prominence in the 1960s. Many of its members—as Cronkite suggested—had broader political concerns and also belonged to anti-war, civil rights, free speech, feminist, and gay liberation campaigns. But they were distinctive enough to merit their own name. In the 1960s and '70s, many not-always-admiring sobriquets were attached to this new demographic, including "preservationists" (from 1961), "tree-huggers" (1965), "environmentalists" (1966), "ecological activists," "eco-activists," "eco-freaks" (1969), and "eco-nuts" (1971). But

one of them proved universally popular. It was short, simple, easy to pronounce, could be translated into virtually every language, and was full of meaning as well as color.[39]

In the 1960s and '70s, many political organizations identified themselves with colors. Hindu nationalists were saffron, Iranian modernizers were white, anarchists were black, and communists were the hue that lurked under every bed. In 1961, anti-war campaigners greedily sequestered the entire spectrum with the rainbow flag. In this competitive chromatic marketplace environmentalists weren't even the first to appropriate green, which had earlier been associated with the Civil Rights Movement. "The essential color of the power that Negroes most desperately need in this country," declared Walter Fauntroy in 1966, "is not black or white, but green."[40] Fauntroy was referring to the color of the dollar, arguing that only wealth could secure meaningful social progress for African Americans. Others, meanwhile, used green to refer to less specific political change. In *The Greening of America*, published in 1970, Charles Reich proposed that the various countercultures of the 1960s had the power to alter the public's consciousness and revitalize American society.

> The extraordinary thing about this new consciousness is that it has emerged out of the wasteland of the Corporate State, like flowers pushing up through the concrete pavement. Whatever it touches it beautifies and renews ... For one who thought the world was irretrievably encased in metal and plastic and sterile stone, it seems a veritable greening of America.[41]

Reich's green wasn't explicitly environmental. "I wasn't really thinking of the way it's now thought of: everything becoming uniformly green in the ecological sense," he later recalled. "I intended it to be multi-colored as the '60s always was to me, so it was an exuberant title for me."[42] Reich was nevertheless using the color of vegetation as a metaphor for spring, hope, and renewal.

Though widespread use of "green" to refer to the environmental movement began in the early 1970s, the earliest use of the term dates back to 1967, to a long and often disparaging study of hippies. Its authors, psychiatrists Louis J. West and James Allen, described their subjects as "Bohemians, the beatniks, the surf set, shadow campuses,

the folk-rock followers, God-is-dead mourners, the school dropouts and college dropouts and establishment dropouts, and the lotus eaters."[43] West and Allen argued that this ragbag belonged to an increasingly ubiquitous "green rebellion." "The color, from our brush, symbolizes [the green rebellion's] love of nature ('flower children'), its verdantly ingenuous ideals, and of course, its 'grass.'"[44] By 1968, the phrase "green rebellion" had been cited or repeated in half a dozen academic publications, and by 1969 it appeared in major national newspapers together with related labels like "green movement" and "green revolution."[45]

The new meaning of "green" gained further traction at an unruly gathering in Vancouver in February 1970. The Don't Make a Wave Committee was meeting in Vancouver to discuss a nuclear test planned by the United States at the remote Alaskan island of Amchitka. They unanimously agreed to sail to Amchitka and "bear witness" to the explosion. At the meeting's conclusion its chairman signed off with the fashionable valediction, "Peace," to which a twenty-three-year-old community worker called Bill Darnell responded: "Let's make that a *green* peace." The group subsequently decided to name their first boat *The Green Peace*.[46] Their voyage proved unsuccessful—the detonation went ahead as planned on November 6, 1971—but attracted a good deal of attention, inspiring strikes, walkouts, sit-ins, petitions, and parliamentary motions, and undoubtedly played a role in the US Atomic Energy Commission's decision to halt the testing program a few months later. Greenpeace is now one of the world's largest environmental organizations, with outposts in more than forty countries and almost three million supporters.

In the 1970s, "green" entered European politics. The process began in West Germany in 1977, when anti-nuclear protesters put up candidates for local and state elections under the term *grüne Liste*. "Green lists" appeared in France and Belgium at roughly the same time, but in Germany they evolved into "green" parties. The first was Grüne Aktion Zukunft (Green Action Future), formed by the conservative ecologist Herbert Gruhl in July 1978. By January 1980, it was die Grünen—a new national party that planned to run in the autumn's federal elections. Its first national manifesto, capped by an image of a sunflower against a green background, began as follows:

> We are the alternative to the traditional parties. We have emerged from a group of green, colorful and alternative Lists and parties. We are united with all those who are involved in the new democratic movements: in life, nature, and environmental protection . . . We see ourselves as part of the green movement [*grünen Bewegung*] around the world.[47]

Die Grünen won just 1.5 percent of the vote, not enough for a single seat in the Bundestag, but spawned a wave of environmental parties around Europe in the 1980s. Most likewise called themselves "green":

1981	Comhaontas Glas (Ireland)
1981	Miljöpartiet de Gröna (Sweden)
1982	Os Verdes (Portugal)
1982	Vereinte Grüne Österreichs (Austria)
1983	De Grønne (Denmark)
1983	Die Grüne Partei (Switzerland)
1983	The Green Party of Canada (Canada)
1983	De Groenen (Netherlands)
1983	Déi Gréng Alternativ (Luxembourg)
1984	Green Party of the United States (USA)
1984	Les Verts (France)
1985	Los Verdes (Spain)
1985	The Green Party (UK)
1986	Partido Verde (Brazil)
1986	Die Grüne Alternative (Austria)
1987	Partido Verde Eto-Ecologista (Uruguay)
1987	Vihreä Liitto (Finland)
1987	Liste Verdi (Italy)
1988	Miljøpartiet De Grønne (Norway)
1989	Zelena Partija Bulgaria (Bulgaria)

Even established environmental groups rebranded. Britain's Ecology Party had been founded (originally as PEOPLE) in 1973—long before die Grünen triggered the green wave in European politics—but after a long debate at its annual conference in September 1985, members decided to rename it the Green Party. They did so partly to better affiliate with their international counterparts and partly to reassert their domestic preeminence in environmental matters. "We have to be the

yardstick by which other people measure their greenness," the party's international liaison secretary told the *Guardian*. "If we say now we are the Green Party, within five years we will be the definition of what Green is."[48]

The green parties' success came quickly. At its second federal election in March 1983 die Grünen quadrupled its 1980 share of the vote, winning twenty-seven seats in the Bundestag and becoming the first new party to enter the German Parliament in over thirty years. In 1989, Britain's Green Party won 14.5 percent of the vote in European elections, part of a crop of green parties that returned with thirty-two seats in the European Parliament. In the following decade, similar organizations began to appear outside Europe. Today there are nearly 100 recognized green parties around the world.[49] As they matured, their environmental concerns evolved into a political worldview that included pacifism, social justice, and electoral reform, so enriching the political meanings of green. By the turn of the millenium the word denoted an ideology, comparable with conservatism, socialism, or liberalism.[50]

Alongside their political growth, green views began to permeate public consciousness. In the 1970s and '80s, western consumers became increasingly aware of the environmental implications of their purchases, generating mainstream demand for novelties like organic foods and cruelty-free cosmetics. *The Green Consumer Guide* (1988), which sold more than a million copies globally, told shoppers that every purchase had potentially significant environmental consequences:

> Every day of the week, whether we are shopping for simple necessities or for luxury items, for fish fingers or for fur coats, we are making choices that affect the environmental quality of the world we live in. Take a bite out of a hamburger, we are told, and we may be taking a bite of the world's rainforests. Buy the wrong car and we may end up not only with a large fuel bill, but also with fewer trees and, quite possibly, less intelligent children. Spray a handful of hair gel or a mist of furniture polish from certain aerosols, and you help destroy the planet's atmosphere—increasing everyone's chances of contracting skin cancer . . . Part of the solution, in fact, is in your hands.[51]

"Green consumption" permanently transformed the consumer landscape. Goods are now covered in green ticks, seals, stickers, symbols,

and other verdant certifications—proof the products are made sustainably. The measures are doubtless effective—a recent survey found that almost half of consumers are motivated to purchase by "environmentally friendly" packaging (few seem to be aware that many of those green colorants, being chlorine- or bromine-based, are themselves hazardous to the environment).[52]

It is now virtually impossible to avoid green's environmental connotations. We are perpetually advised to "buy green," "go green," "think green," "live green," and "be green"—whether we want to or not. But if we can disregard the politics, we might notice something striking. Green has acquired new meanings more recently, swiftly, and comprehensively than any other hue. Before 1970, few people knew what environmentalism was, let alone identified it with a color. Now, however, "green" is a keyword of our times, loaded in the way that "gender," "sexuality," "nation," "race," and "ethnicity" are, and connected to a package of attitudes and activities that includes ethical eating, organic produce, recycling, renewable energy, pollution, deforestation, climate change, wildlife protection, and sustainable development. None of these things is literally green, but their metaphorical greenness is understood all over the world.

As a young painter growing up in suburban London in the 1960s, David Nash had always struggled with green. He tried many times to use it in his pictures, but somehow it always resisted. "It so belongs in nature," he concluded. "It just doesn't look right on a canvas."[53] In 1967—the year West and Allen first identified a "green rebellion" among America's youth—the twenty-three-year-old Nash relocated to the moss-green valleys of Snowdonia and was soon working almost exclusively in wood, hacking "bonk" pieces with axes and chainsaws and fashioning intricate constructions from branches and twigs. As he scavenged for hazel, oak, beech, birch, and willow in the forests around his home, he came to see his material as part of a larger organic process. Trees, of course, have life cycles. They are born in the soil, grow, mature, and die, before returning to the earth. Nash was fascinated by this process and started monitoring it like a professional botanist.

One day in May, he was driving to a wood yard when he spotted some oaks budding into life by the road. He stopped the car and approached

them. Nash noticed the new leaves, which were perhaps only hours old, were an appealing shade of amber. He returned to the trees every day thereafter, watching their leaves turn gold, then yellow, then pale green, then darkening as their chlorophyll formed. Within two weeks they were a deep leathery viridian that would endure for the rest of the summer. Nash was determined to chronicle this brief but dramatic color change. He spent weeks searching for the right pigments, eventually sourcing them from three separate suppliers. He ground an assortment of Sennelier, Unison, and Schmincke pastels into powders and applied them with a cloth into five self-contained rectangles. The resulting artworks, *Oak Leaves Through May*, represent one of the world's great vitalizing processes: the genesis of natural green (**Plate 52**).[54]

Nash developed a fierce ecological conscience, becoming particularly concerned with the uncertain prospects for plants and trees; he watched in dismay as a beetle-borne fungus decimated Britain's elm population in the 1970s. He was also inspired by Jean Giono's *The Man Who Planted Trees*, the lyrical parable of a lonely French shepherd who secretly plants a vast forest, turning a barren wilderness into a verdant paradise. Nash embarked on a series of living sculptures, planting bluebells, transplanting turf, weaving rings of brambles— then waiting for nature to complete, or destroy, what he had started. The most ambitious of these works was conceived on a plot of land hidden away on a hillside in the Ffestiniog valley. Nash's father had purchased Cae'n-y-Coed ("Field in the Trees") in the 1960s, which then contained a small but beautiful wood. In 1972, a disreputable local woodman cut down almost every tree on the property, transforming the verdant grove into a wasteland. Nash was appalled by the devastation but saw in it an opportunity. In February 1977, he measured out a circle roughly nine meters in diameter and planted twenty-two ash trees around it. He called his creation *Ash Dome*.[55]

Ash—which by coincidence provided him with his surname ("Nash" derives from the Middle English *Atten Ashe*, describing someone living near ash trees)—is tough but pliable, and unusually receptive to human manipulation: it can be twisted, bent, pruned, and grafted, yet bounce back ever stronger. Nash, who had studied local hedging techniques while planning the piece, applied several of them to the

saplings. In 1981, he grafted branches onto eight of them, ensuring that all had a branch in the correct place to take up the lead growth. Two years later, he cut a wedge out of each trunk, bent it clockwise, bandaged the suture, and tied the trees to stakes to hold them in position. With diligent pruning, he encouraged each tree to twist one way then the other like arabesques on an Islamic tile. For Nash, whose second son was born in the same month as the ash saplings were planted, *Ash Dome* wasn't only a gift to the next generation but a "green" initiative of his own—an idealistic proclamation from a dying world:

> The Cold War was still a threat. There was serious economic gloom, very high unemployment in our country, and nuclear war was a real possibility. We were killing the planet, which we still are because of greed. In Britain, our governments were changing quickly, so we had very short-term political and economic policies. To make a gesture by planting something for the twenty-first century, which was what *Ash Dome* was about, was a long-term commitment, an act of faith.[56]

His faith and care were richly rewarded. Over the course of four decades Nash's twenty-two saplings grew up, and together, into a large vaulted chamber—a temple made from and consecrated to nature. The trees delineate its porous walls, kinking like hosepipes toward the sky (**Plate 53**).

Ash Dome's hues are ever-changing. In the long Welsh winters it appears almost monochrome—a thatch of spidery black lines against a slate-gray sky—but in May it erupts into color. Brown buds explode into lime-green fingers, unfold like outstretched hands, and blossom into emerald leaves. The greens are clean, vital, and infinitely diverse. Wobbling in wind and animated by sunshine, they oscillate between dark and light, cold and warm, pallid and vivid. At this irrepressible time of year, *Ash Dome* recalls Philip Larkin's poem "The Trees," composed in 1967:

> The trees are coming into leaf
> Like something almost being said;
> The recent buds relax and spread,
> Their greenness is a kind of grief.

Is it that they are born again
And we grow old? No, they die too,
Their yearly trick of looking new
Is written down in rings of grain.

Yet still the unresting castles thresh
In fullgrown thickness every May.
Last year is dead, they seem to say,
Begin afresh, afresh, afresh.[57]

The annual euphoria aroused by the year's first burst of chlorophyll has been a feature of human experience since before the first Neolithic farmers saved their crops. But Larkin, whose pessimism was as deep-rooted as his eponymous trees, reminds us that new life is always preceded and ultimately followed by death.

David Nash wanted *Ash Dome* to outlive him and his genera-tion—as a monument to creation when so much of nature was being destroyed. But his circle of life has recently fallen victim to the very process it was supposed to transcend. *Hymenoscyphus fraxineus* attacks the bark, branches, and leaves of ash trees. The fungus was first noticed in Poland in 1992 and spread across Europe from there, possibly on plants and saplings distributed by nurseries. Ash dieback, as it is better known, was confirmed in England in 2012 and reached Wales a year later.[58] *Ash Dome* began to exhibit symptoms of dieback in the summer of 2017: some of its leaves turned brown or wilted, and cankers or lesions appeared on its bark. By the following summer one of the trees was almost dead, five had lost most of their upper leaves, and the foliage on others was beginning to discolor. Nash estimates that within a decade all twenty-two will have died. The irony isn't lost on him. "I have been documenting *Ash Dome*—following it. I've been watching it living and growing . . . but now I'm watching it dying."[59]

Let us return to Genesis, where the first chapter of this book began: after God creates the universe out of pitch-black darkness and makes a human from bloodred earth, he plants a gloriously green garden. He fills it with fecund and nutritious trees, runs a river through the orchards, and makes humans the guardians of his creation. But when his tenants take advantage of their position, God expels them from his

estate. Adam is banished to the wilderness with Eve and forced to farm the barren dust whence he sprang, with both denied the blessing of eternal life. This ancient story is supposed to describe our distant past, but it might also foretell our future. It is, after all, about clever creatures who wake up in paradise and thrive on its bounty, before ruining it—and themselves.

Over the last few decades we have watched as global temperatures have risen, ice caps have receded, rainforests have shrunk, coral reefs have disappeared, devastating floods and droughts have become more common, and countless animal species have gone extinct. The Earth's ecosystems have changed so quickly and dramatically that many experts believe we have crossed a critical, even irreversible, threshold. Until recently, most of human civilization unfolded within the "ecological Eden" of the Holocene, whose relatively mild, stable conditions enabled our ancestors to settle, farm, prosper, and proliferate. Now, however, we dominate the Earth so appreciably that we have arguably pushed it into a new geological epoch—the Anthropocene—which may end up destroying the species after which it was named.[60]

Which colors will define the Anthropocene? At this stage we can only speculate. If average global temperatures reach 4°C above their preindustrial levels, which is likely by the end of the century if we don't arrest the pace of change, dark-green rainforests could turn into sage-green savannas and emerald grasslands could become khaki deserts (though in some places the opposite will happen).[61] As phytoplankton dependent on the cooler waters of the subtropics die out, our oceans might become bluer.[62] Meanwhile, increasingly severe droughts could make the brilliant displays of autumn foliage less common because leaves will die and fall before they have a chance to change color.[63] Attempts to mitigate or reverse climate change won't return the world to its prelapsarian state but will simply alter it in other ways. Pumping sulfur dioxide into the upper atmosphere to reflect sunlight into space and thereby cool the planet—one of the leading geoengineering proposals currently under consideration—might end up bleaching our cerulean skies white.[64] Of all the pigments we've painted over this planet since we first fell in love with color, the most prolific might be the ones we didn't mean to make.

For now at least, the dominant color of the Anthropocene is the

one we presume it is destroying. Over the last thirty-five years, 18 million km² of new vegetation has appeared on the planet—an area roughly twice the size of the United States. The Earth, surprisingly, is greener today than it has been for millennia. These changes have been caused by the rapid expansion of cultivation and fertilization around the world, by rising temperatures and rainfall associated with global warming, and above all by increased atmospheric carbon dioxide levels, which—despite posing a grave threat to us—are a significant catalyst of plant growth.[65] In the short term our landscapes are likely to become greener still, as we embark on vast tree-planting programs designed to soak up excess carbon dioxide. Many scientists are convinced that leaves, and the miraculous green pigment that lurks within them, will prove a crucial weapon in our battle against climate change.[66]

The geological and political changes of the last few decades are evidence of green's remarkable resilience, both physically and symbolically. Like a plant drawing on nutrients from the world in which it grows, the color has absorbed and been sustained by nature's meanings for thousands of years. They have stemmed from agriculture, horticulture, religion and, most recently, the environmental movement. Though they branch off in different directions and flourish in myriad ways, all it seems are rooted in the same foundational sentiment. For Neolithic farmers watching shoots emerge from the soil, desert-dwelling Muslims dreaming of a garden paradise, and modern-day activists determined to bring about a sustainable future, green was, and is, a color of hope—the hope that, after a long cold winter or a drought-ridden summer, the arrival of chlorophyll will herald a new beginning.

The World According to Color

It is a defining trait of our species to produce and pursue meaning. We attach it to our experiences, to everyday events, and to virtually everything in the world around us. Our quest for meaning informs every encounter and relationship, motivates every abstract thought, and underpins all of art and culture. We manufacture it every waking moment of every day, often without realizing we are doing so. Every time we open our mouths to utter a word, we are literally blowing meaning into the world. Those meanings may at some level be fictitious, but we consistently convince ourselves otherwise. After all, a satisfying fantasy is infinitely preferable to the alternative—that existence itself is meaningless.

As soon as we were cognitively capable, we developed a swathe of practices—language, ritual, myth, religion, art—to impart significance to otherwise insignificant lives. They offered assurances that good fortune could be invoked, that the gods were on our side and, perhaps most importantly, that life continued after death. Color played a central role in these activities from the start. Tens of thousands of years before the earliest cave paintings, humans were excavating, processing, and trading red pigments, applying it to their bodies, and scattering it into graves. The color of blood had become one of humanity's first symbols—a metaphor for life, fertility, and virility; sustaining the living and supposedly reviving the dead.

At first, we didn't have many colors to choose from. For thousands of generations our ancestors had just a handful of earth pigments at their disposal: carbon blacks, calcite whites, red and yellow ochres, brown umbers. It was only toward the end of the Neolithic period that they devised new colorants: indigo (used in South America as

early as 4000 BCE), vermilion (appearing in Spain from 3000 BCE), Egyptian blue (synthesized in Egypt around 2500 BCE), Tyrian purple (developed in the Near East c. 1500 BCE), and Han purple (invented in China c. 800 BCE). None of these products would have emerged without extensive mining facilities, large workforces, and complicated manufacturing processes—themselves evidence of the considerable importance their makers already ascribed to color. These colors inevitably became status symbols. Some pigments and dyes were as expensive as the finest luxuries, available only to the rich and powerful.

How different things are today. Since the scientific breakthroughs of the 1850s, millions of colored compounds have been synthesized. There are now more than 40,000 dyes and pigments on the market, with new ones appearing almost every week.[1] Modern life is drenched in colors that were previously unimaginable, or at least inaccessible. Color has become so common, and so cheap, that most of us take it for granted. A few centuries ago, a basic box of crayons, with its hues lined up like a rainbow, would have sent emperors and alchemists into raptures; nowadays, it can barely even keep a toddler occupied. Paint manufacturers, meanwhile, offer so many tints and shades that they've run out of sensible names for them: hence "Dead Salmon," "Elephant's Breath," and "Churlish Green."

Color, of course, isn't simply surface decoration. It seeps deep into our lives, saturating our words, thoughts, and feelings, belonging to a larger web of significance that our species weaves around itself. For millennia, we have used color as a universal language, to communicate ideas of fundamental importance: how to live and love, what to worship or fear, who we are and where we belong. It might even be our most powerful bearer of meaning, because it speaks to us in such a direct and vivid voice. But color doesn't only transmit meaning; it creates the context in which those meanings exist. Oscillating between nature and culture, experience and understanding, it mediates our relationship with the world. Color is an ever-present prism through which we see the people, places, and objects around us, as well as how we think and feel about them. Like the air we breathe, or the water in which we swim, we are enmeshed in it.

By now it should be clear that this isn't so much a story about color as it is about us—the symbols we make, and the concerns that

inform them. In this book I've used seven colors to understand seven deep-rooted preoccupations. In the apparent blackness of darkness we discerned our deepest fears; in the glossy reds of blood we saw reflected our own lives and bodies; in the blinding yellow sun we glimpsed, through squinted eyes, our most powerful gods; and in cerulean skies and and seas we imagined worlds beyond our horizons. We championed clean white surfaces as paragons of visual, moral, and social purity, celebrated the synthetic purples of the nineteenth century as beacons of technological progress, and embraced the myriad greens of nature as emblems of paradise and renewal. We have projected these hopes, anxieties, and obsessions onto color for thousands of years. The history of color, therefore, is also a history of humanity.

The ancient Egyptian term for "color" was *iwn*—a word that also meant "skin," "nature," "character," and "being," and was represented in part by a hieroglyph of human hair. The members of that formidable civilization had noticed a striking resemblance between colors and humans. To them colors were just like people—full of life, energy, power, and personality. We now understand, as the Egyptians could only sense, how thoroughly the two are entangled. Color, after all, is ultimately made by its perceivers. Every hue we see around us is actually manufactured within us—in the same gray matter that forms language, stores memories, stokes emotions, shapes thoughts, and gives rise to consciousness. Color is a pigment of our imaginations that we paint all over the world. Larger than any city, more intricate than any machine, more beautiful than any painting, it might in fact be the greatest human creation of them all.

Acknowledgments

This book has been a while in the making. It was originally conceived back in 2013 as a series of brief essays about color in western art, and for a time I believed my own assurances that the project would be a straightforward one. But nothing about color is straightforward. The more I researched the subject, the more it expanded, luring me down blind alleys and answering my questions with countless other questions. I repeatedly extended my chronological and geographical scope, and found myself straying into dozens of other disciplines. In the end I spent seven exhilarating years researching the subject, and then another one trying to distill my mountain of notes into a book.

Most of the investigative work was undertaken as a Fellow of Gonville and Caius College, Cambridge, where for five years my research was supported by a generous donation from Christopher and Shirley Bailey. Caius was particularly conducive to the interdisciplinary research that informs this book: the College counts among its Fellowship distinguished scholars in many fields, many of whom shared their considerable expertise with me. I am indebted to the neuroscientist John Mollon, who scoured a full draft of the book for scientific errors (he found several); to the theoretical physicist Will Handley, who had to explain the colors of the early universe to me more than once; to the archaeologist and anthropologist Manuel Will, who cast his eyes over my discussion of prehistoric humans; to Jens Scherpe, who helped me translate an esoteric Danish account of the discovery of the Trundholm Sun Chariot; and to John Casey, K. J. Patel, Alan Fersht, and Robin Holloway, who supported me—and challenged me—throughout the writing process.

I am grateful too to my literary agent David Godwin, not least for

introducing me to my publisher; to Stuart Proffitt, for commissioning the book, for his patience as I wrote it, and for his guidance at each of the many crossroads I reached; to my copy-editor David Watson, who endured last-minute revisions with good cheer; to Rebecca Lee, for steering the book through to publication; to Fiona Livesey and Ania Gordon, for sharing it with the world; and of course to my editor Ben Sinyor. Ben read my words with unflagging attention and intelligence throughout the process, making several critical interventions, and ultimately helping me to find the book I wanted to write.

The writing of this book didn't only make demands of me but of those to whom I am close. I am grateful to my father for going through an early draft (and calling it the most boring thing he had ever read—after my doctoral dissertation), to my mother, whose weekly offerings of childcare allowed me to make many more journeys to the library than I could have hoped for, and to my parents-in-law Harshad and Liz Topiwala for the keys to their garden shed. When I lived there, working sixteen-hour days for several weeks at a time, the only thing that kept me going was Harshad's Gujarati food. Above all, I am thankful to—and thankful *for*—my wife, Kirty. She is my rock, my best friend, my sounding board, my inspiration. And how can I forget my son, Rafi, who crash-landed into our world in November 2018, and has filled our lives with color ever since.

Notes

INTRODUCTION

1. O. Pamuk, *My Name Is Red*, trans. E. Göknar (London: Faber and Faber, 2001), p. 227.
2. Nizami, *Haft Paykar*, trans. J. Scott Meisami (Oxford and New York: Oxford University Press, 1995). For more on the poem's color symbolism, see G. Krotkoff, "Color and number in the *Haft Paykar*," in R. Savory and D. Agius, eds., *Logos Islamikos: Studia Islamica in Honorem Georgii Michaelis Wickens* (Toronto: Political Institute of Medieval Studies, 1984), pp. 97–118.
3. Quoted in M. Merleau-Ponty, *The Primacy of Perception*, ed. J. Edie (Evanston: Northwestern University Press, 1964), p. 180.
4. The first channel compares signals from L- and M-cones. If it receives only L signals, it concludes that the cones have absorbed long-wave red light; if it receives only M signals, it concludes that they have absorbed medium-wave green light. The next channel compares signals from S-cones with those from L- and M-cones. S signals indicate blue, while L and M signals indicate yellow. The final, monochromatic, channel adds up signals from the L- and M-cones. If both are firing, we see white; if neither is firing, we see black.
5. Male color blindess has different causes. At least 6 percent of men are anomalous trichromats, who possess three cone types, one shifted along the spectrum. Under 2 percent have only two cone types, and are thus called dichromats.
6. J. Albers, *Interaction of Color* (New Haven and London: Yale University Press, 1963), p. 3.
7. One of these studies analyzed the results of four combat sports (boxing, tae kwon do, Greco-Roman wrestling, and freestyle wrestling) at the 2004 Olympic Games. In each of the events competitors were randomly assigned red or blue outfits. If color played no role in the outcomes of

the contests, the number of red and blue wins would have been roughly equal. But this was not what happened. The researchers found that red outfits conferred a significant advantage on their wearers. Indeed, when evenly ranked athletes fought each other, the competitor in red was 20 percent more likely to win than the competitor in blue. R. Hill and R. Barton, "Red enhances human performance in contests," *Nature*, vol. 435 (May 19, 2005), p. 293. Another study examined English football league results between 1946 and 2003, finding that teams in red shirts were more successful than others. M. Attrill et al., "Red shirt color is associated with long-term team success in English football," *Journal of Sports Sciences,* vol. 26, no. 6 (May 2008), pp. 577–82.

8. T. Matsubayashi et al., "Does the installation of blue lights on train platforms shift suicide to another station? Evidence from Japan," *Journal of Affective Disorders,* vol. 169 (December 2014), pp. 57–60.

9. See S. Singh, "Impact of color on marketing," *Management Decision*, vol. 44, no. 6 (2006), pp. 783–9; and K. Fehrman and C. Fehrman, *Color: The Secret Influence* (Upper Saddle River: Prentice Hall, 2000), pp. 141–58.

10. E. Bolton, *His Elements of Armories* (London: George Eld, 1610), p. 169.

11. C. Soriano and J. Valenzuela, "Emotion and color across languages: Implicit associations in Spanish color terms," *Social Science Information,* vol. 48, no. 3 (2009), pp. 421–2.

12. "Pink or blue?," *The Infant's Department* (June 1918), p. 161.

13. The phrase dates back to the early 1960s but, like many famous quotations, it is false. The fashion editor Diana Vreeland is believed to have coined the phrase, calling pink "the navy blue of India." It was reworked in the late 1970s, with "neutral" replacing "navy" and becoming "black" in the early 1980s. See B. Zimmer, "On the trail of 'the new black' (and 'the navy blue')," *Language Log* (28 December 2006). http://itre.cis .upenn.edu/~myl/languagelog/archives/003981.html (accessed: July 30, 2018).

14. C. Dior, *The Little Dictionary of Fashion* (London: V&A Publications, 2007 (first ed. 1954)), p. 14.

15. Cheskin, MSI-ITM, and CMCD Visual Symbols Library, *Global Market Bias, Part 1—Color* (2004). http://www.marketingresearchbase.nl /Uploads/Files/2004_Global_Color_2d_A4.pdf (accessed: July 31, 2018).

16. See F. Adams and C. Osgood, "A cross-cultural study of the affective meanings of color," *Journal of Cross-Cultural Psychology,* vol. 4, no. 2 (June 1973), pp. 135–56.

17. These included *xiuhtic* (blue/green turquoise), *chalchihuitl* (green/blue), *xiuhuitl* (green), *quiltic* (light green), *nochtli* (medium green), *quilpalli*

(intense green), and *matlaltic* (dark green). E. Ferrer, "El color entre los pueblos nahuas," *Estudios de Cultura Nahuatl*, vol. 31 (2005), p. 204.

18. D. Turton, "There's no such beast: Cattle and color naming among the Mursi," *Man*, vol. 15, no. 2 (June 1980), pp. 320–38. The British, once passionate equestrians, possess a large group of color terms that refer exclusively to horses, including bay, buckskin, chestnut, cremello, dun, palomino, perlino, piebald, roan, skewbald, smokey, and sorrel.

19. For an excellent survey, see R. Kuehni and A. Schwarz, *Color Ordered: A Survey of Color Systems from Antiquity to the Present* (Oxford: Oxford University Press, 2008).

CHAPTER 1: OUT OF DARKNESS

1. "Sonnet of Black Beauty," in *The Poems English and Latin of Edward Lord Herbert of Cherbury*, ed. G. Moore Smith (Oxford: Clarendon Press, 1923), p. 38. The poem was first published in 1665, after Cherbury's death.

2. R. Fludd, *Tractatus secundus de naturae simia seu technica macrocosmi*, 2nd edition (Frankfurt: Johan-Theodor de Bry, 1624), pp. 701–2.

3. R. Fludd, *De Utriusque Cosmi Historiae, maioris scilicet et minoris, metaphysica, physica, atque technica historia* (Oppenheim: Johan-Theodor de Bry, 1617), p. 26.

4. Ibid.

5. "Discourse of Hermes Trismegistus: Poimandres," 1:4, in B. Copenhaver, ed., *Hermetica: The Greek Corpus Hermeticum and the Latin Asclepius in a New English Translation with Notes and Introduction* (Cambridge: Cambridge University Press, 1992), p. 1.

6. For more, see N. Emerton, "Creation in the thought of J. B. van Helmont and Robert Fludd," in P. Rattansi and A. Clericuzio, eds., *Alchemy and Chemistry in the 16th and 17th Centuries* (Dordrecht, Boston, and London: Kluwer Academic Publishers, 1994), pp. 85–102.

7. "Creation Hymn" (10:129), *The Rig Veda*, trans. W. Doniger (London: Penguin, 2005), pp. 4–5.

8. J. Major et al., *The Huainanzi: A Guide to the Theory and Practice of Government in Early Han China*, 7.1 (New York: Columbia University Press, 2010), p. 240.

9. Quoted in M. Witzel, *The Origins of the World's Mythologies* (Oxford: Oxford University Press, 2012), p. 110.

10. I am grateful to my colleague Will Handley at Gonville and Caius College, Cambridge, for his assistance on this matter. For more on the early

colors of the universe, see W. Handley, "Kinetic initial conditions for inflation: Theory, observations and methods," PhD thesis (University of Cambridge, 2016), p. 13.

11. See A. Parker, *In the Blink of an Eye: How Vision Sparked the Big Bang of Evolution* (New York: Basic Books, 2003).

12. P. Bogard, *The End of Night: Searching for Natural Darkness in an Age of Artificial Light* (New York: Black Bay, 2014).

13. C. Grillon et al., "Darkness facilitates the acoustic startle reflex in humans," *Biological Psychiatry*, vol. 42, no. 6 (September 1997), pp. 453–60.

14. The phobia has a number of names, including *nyctophobia, achluophobia,* and *lygophobia.* For more on the survey, conducted by the American National Institute of Mental Health in 2014, see D. Jagdag and A. Balgan, "The fear in Mongolian society: Comparative analysis," *Asian Journal of Social Sciences and Humanities*, vol. 4, no. 2 (May 2015), p. 147.

15. E. Burke, *A Philosophical Inquiry into the Origin of Our Ideas of the Sublime and Beautiful* (London: J. Dodsley, 1767), p. 280. Burke wasn't the first to think this way. According to Isidore of Seville in the seventh century, the word "night" derived from the Latin *nocendo*, meaning "harming." *Isidore of Seville's Etymologies: Complete English Translation*, trans. P. Throop, vol. 1 (Charlotte: MedievalMS, 2013), xxxi.1.

16. J. Locke, *An Essay Concerning Human Understanding and a Treatise on the Conduct of Understanding* (Philadelphia: Hayes and Zell, 1854), p. 262.

17. For a clear introduction, see S. Lieu, *Manichaeism in the Later Roman Empire and Medieval China: A Historical Survey* (Manchester: Manchester University Press, 1985), pp. 1–24.

18. Cited in G. Gnoli, "Manichaeism: An overview," in M. Eliade, ed., *The Encyclopedia of Religion*, vol. 9 (New York: Macmillan, 1987), pp. 161–70.

19. St. Augustine, *Concerning the City of God Against the Pagans*, trans. G. Evans (London: Penguin, 2003), Book XII: 7.

20. For two excellent discussions, see R. Sorensen, *Seeing Dark Things: The Philosophy of Shadows* (Oxford: Oxford University Press, 2008); and A. Gilchrist, *Seeing Black and White* (Oxford: Oxford University Press, 2006).

21. See R. Kuehni and A. Schwarz, *Color Ordered: A Survey of Color Order Systems from Antiquity to the Present* (New York: Oxford University Press, 2008), pp. 28–32.

22. Bolton, *His Elements of Armories*, p. 144.

23. L. B. Alberti, *On Painting*, trans. C. Grayson (London: Penguin, 1991), p. 46.

24. I. Newton, *Opticks; or, a Treatise of the Reflections, Refractions, Inflexions and Colors of Light. Also Two Treatises of the Species and Magnitude of Curvilinear Figures* (London: Smith and Walford, 1704).

25. For an old but thought-provoking comparison between black, darkness, and silence, see R. Allers, "On darkness, silence, and the nought," *The Thomist: A Speculative Quarterly Review*, vol. 9, no. 4 (October 1946), pp. 515–72.

26. M. Neifeld, "The Ladd-Franklin theory of the black sensation," *Psychological Review*, vol. 31, no. 6 (November 1924), p. 499.

27. The exact cause of "intrinsic gray" is unknown: some have proposed that it results from thermal transformations of optical pigments in our retinas; others have suggested that it's triggered by discharging chemical messengers in our visual pathways. For more, see N. Elcott, *Artificial Darkness: An Obscure History of Modern Art and Media* (Chicago: University of Chicago Press, 2016), pp. 30–33.

28. See, for instance, E. Hering, "Über die sogenannte Intensität der Lichtempfindung und über die Empfindung des Schwarzen," *Sitzungsberichte der Kaiserlichen Akademie der Wissenschaften*, vol. 69 (1874), p. 97.

29. A. Gelb, "Die 'Farbenkonstanz' der Sehdinge," *Handbuch der normalen und pathologischen Physiologie*, vol. 12 (1929), pp. 594–678.

30. For three important studies on the perception of black, see V. Volbrecht and R. Kliegl, "The perception of blackness: An historical and contemporary review," in W. Backhaus et al., eds., *Color Vision: Perspectives from Different Disciplines* (Berlin: De Gruyter, 1998), pp. 187–206; C. Cicerone et al., "Perception of blackness," *Journal of the Optical Society of America*, vol. 3, no. 4 (1986), pp. 432–6; and K. Shinomori et al., "Spectral mechanisms of spatially induced blackness: Data and quantitative model," *Journal of the Optical Society of America*, vol. 14, no. 2 (1997), pp. 372–87.

31. In Old English, black had a double meaning: *blac* meant "bright," "shining," "glittering," or "pale," while *blaec* meant a soot or coal-black color. Both probably related to fire: *blac* described the brightness of the inferno; *blaec* described its burned residue. For more, see J. Joyce, "Semantic development of the word black: A history from Indo-European to the present," *Journal of Black Studies*, vol. 11, no. 3 (March 1981), pp. 307–12.

32. *The Book of the Dead: The Papyrus of Ani*, trans. E. Wallis Budge (London: British Museum, 1895), p. 342.

33. For more on Egyptian attitudes to color, see G. Robins, "Color symbolism," in D. B. Redford, ed., *The Oxford Encyclopedia of Ancient Egypt*, vol. 1 (Oxford: Oxford University Press, 2001), pp. 291–4.

34. Cicero, "P. Vatinium testem interrogatio," in *The Orations of Marcus Tullius Cicero*, trans. C. Yonge (London: George Bell and Sons, 1891), pp. 30–32.

35. Cassius Dio, *Roman History*, trans. E. Cary and H. Foster (London: Heinemann, 1924), Book 67, pp. 336–8. Domitian's guests exacted their revenge in the end. On September 18, 96 CE, eight conspirators made their way into his private chambers and stabbed him to death. http://penelope.uchicago.edu/Thayer/E/Roman/Texts/Suetonius/12Caesars/Domitian*.html#ref:moon_in_Aquarius.

36. St. Jerome, *Homilies on the Psalms*, trans. M. L. Ewald (Westminster, MD: Newman, 1964), p. 140.

37. See K. Lowe, "The global consequences of mistranslation: The adoption of the 'black but . . .' formulation in Europe, 1440–1650," *Religions*, vol. 3 (2012), pp. 544–55.

38. G. L. Byron, *Symbolic Blackness and Ethnic Difference in Early Christian Literature* (London: Routledge, 2002), pp. 41–51.

39. E. B. Virsaladze, *Gruzinskie Narodnye Predaniya i Legendy* (Moscow: Nauka, 1973), p. 268.

40. For these and more, see *Oxford English Dictionary*, 2nd ed., vol. 2 (Oxford: Clarendon Press, 1989), pp. 238–44.

41. There is some debate about whether Shakespeare had a stable basic color term for orange, which is first recorded in English in 1557. He used the adjective once, in modified form, when Bottom in *A Midsummer's Night Dream* (Act 1, Scene 2) mentioned an "orange-tawny beard." He deployed a number of other nonbasic color terms, including crimson (sixteen times), tawny (thirteen times), scarlet (twelve times), swart, swarth or swarthy (seven times), and gold or golden—which didn't refer only to color—over 100 times.

42. These figures concur with those found in A.-M. Janziz, *A Study of Color Words in Shakespeare's Works*, PhD thesis (University of Sheffield, 1997). http://etheses.whiterose.ac.uk/14443/1/266836.pdf (accessed: November 22, 2017). For more on Shakespeare's colors, see also P. Bock, "Color terms in Shakespeare," in P. Bock, ed., *Shakespeare and Elizabethan Culture* (New York: Schocken Books, 1984), pp. 123–33.

43. Shakespeare wasn't the first to employ such phrases. "Coal-black" first appeared in the thirteenth century, "pitch-black" originated in the fourteenth century, and "jet-black" emerged in the fifteenth century.

44. W. Shakespeare, *A Midsummer Night's Dream* (Act 5, Scene 1).

45. For more, see E. Bronfen, *Night Passages: Philosophy, Literature, and Film*, trans. E. Bronfen and D. Brenner (New York: Columbia University Press, 2013), pp. 109–35.

46. J. Milton, *Paradise Lost: A Poem in Ten Books* (London: Peter Parker, Robert Boulter and Matthias Walker, 1667), np; L. Sterne, *The Life and Opinions of Tristram Shandy, Gentleman*, vol. 1 (York: Ann Ward, 1759), pp. 73–4.

47. G. de Nerval, *Les Filles du feu* (Paris: Michel Lévy Frères, 1854). This version trans. W. Stone.

48. E. A. Poe, *The Raven and Other Poems* (New York: Wiley and Putnam, 1845), np.

49. These definitions are all abbreviated versions of those provided by the *Oxford English Dictionary*. For the full list, see *Oxford English Dictionary*, 2nd ed., vol. 2 (Oxford: Clarendon Press, 1989), pp. 244–52. For a similar list, see J. Stabler and F. Goldberg, "The black and white symbolic matrix," *International Journal of Symbology*, vol. 4 (July 1973), pp. 27–35.

50. Black negatives were identified in 890 milliseconds, while white negatives took 909 milliseconds. White positives were identified in 863 milliseconds, while black positives took 876 milliseconds. B. Meier et al., "Black and white as valence cues: A large-scale replication effort of Meier, Robinson, and Clore (2004)," *Social Psychology*, vol. 46 (2015), pp. 174–8. The earlier investigation was B. Meier et al., "Why good guys wear white: Automatic inferences about stimulus valence based on brightness," *Psychological Science*, vol. 15, no. 2 (2004), pp. 82–7.

51. J. Williams and J. K. Roberson, "A method for assessing racial attitudes in preschool children," *Educational and Psychological Measurement*, vol. 27 (1967), pp. 671–89.

52. See L. Porter, *Tarnished Heroes, Charming Villains and Modern Monsters: Science Fiction in Shades of Gray on 21st Century Television* (Jefferson: McFarland, 2010).

53. J. Tanizaki, *In Praise of Shadows*, trans. T. Harper and E. Seidensticker (Stony Creek: Leete's Island Books, 1977), p. 31.

54. Quoted in W. Theodore de Bary, "The vocabulary of Japanese aesthetics, I, II, III," in N. Hume, ed., *Japanese Aesthetics and Culture: A Reader* (Albany: State University of New York Press, 1995), p. 52.

55. Tanizaki, *In Praise of Shadows*, pp. 16–17.

56. See T. Izutsu, "The elimination of color in Far Eastern art and philosophy," *Eranos Jahrbuch: "The Realms of Color,"* 1972 (Leiden: E. J. Brill, 1974), pp. 429–64.

57. See, for instance, Laozi, *The Daodejing of Laozi*, ed. P. Ivanhoe (Indianapolis: Hackett, 2003), p. 12.

58. Quoted in H. Paul Varley, "Cultural life in medieval Japan," in J. Whitney Hall and K. Yamamura, eds., *The Cambridge History of Japan*, vol. 3 (Cambridge: Cambridge University Press, 1988), p. 453. For an alternative translation, see H. Shirane, ed., *Traditional Japanese Literature: An Anthology, Beginnings to 1600* (New York: Columbia University Press, 2012), p. 307.

59. See T. Tsien, *Collected Writings on Chinese Culture* (Hong Kong: Chinese University of Hong Kong, 2011), pp. 115–27.

60. This passage, from *Records of Famous Paintings of All the Dynasties*, is quoted in Editorial Committee of Chinese Civilization, ed., *China: Five Thousand Years of History and Civilization* (Hong Kong: University of Hong Kong, 2007), p. 733. For an alternative translation, see W. Acker, *Some T'ang and Pre-T'ang Texts on Chinese Painting* (Leiden: Brill, 1954), p. 185.

61. See J. Parker, *Zen Buddhist Landscape Arts of Early Muromachi Japan 1336–1573* (Albany: State University of New York Press, 1999).

62. I. Tanaka, *Japanese Ink Painting: Shubun to Sesshu* (Tokyo and New York: Weatherhill, 1972), p. 105.

63. For an excellent discussion, see Yukio Lippit, "Of modes and manners in Japanese ink painting: Sesshu's *Splashed Ink Landscape* of 1495," *Art Bulletin*, vol. 94, no. 1 (March 2012), pp. 50–77.

64. K. Morrissey Thompson, *The Art and Technique of Sumi-e Japanese Ink Painting* (Clarendon: Tuttle Publishing, 2012).

65. For more on this, see D. Keene, "Japanese aesthetics," *Philosophy East and West*, vol. 19, no. 3 (July 1969), p. 297.

66. Now, though, the Japanese increasingly use the "internationalized term" *color terebi*. H. Zollinger, "Categorical color perception: Influence of cultural factors on the differentiation of primary and derived basic color terms in color naming by Japanese children," *Vision Research*, vol. 28, no. 12 (1988), pp. 1379–82.

67. *Washington Post* (June 26, 1983), p. K3.

68. Alberti, *On Painting*, p. 84.

69. Quoted in J. Wilson-Bareau, ed., *Manet by Himself: Correspondence and Conversation, Paintings, Pastels, Prints and Drawings* (London: TimeWarner, 2004), p. 42. For more on this relationship, see J. Wilson-Bareau, "Manet and Spain," in G. Tinterow and G. Lacambre, eds., *Manet/Velázquez: The French Taste for Spanish Painting* (New Haven and London: Yale University Press, 2003), pp. 203–58.

70. See M. R. Kessler, "Unmasking Manet's Morisot," *The Art Bulletin*, vol. 81, no. 3 (1999), pp. 473–89. The painting's blackness had a great impact on those who saw it. The poet Paul Valéry wrote: "What struck me before all else was the *black*—the absolute black of a little mourning hat, along with its tie strings as they mingle among the locks of chestnut hair and rosy gleams of light on them; it is a black that could only be Manet's . . . What with those overpowering blacks, the cool simplicity of the background, the pale or rosy luminosity of the flesh, the odd silhouette of the hat, which was 'young' and 'the latest fashion,' the confusion of curls, tie strings and ribbon to each side of the face; the face itself with its great eyes whose vague fixity suggests the profoundest abstraction, a sort of *presence in absence*—the total effect adds up to a singular impression of . . . *poetry*." Quoted in C. Armstrong, *Manet Manette* (New Haven and London: Yale University Press, 2002), p. 175. For more on Manet's black, see C. Imbert, "Manet: Effects of black," *Paragraph*, vol. 34, no. 2 (July 2011), pp. 187–98.

71. O. Redon, *To Myself: Notes on Life, Art and Artists*, trans. M. Jacob and J. Wasserman (New York: George Braziller, 1986), p. 103.

72. Quoted in J. Richardson, *A Life of Picasso: 1881–1906*, vol. 1 (London: Random House, 1991), p. 417.

73. H. Matisse, "Black is a color" (1946), in J. Flam, ed., *Matisse on Art* (Oxford: Phaidon, 1978), pp. 106–7.

74. Quoted in A. Vollard, *Renoir: An Intimate Record*, trans. H. van Doren and R. Weaver (New York: Dover, 1990), p. 52.

75. For more, see S. Rosenthal, *Black Paintings* (Munich: Haus der Kunst, 2007); and S. Terenzio, *Robert Motherwell and Black* (New York: Petersburg Press, 1980).

76. A. Reinhardt, "Black, Symbol" (n.d.), in B. Rose, ed., *Art-as-art: The Selected Writings of Ad Reinhardt* (Berkeley and Los Angeles: University of California Press, 1975), p. 96.

77. W. Smith, "Ad Reinhardt's Oriental aesthetic," *Smithsonian Studies in American Art*, vol. 4, no. 3/4 (summer–autumn 1990), pp. 22–45.

78. Reinhardt, "End" (n.d.), in Rose, *Art-as-art*, p. 112.

79. Soulages had repeated this story in a number of iterations. In some versions he was six years old; in others, his interlocutor was his sister. This version quoted in B. Ceysson, *Soulages*, trans. S. Jennings (Bergamo: Boffini Press, 1980), p. 57.

80. Quoted in ibid., p. 60.

81. Quoted in Z. Stillpass, "Pierre Soulages," *Interview* (May 7, 2014). https://www.interviewmagazine.com/art/pierre-soulages (accessed: February 7, 2018).

CHAPTER 2: INVENTING HUMANITY

1. Pamuk, *My Name Is Red*, p. 227.
2. J.-M. Chauvet, E. B. Deschamps, and C. Hilaire, *Chauvet Cave: The Discovery of the World's Oldest Paintings* (London: Thames and Hudson, 1996), pp. 41–2.
3. See M. Lorblanchet, "Peindre sur les parois des grottes," *Revivre la Préhistoire, Dossier de l'Archéologie*, vol. 46 (1980), pp. 33–9.
4. For more on prehistoric hands, see I. Morley, "New questions of old hands: Outlines of human representation in the Palaeolithic," in C. Renfrew and I. Morley, eds., *Image and Imagination: A Global Prehistory of Figurative Representation* (Cambridge: McDonald Institute of Archaeological Research, 2007), pp. 69–82.
5. The full text of *Atrahasis* is in *Myths from Mesopotamia: Creation, the Flood, Gilgamesh, and Others*, trans. S. Dalley (Oxford: Oxford University Press, 2000), pp. 1–38.
6. For an old rumination on this issue, see John Donne's twenty-fifth sermon, in *The Works of John Donne*, vol. 1 (London: John W. Parker, 1838), pp. 502–3.
7. N. Psychogios et al., "The human serum metabolome," *PLoS ONE*, vol. 6, no. 2 (February 16, 2011), np.
8. Most vertebrates have red blood, but in many organisms it is a different color. Crustaceans and molluscs have blue blood (colored by hemocyanin), worms and leeches have green blood (chlorocruorin), and some marine worms have purple blood (hemerythrin).
9. For a wide-ranging discussion of blood, see C. Knight, *Blood Relations: Menstruation and the Origins of Culture* (New Haven and London: Yale University Press, 1991).
10. J. J. Hublin et al., "New fossils from Jebel Irhoud, Morocco, and the pan-African origin of *Homo sapiens*," *Nature*, vol. 546 (June 8, 2017), pp. 289–92.
11. For a superb and passionate discussion, see S. McBrearty and A. Brooks, "The revolution that wasn't: A new interpretation of the origin of modern human behavior," *Journal of Human Evolution*, vol. 39 (2000), pp. 453–563.
12. Red ochre's color is largely though not exclusively produced by a charge transfer between oxygen and iron. Excited by photons of energy, oxygen electrons leap out of their orbits and join unfilled iron shells, absorbing short wavelengths of visible light and so acquiring a red hue. R. Tilley, *Color and the Optical Properties of Materials*, 2nd ed. (Chichester: Wiley and Sons, 2011), pp. 346–7.

13. Use by *Homo erectus* is controversial. See K. P. Oakley, "Emergence of higher thought 3.0–0.2 Ma B.P.," *Philosophical Transactions of the Royal Society of London*, vol. 292 (1981), pp. 205–11; and A. Marshack, "On Paleolithic ochre and the early uses of color and symbol," *Current Anthropology*, vol. 22, no. 2 (April 1981), pp. 188–91. For Neanderthal use, see W. Roebroeks et al., "Use of red ochre by early Neandertals," *Proceedings of the National Academy of Sciences*, vol. 109, no. 6 (February 2012), pp. 1889–94.

14. L. Barham, "Possible early pigment use in South-Central Africa," *Current Anthropology*, vol. 39 (1998), pp. 703–10; P. van Peer et al., "The Early to Middle Stone Age transition and the emergence of modern human behavior at site 8-B-11, Sai Island, Sudan," *Journal of Human Evolution*, vol. 45 (2003), pp. 187–93. For more, see C. W. Marean et al., "Early human use of marine resources and pigment in South Africa during the Middle Pleistocene," *Nature*, vol. 449 (October 18, 2007), pp. 905–8; and C. W. Marean, "When the sea saved humanity," *Scientific American*, vol. 303 (2010), pp. 54–61. See also F. d'Errico, "Le rouge et le noir: Implications of early pigment use in Africa, the Near East and Europe for the origin of cultural modernity," *South African Archaeological Society*, vol. 10 (2000), pp. 168–74.

15. I. Watts, M. Chazan, and J. Wilkins, "Early evidence for brilliant ritualized display: Specularite use in the Northern Cape (South Africa) between 500 and 300 ka," *Current Anthropology*, vol. 57, no. 3 (June 2016), pp. 287–310.

16. C. Henshilwood et al., "A 100,000-year-old ochre-processing workshop at Blombos Cave, South Africa," *Science*, vol. 344, no. 6053 (October 14, 2011), pp. 219–22.

17. See C. Henshilwood et al., "Emergence of modern human behavior: Middle Stone Age engravings from South Africa," *Science*, vol. 295, no. 1278 (February 15, 2002), pp. 1278–80; and C. Henshilwood et al., "Engraved ochres from the Middle Stone Age levels at Blombos Cave, South Africa," *Journal of Human Evolution*, vol. 57 (2009), pp. 27–47.

18. R. Rifkin, "Assessing the efficacy of red ochre as a prehistoric hide tanning ingredient," *Journal of African Archaeology*, vol. 9 (2011), pp. 131–58.

19. R. Rifkin et al., "Assessing the photoprotective effects of red ochre on human skin by in vitro laboratory experiments," *South African Journal of Science*, vol. 111, nos. 3/4 (2015), pp. 1–8.

20. C. Duarte, "Red ochre and shells: Clues to human evolution," *Trends in Ecology and Evolution*, vol. 29, no. 10 (October 2014), pp. 560–65.

21. C. Knight, C. Power, and I. Watts, "The human symbolic revolution: A Darwinian account," *Cambridge Archaeological Journal*, vol. 5, no. 1 (1995), p. 87.

22. For evidence of other binders elsewhere, see P. Villa et al., "A milk and ochre paint mixture used 49,000 years ago at Sibudu, South Africa," *PLoS ONE*, vol. 10, no. 6 (June 2015), np.

23. See Knight, Power, and Watts, "Human symbolic revolution." For later elaborations of this theory, see C. Power, "'Beauty magic': The origins of art," in R. Dunbar et al., eds., *The Evolution of Culture: An Interdisciplinary View* (Edinburgh: Edinburgh University Press, 1999), pp. 92–112; and I. Watts, "Red ochre, body-painting, and language: Interpreting the Blombos ochre," in R. Botha and C. Knight, eds., *The Cradle of Language* (Oxford: Oxford University Press, 2009), pp. 62–92.

24. See Power, "Beauty magic," pp. 102–7.

25. G. Borg and M. Jacobsohn, "Ladies in red—mining and use of red pigment by Himba women in Northwestern Namibia," *Tagungen des Landesmuseums für Vorgeschichte Halle*, vol. 10 (2013), pp. 43–51.

26. A. Jacobson-Widding, *Red-White-Black as a Mode of Thought: A Study of Triadic Classification by Colors in the Ritual Symbolism and Cognitive Thought of the Peoples of the Lower Congo* (Uppsala: Acta Universitatis Upsaliensis, 1979), pp. 158–60.

27. Other than the large quantities of red ochre found in prehistoric sites, it has no archaeological foundation. Moreover, the positing of such continuities between prehistoric humans and contemporary tribal communities is problematic to say the least.

28. N. Shoemaker, "How Indians got to be red," *American Historical Review*, vol. 102, no. 3 (June 1997), pp. 625–44.

29. For a more detailed account, see R. Sharer and L. Traxler, *The Ancient Maya* (Stanford: Stanford University Press, 2006), pp. 751–4.

30. B. de Sahagún, *Historia general de las cosas de la Nueva España*. Quoted in A. Lopez Austin, *The Human Body and Ideology: Concepts of the Ancient Nahuas*, vol. 1 (Salt Lake City: University of Utah Press, 1988), p. 168.

31. For an excellent discussion of Mayan color, see S. Houston et al., *Veiled Brightness: A History of Ancient Mayan Color* (Austin: University of Texas Press, 2009).

32. B. Díaz del Castillo, *The Discovery and Conquest of Mexico, 1517–1521*, trans. A. P. Maudslay (New York: Farrar, Straus and Cudahy, 1973), p. 192.

33. E. Hill Boone, ed., *Painted Architecture and Polychrome Monumental Sculpture in Mesoamerica* (Washington, DC: Dumbarton Oaks Research Library and Collection, 1985), pp. 173–82.

34. For a wider discussion, see M. de Orellana, "From Red to Mexican Pink," *Artes de Mexico*, vol. 111 (November 2013), pp. 73–96. See also Houston, *Veiled Brightness*, pp. 44–50.

35. M. de Agredos Pascual et al., "Annatto in America and Europe: Tradition, treatises and elaboration of an ancient color," *Arché: Publicación del Instituto Universitario de Restauración del Patrimonio de la UPV*, vols. 4–5 (2010), pp. 97–102.

36. L. Gurgel et al., "Studies on the antidiarrheal effect of dragon's blood from *Croton urucurana*," *Phytotherapy Research*, vol. 15, no. 4 (June 2001), pp. 319–22.

37. *Popol Vuh: The Mayan Book of the Dawn of Life*, trans. D. Tedlock (New York: Simon and Schuster, 1996), np.

38. T. Eisner et al., "Red cochineal dye (carminic acid): Its role in nature," *Science*, vol. 208, no. 4447 (May 30, 1980), pp. 1039–42.

39. For an old but thorough survey, see R. Tonkin, "Spanish red: An ethnographical study of cochineal and the opuntia cactus," *Transactions of the American Philosophical Society*, vol. 67, no. 5 (1977), pp. 1–84.

40. L. Ammayappan and D. Shakyawar, "Dyeing of carpet woolen yarn using natural dye from cochineal," *Journal of Natural Fibers*, vol. 13, no. 1 (2016), pp. 42–53.

41. For two excellent discussions, see E. Phipps, *Cochineal: The Art History of a Color* (New Haven and London: Yale University Press, 2010); and C. Marichal, "Mexican cochineal and European demand for a luxury dye, 1550–1850," in B. Adam and B. Yun-Casalilla, eds., *Global Good and the Spanish Empire, 1492–1824: Circulation, Resistance and Diversity* (London: Palgrave, 2014), pp. 197–215.

42. S. de Jesus Mendez-Gallegos et al., "Carmine cochineal *dactylopius coccus costa* (rhynchota: Dactylopiidae): Significance, production and use," *Advances in Horticultural Science*, vol. 17, no. 3 (2003), pp. 165–71.

43. C. Norton and X. Gao, "Zhoukoudian Upper Cave revisited," *Current Anthropology*, vol. 49, no. 4 (August 2008), pp. 732–45.

44. H. Mai et al., "Characterization of cosmetic sticks at Xiaohe Cemetery in early Bronze Age Xinjiang, China," *Scientific Reports*, no. 18939 (January 2016), np.

45. E. Brenner, "Human body preservation—old and new techniques," *Journal of Anatomy*, vol. 224, no. 3 (March 2014), pp. 316–44.

46. J. Needham, *Science and Civilization in China*, vol. 5, part III (Cambridge: Cambridge University Press, 1976), p. 87.

47. Ibid., p. 111.

48. J. Cooper, *Chinese Alchemy: Taoism, the Power of Gold, and the Quest for Immortality* (Newburyport: Weiser, 2016), p. 23.

49. See C. Miguel et al., "The alchemy of red mercury sulphide: The production of vermilion for medieval art," *Dyes and Pigments*, vol. 102 (2014), pp. 210–17.

50. For a discussion, see R. J. Cutter, "To make her mine: Women and the rhetoric of property in early and medieval Fu," *Early Medieval China*, vol. 19 (2013), p. 48.

51. S. Miklin-Kniefacz et al., "Searching for blood in Chinese lacquerware: *zhu xie hui*," *Studies in Conservation*, vol. 61, no. 3 (August 2016), pp. 45–51. See also A. Heginbotham et al., "Some observations on the composition of Chinese lacquer," *Studies in Conservation*, vol. 61, no. 3 (August 2016), pp. 28–37.

52. J. Wyatt and B. Brennan Ford, *East Asian Lacquer: The Florence and Herbert Irving Collection* (New York: Metropolitan Museum of Art, 1992), pp. 96–7.

53. D. Lary, "Chinese reds," in I. Germani and R. Swales, eds., *Symbols, Myths and Images of the French Revolution: Essays in Honor of James Leith* (Regina: Canadian Plains Research Center, 1998), pp. 307–20.

54. "Eulogy of Mao Zedong" (1978), cited in X. Lu, *Rhetoric of the Chinese Cultural Revolution: The Impact on Chinese Thought, Culture, and Communication* (Columbia: University of South Carolina Press, 2020), p. 102.

55. See H. Qiang, "A study of the metaphor of 'red' in Chinese culture," *American International Journal of Contemporary Research*, vol. 1, no. 3 (November 2011), pp. 99–102.

56. See Z. Kövecses, *Metaphor: A Practical Introduction* (Oxford: Oxford University Press, 2010), pp. 140–44.

57. See H.-N. Ho, "Color-temperature correspondences: When reactions to thermal stimuli are influenced by color," *PLoS ONE*, vol. 9, no. 3 (March 2014), e91854 20. For the reverse association, see K. Tomaselli, "Blue is hot, red is cold: Doing reverse cultural studies in Africa," *Cultural Studies ↔ Critical Methodologies*, vol. 1, no. 3 (2001), pp. 283–318.

58. A. Kapoor, in *The John Tusa interviews*, BBC Radio 3 (July 6, 2003), available online at http://www.bbc.co.uk/programs/pooncbc1 (accessed: January 2, 2018).

59. The trumpet comparison dates back at least to the eighteenth century. In 1789, Erasmus Darwin wrote of a blind man who asked if scarlet was comparable to the sound of trumpets. E. Darwin, *The Botanic Garden*, part II (London: J. Jackson, 1789), p. 129.

60. Pamuk, *My Name Is Red*, p. 227.

61. Ibid., p. 225.

62. H. Christian Andersen, "The Red Shoes," in *The Complete Fairy Tales* (Ware: Wordsworth Editions, 1997), pp. 322–9.

63. For a useful survey of this huge quantity of research, see A. Elliot and M. Maier, "Color psychology: Effects of perceiving color on psychological functioning in humans," *Annual Review of Psychology*, vol. 65 (2014), pp. 95–120.

64. L. Jones, "Tinted films for sound positives," *Transactions of the Society of Motion Picture Engineers*, vol. 13, no. 37 (May 1929), pp. 199–226.

65. F. Taylor, "The king and queen of color," *The Rotarian* (August 1944), pp. 26–7.

66. See S. Street, "A suitable job for a woman: Color and the work of Natalie Kalmus," in C. Gledhill and J. Knight, eds., *Doing Women's Film History: Reframing Cinemas, Past and Present* (Champaign-Urbana: University of Illinois Press, 2015), pp. 206–17.

67. N. Kalmus, "Color consciousness," *Journal of the Society of Motion Picture Engineers* (August 1935), p. 142.

68. Ibid., p. 143.

69. "Let's talk about *Pierrot*," *Godard on Godard*, trans. T. Milne (New York and London: Da Capo, 1972), p. 217.

70. For more on Herrmann's music, see T. Schneller, "Unconscious anchors: Bernard Herrmann's music for *Marnie*," *Popular Music History*, vol. 5, no. 1 (2010), pp. 55–104.

71. For a longer analysis of the film, see J. Belton, "Color and meaning in *Marnie*," in S. Brown et al., eds., *Color and the Moving Image: History, Theory, Aesthetics* (London: Routledge, 2013), pp. 189–95; and I. Shaham, "Seeing red: The female body and the body of the text in Hitchcock's *Marnie*," in *Sensational Pleasures in Cinema, Literature and Visual Culture*, pp. 245–57.

72. Quoted and translated in L. Roulet, "Ana Mendieta and Carl Andre: Duet of leaf and stone," *Art Journal*, vol. 63, no. 3 (2004), p. 89.

73. Cited in C. Merewether, "From inscription to dissolution: An essay on expenditure in the work of Ana Mendieta," in C. Fusco, ed., *Corpus Delecti: Performance Art of the Americas* (London and New York: Routledge, 2000), p. 137.

74. Quoted in C. Gray, "Earth art," *Providence Journal-Bulletin* (April 21, 1984), np.

75. J. Walder, "A death in art," *New York Magazine* (December 16, 1985), p. 46.

76. Quoted in P. Barreras del Rio and J. Perreault, *Ana Mendieta: A Retrospective* (New York: New Museum of Contemporary Art, 1988), p. 10.

CHAPTER 3: TWILIGHT OF THE IDOLS

1. Like many of Picasso's famous utterances, this quotation is to my knowledge unsourceable and may be apocryphal.

2. For some of the quasi-religious responses, see F. Gibbons, "Tate Modern awakes to Dane's rising sun," *Guardian* (October 16, 2003), p. 13.

3. For a clear and concise explanation of this process, see S. Wilk, "The yellow sun paradox," *Optics and Photonics News*, vol. 20, no. 3 (March 2009), np.

4. Most stars are divided into seven categories (O, B, A, F, G, K, M), according to visual appearance, with G-type stars characterized by an apparent yellow color. There are many such stars in the universe. The closest, apart from our own sun, is Alpha Centauri A.

5. For a superb discussion of the physics and culture of the sun, see R. Cohen, *Chasing the Sun: The Epic Story of the Star That Gives Us Life* (London: Simon and Schuster, 2010).

6. Quoted in M. Müller, *Comparative Mythology: An Essay* (London: George Routledge and Sons, 1909), p. xi.

7. My translation. Original French quoted in H. Brougham, *Lives of the Men of Letters of the Time of George III* (London and Glasgow: Richard Griffin, 1856), p. 121.

8. One scholar called him "a voluptuary, an intellectual lightweight, an atheist, ultimately a maniac." C. Aldred, *Akhenaten, Pharaoh of Egypt: A New Study* (New York: McGraw Hill, 1968), p. 7.

9. This translation is reproduced in T. Wilkinson, *The Rise and Fall of Ancient Egypt* (London: Bloomsbury, 2013), pp. 290–91.

10. I. Fleming, *Goldfinger* (London: Jonathan Cape, 1959), pp. 260–61.

11. For a useful account, see E. Prior, "How much gold is there in the world?," *BBC News* (April 1, 2013), http://www.bbc.co.uk/news /magazine-21969100 (accessed: January 11, 2018).

12. See C. Corti and R. Holliday, eds., *Gold: Science and Applications* (Boca Raton: CRC Press, 2009); and H. Bachmann, *The Lure of Gold: An Artistic and Cultural History* (New York: Abbeville Press, 2006).

13. "Gold," *Oxford English Dictionary*, 2nd ed., vol. 7 (Oxford: Clarendon Press, 1989), p. 652.

14. K. Saeger and J. Rodies, "The color of gold and its alloys: The mechanism of variation in optical properties," *Gold Bulletin*, vol. 10, no. 1 (1977), pp. 10–14.

15. Y. Almirantis, "The paradox of the planetary metals," *Journal of Scientific Exploration*, vol. 19, no. 1 (2005), pp. 31–42.

16. For more on these objects, see M. Cahill, "Here comes the Sun . . . ," *Archaeology Ireland*, vol. 29, no. 1 (spring 2015), pp. 26–33.

17. S. Muller, "Solbilledet fra Trundholm," *Nordiske Fortidsminder*, vol. 1, no. 6 (1903), pp. 2–38. I am grateful to my colleague at Gonville and Caius College, Cambridge, Jens Scherpe, for assisting me in the translation of this paper.

18. K. Randsborg, "Spirals! Calendars in the Bronze Age in Denmark," www.rockartscandinavia.com/images/articles/randsborga9.pdf (accessed: January 12, 2018).

19. K. Kristiansen, "Rock art and religion: The sun journey in Indo-European mythology and Bronze Age rock art," in Å. Fredell, K. Kristiansen, and F. Criado Boado, eds., *Representations and Communications: Creating an Archaeological Matrix of Late Prehistoric Rock Art* (Oxford and Oakville: Oxbow Books, 2010), pp. 93–115.

20. L. James, *Mosaics in the Medieval World: From Late Antiquity to the Fifteenth Century* (Cambridge: Cambridge University Press, 2017), p. 117.

21. In the original Latin it read "Aut lux hic nata est, aut capta hic libera regnat." The line appears in the Chapel of Sant'Andrea, the archbishop's private chapel, now part of the Archiepiscopal Museum in Ravenna.

22. For a contemporary description of the process, see C. Cennini, *The Craftsman's Handbook*, trans. D. Thompson (New York: Dover, 1960), pp. 79–85.

23. Though gold was unquestionably artists' preferred light-like material, it was so expensive that cheaper substitutes were inevitably sought. Ancient Greeks mixed fish or tortoise bile with chalk and vinegar to make golden writing ink. Metalworkers coated tin and silver with yellow lacquer and hoped no one would notice. Medieval painters combined egg yolks and mercury with celandine to produce alluring but short-lived golden colorants. In the thirteenth century artists began manufacturing an inexpensive pigment called "mosaic gold" from sulphide of tin that fooled many a medieval eye. The most successful lookalike was orpiment, its name originating in the Latin *auripigmentum*, meaning "gold pigment" or "gold paint." Made from arsenic and sulfur, orpiment poisoned anyone who spent much time with it—but it produced a yellow pigment so lustrous that some connoisseurs thought it was the real thing. The Chinese called it the "sperm of gold." For more, see D. Thompson, *The Materials and Techniques of Medieval Painting* (New York: Dover, 1956), pp. 174–89.

24. Alberti, *On Painting*, p. 85.

25. S. Vignolini et al., "Directional scattering from the glossy flower of *Ranunculus*: How the buttercup lights up your chin," *Journal of the Royal Society: Interface*, vol. 9, no. 71 (June 7, 2012), pp. 1295–301.

26. D. Basker and M. Negbi, "Uses of saffron," *Economic Botany*, vol. 37, no. 2 (1983), pp. 228–36.

27. Homer, *Iliad*, trans. S. Butler (London: Longmans, Green, 1898), Book XXIII, lines 225–30.

28. Virgil, *Aeneid*, Book VII, lines 28–35. Translation in R. Jenkyns, *Virgil's Experience: Nature and History: Times, Names, and Places* (Oxford: Clarendon Press, 1998), p. 469.

29. Indian National Congress, *Report of the National Flag Committee* (Ahmedabad: All India Congress Committee, 1931), p. 4.

30. Quoted in S. Jha, *Reverence, Resistance and Politics of Seeing the National Flag* (Delhi: Cambridge University Press, 2016), p. 114.

31. *Organizer* (August 14, 1947), p. 6.

32. "The Bhagwa Dhwaj," hssuk.org/the-bhagwa-dhwaj-saffron-flag / (accessed: January 14, 2018).

33. See T. Blom Hansen, *The Saffron Wave: Democracy and Hindu Nationalism in Modern India* (Princeton: Princeton University Press, 1999).

34. S. Hewlings and D. Kalman, "Curcumin: A review of its effects on human health," *Foods*, vol. 6, no. 92 (2017), pp. 1–11.

35. P. Ravindran et al., eds., *Turmeric: The Genus Curcuma* (Boca Raton: CRC Press, 2007), pp. 1–5.

36. *Glory of Ganesha* (Chinmaya: Central Chinmaya Mission Trust, 1986), p. 107.

37. For an old but interesting account, see W. Dymock, "The use of turmeric in Hindoo ceremonial," *Journal of the Anthropological Society of Bombay*, vol. 2 (1891), pp. 441–8.

38. All of this material is drawn from D. Sopher, "Indigenous uses of turmeric *(curcuma domestica)* in Asia and Oceania," *Anthropos*, vol. 59, nos. 1/2 (1964), p. 119.

39. Puyi, *From Emperor to Citizen: The Autobiography of Aisin-Gioro Pu Yi*, vol. 1 (Beijing: Foreign Languages Press, 1964), np. Quoted in J. Zhou and G. Taylor, *The Language of Color in China* (Newcastle: Cambridge Scholars Publishing, 2018), p. 64.

40. Havelock Ellis, "The psychology of yellow," *Popular Science Monthly*, vol. 68 (May 1906), p. 460.

41. S. Connor, *The Book of Skin* (Ithaca: Cornell University Press, 2004), p. 164.

42. M. Channing Linthicum, "Malvolio's cross-gartered yellow stockings," *Modern Philology*, vol. 25, no. 1 (August 1927), pp. 87–93.

43. See https://history.hanover.edu/courses/excerpts/344latj.html (accessed: January 13, 2018).

44. G. Kisch, "The yellow badge in history," *Historia Judaica: A Journal of Studies in Jewish History Especially in Legal and Economic History of the Jews*, vol. 4, no. 2 (October 1942), pp. 95–144.

45. F. Classen, "From iconic O to yellow hat: Anti-Jewish distinctive signs in Renaissance Italy," in L. Greenspoon, ed., *Fashioning Jews: Clothing, Culture, and Commerce* (West Lafayette: Purdue University Press, 2013), p. 36. Yellow marks of various kinds remained in use until the late eighteenth century in Europe and were notoriously revived in the twentieth century. On September 1, 1941, the Nazis issued the following police decree: "Jews who have completed their sixth year are forbidden to show themselves in public without the Jew star. The Jew star consists of a six-pointed star, outlined in black on yellow cloth the size of the palm of one's hand, with a black superscription: 'Jew.' It must be worn visible and firmly sewed to the left breast of clothing." Cited in Kisch, "The yellow badge in history," p. 134.

46. R. Boyle, *Experiments and Considerations Touching Colors* (London: Henry Herringham, 1664), pp. 219–21.

47. See J. Le Blon, *Coloritto, or the Harmony of Coloring in Painting Reduced to Mechanical Practice* (London, c. 1725), p. 28.

48. H. Lang, "Trichromatic theories before Young," *Color: Research and Application*, vol. 8 (1983), pp. 221–31; and F. Birren, "J. C. Le Blon, discoverer and developer of the red-yellow-blue principle of color printing and color mixture," *Color: Research and Application*, vol. 6, no. 2 (summer 1981), pp. 85–92.

49. J. W. von Goethe, "Konfession des Verfassers," in R. Matthaei, ed., *Goethe's Color Theory* (New York: Van Nostrand Reinhold, 1970), pp. 198–201.

50. J. W. von Goethe, *Theory of Colors*, trans. C. L. Eastlake (Mineola: Dover Publications, 2006), p. 151.

51. Ibid., pp. 169–73.

52. Ibid., pp. 168–9.

53. Quoted in W. Thornbury, *The Life of J. M. W. Turner: Founded on Letters and Papers Furnished by His Friends and Academicians*, vol. 2 (London: Hurst and Blackett, 1862), p. 139.

54. Turner's *Chemistry Sketchbooks*, in the Tate's collection, contain five whole pages of formulas for new yellows.

55. J. Townsend, "The materials of J. M. W. Turner: Pigments," *Studies in Conservation*, vol. 38, no. 4 (November 1993), pp. 231–54.

56. Quoted in Thornbury, *Life of Turner*, p. 141.

57. J. Jennings, *The Family Cyclopedia: Being a Manual of Useful and Necessary Knowledge* (London: Sherwood, Gilbert and Piper, 1822), pp. 307–8.

58. L. Monico et al., "Evidence for degradation of the chrome yellows in van Gogh's *Sunflowers*: A study using noninvasive in situ methods and synchrotron-radiation-based X-ray techniques," *Angewandte Chemie International Edition*, vol. 54, no. 47 (November 2015), pp. 13923–7.

59. G. Field, *Chromatography; or, a Treatise on Colors and Pigments, and of Their Powers in Painting*, 2nd ed. (London: Moyes and Barclay, 1841), p. 143.

60. Townsend, "The Materials of Turner," p. 249.

61. The comment was directed at Turner's *Burning of the House of Lords and Commons, 16th October 1834* (painted 1835) in the Tate. Quoted in Thornbury, *Life of Turner*, p. 327.

62. *London Literary Gazette* (May 13, 1826), p. 298.

63. *Morning Chronicle* (June 15, 1827), np.

64. *British Press* (April 30, 1826), np.

65. Turner to Balmanno, in J. Gage, ed., *Collected Correspondence of J. M. W. Turner* (Oxford: Clarendon Press, 1980), p. 115.

66. See J. Gage, "Turner's annotated books: Goethe's 'Theory of Colors'," *Turner Studies*, vol. 4, no. 2 (1984), pp. 34–52.

67. Goethe, *Theory of Colors*, p. 34.

68. "Deep volcanian yellow" is John Keats' phrase, used in "Lamia," in *Lamia, Isabella, the Eve of St. Agnes, and Other Poems* (London: Taylor and Hessey, 1820), p. 12.

69. See J. Hamilton, *Turner and the Scientists* (London: Tate Gallery Publishing, 1998), pp. 58–73.

70. For a similar analysis of Claude Monet's *Impression: Sunrise* (1872), see M. Livingstone, *Vision and Art: The Biology of Seeing* (New York: Abrams, 2014), pp. 118–21.

71. This is John Gilbert's account of Turner's reworking process: "He was absorbed in his work, did not look about him, but kept on scumbling a lot of white into his picture—nearly all over it . . . The picture was a mass of red and yellow in all varieties. Every object was in this fiery state. He had a large palette, nothing on it but a huge lump of flake-white: he had two or three biggish hog tools to work with, and with these he was driving the white into all the hollows, and every part of the surface. This was

the only work he did, and it was the finishing stroke. The sun, as I have said, was in the center . . . The picture gradually became wonderfully effective, just the effect of brilliant sunshine absorbing everything, and throwing a misty haze over every object. Standing sideway of the canvas, I saw that the sun was a lump of white, standing out like the boss of a shield." Quoted in I. Warrell, ed., *J. M. W. Turner* (London: Tate Publishing, 2007), p. 138.

72. O. Goldsmith, *Dr. Goldsmith's Roman History Abridged by Himself for the Use of Schools—Roman History* (London: Baker and Leigh, 1772), p. 85.

73. Quoted in A. Bailey, *J. M. W. Turner: Standing in the Sun* (London: Tate, 2013), pp. 343–5.

74. *Spectator* (February 11, 1837), np.

75. J. Ruskin, *Modern Painters*, vol. 1 (London: Smith, Elder, 1844), p. 92.

76. *Blackwood's Edinburgh Magazine* (October 1843), p. 503.

77. J. Wykeham Archer, "Joseph William Mallord Turner, R.A.," *Once a Week* (February 1, 1862), p. 166.

78. William Bartlett, quoted in A. Finberg, *The Life of J. M. W. Turner R.A.* (Oxford: Clarendon Press, 1961), p. 438.

79. J. Ruskin, "Letter 45" (September 1874), from *Fors Clavigera: Letters to the Workmen and Laborers of Great Britain*, reproduced in E. T. Cook and A. Wedderburn, eds., *Library Edition: The Works of John Ruskin*, vol. 28 (London: George Allen, 1907), p. 147.

CHAPTER 4: BEYOND THE HORIZON

1. R. Frost, "Fragmentary Blue," *Harper's Magazine* (July 1920).

2. Known to the native community as Mer, Murray Island now falls under the jurisdiction of Queensland, Australia.

3. W. H. R. Rivers, *Reports of the Cambridge Anthropological Expedition to Torres Straits*, vol. 2: *Physiology and Psychology* (Cambridge: Cambridge University Press, 1901), p. 2.

4. W. H. R. Rivers, "Primitive color vision," *Popular Science Monthly*, vol. 59 (May 1901), p. 51.

5. Rivers, *Reports*, p. 67.

6. W. Gladstone, *Studies on Homer and the Homeric Age* (Oxford: Oxford University Press, 1858), vol. 3, p. 482.

7. G. Deutscher, *Through the Language Glass: How Words Color Your World* (London: William Heinemann, 2010), p. 42.

8. L. Geiger, *Contributions to the History of the Development of the Human Race*, trans. D. Asher (London: Trubner, 1880), pp. 48–63.

9. H. Magnus, "A research study of primitive people's awareness and perception of color" (1880), trans. I. Marth, reproduced in B. Saunders, ed., *The Debate About Color Naming in C19th German Philology* (Leuven: Leuven University Press, 2007), pp. 133–82.

10. B. Berlin and P. Kay, *Basic Color Terms: Their Universality and Evolution* (Berkeley: University of California Press, 1969). The original languages were Arabic, Bulgarian, Catalan, Cantonese, Mandarin, English, Hebrew, Hungarian, Ibibio (Nigeria), Indonesian, Japanese, Korean, Pomo (California), Spanish, Swahili, Tagalog (Philippines), Thai, Tzeltal (Mexico), Urdu, and Vietnamese.

11. P. Kay and L. Maffi, "Green and blue," in M. Dryer and M. Haspelmath, eds., *The World Atlas of Language Structures Online* (Leipzig: Max Planck Institute for Evolutionary Anthropology, 2013), http://wals.info/chapter/134 (accessed: October 14, 2017).

12. J. T. Bagnara, P. J. Fernandez, and R. Fujii, "On the blue coloration of vertebrates," *Pigment Cell Research*, vol. 2 (February 2007), pp. 14–26.

13. A recent study supports this proposition. Its authors argued that color-naming depends above all on "usefulness." Most languages are better at describing warm colors than cool colors because behaviorally relevant objects are typically warm-colored, while backgrounds are typically cool-colored. E. Gibson et al., "Color naming across languages reflects color use," *PNAS*, vol. 114, no. 40 (3 October 2017), pp. 10785–890.

14. For a discussion, see G. Hoeppe, *Why the Sky Is Blue: Discovering the Color of Life*, trans. J. Stewart (Princeton: Princeton University Press, 2007), pp. 52–76.

15. R. Frost, "Fragmentary blue," in *The Poems of Robert Frost* (New York: Modern Library, 1946), p. 231.

16. J. W. von Goethe, *Goethe's Color Theory*, trans. H. Aach (London: Studio Vista, 1971), § 781, p. 170.

17. William Gass was the first to make this observation. W. Gass, *On Being Blue: A Philosophical Inquiry* (Manchester: Carcanet New Press, 1979), p. 21.

18. Zheng He, quoted in J. Needham, *Science and Civilization in China*, vol. 3 (Cambridge: Cambridge University Press, 1959), p. 558.

19. M. Polo, *The Travels*, trans. R. E. Latham (Harmondsworth: Penguin, 1972), pp. 76–7.

20. R. J. H. Clark and D. G. Cobbold, "Characterization of sulfur radical anions in solutions of alkali polysulfides in dimethylformamide and

hexamethylphosphoramide and in the solid state in ultramarine blue, green, and red," *Inorganic Chemistry*, vol. 17 (November 1978), pp. 3169–74. See also J. Mertens, "The history of artificial ultramarine (1787–1844): Science, industry and secrecy," *Ambix*, vol. 51, no. 3 (November 2004), pp. 219–44.

21. See G. Herrmann, "Lapis lazuli: The early phases of its trade," *Iraq*, vol. 30 (spring 1968), pp. 21–57.

22. In several medieval maps, notably the Hereford Mappa Mundi, modern-day Afghanistan is shown adjacent to Paradise. See S. Bucklow, *The Alchemy of Paint: Art, Science, and Secrets from the Middle Ages* (London: Marion Boyars, 2009), pp. 45–6.

23. S. Searight, *Lapis Lazuli: In Pursuit of a Celestial Stone* (London: East and West Publishing, 2010), pp. 107–10.

24. C. Cennini, *The Craftsman's Handbook "Il Libro dell' Arte,"* trans. D. V. Thompson (New York: Dover, 1954), pp. 36–9.

25. Ibid., p. 36.

26. *Oltremare* referred to many overseas products.

27. B. Berrie, "Pigments in Venetian and Islamic painting," in S. Carbone, ed., *Venice and the Islamic World, 828–1797* (New York: Metropolitan Museum of Art and Yale University Press, 2007), p. 144.

28. A minor civil servant was paid roughly 70 florins a year. A senior official earned as much as 300 florins. A modest cottage on the outskirts of Florence cost between 1 and 2 florins a year. A grand property in the city center could be rented for between 20 and 50 florins.

29. G. Vasari, *The Lives of the Artists*, trans. J. Conaway Bondanella and P. Bondanella (Oxford: Oxford University Press, 2008), pp. 260–61.

30. Lord Byron, "Childe Harold's Pilgrimage," Canto IV, in *The Poetical Works of Lord Byron*, vol. 1 (Edinburgh: William Nimmo, 1861), p. 604.

31. D. Howard, "Venice and Islam in the Middle Ages: Some observations on the question of architectural influence," *Architectural History*, vol. 34 (1991), p. 59.

32. Text translated by, and reprinted in, D. Chambers and B. Pullan, eds., *Venice: A Documentary History, 1450–1630* (Oxford: Blackwell, 1992), p. 167.

33. Ibid.

34. L. Matthew, "'Vendecolori a Venezia': The reconstruction of a profession," *Burlington Magazine*, vol. 144 (November 2002), pp. 680–86.

35. See P. Hills, *Venetian Color: Marble, Mosaic, Painting and Glass, 1250–1550* (New Haven and London: Yale University Press, 1999), p. 9.

36. C. Ridolfi, *The Life of Titian*, trans. J. C. Bondanella and P. Bondanella (University Park: Pennsylvania State University Press, 1996), p. 58.

37. S. Hale, *Titian: His Life* (London: HarperPress, 2012), p. 135.

38. M. Boschini, *La carta del navegar pitoresco*, ed. A. Palluccini (Venice: Istituto per la Collaborazione Culturale, 1966), p. 189.

39. A. Lucas and J. Plesters, "Titian's 'Bacchus and Ariadne,'" *National Gallery Technical Bulletin*, vol. 2 (January 1978), pp. 25–47.

40. See their letter to *The Times* (June 2, 1966), p. 15. See also R. Hughes, "How do you clean a Titian?," *Observer* (June 4, 1967), p. 9.

41. *Catalog of a Collection of Pictures from the Danoot and Other Galleries* (London: Thomas Davison, 1830), p. 21.

42. Lucas and Plesters, "Bacchus and Ariadne," pp. 25–47.

43. Ruskin, *Modern Painters*, vol. 1, p. 108.

44. Novalis, *Henry von Ofterdingen: A Novel*, trans. P. Hilty (Prospect Heights: Waveland Press, 1990), p. 15.

45. Novalis, "Blütenstaub," *Athenaeum*, vol. 1 (1798), p. 53.

46. See, for instance, T. Hondo et al., "Structural basis for blue-color development in flower petals from *Commelina communis*," *Nature*, vol. 358 (August 6, 1992), pp. 515–18.

47. See D. Lee, *Nature's Palette: The Science of Plant Color* (Chicago: University of Chicago Press, 2007), pp. 180–82.

48. S. Magnussen, L. Spillmann, F. Sturzel, and J. Werner, "Unveiling the foveal blue scotoma through an afterimage," *Vision Research*, vol. 44 (February 2004), pp. 377–83.

49. The phenomenon is widely known as the "Purkinje Effect" or "Purkinje Shift." For more, see R. N. Priestland, "Who was . . . Jan Evangelista Purkyne?," *Biologist*, vol. 34, no. 5 (1987), pp. 249–50.

50. See S. M. Khan and S. N. Pattanaik, "Modeling blue shift in moonlit scenes using rod cone interaction," *Journal of Vision*, vol. 4, no. 8 (August 2004), p. 316.

51. K. Vietor, *Goethe the Poet*, trans. M. Hadas (Cambridge, MA: Harvard University Press, 1970), p. 31.

52. J. W. von Goethe, "The Sorrows of Werther," trans. R. Boylan, in *Novels and Tales by Goethe* (London: Henry Bohn, 1854), p. 313.

53. M. Bald, *Literature Suppressed on Religious Grounds* (New York: Facts on File, 2006), p. 315.

54. R. Bell, "In Werther's thrall: Suicide and the power of sentimental reading in early national America," *Early American Literature*, vol. 46 (2011), p. 95.

55. A. E. Pratt, *The Use of Color in the Verse of the English Romantic Poets* (Chicago: Chicago University Press, 1898).

56. J. Keats, *John Keats: The Living Year, 21 September 1818 to 21 September 1819*, ed. R. Gittings (New York: Barnes and Noble, 1968), p. 225.

57. J. Keats, *The Complete Works of John Keats*, vol. 2, ed. Buxton Forman (New York: Thomas Crowell, 1895), pp. 198–9.

58. H. Lees, *Mallarmé and Wagner: Music and Poetic Language* (Aldershot: Ashgate, 2007), p. 128.

59. *Stéphane Mallarmé: Selected Poetry and Prose*, ed. M. A. Caws (New York: New Directions, 1982), pp. 14–16.

60. W. Kandinsky, cited in I. Aronov, *Kandinsky's Quest: A Study in the Artist's Personal Symbolism, 1866–1907* (New York: Peter Lang, 2006), p. 3.

61. W. Kandinsky, "Reminiscences," trans. P. Vergo, in K. Lindsay and P. Vergo, eds., *Kandinsky: Complete Writings on Art* (New York: Da Capo, 1994), p. 363.

62. Ibid., p. 357.

63. W. Kandinsky, "On the spiritual in art," trans. P. Vergo, in K. Lindsay and P. Vergo, eds., *Kandinsky: Complete Writings on Art* (New York: Da Capo, 1994), p. 160.

64. Ibid., p. 179.

65. Ibid., pp. 181–2.

66. Quoted in R. Heller, "The Blue Rider," in M. Konzett, *Encyclopedia of German Literature* (Chicago and London: Fitzroy Dearborn, 2000), p. 119.

67. P. C. Chemery, "Sky," *Encyclopedia of Religion*, vol. 13 (New York: Macmillan, 1987), pp. 345–53.

68. H.-B. de Saussure, "Description d'un cyanomètre ou d'un appareil destiné à mesurer la transparence de l'air," *Mémoires de l'Académie Royale des Sciences Turin*, vol. 4 (1788–9), pp. 409–25.

69. For more on the project, see G. P. Kennedy, *Touching Space: The Story of Project Manhigh* (Atglen: Schiffer Publishing, 2007).

70. D. G. Simons and D. A. Schanche, *Man High* (New York: Doubleday, 1960), pp. 135–6.

71. D. G. Simons, "A journey no man had taken," *Life* (September 2, 1957), pp. 19–27.

72. J. van Nimmen, L. C. Bruno, and R. L. Rosholt, *NASA Historical Data Book 1958–1968*, vol. I: *NASA Resources* (Washington, DC: National Aeronautics and Space Administration, 1976), p. 6.

73. President's Science Advisory Committee, *Introduction to Outer Space* (Washington, DC: US Government Printing Office, 1958), p. 1. This passage is often believed to be the origin for the famous *Star Trek* line: "to boldly go where no man has gone before."

74. Y. Klein, "The Chelsea Hotel manifesto" (1961), reproduced in B. Cora and D. Moquay, *Yves Klein* (Milan: Sylvana Editoriale, 2009), p. 207.

75. For Klein and Rosicrucianism, see T. McEvilley, *Yves the Provocateur: Yves Klein and Twentieth-Century Art* (Kingston: McPherson, 2010), pp. 195–223.

76. Cited in M. Auping, *Declaring Space: Mark Rothko, Barnett Newman, Lucio Fontana, Yves Klein* (Munich and New York: Prestel, 2007), p. 55.

77. Y. Klein, "Sorbonne lecture" (1959), reproduced in C. Harrison and P. Wood, eds., *Art in Theory 1900–1990: An Anthology of Changing Ideas* (Oxford: Blackwell, 2001), p. 805.

78. Patent no. 63471 (May 19, 1960), L'Institut National de la Propriété Industrielle.

79. Quoted in Museum of Modern Art, *MoMA Highlights* (New York: Museum of Modern Art, 2004), p. 242.

80. Klein used the term "blue revolution" in an unsolicited letter to the American president, as well as elsewhere. See Y. Klein to D. Eisenhower, May 20, 1958, reproduced in H. Weitemeier, *Yves Klein* (Cologne: Taschen, 2001), p. 35.

81. S. Stich, *Yves Klein* (London: Hayward Gallery, 1994), pp. 146–8.

82. Brueghel's authorship of the painting remains in doubt. For a poetic rumination on the oblivious figures, see W. H. Auden, "Musée des Beaux Arts," in *Another Time: Poems by W. H. Auden* (London: Faber and Faber, 1940), p. 34.

83. Another example is Jacques Majorelle, whose "Majorelle Blue" is abundant in his garden in Marrakech, purchased in 1980 by Yves Saint Laurent and Pierre Bergé.

84. In 1968, Gagarin was killed when a fighter plane he was piloting fell, Icarus-like, from the sky.

85. For a superb discussion, see D. Cosgrove, *Apollo's Eye: A Cartographic Genealogy of the Earth in the Western Imagination* (Baltimore and London: Johns Hopkins University Press, 2001).

86. Quoted in *The New York Times* (April 16, 1961), p. 50.

87. Quoted in *The Times of India* (April 14, 1961), p. 1.

88. See G. Titov, *My Blue Planet*, NASA technical translation (Washington, DC: NASA, 1975).

89. NASA, "Gemini XI voice communications: Air-to-ground, ground-to-air and on-board transcription" (1967), p. 141, https://www.jsc.nasa.gov/history/mission_trans/GT11_TEC.PDF (accessed: October 16, 2017).

90. For a detailed account of the mission, see R. Zimmerman, *Genesis: The Story of Apollo 8: The First Manned Flight to Another World* (New York and London: Four Walls Eight Windows, 1998).

91. F. Borman, *Countdown: An Autobiography* (New York: Silver Arrow, 1988), p. 212.

92. NASA, "Apollo 8 onboard voice transcription, as recorded on the space-craft onboard recorder" (January 1969), pp. 113–14, https://www.jsc.nasa.gov/history/mission_trans/AS08_CM.PDF (accessed: October 16, 2017).

93. For a discussion, see R. Poole, *Earthrise: How Man First Saw the Earth* (New Haven and London: Yale University Press, 2008), pp. 1–35.

94. This may have been why President Johnson sent a copy of *Earthrise* to all the world's leaders. "A conversation about the U.S. Space Program with former President Lyndon B. Johnson," broadcast during *Man on the Moon: The Epic Journey of Apollo 11*. CBS, July 21, 1969, https://www.youtube.com/watch?v=j5TwzPIFTikandt=146s (accessed: October 17, 2017).

95. Since 1968, countless other photographs have confirmed the Earth's unusual complexion. In 1972, NASA's *Blue Marble* showed a predominantly blue globe, overpainted with spirals of white clouds. And in 1990 an image captured by *Voyager I* from a distance of 3.7 billion miles revealed the planet to be little more than what Carl Sagan famously called a "pale blue dot" in the darkness. See Carl Sagan, *Pale Blue Dot: A Vision of the Human Future in Space* (New York: Random House, 1994).

96. *Evening Star* (December 23, 1968), np.

97. Interview in *Final Frontier* (December 1988), quoted in Poole, *Earthrise*, p. 2.

CHAPTER 5: POISONOUS PURITY

1. H. Melville, *Moby-Dick; or, The Whale* (New York: Harper and Brothers, 1851), p. 216.

2. "Our story," http://www.thewhitecompany.com/help/our-story/ (accessed: January 24, 2020).

3. Many of these advertisements have been collected online by "The Laundry Lab," and can be found here: https://www.youtube.com/channel/UCQx5HC38CX4VuimOyMAB2qw (accessed: January 24, 2018).

4. M.-H. Ropers et al., "Titanium dioxide as food additive," in M. Janus, ed., *Application of Titanium Dioxide* (InTech, 2017), np.

5. Zion Market Research, "Global skin lightening products market will reach USD 8,895 million by 2024" (January 10, 2019), https://www.globenewswire.com/news-release/2019/01/10/1685903/0/en/Global-Skin-Lightening-Products-Market-Will-Reach-USD-8-895-Million-By-2024-Zion-Market-Research.html (accessed: March 11, 2021).

6. I. Newton, "A Letter of Mr. Isaac Newton . . . containing his new theory about Light and Colors," *Philosophical Transactions of the Royal Society*, vol. 80 (February 19, 1671/2), pp. 3075–87.

7. I. Newton, *Opticks; or, a Treatise of the Reflections, Refractions, Inflexions and Colors of Light. Also Two Treatises of the Species and Magnitude of Curvilinear Figures* (London: Smith and Walford, 1704), pp. 130–31.

8. For an important early discussion, see V. Turner, *The Forest of Symbols: Aspects of Ndembu Ritual* (Ithaca: Cornell University Press, 1970).

9. For more, see A. Nairn et al., *The Ocean Basins and Margins*, vol. 8: *The Tethys Ocean* (New York: Springer, 1996).

10. "The city, which was not built in a manner suitable to the grandeur of the empire, and was liable to inundations of the Tiber, as well as to fires, was so much improved under his administration that he boasted, not without reason, that he 'found it of brick, but left it of marble.'" C. Suetonius Tranquillus, "Life of Augustus," in *The Lives of the Twelve Caesars*, ed. A. Thompson (Philadelphia: Gebbie, 1889), 28:3.

11. M. Bradley, "The importance of color on ancient marble sculpture," *Art History*, vol. 32, no. 3 (2009), pp. 427–57.

12. This quotation comes from the manuscript of Leonardo's proposed treatise on painting, now in the Vatican (known as the *Codex Urbinas 1270*). Quoted in C. Farago, *Leonardo da Vinci's Paragone: A Critical Interpretation* (Leiden: Brill Studies, 1992), np.

13. "The first time I was in Rome when I was very young, the pope was told about the discovery of some very beautiful statues in a vineyard near S. Maria Maggiore. The pope ordered one of his officers that he run and tell Giuliano da Sangallo to go and see them . . . Since Michelangelo Buonarroti was always to be found at our house, my father having summoned him and having assigned him the commission of the pope's tomb, my father wanted him to come along, too. I joined the group and we went. I climbed down to where the statues were when immediately my father said, 'That is the *Laocoön*, which Pliny mentions.' Then they dug the hole wider so they could pull the statue out. As soon as it was visible everyone started to draw, all the while discoursing on ancient things, chatting as well about the ones in Florence." Letter from Francesco da Sangallo, published in C. Fea, *Miscellanea Filologica Critica e Antiquaria* (Rome: Pagliarini, 1790–1836), pp. 329–31.

14. P. Norton, "The lost sleeping cupid of Michelangelo," *Art Bulletin*, vol. 39, no. 4 (December 1957), pp. 251–7.

15. See M. Hirst, "Michelangelo, Carrara, and the marble for the Cardinal's Pietà," *Burlington Magazine*, vol. 127, no. 984 (March 1985), pp. 152–9.

16. Letter to B. Varchi, reproduced in E. Ramsden, ed., *The Letters of Michelangelo*, trans. E. Ramsden (Stanford: Stanford University Press, 1963), p. 280.

17. G. Warwick, "'The story of the man who whitened his face': Bernini, Galileo, and the science of belief," *The Seventeenth Century*, vol. 29, no. 1 (2014), pp. 1–29.

18. J. Winckelmann, *Reflections on the Imitation of Greek Works in Painting and Sculpture*, trans. E. Heyer and R. Norton (La Salle: Open Court, 1987), p. 5.

19. J. Winckelmann, *History of the Art of Antiquity*, trans. H. Mallgrave (Los Angeles: Getty, 2006), p. 334.

20. Ibid., p. 195.

21. Ibid., p. 196.

22. For a discussion of this important phrase, see A. Potts, *Flesh and the Ideal: Winckelmann and the Origins of Art History* (New Haven and London: Yale University Press, 1994), pp. 1–11.

23. D. Hume, "On the Standard of Taste," in *Four Dissertations* (London: A. Millar, 1757), p. 215.

24. I. Kant, "The Critique of Judgment" (1790), in *The Greatest Works of Immanuel Kant: Complete Critiques, Philosophical Works, and Essays*, trans. J. Meiklejohn (Frankfurt: Musiacum, 2017), np.

25. Goethe, *Theory of Colors*, p. 55.

26. Winckelmann, *Art of Antiquity*, p. 26.

27. Quoted in V. Finlay, *Color: Travels Through the Paintbox* (London: Folio Society, 2009), p. 116.

28. For examples, see A. Blühm, *Color of Sculpture 1840–1910* (Amsterdam: Van Gogh Museum, 1996), pp. 12–13.

29. For more, see P. Maravelaki-Kalaitzaki, "Black crusts and patinas on Pentelic marble from the Parthenon and Erechtheum (Acropolis, Athens): Characterization and origin," *Analytica Chimica Acta*, vol. 532, no. 2 (March 14, 2005), pp. 187–98.

30. "Obituary," *The Times* (May 26, 1939), np.

31. These are The British Museum's own estimates. I. Jenkins, "Cleaning and controversy: The Parthenon sculptures 1811–1939," *The British Museum Occasional Paper*, no. 146 (2001), pp. 2, 28–30. For another account, claiming more extensive damage, see W. St. Clair, "The Elgin Marbles: Questions of stewardship and accountability," *International Journal of Cultural Property*, vol. 8, no. 2 (1999), pp. 391–521.

32. *The Sunday Times* (May 14, 1939), np.

33. Cited in Jenkins, "Cleaning and controversy," p. 38.

34. T. van Doesburg, "Toward white painting" (1929), in D. Batchelor, ed., *Color* (London: Whitechapel Gallery, 2008), p. 88.

35. Le Corbusier, "a coat of whitewash—the Law of Ripolin," *The Decorative Art of Today*, trans. J. Dunnett (London: Architectural Press, 1987), pp. 185–92.

36. For a famous (and controversial) account, see Martin Bernal's three-volume *Black Athena: The Afroasiatic Roots of Classical Civilization*, published between 1987 and 2006.

37. G. Crone, *The Voyages of Cadamosto and Other Documents on Western Africa in the Second Half of the Fifteenth Century* (London: Hakluyt Society, 1937), p. 1.

38. Ibid., p. 49.

39. For a detailed discussion of the significance of the passage, see G. Taylor, *Buying Whiteness: Race, Culture, and Identity from Columbus to Hip-hop* (New York: Palgrave Macmillan, 2005), pp. 55–71.

40. Ibid., p. 132.

41. For more on this rich and well-covered territory, see ibid., pp. 187–265; W. Jordan, *White over Black: American Attitudes Toward the Negro, 1550–1812* (Williamsburg: University of North Carolina Press, 2012); and T. Allen, *The Invention of the White Race* (London: Verso, 2012).

42. Quoted in Jordan, *White over Black*, p. 44.

43. Anti-miscegenation statutes remained a feature of American law until well into the twentieth century. They were still in place in sixteen southern states as late as 1967, when the US Supreme Court ruled them unconstitutional. US Supreme Court, Loving v. Virginia, 388 U.S. 1 (decided June 12, 1967).

44. C. Linnaei, *Systema Naturae*, 10th ed. (Holmiae: Laurentii Salvii, 1758–9), vol. 1, pp. 20–24.

45. Quoted in B. Baum, *The Rise and Fall of the Caucasian Race: A Political History of Racial Identity* (New York and London: New York University Press, 2008), p. 63.

46. B. Craiglow, "Vitiligo in American history: The case of Henry Moss," *Archives of Dermatology*, vol. 144, no. 9 (2008), p. 1242.

47. Pliny, *Natural History*, trans. P. Holland, Book 2 (London: George Barclay, 1847–8), p. 119.

48. G.-L. Buffon, "Variétés dans l'espèce humaine," in *Histoire naturelle, générale et particulière* (Paris: Imprimerie Royale, 1749), reproduced in C.-O. Doron, "Race and genealogy: Buffon and the formation of the concept of 'race,'" *Journal of Philosophical Studies*, vol. 22 (2012), p. 96.

49. J. Blumenbach, "On the natural variety of mankind" (1775), reproduced in *The Anthropological Treatises of Johann Friedrich Blumenbach*, trans. T. Bendyshe (London: Longman et al., 1865), p. 269.

50. See N. Jablonski and G. Chaplin, "The colors of humanity: The evolution of pigmentation in the human lineage," *Philosophical Transactions of the Royal Society B (Biological Sciences)*, vol. 372, no. 1,724 (July 5, 2017), article 20160349.

51. Buffon had in fact earlier suggested that the "mode of living" explained the different complexions of populations living at similar latitudes, but Smith made it a centerpiece of his thesis.

52. S. Stanhope Smith, *An Essay on the Causes of the Variety of Complexion and Figure in the Human Species* (Philadelphia: John Stockdale, 1789), p. 51.

53. Ibid., p. 14.

54. For more on this remarkable man, see A. Brodsky, *Benjamin Rush: Patriot and Physician* (New York: St. Martin's Press, 2004); R. Noth, "Benjamin Rush, MD: Assassin or beloved healer?," *Baylor University Medical Center Proceedings*, vol. 13, no. 1 (January 2000), pp. 45–9; and D. D'Elia, "Dr. Benjamin Rush and the Negro," *Journal of the History of Ideas*, vol. 30, no. 3 (July–September 1969), pp. 413–22.

55. B. Rush, "Observations intended to favor a supposition that the black color (as it is called) of the negroes is derived from the leprosy," *American Philosophical Society Transactions*, vol. 4 (1799), p. 293.

56. Ibid., p. 295.

57. The text had been influenced by an earlier work by the Dutch anatomist Pieter Camper. C. White, *An Account of the Regular Gradation in Man, and in Different Animals and Vegetables; and from the Former to the Latter* (London: C. Dilly, 1799), p. 51.

58. Stanhope Smith, *Variety of Complexion*, p. 49.

59. The misapprehension might also have been linguistic limitations. European skin inhabits the part of color space that is most poorly served by clear and basic color terms. For more on this, see M. Changizi et al., "Bare skin, blood and evolution of primate color vision," *Biology Letters*, vol. 2, no. 2 (June 2006), pp. 217–21.

60. For more, see R. Dyer, *White: Essays on Race and Culture* (London: Routledge, 1997).

61. Quoted in G. Vigarello, *Concepts of Cleanliness: Changing Attitudes in France Since the Middle Ages*, trans. J. Birrell (Cambridge: Cambridge University Press, 2008), p. 80. See also pp. 58–77.

62. For more, see G. Markovitz and D. Rosner, *Deceit and Denial: The Deadly Politics of Industrial Pollution* (London: University of California Press, 2013), pp. 64–107.

63. See J. Nederveen Pietersee, *White on Black: Images of Africa and Blacks in Western Popular Culture* (New Haven: Yale University Press, 1992), pp. 195–8.

64. Cited in J. M. Massing, "From Greek proverb to soap advert: Washing the Ethiopian," *Journal of the Warburg and Courtauld Institutes*, vol. 58 (1995), p. 183.

65. Ibid., p. 182.

66. "The White Man's Burden," *McClure's Magazine*, vol. 13 (October 1899), p. 1.

67. A. McClintock, *Imperial Leather: Race, Gender, and Sexuality in the Colonial Contest* (London: Routledge, 1995), p. 212.

68. https://www.nytimes.com/2017/10/08/business/dove-ad-racist.html (accessed: March 11, 2021).

69. https://www.dailymail.co.uk/femail/article-4379350/Nivea-apologizes -controversial-White-Purity-ad.html (accessed: May 18, 2020).

70. Melville, *Moby-Dick*, p. 208.

CHAPTER 6: THE SYNTHETIC RAINBOW

1. "Perkins's [*sic*] purple," *All the Year Round* (September 10, 1859), p. 469.

2. For a superb summary of Runge's career, see E. Leslie, *Synthetic Worlds: Nature, Art and the Chemical Industry* (London: Reaktion, 2005).

3. F. Runge, *Der Bildungstrieb der Stoffe: Veranschaulicht in selbstständig gewachsenen Bildern* (Oranienburg: Selbstverlag, 1855), p. 32. My translation.

4. For a discussion of the project, see H. H. Bussemas, G. Harsh, and L. S. Ettre, "Friedlieb Ferdinand Runge (1794–1867): "'Self-grown pictures' as precursors of paper chromatography," *Chromatographia*, vol. 38, nos. 3–4 (February 1994), pp. 243–54; and E. Schwenk, "Friedlieb Runge and his capillary designs," *Bulletin for the History of Chemistry*, vol. 30, no. 1 (2005), pp. 30–34.

5. Diesbach had been working in the laboratory of the alchemist Johann Konrad Dippel and was attempting to produce a red pigment based on cochineal. He borrowed some of the potash that Dippel had been using to make a universal medicine. Dippel's contaminated potash produced not a red but a blue precipitate. Diesbach and Dippel kept their production method secret for twenty years until it was published, in England, in 1724. By the 1730s, it was widely used by artists in Europe and beyond. It furnished the blues in Hokusai's famous woodblock print *Under the*

Wave off Kanagawa (often called *The Great Wave*) in the 1830s and continues to be used today.

6. The three chemists were Jean-Baptiste Guimet from Toulouse, Christian Gottlob Gmelin from Tübingen, and Friedrich August Köttig from Meissen. Where natural ultramarine sold at 3,000–5,000 francs per pound, Guimet's ultramarine sold at approximately 400 francs per pound. See J. Plesters, "Ultramarine blue, natural and artificial," in A. Roy, ed., *Artists' Pigments: A Handbook of Their History and Characteristics*, vol. 2 (Oxford: Oxford University Press, 1993), p. 55. See also J. Mertens, "The history of artificial ultramarine (1787–1844): Science, industry and secrecy," *Ambix*, vol. 51, no. 3 (November 2004), pp. 219–44.

7. M. Astour, "The origin of the terms "'Canaan,' 'Phoenician,' and 'Purple,'" *Journal of Near Eastern Studies*, vol. 24, no. 4 (October 1965), pp. 346–50.

8. The varieties in hue were manipulated by choice of molluscs, exposure to light, duration of simmering, and choice of reducing agents. These methods didn't simply produce hues on the red–blue axis, they also created yellows and greens.

9. Pliny, *Natural History*, chapter 60, §.36.

10. See P. Friedländer, "Über den Farbstoff des antiken Purpurs aus murex brandari," *Berichte der Deutschen Chemischen Gesellschaft*, vol. 42 (1909), pp. 765–70.

11. Diocletian, *An Edict of Diocletian, Fixing a Maximum of Prices Throughout the Roman Empire, A.D. 303*, trans. W. M. Leake (London: John Murray, 1826).

12. For an old but excellent survey, see M. Reinhold, *History of Purple as a Status Symbol in Antiquity* (Latomus: Brussels, 1970). This love of purple might explain why the Romans had such a rich and sophisticated lexicon for the color. Their terms included: *purpura amethystine* (amethyst purple), *conchyliatus* (pale lavender), *ferrugineus* (purplish red), *heliotropium* (reddish blue-red), *hyacinthinus* (reddish violet), *ianthinus* (violet), *indicum* (indigo), *malva* (mauve), *molocinus* (mauve), *ostrinus* (reddish purple), *purpureus laconicus* (dark rose purple), *ruber Tarentinus* (reddish violet), *tyrianthinus* (violet-purple), *viola serotina* (blue-red), and *violeus* (violet). For more, see J. L. Sebesta and L. Bonfante, eds., *The World of Roman Costume* (Madison: University of Wisconsin Press, 2001), p. 241.

13. Pliny, *Natural History,* book IX, chapter 60, §. 128.

14. M. Reinhold, *Studies in Classical History and Society* (Oxford: Oxford University Press, 2002), pp. 30–31.

15. For more on the chamber, see Anna Komnene's *Alexiad*, first composed in the twelfth century. The standard modern translation is A. Comnena, *The Alexiad*, trans. E. R. A. Sewter (Harmondsworth: Penguin, 1969).

16. There were inevitably attempts to re-create it: in 1684 the English physician William Cole extracted a serviceable purple dye from dog-whelks collected in the Bristol Channel. W. Cole, "A letter from Mr. William Cole of Bristol, to the Phil. Society of Oxford; containing his observations on the purple fish," *Philosophical Transactions*, vol. 15 (1685), pp. 1278–86.

17. The first to isolate aniline was the German chemist Otto Unverdorben in 1826, naming the product *crystallin*. Friedlieb Runge treated distilled aniline with calcium chloride in the 1830s, producing a violet-blue liquid that he named *cyanol*. Carl Julius Fritsche was the first to call the substance *aniline*, in 1840. For a prehistory of aniline, see W. T. Johnson, "The discovery of aniline and the origin of the term 'aniline dye,'" *Biotechnic and Histochemistry*, vol. 83, no. 2 (2008), pp. 83–7.

18. M. J. Plater and A. Raab, "Who made mauveine first: Runge, Fritsche, Beissenhirtz or Perkin?," *Journal of Chemical Research*, vol. 40 (December 2016), pp. 758–62.

19. W. H. Perkin, "Address to the Society of Chemical Industry, New York, 6 October 1906," *Science*, vol. 24, no. 616 (October 19, 1906), p. 490.

20. W. H. Perkin, "Hofmann Memorial Lecture: The origin of the coal-tar color industry, and the contributions of Hofmann and his pupils," *Journal of the Chemical Society*, vol. 69, no. 1 (1896), p. 596.

21. Quinine wasn't fully synthesized until 1944.

22. For a detailed description of this process, see Anthony Travis' superb *The Rainbow Makers: Origins of the Synthetic Dyestuffs Industry in Western Europe* (Bethlehem: Lehigh University Press, 1993), pp. 31–7.

23. R. Pullar to W. H. Perkin (June 12). Quoted in Perkin, "Hofmann Memorial Lecture," p. 604.

24. W. H. Perkin, "Specification of William Henry Perkin: Dyeing Fabrics," patent no. 1984, dated August 26, 1856; sealed February 20, 1857 (London: Eyre and Spottiswoode, 1856), p. 3.

25. For a readable account, see S. Garfield, *Mauve: How One Man Invented a Color That Changed the World* (London: Faber and Faber, 2000).

26. R. Hunt, "Murexide or Tyrian Purple," *Art Journal*, vol. 7, no. 13 (1861), p. 115.

27. *Illustrated London News* (August 29, 1857), p. 230. The last time purple hues had been fashionable was in the mid-1830s, when "pale blue, lilac, mauve, rose-color" were declared the colors of the month in July 1836. *Punch* (July 1, 1836), p. 153.

28. For a detailed discussion, see *Englishwoman's Review and Newspaper* (January 30, 1858), p. 333.

29. *Lady's Newspaper* (April 10, 1858), p. 229.

30. There are about 4,000 species of mallow plant, the most ubiquitous in Europe being the common mallow (*Malva sylvestris*). The flower's corolla contained five rose-purple petals, and often grew to about a meter high.

31. In a paper given to the Royal Society in 1863 he also renamed the base *mauveine*. The "ine" suffix was a chemical convention that had also been applied to the compounds from which it was made, i.e., aniline.

32. "Perkins's purple," p. 469.

33. "Epsom," *Lady's Newspaper* (May 29, 1858), p. 341; "Summer Balls," *La Mode* (June 1, 1858), p. 4.

34. "The mauve measles," *Punch*, vol. 37 (January 1, 1859), p. 81. "Mauve measles" didn't only afflict women. *Le Follet* published a story in which a gentleman caught the disease while walking through Kensington Gardens. "The first symptoms," he wrote, "appeared almost immediately in a line all round my throat . . . The fever next appeared on my hands, after a visit to Houbigant Chardin, in Regent Street; it then extended to the region of my heart, gradually radiating over my whole body, until it flew to my head; and at last I found that I had fairly put my foot in it! Yes—from head to foot—from top to toe—I displayed indications of the fever which consumed me, until at last—like the unconscious ribbon that so effectually inoculated me—I became a perfect *mauve beau!*" "In the wrong box: or, the mauve fever," *Le Follet: Journal du Grand Monde, Fashion, Polite Literature, Beaux Arts* (September 1, 1859), p. 65.

35. M. da Conceicao Oliveira et al., "Perkin's and Caro's mauveine in Queen Victoria's lilac postage stamps: A chemical analysis," *Chemistry: A European Journal*, vol. 20 (2014), pp. 1808–12. I am grateful to Hugh Jefferies at Stanley Gibbons for clarifying some of these issues.

36. *Vanity Fair* (May 11, 1859), p. 228.

37. It has been suggested that Verguin had been employed by the Renards to conduct such experiments on aniline, but the details of any such arrangement are unclear. See H. van den Belt, "Why monopoly failed: The rise and fall of Société La Fuchsine," *British Journal for the History of Science*, vol. 25, no. 1 (March 1992), pp. 47–8.

38. The fuchsia was originally named after the sixteenth-century German botanist Leonhart Fuchs.

39. Nicholson developed the colorants with David Simpson Price, though it was Price who was named on the patent. D. S. Price, "Colors for Dyeing

263

and Printing," patent no. 1288, dated May 25, 1859; sealed November 4, 1859 (London: Eyre and Spottiswoode, 1859), pp. 3–4.

40. H. Medlock, "Improvements in the preparation of red and purple dyes," patent no. 126, dated January 18, 1860; sealed July 13, 1860 (London: Eyre and Spottiswoode, 1860).

41. The name "Magenta" probably originated with the Roman term *castrum Maxentiae* (Maxentius's fort), named after Emperor Marcus Aurelius Valerius Maximus (c. 278–312).

42. *The Times* (June 14, 1859), p. 9.

43. See, for instance, the advertisement for Rimmel's "The Magenta" lipstick, *Lady's Newspaper* (February 9, 1861), p. 95.

44. For magenta-bound books and journals, see *Fun* (December 15, 1864), p. 14; for Sewell and Co.'s magenta carpets, see *Lady's Newspaper* (December 1, 1860), p. 360; for Amott's magenta ties, see *Observer* (December 24, 1859), p. 8; for Peter Robinson's magenta-lined opera cloaks, see *Peter Parley's Annual* (1860), p. 5; for Richard Ford's "Eureka shirts" in magenta, see *Bell's Life in London and Sporting Chronicle* (December 9, 1860), p. 2; and for magenta by the bottle, see *Lady's News* (December 8, 1860), p. 374.

45. "Ignoramus at the Exhibition," *All the Year Round* (August 23, 1862), p. 561. Hofmann's comments cited in M. R. Fox's wonderful but sadly unfinished *Dye-makers of Great Britain, 1856–1976: A History of Chemists, Companies, Products and Changes* (Manchester: Imperial Chemicals Industry, 1987), p. 37.

46. "Ignoramus at the Exhibition," p. 561.

47. *The Times* (October 17, 1862), p. 1.

48. *The Times* (February 17, 1863), p. 1.

49. Medlock, "Improvements in the preparation of red and purple dyes."

50. Nicholson in turn appealed in July, but the House of Lords upheld the ruling. Records of the case can be found in the national newspapers throughout the period. For the final ruling, see *The Times* (January 16, 1865), p. 10.

51. Long after the case had been settled, Nicholson continued to issue warnings to Read Holliday. After yet another letter, in August 1866, asking them to terminate production of their own magenta, a clearly exasperated Holliday responded: "We have been dragged before the Vice-Chancellor, the Solicitor-General twice, the Lord Chancellor, and finally the House of Lords; now, you are determined we must go back to the Solicitor or Attorney General. Where is this provocation to end? Is it in our ruin?" Cited in Fox, *Dye-makers*, pp. 66–7.

52. See H. van den Belt, "Action at a distance: A. W. Hofmann and the French patent disputes (1860–1863), or how a scientist may influence legal decisions without appearing in court," in R. Smith and B. Wynne, eds., *Expert Evidence: Interpreting Science in the Law* (London: Routledge, 1989), pp. 184–209.

53. For two thorough discussions of La Fuchsine, see van den Belt, "Why monopoly failed," pp. 45–63; and Travis, *Rainbow Makers*, pp. 106–24.

54. The dyes were named "Hofmann's Violets," and ranged from blue-violet to red-violet. Perkin, "Hofmann Memorial Lecture," p. 617. For a full list of similar dyes, including the ones named above, see C. O'Neill, *A Dictionary of Dyeing and Calico Printing; Containing a Brief Account of All the Substances and Processes in Use in the Arts of Dyeing and Printing Textile Fabrics; With Practical Receipts and Scientific Information* (Philadelphia: Henry Carey Baird, 1869), pp. 2–38.

55. H. Taine, *Notes on England*, trans. E. Hyams (London: Caliban Books, 1995), p. 57.

56. T. Salter, *Field's Chromatography, Revised, Rewritten and Brought Down to the Present Time* (London: Winsor and Newton, 1869), pp. 161–3.

57. For the first figure, see J. P. Murmann, *Knowledge and Competitive Advantage: The Coevolution of Firms, Technology, and National Institutions* (Cambridge: Cambridge University Press, 2003), p. 25. There has been some dispute about the second figure. I have located three different totals: 921, 1,200, and 2,000. For more, see F. Redlich, *Die volkswirtschaftliche Bedeutung der deutschen Teerfarbenindustrie* (Munich: Duncker and Humblot, 1914), pp. 11, 44.

58. A. Tager, "Why was the color violet rarely used by artists before the 1860s?," *Journal of Cognition and Culture*, vol. 18, nos. 3–4 (August 13, 2018).

59. Other lesser purples from the period included burned carmine, Indian purple, violet carmine, orchil, bismuth purple, burned madder, gold purple, Prussian purple, sandalwood purple, and tin violet. For a discussion, see Salter, *Field's Chromatography*, pp. 295–308.

60. J. Whistler to B. Whistler (June 11, 1891), MS. Whistler W584, Glasgow University Library, http://www.whistler.arts.gla.ac.uk/correspondence/freetext/display/?cid=6591andq=analineandyear1=1829andyear2=1903andrs=1 (accessed: August 30, 2017).

61. J. Reynolds, "Eighth discourse," in *The Literary Works of Sir Joshua Reynolds*, ed. H. Beechey, vol. 1 (London: Henry Bohn, 1846), p. 454.

62. Quoted in W. H. Hunt, *Pre-Raphaelitism and the Pre-Raphaelite Brotherhood*, vol. 1 (London: Macmillan, 1905), p. 88.

63. Holman Hunt used a particularly elaborate method to brighten his grounds. He purchased extra-primed white canvases, then covered them with a fresh white ground of his own, often of lead mixed with zinc. On the morning of each painting day he would add yet another fresh coat of white paint for the day. He sometimes even painted directly into the wet white ground, believing (erroneously) that it would make his colors even more brilliant.

64. For more on Holman Hunt's technique, see J. Townsend et al., *Pre-Raphaelite Painting Techniques 1848–56* (London: Tate, 2004), p. 62; and M. Katz, "William Holman Hunt and the Pre-Raphaelite technique," in *Historical Painting Techniques, Materials, and Studio Practice*, University of Leiden, June 26–29, 1995 (Los Angeles: Getty Conservation Institute, 1995), pp. 158–65.

65. For an important early interpretation, see J. D. Macmillan, "Holman Hunt's Hireling Shepherd: Some reflections on a Victorian pastoral," *Art Bulletin*, vol. 54, no. 2 (June 1972), pp. 187–97. For a different view, see K. D. Kriz, "An English arcadia revisited and reassessed: Holman Hunt's *The Hireling Shepherd* and the rural tradition," *Art History*, vol. 10, no. 4 (December 1987), pp. 475–91.

66. W. Holman Hunt to J. E. Phythian (January 21, 1897), Manchester City Art Gallery.

67. *The Albion* (June 5, 1852), p. 273; W. Thornbury, *The Life of J.M.W. Turner, R.A.: Founded on Letters and Papers Furnished by His Friends and Fellow Academicians*, vol. 2 (London: Hurst and Blackett, 1862), p. 211; *Athenaeum* (May 22, 1852), pp. 581–2.

68. A. Walker, *The Color Purple: A Novel* (New York: Harcourt Brace Jovanovich, 1982), p. 167. Walker later said she chose the hue because "it is always a surprise but it is everywhere in nature." A. Walker, "Preface to the tenth anniversary edition," *The Color Purple* (New York: Phoenix, 2011), p. i.

69. Arthur Hughes was mocked for his purple proclivities. "A violet poet in a violet copse, or a violet domestic fireside with a whole violet family" is how one critic described his work. *Cornhill Magazine*, vol. 6 (July to December 1862), p. 116.

70. V. Surtees, ed., *The Diary of Ford Madox Brown* (New Haven and London: Yale University Press, 1981), p. 19.

71. F. M. Brown, "List of favorite things" (October 2, 1866), *Ford Madox Brown Papers*, MA 4500. Pierpont Morgan Library, New York.

72. Quoted in L. Cabot Perry, "Reminiscences of Claude Monet from 1889 to 1909," *American Magazine of Art*, vol. 18, no. 3 (March 1927), p. 120.

73. Quoted in R. Fry, *Cézanne: A Study of His Development* (London: Macmillan, 1929), p. 57.

74. https://curiosity.com/topics/monet-may-have-been-able-to-see -ultraviolet-light-curiosity/ (accessed: March 11, 2021).

75. For more on Impressionist color, see G. Roque, "Chevreul and Impressionism: A reappraisal," *Art Bulletin*, vol. 78, no. 1 (1996), pp. 26–39.

76. Cited in L. A. Kalba, *Color in the Age of Impressionism: Commerce, Technology, and Art* (University Park: Pennsylvania State University Press, 2017), p. 113.

77. A. Wolff, *Le Figaro* (April 3, 1876), p. 1.

78. See A. de Lostalot, "Exposition des œuvres de M. Claude Monet," *Gazette des Beaux-Arts* (April 1, 1883), p. 344. For more, see O. Reutersvärd, "The 'violettomania' of the Impressionists," *Journal of Aesthetics and Art Criticism*, vol. 9, no. 2 (December 1950), pp. 106–10.

79. Quoted in B. Ehrlich White, ed., *Impressionism in Perspective* (Englewood Cliffs: Prentice Hall, 1978), p. 40.

80. J. K. Huysmans, "L'exposition des Indépendants en 1880," reprinted in *L'Art Moderne* (Paris: Librairie Plon, 1883), p. 90 (my translation).

81. M. Nordau, *Degeneration* (New York: Appleton, 1895), pp. 536–7.

82. Ibid., p. 48.

83. Quoted in E. Raynaud, *La Mêlée symboliste*, vol. 1 (Paris: Nizet, 1918), p. 64.

84. O. Wilde to R. Ross (May 14, 1900), in *Letters of Oscar Wilde*, ed. R. Hart-Davis (New York: Harcourt, Brace and World, 1962), p. 828.

85. J. K. Huysmans, *Against the Grain*, trans. J. Howard (New York: Lieber and Lewis, 1922), p. 48.

86. Quoted in J. Claretie, *La Vie à Paris, 1881* (Paris: Victor Havard, 1881), p. 226.

87. For more on the matter, see R. Baker, "Nineteenth century synthetic textile dyes: Their history and identification on fabric," PhD dissertation: University of Southampton, 2011), pp. 53–6. See also Dan Fagin's Pulitzer Prize–winning *Toms River: A Story of Science and Salvation* (New York: Bantam, 2013).

88. H. G. Wells, "The purple pileus," *Black and White* (December 1896).

89. F. White, "The purple terror," *Strand Magazine* (September 1898).

90. F. Jane, *The Violet Flame: A Story of Armageddon and After* (London: Ward, Lock, 1899).

91. For a brief but excellent summary of his life and work, see John Sutherland's introduction to M. P. Shiel, *The Purple Cloud* (London: Penguin, 2012).

92. M. P. Shiel, *The Purple Cloud* (London: Chatto and Windus, 1901), pp. 71–2.

93. Ibid., p. 113.

94. Ibid., p. 119.

95. Taine, *Notes on England*, pp. 7–8.

96. For more on the subject, see C. Corton, *London Fog: The Biography* (Cambridge, MA: Harvard University Press, 2015).

97. C. Monet to A. Monet (February 3, 1901), in *Monet by Himself*, ed. R. Kendall, trans. B. Strevens Romer (London: Time Warner, 2004), p. 137.

98. Quoted in D. Wildenstein, *Monet or the Triumph of Impressionism* (Cologne: Taschen, 1996), p. 345.

99. C. Dickens, *Our Mutual Friend* (London: Chapman and Hall, 1865), vol. 2, p. 1.

100. A. Watson, "The Lower Thames," *The Magazine of Art*, vol. 7 (1884), p. 109.

101. A. and T. Novakov, "The chromatic effects of late nineteenth-century London fog," *Literary London: Interdisciplinary Studies in the Representation of London*, vol. 4, no. 2 (September 2006).

CHAPTER 7: PARADISE LOST

1. H. Hodgkin, interview with A. Woods, "Where silence becomes objects," University of Dundee (1998), https://howard-hodgkin.com/resource/where-silence-becomes-objects (accessed: March 11, 2021).

2. The process is known as endosymbiosis. For a recent contribution to the topic, see J. de Vries and J. Archibald, "Did plastids evolve from a freshwater cyanobacterium?," *Current Biology*, vol. 27, no. 3 (February 6, 2017), pp. 103–5.

3. S. Reiney, "Carbon dioxide fertilization greening Earth, study finds," NASA (April 26, 2016), https://www.nasa.gov/feature/goddard/2016/carbon-dioxide-fertilization-greening-earth (accessed: September 8, 2017). Chlorophyll was first isolated and named 200 years ago. For the original study, see P. J. Pelletier and J.-B. Caventou, "Notice sur la matière verte des feuilles [chlorophylle]," *Journal de Pharmacie*, vol. 3 (1817), pp. 486–91.

4. "And here were forests ancient as the hills, / enfolding sunny spots of greenery." S. T. Coleridge, *Christabel; Kubla Khan: A Vision; The Pains of Sleep* (London: John Murray, 1816). For a discussion, see S. Perry, "Was Coleridge green?," in J. Rignall and H. G. Klaus, eds., *Ecology and the Literature of the British Left: The Red and the Green* (London and New York: Routledge, 2016), pp. 33–44.

NOTES

5. For a detailed discussion, see J. N. Nishio, "Why are higher plants green? Evolution of the higher plant photosynthetic pigment complement," *Plant, Cell and Environment*, vol. 23 (2000), pp. 539–48. See also K. Than, "Early Earth was purple, study suggests," *Live Science* (April 10, 2007), https://www.livescience.com/1398–early-earth-purple -study-suggests.html (accessed: January 29, 2018).

6. B. Milne et al., "Unraveling the intrinsic color of chlorophyll," *Angewandte Chemie*, vol. 127 (2015), pp. 2198–201.

7. See D. Lee, *Nature's Palette: The Science of Plant Color* (Chicago and London: University of Chicago Press, 2007), pp. 121–58.

8. For a discussion, see A. Bompas et al., "Spotting fruit versus picking fruit as the selective advantage of human color vision," *i-Perception*, vol. 4, no. 2 (2013), pp. 84–94.

9. See "green, adj. and n.1," *OED Online* (June 2017), Oxford University Press, http://www.oed.com/view/Entry/81167?rskey=IeA28Dandresult =2andisAdvanced=false (accessed: September 8, 2017).

10. J. Tierney et al., "Rainfall regimes of the green Sahara," *Science Advances*, vol. 3, no. 1 (January 18, 2017), http://advances.sciencemag .org/content/3/1/e1601503.full (accessed: January 29, 2018).

11. The minerals included amazonite, chrysocolla, fluorapatite, malachite, serpentinite, and turquoise. D. Mayer and N. Porat, "Green stone beads at the dawn of agriculture," *Proceedings of the National Academy of Sciences of the United States of America*, vol. 105, no. 25 (June 2008), pp. 8548–51.

12. Cited in J. Ragai, "Color: Its significance and production in ancient Egypt," *Endeavor*, vol. 10, no. 2 (1986), p. 77.

13. Quoted by R. Wilkinson, *Symbol and Magic in Egyptian Art* (London: Thames and Hudson, 1994), pp. 108–9.

14. R. Rands, "Some manifestations of water in Mesoamerican art," *Anthropological Papers 48: Smithsonian Institution Bureau of American Ethnology Bulletin*, no. 157 (1955), p. 356.

15. B. Sahagún, *Florentine Codex: General History of the Things of New Spain*, trans. A. Anderson and C. Dibble (Santa Fe: School of American Research, 1950–82), Book 11, p. 222.

16. C. Feest, "Vienna's Mexican treasures: Aztec, Mixtec, and Tarascan works from 16th century Austrian collections," *Archiv für Völkerkunde*, vol. 44 (1990), pp. 9–14.

17. "The fall of Tollan," in *History and Mythology of the Aztecs: The Codex Chimalpopoca*, trans. J. Bierhorst (Tucson: University of Arizona Press, 1992), p. 156.

269

18. H. von Bingen, *Hildegardis Causae et curae*, ed. P. Kaiser (Leipzig: Teubner, 1903), 105:17–20. For more, see V. Sweet, "Hildegard of Bingen and the greening of medieval medicine," *Bulletin of the History of Medicine*, vol. 73, no. 3 (fall 1999), pp. 381–402; and V. Sweet, *Rooted in the Earth, Rooted in the Sky: Hildegard of Bingen and Premodern Medicine* (London: Routledge, 2006), pp. 124–54.

19. J. de Courtois, *Le Blason de toutes armes et éscutz* (Paris: Pierre Le Caron, 1495), np. The translation is Michel Pastoureau's, in *Green: The History of a Color* (Princeton: Princeton University Press, 2014), p. 125.

20. See, for instance, at 16:13 and 35:27–8.

21. Qur'an 55:64.

22. See G. Doherty, *Paradoxes of Green: Landscapes of a City-State* (Oakland: University of California Press, 2017), p. 7.

23. Hadith 78:149, https://sunnah.com/bukhari/78 (accessed: January 29, 2018).

24. Hadith 97:92, https://sunnah.com/bukhari/97/92 (accessed: January 29, 2018).

25. Hadith 60:457, https://muflihun.com/bukhari/60/457 (accessed: January 29, 2018).

26. Quoted in S. Mahmoud, "Color and the mystics," in J. Bloom and S. Blair, eds., *And Diverse Are Their Hues: Color in Islamic Art and Culture* (New Haven: Yale University Press, 2011), p. 117.

27. For a discussion, see H. Corbin, *The Man of Light in Iranian Sufism*, trans. N. Pearson (New Lebanon: Omega, 1971), esp. pp. 76–80.

28. Reproduced in D. Roxburgh, ed., *Turks: A Journey of a Thousand Years, 600–1600* (London: Royal Academy of Arts, 2005), pp. 431–2.

29. For more on this subject, see E. Clark, *Underneath Which Rivers Flow: The Symbolism of the Islamic Garden* (London: Prince of Wales's Institute of Architecture, 1996); and E. Moynihan, *Paradise as a Garden in Persia and Mughal India* (London: Scolar Press, 1982).

30. Quoted in W. Begley, "The myth of the Taj Mahal and a new theory of its symbolic meaning," *Art Bulletin*, vol. 61, no. 1 (March 1979), p. 7.

31. Qur'an 89:27–30.

32. R. Carson, *Silent Spring* (Boston: Houghton Mifflin, 1962), pp. 14–15.

33. Ibid., p. 85.

34. L. Lear, *Rachel Carson: Witness for Nature* (Boston: Mariner Books, 1997), pp. 428–9. See also M. Smith, "'Silence, Miss Carson!' Science, Gender, and the Reception of 'Silent Spring,'" *Feminist Studies*, vol. 27, no. 3 (autumn 2001), pp. 733–52. For a sober critique of the book, see

R. Meiners and A. Morriss, "*Silent Spring* at 50: Reflections on an Environmental Classic," *PERC Policy Series*, no. 51 (2012), pp. 1–28.

35. K. Sale, *The Green Revolution: The American Environmental Movement 1962–1992* (New York: Hill and Wang, 1993), pp. 3–5.

36. See *Observer* (October 22, 1961), p. 14; *New York Times* (November 8, 1961), p. 37; and *New York Times* (June 10, 1962), p. 175.

37. See J. McCormick, *Reclaiming Paradise: The Global Environmental Movement* (Bloomington and Indianapolis: Indiana University Press, 1995), pp. 56–61.

38. W. Cronkite, *CBS News Special Report* (April 1970), https://www.youtube.com/watch?list=PL3480E41AA956A42Bandtime_continue=101andv=WbwC281uzUs (accessed: January 29, 2018).

39. These dates are taken from the *Oxford English Dictionary*.

40. "Black Power termed only a slogan—the color of real power is green," *Washington Post* (August 19, 1966), p. c1.

41. C. Reich, *The Greening of America* (Harmondsworth: Penguin, 1971), pp. 328–9.

42. Quoted in D. Schwarz, "The Greening of America turns 40," CBC News (September 23, 2010), http://www.cbc.ca/news/world/the-greening-of-america-turns-40-1.913853 (accessed: February 1, 2018).

43. L. West and J. Allen, "The green rebellion: Notes on the life and times of American hippies," *Sooner Magazine*, vol. 40 (1967), p. 6.

44. Ibid., p. 5.

45. See, for instance, *Washington Post* (November 20, 1969), p. H7.

46. My account is based on a personal interview with Bill Darnell (September 24, 2015). For a similar description of events, see R. Weyler, *Greenpeace: How a Group of Ecologists, Journalists and Visionaries Changed the World* (Emmaus: Rodale, 2004), pp. 66–8. See also F. Zelko, "Making Greenpeace: The development of direct action environmentalism in British Columbia," *BC Studies*, vols. 142–3 (summer/autumn 2004), pp. 236–7.

47. "Die Grünen," *Das Bundesprogramm* (1980), p. 4, my translation, https://www.boell.de/sites/default/files/assets/boell.de/images/download_de/publikationen/1980_001_Grundsatzprogramm_Die_Gruenen.pdf (accessed: January 29, 2018).

48. *Guardian* (September 23, 1985), p. 4.

49. Global Greens, "Member parties," https://www.globalgreens.org/member-partics (accessed: January 29, 2018).

50. For a discussion, see M. Humphrey, "Green ideology," in M. Freeden and M. Stears, eds., *Oxford Handbook of Political Ideologies*, http://www

.oxfordhandbooks.com/view/10.1093/oxfordhb/9780199585977
.001.0001/oxfordhb-9780199585977–e-011 (accessed: January 29, 2018).

51. J. Elkington and J. Hailes, *The Green Consumer Guide* (London: Victor Gollancz, 1988), p. 2.

52. The Sustainability Imperative, "New insights on consumer expectations" (October 2015), http://www.nielsen.com/content/dam/nielsenglobal/dk /docs/global-sustainability-report-oct-2015.pdf (accessed: January 29, 2018).

53. Author's interview (April 17, 2019).

54. Ibid.

55. For a detailed account of the origin of *Ash Dome*, see D. Nash, interviewed by D. Hooker (June 7, 1995), *National Life Stories: Artists' Lives C466/32*, https://sounds.bl.uk/related-content/TRANSCRIPTS/021T -C0466X0032XX-ZZZZA0.pdf (accessed: October 8, 2018).

56. D. Nash, quoted in J. Grande, "Real living art: A conversation with David Nash," *Sculpture*, vol. 20, no. 10 (December 2001), www.sculpture.org /documents/scmag01/dec01/nash/nash.shtml (accessed: September 20, 2018).

57. P. Larkin, "The Trees," *High Windows* (London: Faber and Faber, 1974), p. 6.

58. For an overview, see "Chalara dieback of ash (*Hymenoscyphus fraxineus*)," https://www.forestry.gov.uk/ashdieback (accessed: October 7, 2018). See also B. Wylder et al., "Evidence from mortality dating of *Fraxinus excelsior* indicates ash dieback (*Hymenoscyphus fraxineus*) was active in England in 2004–2005," *Forestry: An International Journal of Forest Research*, vol. 91, no. 4 (October 2018), pp. 434–43.

59. Author's interview (September 19, 2018).

60. J. Rockström, "Bounding the planetary future: Why we need a great transition" (April 2015), http://www.greattransition.org/images/GTI _publications/Rockstrom-Bounding_the_Planetary_Future.pdf (accessed: January 31, 2018).

61. S. Higgins and S. Scheiter, "Atmospheric CO_2 forces abrupt vegetation shifts locally, but not globally," *Nature*, vol. 488 (June 27, 2012), pp. 209–12.

62. S. Dutkiewicz et al., "Ocean color signature of climate change," *Nature Communications*, vol. 10, no. 578 (February 4, 2019), np.

63. A. Thompson, "Drought and climate change could throw fall colors off schedule," *Scientific American* (November 1, 2016), np.

64. A. Robock, "Stratospheric aerosol geoengineering," *Issues in Environmental Science and Technology*, vol. 38 (January 2014), pp. 162–85.

65. See Z. Zhu et al., "Greening of the Earth and its drivers," *Nature Climate Change*, vol. 5 (April 2016), pp. 791–5.
66. See, for instance, this widely covered but contested article: J.-F. Bastin et al., "The global tree restoration potential," *Science* (July 5, 2019), pp. 76–9.

THE WORLD ACCORDING TO COLOR

1. H. Zollinger, *Color Chemistry: Syntheses, Properties, and Applications of Organic Dyes and Pigments* (New York: John Wiley and Sons, 2003), p. 1.

Further Reading

Albers, J., *Interaction of Color* (New Haven and London: Yale University Press, 2013).

Balfour-Paul, J., *Indigo: Egyptian Mummies to Blue Jeans* (London: British Museum Press, 1998).

Ball, P., *Bright Earth: The Invention of Color* (London: Viking, 2001).

Batchelor, D., *Chromophobia* (London: Reaktion, 2001).

Batchelor, D., ed., *Color: Documents of Contemporary Art* (Cambridge, MA, and London: MIT Press and Whitechapel Gallery, 2008).

Batchelor, D., *The Luminous and the Grey* (London: Reaktion, 2014).

Berlin, B., and P. Kay, *Basic Color Terms: Their Universality and Evolution* (Berkeley: University of California Press, 1969).

Bloom, J., and S. Blair, eds., *And Diverse Are Their Hues: Color in Islamic Art and Culture* (New Haven: Yale University Press, 2011).

Brown, S., et al., eds., *Color and the Moving Image: History, Theory, Aesthetics* (London: Routledge, 2013).

Bucklow, S., *The Alchemy of Paint: Art, Science, and Secrets from the Middle Ages* (London: Marion Boyars, 2009).

Bucklow, S., *Red: The Art and Science of a Color* (London: Reaktion, 2016).

Byrne, A., and D. Hilbert, eds., *Readings on Color*, 2 vols. (Cambridge, MA, and London: MIT Press, 1997).

Deutscher, G., *Through the Language Glass: How Words Color Your World* (London: William Heinemann, 2010).

Doran, S., *The Culture of Yellow: The Visual Politics of Late Modernity* (London: Bloomsbury, 2013).

Dyer, R., *White: Essays on Race and Culture* (London: Routledge, 1997).

Fehrman, K., and C. Fehrman, *Color: The Secret Influence* (Upper Saddle River: Prentice Hall, 2000).

Gage, J., *Color and Culture: Practice and Meaning from Antiquity to Abstraction* (London: Thames and Hudson, 1994).

Gage, J., *Color and Meaning: Art, Science, and Symbolism* (Berkeley and Los Angeles: University of California Press, 1999).

Garfield, S., *Mauve: How One Man Invented a Color That Changed the World* (London: Faber and Faber, 2000).

Gass, W., *On Being Blue: A Philosophical Inquiry* (Manchester: Carcanet New Press, 1979).

George, V., *Whitewash and the New Aesthetic of the Protestant Reformation* (London: Pindar Press, 2013).

Gilchrist, A., *Seeing Black and White* (Oxford: Oxford University Press, 2006).

Harvey, J., *The Story of Black* (London: Reaktion, 2013).

Hills, P., *Venetian Color: Marble, Mosaic, Painting and Glass, 1250–1550* (New Haven and London: Yale University Press, 1999).

Houston, S., et al., *Veiled Brightness: A History of Ancient Mayan Color* (Austin: University of Texas Press, 2009).

Jarman, D., *Chroma* (London: Century, 1994).

Kuehni, R., and A. Schwarz, *Color Ordered: A Survey of Color Systems from Antiquity to the Present* (Oxford: Oxford University Press, 2008).

Lamb, T., and J. Bourriau, eds., *Color: Art and Science* (Cambridge: Cambridge University Press, 1995).

Lee, D., *Nature's Palette: The Science of Plant Color* (Chicago: University of Chicago Press, 2007).

Leslie, E., *Synthetic Worlds: Nature, Art and the Chemical Industry* (London: Reaktion, 2005).

Mavor, C., *Blue Mythologies: Reflections on a Color* (London: Reaktion, 2013).

Nassau, K., *The Physics and Chemistry of Color: The Fifteen Causes of Color* (New York: Wiley, 1983).

Nelson, M., *Bluets* (Seattle and New York: Wave Books, 2009).

Pamuk, O., *My Name Is Red*, trans. E. Göknar (London: Faber and Faber, 2001).

Pastoureau, M., *Blue: The History of a Color* (Princeton: Princeton University Press, 2001).

Pastoureau, M., *Black: The History of a Color* (Princeton: Princeton University Press, 2009).

Pastoureau, M., *Green: The History of a Color* (Princeton: Princeton University Press, 2014).

Phipps, E., *Cochineal: The Art History of a Color* (New Haven and London: Yale University Press, 2010).

Shevell, S., ed., *The Science of Color* (Kidlington: Optical Society of America, 2003).

Smith, B., *The Key of Green: Passion and Perception in Renaissance Culture* (Chicago and London: University of Chicago Press, 2009).

Taylor, G., *Buying Whiteness: Race, Culture, and Identity from Columbus to Hip-hop* (New York: Palgrave Macmillan, 2005).

Theroux, A., *The Primary Colors: Three Essays* (London: Picador, 1995).

Theroux, A., *The Secondary Colors: Three Essays* (New York: Henry Holt, 1996).

Tilley, R., *Color and the Optical Properties of Materials*, 2nd ed. (Chichester: Wiley and Sons, 2011).

Travis, A., *The Rainbow Makers: Origins of the Synthetic Dyestuffs Industry in Western Europe* (Bethlehem: Lehigh University Press, 1993).

Index

Nefertiti, 81–2, 82
Neoclassicism, 149–51, 155
Neolithic communities, 200, 223, 224–5
Nero, Roman Emperor, 170
Nerval, Gerard de, 31–2
Newton, Isaac, 12, 22–3, 100, 101, 144, 150
Nicholson, Ben, 154
Nicholson, Edward Chambers, 176–8, 194
Nivea (German brand), 165–6
Nizâmî Ganjavî, *Haft Paykar* (*Seven Beauties*), 1–2, 12
nopal (prickly pear cactus), 59, 60
Nordau, Max, *Entartung* (*Degeneration*), 186–7
Norham Castle, Sunrise (Turner painting), 107
Norse mythology, 86, 112
Novalis (Friedrich von Hardenberg), *Heinrich von Ofterdingen*, 122–4, 125
nuclear fusion, 4, 79
nuclear tests, 215
nut oil, 181

Oak Leaves Through May (David Nash artwork), 218–19
occult beliefs, 16
ochre, 48, 52–6, 61–2, 69, 70–1, 224
the Olmecs, 202
Olympia, 152
Optical Society of America, 12
orange, 4, 12, 22–3, 70, 93, 94, 100, 102, 113, 205
Ottens, Sarah Ann, 74
Ottoman Turks, 208
oxygen, 50, 79, 98, 172

oxygenated blood, 50, 60, 61, 68
and photosynthesis, 197

Paestum, 149
pagan societies, 86, 89, 97, 204
paints/pigments/colorants, x
achiotl (or *annatto*, red colorant), 58–9
alizarin crimson, 185
blacks produced by light and heat, 25, 38
blues imported to Europe, 117
breakthroughs of 1850s, 167–8, 180, 185–6, 188, 225
cadmium, 169
"carbon black," 25
chromatic revolution (from end of fifteenth century), 118–22
chrome yellow, 104–6, 107, 108, 169
cobalt blue, 169, 208
cochineal (*dactylopius coccus*), 59–61
"color shops" (*vendecolori*) in Venice, 118–19
Egyptian blue, 225
emerald green, 169, 181, 207
greens made from arsenic, 169
ink, 38–40, 43, 46, 101
Islamic greens, 208–9
kaqche' (red colorant), 59
Yves Klein's blue, 134–6
kokowai (Maori paint), 56
medieval industry, 118–19
new at end of Neolithic period, 224–5
otjize (red paste), 54–5
Prussian blue, 131, 168–9, 184
red ochre, 48, 52–6, 61–2, 69, 70–1, 224